Portable Edition | Book 2 **Fifth Edition**

ART HISTORY

Medieval Art

MARILYN STOKSTAD

Judith Harris Murphy Distinguished Professor of Art History Emerita
The University of Kansas

MICHAEL W. COTHREN

Scheuer Family Professor of Humanities
Department of Art, Swarthmore College

PEARSON

Boston Columbus Indianapolis New York San Francisco Upper Saddle River
Amsterdam Cape Town Dubai London Madrid Milan Munich Paris Montréal Toronto
Delhi Mexico City São Paulo Sydney Hong Kong Seoul Singapore Taipei Tokyo

Editorial Director: Craig Campanella
Editor in Chief: Sarah Touborg
Senior Sponsoring Editor: Helen Ronan
Editorial Assistant: Victoria Engros
Vice-President, Director of Marketing: Brandy Dawson
Executive Marketing Manager: Kate Mitchell
Marketing Assistant: Paige Patunas
Managing Editor: Melissa Feimer
Project Managers: Barbara Cappuccio and Marlene Gassler
Senior Operations Supervisor: Mary Fischer
Operations Specialist: Diane Peirano
Media Director: Brian Hyland
Senior Media Editor: David Alick
Media Project Manager: Rich Barnes
Pearson Imaging Center: Corin Skidds
Printer/Binder: Courier / Kendallville
Cover Printer: Lehigh-Phoenix Color / Hagerstown

This book was designed by
Laurence King Publishing Ltd, London
www.laurenceking.com

Editorial Manager: Kara Hattersley-Smith
Senior Editor: Clare Double
Production Manager: Simon Walsh
Page Design: Nick Newton
Cover Design: Jo Fernandes
Picture Researcher: Evi Peroulaki
Copy Editor: Jennifer Speake
Indexer: Vicki Robinson

Cover image: Bishop Odo Blessing the Feast from the Bayeux Embroidery. Norman–Anglo-Saxon, perhaps from Canterbury, Kent, England. c. 1066–1082. Linen with wool embroidery, height 20″ (50.8 cm). Musée de la Tapisserie, Bayeux, France/The Bridgeman Art Library.

Credits and acknowledgments borrowed from other sources and reproduced, with permission, in this textbook appear on the appropriate page within text or on the credit pages in the back of this book.

Library of Congress Cataloging-in-Publication Data
Stokstad, Marilyn
 Art history / Marilyn Stokstad, Judith Harris Murphy Distinguished
Professor of Art History Emerita, The University of Kansas, Michael W.
Cothren, Scheuer Family Professor of Humanities, Department of Art,
Swarthmore College. -- Fifth edition.
 pages cm
 Includes bibliographical references and index.
 ISBN-13: 978-0-205-87347-0 (hardcover)
 ISBN-10: 0-205-87347-2 (hardcover)
1. Art--History--Textbooks. I. Cothren, Michael Watt. II. Title.
 N5300.S923 2013
 709--dc23

 2012027450

10 9 8 7 6 5 4 3

Prentice Hall
is an print of

PEARSON

www.pearsonhighered.com

ISBN 10: 0-205-87377-4
ISBN 13: 978-0-205-87377-7

Contents

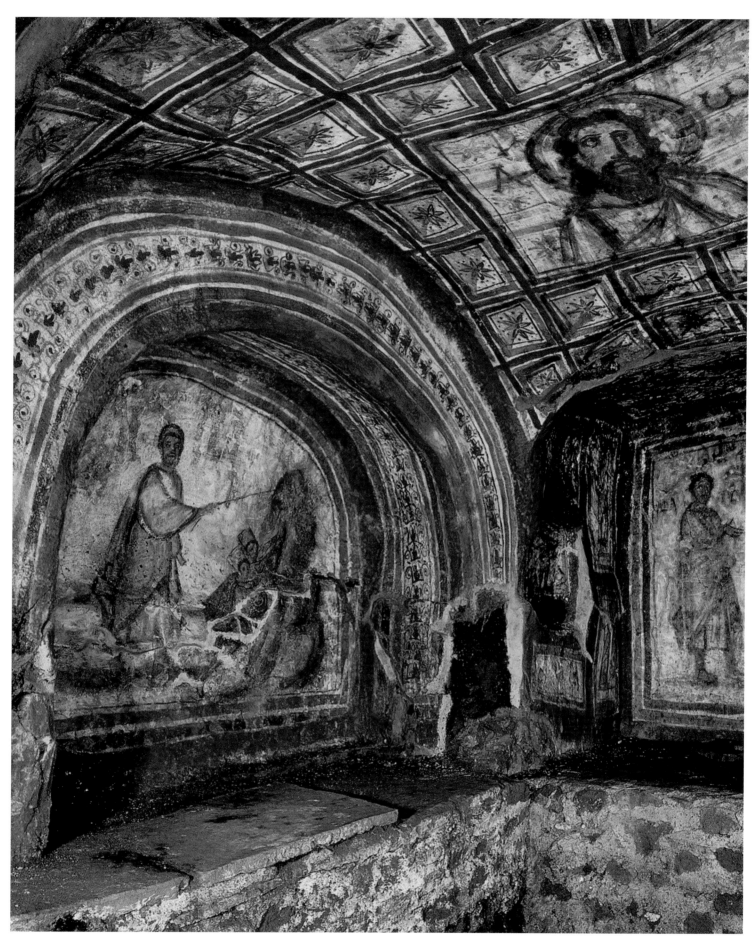

7-1 • CUBICULUM OF LEONIS, CATACOMB OF COMMODILLA
Near Rome. Late 4th century.

Jewish and Early Christian Art

In this painting in a Roman **catacomb** (underground cemetery) (**FIG. 7-1**), St. Peter, like Moses before him, strikes a rock and water flows from it (scene at left). Imprisoned in Rome at the end of his missionary journeys, Peter was said to have converted his fellow prisoners and jailers to Christianity, but he needed water with which to baptize them. Miraculously, a spring gushed forth at the touch of his staff. In spite of his all too human frailty, Peter became the rock (Greek *petros*) on which Jesus founded the Church. He was considered the first bishop of Rome, predecessor of today's pope. By including this episode from the life of Peter in the chamber's decoration, the early Christians, who dug this catacomb as a place to bury their dead, may have sought to emphasize the importance of their own city in Christian history.

In the star-studded heavens painted on the vault of this chamber, floats the face of Christ, flanked by the first and last letters of the Greek alphabet, alpha and omega. Here Christ takes on the guise not of the youthful teacher or miracle worker seen so often in Early Christian art, but of a more mature Greek philosopher, with long beard and hair. The **halo** (circle) of light around his head indicates his importance and his divinity, a symbol appropriated from the conventions of late Roman imperial art, where haloes often appeared around the heads of emperors.

These two catacomb paintings represent two major directions of early Christian art—the narrative and the iconic—that will continue to be important as this visual tradition develops. The **narrative image** recounts an event drawn from St. Peter's life—striking the rock for water—which in turn evokes the establishment of the Church as well as the essential Christian rite of baptism. The **iconic image**—Christ's face flanked by alpha and omega—offers a tangible expression of an intangible concept. The letters signify the beginning and end of time, and, combined with the image of Christ, symbolically represent not a story, but an idea—the everlasting dominion of the heavenly Christ.

Throughout the long and continuing history of Christian art these two tendencies will be apparent—the narrative urge to tell a good story, whose moral or theological implications often have instructional value, and the desire to create iconic images that symbolize the core concepts and values of the developing religious tradition. In both cases, the works of art take on meaning only in relation to viewers' stored knowledge of Christian stories and beliefs. This art was made not to teach non-readers new stories or concepts, as is so often claimed, but rather to remind faithful viewers of stories they had already heard—perhaps to draw specific lessons in their retelling—or to highlight ideas that were central to religious belief and would guide the religious devotional practice it inspired.

LEARN ABOUT IT

7.1 Investigate of the ways in which late antique Jewish and Christian art developed from the artistic traditions of the ancient Roman world.

7.2 Interpret how late antique Jewish and Christian artists used narrative and iconic imagery to convey the foundations of the Christian faith for those already initiated into the life of the Church.

7.3 Understand the relationship between the art and architecture of Jewish and Christian communities and their cultural and political situation within the late Roman Empire.

7.4 Analyze the connection between form and function in buildings created for worship.

((•—[**Listen** to the chapter audio on myartslab.com

JEWS, CHRISTIANS, AND MUSLIMS

Three religions that arose in the Near East still dominate the spiritual life of the Western world today: Judaism, Christianity, and Islam. All three are monotheistic—believing that the same God of Abraham created and rules the universe, and hears the prayers of the faithful. Jews believe that God made a covenant, or pact, with their ancestors, the Hebrews, and that they are God's chosen people. They await the coming of a savior, the Messiah, "the anointed one." Christians believe that Jesus of Nazareth was that Messiah (the name Christ is derived from the Greek term meaning "Messiah"). They believe that in Jesus, God took human form, preached among men and women, suffered execution, then rose from the dead and ascended to heaven after establishing the Christian Church under the leadership of the apostles (his closest disciples). Muslims, while accepting the Hebrew prophets and Jesus as divinely inspired, believe Muhammad to be the last and greatest prophet of God (Allah), the Messenger of God through whom Islam was revealed some six centuries after Jesus' lifetime.

All three are "religions of the book," that is, they have written records of God's will and words: the Hebrew Bible; the Christian Bible, which includes the Hebrew Bible as its Old Testament as well as the Christian New Testament; and the Muslim Qur'an, believed to be the Word of God as revealed in Arabic directly to Muhammad through the archangel Gabriel.

JUDAISM AND CHRISTIANITY IN THE LATE ROMAN WORLD

Both Judaism and Christianity existed within the Roman Empire, along with various other religions devoted to the worship of many gods. The variety of religious buildings excavated in present-day Syria at the abandoned Roman outpost of Dura-Europos (see "Dura-Europos," page 221) represents the cosmopolitan religious character of Roman society in the second and third centuries. The settlement—destroyed in 256 CE—included a Jewish house-synagogue, a Christian house-church, shrines to the Persian cults of Mithras and Zoroaster, and temples to Greek and Roman gods, including Zeus and Artemis.

EARLY JEWISH ART

Although we concentrate here on the art and architecture of the late Roman world, Jewish art has a much longer history. The Jewish people trace their origin to a Semitic people called the Hebrews, who lived in the land of Canaan. Canaan, known from the second century CE by the Roman name Palestine, was located along the eastern edge of the Mediterranean Sea (MAP 7–1). According to the Torah—the first five books of the Hebrew Bible—God promised the patriarch Abraham that Canaan would be a homeland for the Jewish people (Genesis 17:8), a belief that remains important for some Jews to this day.

Jewish settlement of Canaan probably began sometime in the second millennium BCE. According to Exodus, the second book of

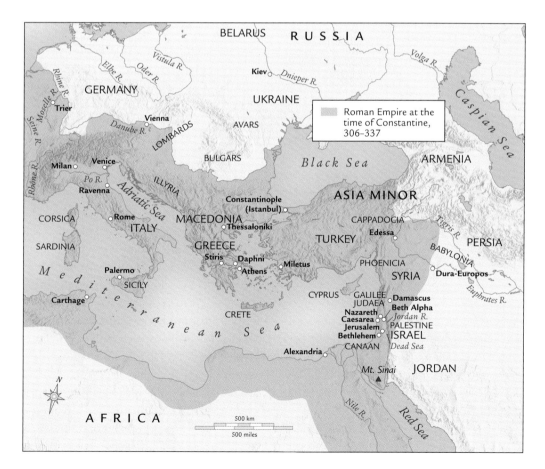

MAP 7–1 • THE LATE ROMAN AND BYZANTINE WORLD

During the period that saw the early spread of Christianity and ultimately its legalization by Constantine, the Roman Empire still extended completely around the shores of the Mediterranean Sea.

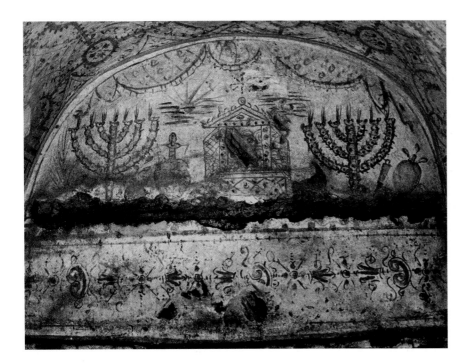

7-2 • ARK OF THE COVENANT AND MENORAHS
Wall painting in a Jewish catacomb, Villa Torlonia, Rome. 3rd century. 3′11″ × 5′9″ (1.19 × 1.8 m).

The menorah form probably derives from the ancient Near Eastern Tree of Life, symbolizing for the Jewish people both the end of exile and the paradise to come.

the Torah, the prophet Moses led the Hebrews out of slavery in Egypt to the promised land of Canaan. At one crucial point during the journey, Moses climbed alone to the top of Mount Sinai, where God gave him the Ten Commandments, the cornerstone of Jewish law. The commandments, inscribed on tablets, were kept in a gold-covered wooden box, the Ark of the Covenant.

Jewish law forbade the worship of idols, a prohibition that often made the representational arts—especially sculpture in the round—suspect. Nevertheless, artists working for Jewish patrons depicted both symbolic and narrative Jewish subjects, and they drew from the traditions of both Near Eastern and Classical Greek and Roman art.

THE FIRST TEMPLE IN JERUSALEM In the tenth century BCE, the Jewish king Solomon built a temple in Jerusalem to house the Ark of the Covenant. According to the Hebrew Bible (2 Chronicles 2–7), he sent to nearby Phoenicia for cedar, cypress, and sandalwood, and for a superb construction supervisor. Later known as the First Temple, this building was the spiritual center of Jewish life. Biblical texts describe courtyards, two bronze pillars (large, free-standing architectural forms), an entrance hall, a main hall, and the Holy of Holies, the innermost chamber that housed the Ark and its guardian cherubim, or attendant angels.

In 586 BCE, the Babylonians, under King Nebuchadnezzar II, conquered Jerusalem. They destroyed the Temple, exiled the Jews, and carried off the Ark of the Covenant. When Cyrus the Great of Persia conquered Babylonia in 539 BCE, he permitted the Jews to return to their homeland (Ezra 1:1–4) and rebuild the Temple, which became known as the Second Temple. When Canaan became part of the Roman Empire, Herod the Great (king of Judaea, 37–34 BCE) restored the Second Temple. In 70 CE, Roman forces led by the general and future emperor Titus destroyed and looted the Second Temple and all of Jerusalem, a campaign the Romans commemorated on the Arch of Titus (see FIG. 6-37). The site of the Second Temple, the Temple Mount, is also an Islamic holy site, the Haram al-Sharif, and is now occupied by the shrine called the Dome of the Rock (see FIGS. 9-3, 9-4).

JEWISH CATACOMB ART IN ROME Most of the earliest surviving examples of Jewish art date from the Hellenistic and Roman periods. Six Jewish catacombs, discovered on the outskirts of Rome and in use from the first to fourth centuries CE, display wall paintings with Jewish themes. In one example, from the third century CE, two menorahs flank the long-lost **ARK OF THE COVENANT (FIG. 7-2)**. The continuing representation of the menorah, one of the precious objects looted from the Second Temple, kept the memory of the lost Jewish treasures alive.

SYNAGOGUES Judaism has long emphasized religious learning. Jews gather in synagogues for study of the Torah—considered a form of worship. A synagogue can be any large room where the Torah scrolls are kept and read; it was also the site of communal social gatherings. Some synagogues were located in private homes or in buildings originally constructed like homes. The first Dura-Europos synagogue consisted of an assembly hall, a separate alcove for women, and a courtyard. After a remodeling of the building, completed in 244–245 CE, men and women shared the hall, and residential rooms were added. Two architectural features distinguished the assembly hall: a bench along its walls and a niche for the Torah scrolls (FIG. 7-3).

Scenes from Jewish history and the story of Moses, as recorded in Exodus, unfold in a continuous visual narrative around the room, employing the Roman tradition of epic historical presentation (see FIG. 6-48). In the scene of **THE CROSSING OF THE RED**

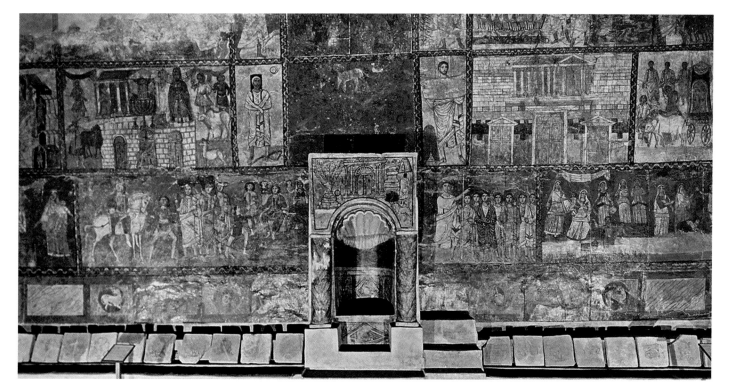

7–3 • WALL WITH TORAH NICHE
From a house-synagogue, Dura-Europos, Syria. 244–245 CE. Tempera on plaster, section approx. 40′ (12.19 m) long.
Reconstructed in the National Museum, Damascus, Syria.

SEA (**FIG. 7–4**), Moses appears twice to signal sequential moments in the dramatic narrative. To the left he leans toward the army of Pharaoh, which is marching along the path that had been created for the Hebrews by God's miraculous parting of the waters, but at the right, wielding his authoritative staff, Moses returns the waters over the Egyptian soldiers to prevent their pursuit. Over each scene hovers a large hand, representing God's presence in both miracles—the parting and the unparting—using a symbol that will also be frequent in Christian art. Hierarchic scale makes it clear who is the hero in this two-part narrative, but the clue to his identity is provided only by the context of the story, which observers would have already known.

In addition to house-synagogues, Jews built meeting places designed on the model of the ancient Roman basilica. A typical

7–4 • THE CROSSING OF THE RED SEA
Detail of a wall painting from a house-synagogue, Dura-Europos, Syria. 244–245 CE. National Museum, Damascus, Syria.

A CLOSER LOOK | The Mosaic Floor of the Beth Alpha Synagogue

by Marianos and Hanina. Ritual Objects, Celestial Diagram, and Sacrifice of Isaac. Galilee, Israel. 6th century CE.

The shrine that holds the Torah is flanked by menorahs and growling lions, the latter perhaps as a security system to protect such sacred objects.

The figures in the four corners are winged personifications of the seasons; this figure holding a shepherd's crook and accompanied by a bird is Spring.

At the center of the zodiac wheel is a representation of the sun in a chariot set against a night sky studded with stars and a crescent moon.

The 12 signs of the zodiac appear in chronological order following a clockwise arrangement around the wheel of a year, implying perpetual continuity since the series has no set beginning and no end. This is Scorpio.

The peaceful coexistence of the lion and the ox (predator and prey) may represent a golden age or peaceable kingdom (Isaiah 11:6–9; 65:25).

Torah shrine and ritual objects.

The Metaphysical Realm

The sun, seasons, and signs of the zodiac.

The Celestial Realm

The Sacrifice of Isaac (Genesis 22:1–19).

The Terrestrial Realm

This ram (identified by inscription) will ultimately take Isaac's place as sacrificial offering. Throughout the mosaic, animals are shown consistently in profile, human beings frontally.

These two texts—one in Aramaic and one in Greek—identify the artists of the mosaic as Marianos and his son Hanina, and date their work to the reign of either Emperor Justin I (518–527) or Justin II (565–578).

Abraham, preparing to sacrifice Isaac, is interrupted by the hand of God rather than by the angel specified in the Bible. Both Abraham and Isaac are identified by inscription, but Abraham's advanced age is signaled pictorially by the streaks of gray in his beard.

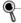 **View** the Closer Look for the mosaic floor of the Beth Alpha Synagogue on myartslab.com

basilica synagogue had a central nave; an aisle on both sides, separated from the nave by a line of columns; a semicircular apse with Torah shrine in the wall facing Jerusalem; and perhaps an atrium and porch, or **narthex** (vestibule). The small fifth-century CE synagogue at Beth Alpha—discovered between the Gilboa mountains and the River Jordan by farmers in 1928—fits well into this pattern, with a three-nave interior, vestibule, and courtyard. Like some other very grand synagogues, it also has a mosaic floor, in this case a later addition from the sixth century. Most of the floor decoration is geometric in design, but in the central nave there are three complex panels full of figural compositions and symbols (see "A Closer Look," page 219) created using 21 separate colors of stone and glass tesserae. The images of ritual objects, a celestial diagram of the zodiac, and a scene of Abraham's near-sacrifice of Isaac, bordered by strips of foliate and geometric ornament, draw on both Classical and Near Eastern pictorial traditions.

EARLY CHRISTIAN ART

At age 30, a Palestinian Jew named Jesus gathered a group of followers, male and female. He performed miracles of healing and preached love of God and neighbor, the sanctity of social justice, the forgiveness of sins, and the promise of life after death. Christian belief holds that, after his ministry on Earth, Jesus was executed by crucifixion, and after three days rose from the dead.

THE CHRISTIAN BIBLE The Christian Bible is divided into two parts: the Old Testament (the Hebrew Bible) and the New Testament. The life and teachings of Jesus of Nazareth were recorded between about 70 and 100 CE in New Testament Gospels attributed to the four evangelists (from the Greek *evangelion*, meaning "good news"): Matthew, Mark, Luke, and John. The order was set by St. Jerome, an early Church scholar who translated the Christian scriptures from Greek into Latin.

In addition to the four Gospels, the New Testament includes the Acts of the Apostles and the Epistles, 21 letters of advice and encouragement written to Christian communities in Greece, Asia Minor, and other parts of the Roman Empire. The final book is Revelation (Apocalypse), a series of enigmatic visions and prophecies concerning the eventual triumph of God at the end of the world, written about 95 CE.

THE EARLY CHURCH Jesus limited his ministry primarily to Jews; it was his apostles, as well as later followers such as Paul, who took his teachings to gentiles (non-Jews). Despite sporadic persecutions, Christianity persisted and spread throughout the Roman Empire. The government formally recognized the religion in 313, and Christianity grew rapidly during the fourth century. As well-educated, upper-class Romans joined the Christian Church, they established an increasingly elaborate organizational structure, ever-more complicated rituals and doctrine, and ambitious and elaborate works of art and architecture.

Christian communities became organized by geographic units, called dioceses, along the lines of Roman provincial governments. Senior church officials called bishops served as governors of dioceses made up of smaller units, known as parishes, headed by priests. A bishop's church is a **cathedral**, a word derived from the Latin *cathedra*, which means "chair" but took on the meaning of "bishop's throne."

Communal Christian worship focused on the central "mystery," or miracle, of the Incarnation of God in Jesus Christ and the promise of salvation. At its core was the ritual consumption of bread and wine, identified as the Body and Blood of Christ, which Jesus had inaugurated at the Last Supper, a Passover seder meal with his disciples just before his crucifixion. Around these acts developed an elaborate religious ceremony, or liturgy, called the **Eucharist** (also known as Holy Communion or the Mass).

The earliest Christians gathered to worship in private apartments or houses, or in buildings constructed after domestic models such as the third-century church-house excavated at Dura-Europos (see "Dura-Europos," opposite). As their worship became more ritualized and complicated, however, Christians developed special buildings—churches and baptisteries—as well as specialized ritual equipment. They also began to use art to visualize their most important stories and ideas (see FIG. 7–1). The earliest surviving Christian art dates to the early third century and derives its styles and its imagery from Jewish and Roman visual traditions. In this process, known as **syncretism**, artists assimilate images from other traditions—either unconsciously or deliberately—and give them new meanings. For example, **orant** figures—worshipers with arms outstretched in prayer—can be pagan, Jewish, or Christian, depending on the context in which they occur. Perhaps the best-known syncretic image is the Good Shepherd. In pagan art, he was Apollo, or Hermes the shepherd, or Orpheus among the animals, or a personification of philanthropy. For Early Christians, he became the Good Shepherd of the Psalms (Psalm 23) and the Gospels (Matthew 18:12–14, John 10:11–16). Such images, therefore, do not have a stable meaning, but are associated with the meaning(s) that a particular viewer brings to them. They remind rather than instruct.

CATACOMB PAINTINGS Christians, like Jews, used catacombs for burials and funeral ceremonies, not as places of worship. In the Christian Catacomb of Commodilla, dating from the fourth century, long rectangular niches in the walls, called *loculi*, each held two or three bodies. Affluent families created small rooms, or **cubicula** (singular, *cubiculum*), off the main passages to house sarcophagi (see FIG. 7–1). The *cubicula* were hewn out of tufo, a soft volcanic rock, then plastered and painted with imagery related to their owners' religious beliefs. The finest Early Christian catacomb paintings resemble murals in houses such as those preserved at Rome and Pompeii.

One fourth-century Roman catacomb contained remains, or relics, of SS. Peter and Marcellinus, two third-century Christians

Our understanding of buildings used for worship by third-century Jews and Christians was greatly enhanced—even revolutionized—by the spectacular discoveries made in the 1930s while excavating the Roman military garrison and border town of Dura-Europos (in modern Syria). In 256, threatened by the Parthians attacking from the east, residents of Dura built a huge earthwork mound around their town in an attempt to protect themselves from the invading armies. In the process—since they were located on the city's margins right against its defensive stone wall—the houses used by Jews and Christians as places of worship were buried under the earthwork perimeter. In spite of this enhanced fortification, the Parthians conquered Dura-Europos. But since the victors never unearthed the submerged margins of the city, an intact Jewish house-synagogue and Christian house-church remained underground awaiting the explorations of modern archaeologists.

We have already seen the extensive strip narratives flanking the Torah shrine in the house-synagogue (see FIG. 7–3). The discovery of this expansive pictorial decoration contradicted a long-held scholarly belief that Jews of this period avoided figural decoration of any sort, in conformity with Mosaic law (Exodus 20:4). And a few blocks down the street that ran along the city wall, a typical Roman house built around a central courtyard held another surprise. Only a discreet red cross above the door distinguished it from the other houses on its block, but the arrangement of the interior clearly documents its use as a Christian place of worship. A large assembly hall that could seat 60–70 people lies on one side of the courtyard, and across from it is a smaller but extensively decorated room with a water tank set aside for baptism, the central rite of Christian initiation (**FIG. 7–5**). Along the walls were scenes from Christ's miracles and a monumental portrayal of women visiting his tomb about to discover his resurrection (below). Above the baptismal basin is a **lunette** (semicircular wall section) featuring the Good Shepherd with his flock, but also including at lower left diminutive figures of Adam and Eve covering themselves in shame after their sinful disobedience (**FIG. 7–6**). Even this early in Christian art, sacred spaces were decorated with pictures proclaiming the theological meaning of the rituals they housed. In this painting, Adam and Eve's fall from grace is juxtaposed with a larger image of the Good Shepherd (representing Jesus) who came to Earth to care for and guide his sheep (Christian believers) toward redemption and eternal life—a message that was especially appropriate juxtaposed with the rite of Christian baptism, which signaled the converts' passage from sin to salvation.

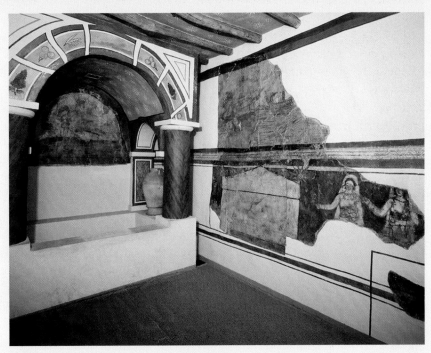

7–5 • RECONSTRUCTION OF BAPTISTERY, WITH FRAGMENTS OF ORIGINAL FRESCO
From Christian house-church, Dura-Europos, Syria. Before 256. Yale University Art Gallery, New Haven, Connecticut.

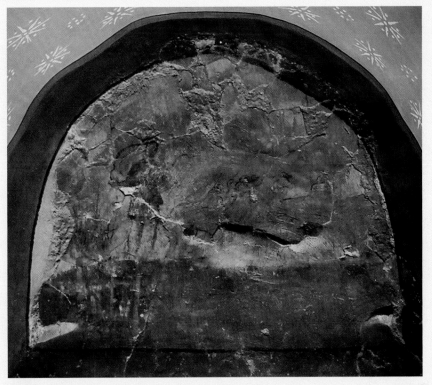

7–6 • THE GOOD SHEPHERD WITH ADAM AND EVE AFTER THE FALL
Detail of lunette fresco in FIG. 7–5.

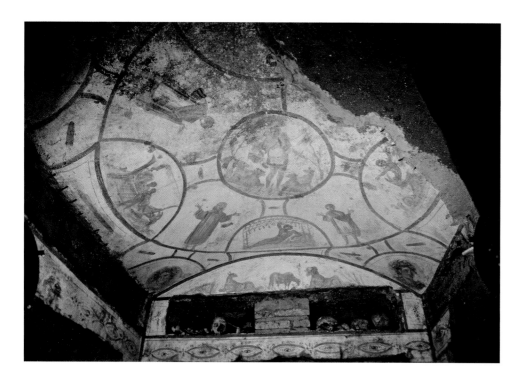

martyred for their faith. Here, the ceiling of a *cubiculum* is partitioned by a central **medallion**, or round compartment, and four semicircular lunettes, framed by arches (**FIG. 7-7**). At the center is a Good Shepherd, whose pose has roots in Classical sculpture. In its new context, the image was a reminder of Jesus' promise "I am the good shepherd. A good shepherd lays down his life for the sheep" (John 10:11).

The semicircular compartments surrounding the Good Shepherd tell the story of Jonah and the sea monster from the Hebrew Bible (Jonah 1–2), in which God caused Jonah to be thrown overboard, swallowed by the monster, and released, repentant and unscathed, three days later. Christians reinterpreted this story as a parable of Christ's death and resurrection—and hence of the everlasting life awaiting true believers—and it was a popular subject in Christian catacombs. On the left, Jonah is thrown from the boat; on the right, the monster spits him up; and below, between these two scenes, Jonah reclines in the shade of a vine, a symbol of paradise. Orant figures stand between the lunettes, presumably images of the faithful Christians who were buried here.

SCULPTURE Early Christian sculpture before the fourth century is rarer than painting. What survives is mainly sarcophagi and small statues and reliefs. A remarkable set of small marble figures, discovered in the 1960s and probably made in third-century Asia Minor, features a gracious **GOOD SHEPHERD** (**FIG. 7-8**). Because it was found with sculptures depicting Jonah—as we have already seen, a popular Early Christian theme—it is probably from a Christian context.

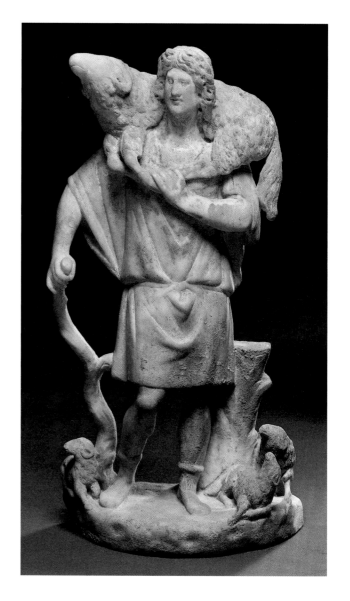

7-8 • THE GOOD SHEPHERD
Eastern Mediterranean, probably Anatolia (Turkey). Second half of the 3rd century. Marble, height 19¾" (50.2 cm), width 6" (15.9 cm). Cleveland Museum of Art. John L. Severance Fund (1965.241)

IMPERIAL CHRISTIAN ARCHITECTURE AND ART

When Constantine issued the Edict of Milan in 313, granting all people in the Roman Empire freedom to worship whatever god they wished, Christianity and Christian art and architecture entered a new phase. Sophisticated philosophical and ethical systems developed, incorporating many ideas from Greek and Roman pagan thought. Church scholars edited and commented on the Bible, and the papal secretary who would become St. Jerome (c. 347–420) undertook a new translation from Hebrew and Greek versions into Latin, the language of the Western Church. The so-called Vulgate (from the same root as the word "vulgar," the Latin *vulgaris*, meaning "common" or "popular") became the official version of the Bible.

ROME

The developing Christian community had special architectural needs. Greek temples had served as the house and treasury of the gods, forming a backdrop for ceremonies that took place at altars in the open air, but with Christianity, an entire community needed to gather inside a building to worship. Christians also needed locations for special activities such as the initiation of new members, private devotion, and burials. Beginning with the age of Constantine, pagan basilicas provided the model for congregational churches, and tombs provided a model for baptisteries and martyrs' shrines (see "Longitudinal-Plan and Central-Plan Churches," page 225).

OLD ST. PETER'S Constantine ordered the construction of a large new basilican church to mark the place where Christians believed St. Peter was buried (**FIGS. 7-9, 7-13**). Our knowledge of what is now called Old St. Peter's (it was destroyed and replaced by a new building in the sixteenth century) is based on written descriptions, drawings made before and while it was being dismantled, the study of other churches inspired by it, and modern archaeological excavations at the site.

Old St. Peter's included architectural elements in an arrangement that has characterized Christian basilican churches ever since. An atrium, or courtyard, in front of the basilica and a narthex across its width in the entrance end provided a place for people who had not yet been baptized. Five doorways—a large, central portal into the nave and two portals on each side—gave access to the church. Columns supporting an entablature lined the nave, forming what is called a nave colonnade. Running parallel to the nave colonnade on each side was another row of columns that created double side aisles; these columns supported round arches rather than an entablature. The roofs of both nave and aisles were supported by wooden rafters. Sarcophagi and tombs lined the side aisles and graves were dug under the floor. At the apse end of the nave, Constantine's architects added an innovative transept—a perpendicular hall crossing in front of the apse. This area provided additional

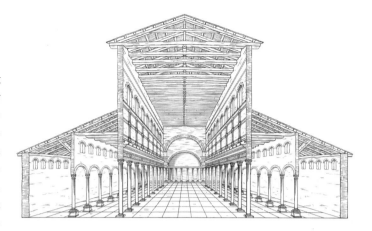

7-9 • RECONSTRUCTION DRAWING OF THE INTERIOR OF OLD ST. PETER'S, ROME
c. 320–327.

Read the document related to Old St. Peter's on myartslab.com

space for the large number of clergy serving the church, and it also accommodated pilgrims visiting the tomb of St. Peter. Old St. Peter's could hold at least 14,000 worshipers, and it remained the largest church in Christendom until the eleventh century.

SANTA SABINA Old St. Peter's is gone, but the church of Santa Sabina in Rome, constructed by Bishop Peter of Illyria (a region in the Balkan peninsula) a century later, between about 422 and 432, appears much as it did in the fifth century (**FIGS. 7-10, 7-11**). The basic elements of the Early Christian basilica are clearly visible here, inside and out: a nave lit by clerestory windows, flanked by single side aisles, and ending in a rounded apse.

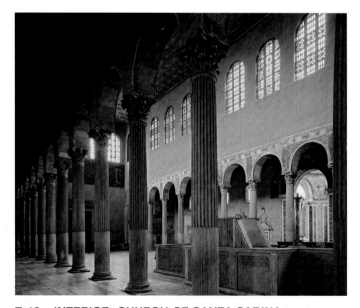

7-10 • INTERIOR, CHURCH OF SANTA SABINA
View from the south aisle near the sanctuary toward the entrance.
c. 422–432.

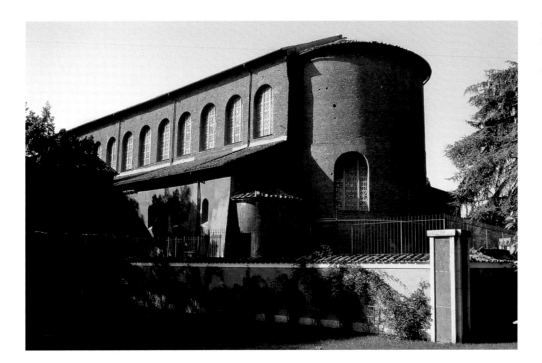

Santa Sabina's exterior is simple brickwork. In contrast, the church's interior displays a wealth of marble veneer and 24 fluted marble columns with Corinthian capitals reused from a second-century pagan building. (Material reused from earlier buildings is known as *spolia*, Latin for "spoils.") The columns support round arches, creating a nave arcade, in contrast to the straight rather than arching nave colonnade in Old St. Peter's. The spandrels between the arches are faced with marble veneer that portrays chalices (wine cups) and paten (bread plates), essential equipment for the Eucharistic rite that took place at the altar. In such basilicas, the expanse of wall between the arcade and the clerestory typically had paintings or mosaics with biblical scenes, but here the decoration of the upper walls is lost.

SANTA COSTANZA Central-plan Roman buildings, with vertical (rather than longitudinal) axes, served as models for Christian tombs, martyrs' churches, and baptisteries (see "Longitudinal-Plan and Central-Plan Churches," opposite). One of the earliest surviving central-plan Christian buildings is the mausoleum of Constantina, daughter of Constantine. Her tomb was built outside the walls of Rome just before 350 (**FIGS. 7-14, 7-15**), and it was consecrated as a church in 1256, dedicated to Santa Costanza (the Italian form of Constantina, who was sanctified after her death). The building is a tall rotunda with an encircling barrel-vaulted passageway called an **ambulatory**. Paired columns with Composite capitals and richly molded entablature blocks support the arcade and dome. Originally, the interior was entirely sheathed in mosaics and veneers of fine marble.

Mosaics still surviving in the ambulatory vault recall the syncretic images in the catacombs. In one section, for example, a bust portrait of Constantina at the crest of the vault is surrounded by a tangle of grapevines filled with **putti**—naked cherubs, derived from pagan art—who vie with the birds to harvest the grapes (**FIG. 7-12**). Along the bottom edges on each side, other *putti* drive wagonloads of grapes toward pavilions housing large vats in which more *putti* trample the grapes into juice for the making of wine. The technique

7-12 • HARVESTING OF GRAPES
Ambulatory vault, church of Santa Costanza, Rome.
c. 350. Mosaic.

The forms of Early Christian buildings were based on two Roman prototypes: rectangular basilicas (see FIGS. 6–44, 6–63, 6–67) and circular or squared structures—including rotundas like the Pantheon (see FIGS. 6–50, 6–51). As in the basilica of Old St. Peter's in Rome (FIG. 7–13), longitudinal-plan churches are characterized by a forecourt, the atrium, leading to an entrance porch, the narthex, which spans one of the building's short ends. Doorways—known collectively as the church's portals—lead from the narthex into a long, congregational area called a nave. Rows of columns separate the high-ceilinged nave from one or two lower aisles on either side. The nave can be lit by windows along its upper level just under the ceiling, called a clerestory, that rises above the side aisles' roofs. At the opposite end of the nave from the narthex is a semicircular projection, the apse. The apse functions as the building's focal point where the altar, raised on a platform, is located. Sometimes there is also a transept, a wing that crosses the nave in front of the apse, making the building T-shape. When additional space (a liturgical choir) comes between the transept and the apse, the plan is known as a Latin cross.

Central-plan buildings were first used by Christians, like their pagan Roman forebears, as tombs. Central planning was also employed for baptisteries (where Christians "died"—giving up their old life—and were reborn as believers), and churches dedicated to martyrs (e.g. San Vitale, see FIG. 8–5), often built directly over their tombs. Like basilicas, central-plan churches can have an atrium, a narthex, and an apse. But instead of the longitudinal axis of basilican churches, which draws worshipers forward along a line from the entrance toward the apse, central-plan buildings, such as the Mausoleum of Constantina—rededicated in 1256 as the church of Santa Costanza (FIG. 7–14)—have a more vertical axis, from the center up through the dome, which may have functioned as a symbolic "vault of heaven."

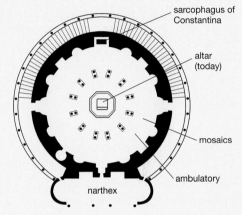

7-14 • PLAN (A) AND SECTION (B) OF THE CHURCH OF SANTA COSTANZA, ROME c. 350.

sarcophagus of Constantina

altar (today)

mosaics

ambulatory

narthex

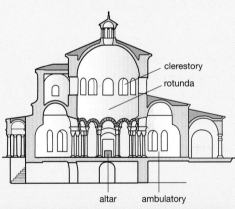

clerestory

rotunda

altar ambulatory

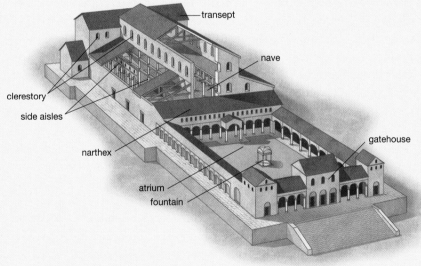

transept

nave

clerestory

side aisles

narthex

gatehouse

atrium

fountain

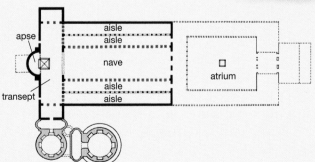

apse

aisle
aisle

nave

atrium

aisle
aisle

transept

7-13 • PLAN (A) AND RECONSTRUCTION DRAWING (B) OF OLD ST. PETER'S
c. 320–327; atrium added in later 4th century. Approx. 394′ (120 m) long and 210′ (64 m) wide.

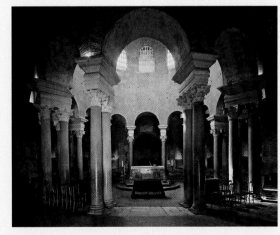

7-15 • CHURCH OF SANTA COSTANZA, ROME
c. 350. View from ambulatory into rotunda.

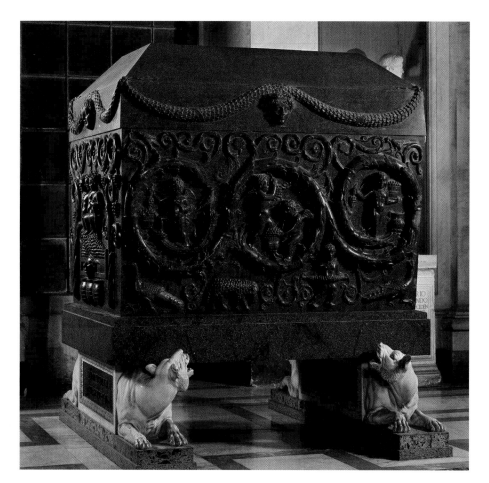

for individual scenes. Junius Bassus was a Roman official who, as the inscription here tells us, was "newly baptized" and died on August 25, 359, at age 42.

In the center of both registers is a triumphant Christ. Above, he appears as a Roman emperor, distributing legal authority in the form of scrolls to flanking figures of SS. Peter and Paul, and resting his feet on the head of Coelus, the pagan god of the heavens, here representing the cosmos to identify Christ as Cosmocrator (ruler of the cosmos). In the bottom register, the earthly Jesus makes his triumphal entry into Jerusalem, like a Roman emperor entering a conquered city. Jesus, however, rides on a humble ass rather than a powerful steed.

Even in the earliest Christian art, such as that in catacomb paintings and here on the sarcophagus of Junius Bassus, artists employed episodes from the Hebrew Bible allegorically since Christians saw them as prefigurations of important events in the New Testament. At the top left, Abraham passes the test of faith and need not sacrifice his son Isaac. Christians saw in this story an allegory that foreshadowed God's sacrifice of his own son, Jesus, which culminates not in Jesus' death, but in his resurrection. Under the triangular gable, second from the end at bottom right, the Hebrew Bible story of Daniel saved by God from the lions prefigures Christ's emergence alive from his tomb. At bottom far left, God tests the faith of Job, who provides a model for the sufferings of Christian martyrs. Next to Job, Adam and Eve have sinned to set in motion the entire Christian redemption story. Lured by the serpent, they have eaten the forbidden fruit and, conscious of their nakedness, are trying to hide their genitals with leaves.

On the upper right side, spread over two compartments, Jesus appears before Pontius Pilate, who is about to wash his hands, symbolizing his denial of responsibility for Jesus' death. Jesus' position here, held captive between two soldiers, recalls (and perhaps could also be read as) his arrest in Gethsemane, especially since the composition of this panel is reflected in the arrests of the

and style are Roman; the subject is traditional, associated with Bacchus and his cult; but the meaning here is new. In a Christian context, the wine refers to the Eucharist and the trampling of grapes for the making of wine becomes an image of death and resurrection. Constantina's pagan husband, however, may have appreciated the parallel, pagan allusion.

Within her mausoleum, Constantina (d. 354) was buried within a spectacularly huge porphyry sarcophagus (**FIG. 7-16**) that was installed across from the entrance on the other side of the ambulatory in a rectangular niche (visible on the plan in FIG. 7-14; an in-place replica peeks over the altar in FIG. 7-15). The motifs are already familiar—the same theme of *putti* making wine that we saw highlighted in the mosaics of the ambulatory vaults. Here the scenes are framed by a huge, undulating grapevine, whose subsidiary shoots curl above and below to fill the flat sides of the box. Striding along its base, peacocks symbolize eternal life in paradise, while a lone sheep could represent a member of Jesus' flock, presumably Constantina herself.

THE SARCOPHAGUS OF JUNIUS BASSUS Carved about the same time, but made of marble, the **SARCOPHAGUS OF JUNIUS BASSUS** (**FIG. 7-17**) is packed with elaborate figural scenes like the second-century CE Dionysiac sarcophagus (see "A Closer Look," page 202), only here they are separated into two registers, where columns, entablatures, and gables divide the space into fields

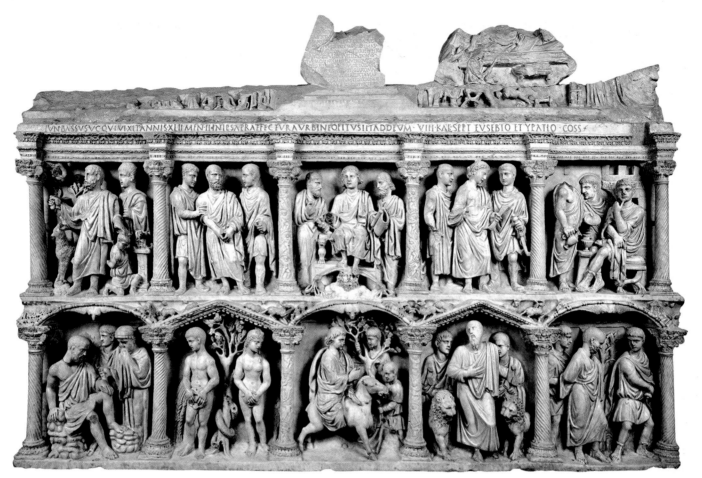

7-17 • SARCOPHAGUS OF JUNIUS BASSUS
Grottoes of St. Peter, Vatican, Rome. c. 359. Marble, 4′ × 8′ (1.2 × 2.4 m).

apostles Peter (top, second frame from the left) and Paul (bottom, far right).

RAVENNA AND THESSALONIKI

As the city of Rome's political importance dwindled, that of other imperial cities grew. In 395, Emperor Theodosius I split the Roman Empire into Eastern and Western divisions, each ruled by one of his sons. Heading the West, Honorius (r. 395–423) first established his capital at Milan, but in 402, to escape the siege by Germanic settlers, he moved his government to Ravenna, on the east coast of Italy. Its naval base, Classis (present-day Classe), had been important since the early days of the empire. In addition to military security, Ravenna offered direct access by sea to Constantinople. When Italy fell in 476 to the Ostrogoths, Ravenna became one of their headquarters, but the beauty and richness of Early Christian buildings can still be experienced there in a remarkable group of especially well-preserved fifth- and sixth-century churches, baptisteries, and oratories, encrusted with mosaics (see "The Oratory of Galla Placidia in Ravenna," page 228).

The history of Thessaloniki (now in modern Greece) as an imperial capital dates back even earlier, to the reorganization of Roman imperial government under Diocletian (see pages 205–207). Galerius—at first Diocletian's Caesar at the creation of the

Tetrarchy in 293 and then emperor of the East from Diocletian's retirement in 305 to his own death in 311—made Thessaloniki his capital, initiating an ambitious building program that included a hippodrome, a palace, and a triumphal arch. After Constantine eliminated his rivals and became sole emperor of the Roman world in 324, Thessaloniki decreased in importance, though it remained a provincial capital and the seat of a powerful bishop. The local Christian community dates to the first century CE. St. Paul's letters written to the church in Thessaloniki during the 50s became part of the New Testament.

THE ROTUNDA CHURCH OF ST. GEORGE IN THESSA-LONIKI Galerius constructed within his palace complex a grand rotunda that may have been intended for his tomb. During the fifth century, this imperial building was converted into a church through the addition of an apse on the east side, an entrance on the west, and an ambulatory encircling the entire rotunda. The interior surface of the huge dome—almost 100 feet in diameter—was covered with lavish golden mosaics, perhaps created by artists who were called here from Constantinople, which was developing into one of the great artistic centers of the Christian Roman world (**FIG. 7-21**). Forming a circle around and above worshipers within the building, 16 standing figures of saints dressed in

One of the earliest surviving Christian structures in Ravenna is a magnificent **oratory** (small chapel) that was attached c. 425–426 to the narthex of the palace church of Santa Croce (**FIG. 7–18**). This building was dedicated to St. Lawrence, but today it bears the name of the remarkable Galla Placidia—daughter of Roman emperor Theodosius I, wife of a Gothic king, sister of emperors Honorius and Arcadius, and mother of Emperor Valentinian III. As regent for her son after 425, she ruled the Western Empire until about 440. The oratory came to be called the Mausoleum of Galla Placidia because she and her family were once believed to be buried there.

This small building is **cruciform**, or cross-shape. A barrel vault covers each of its arms, and a pendentive dome—a dome continuous with its pendentives—covers the square space at the center (see "Pendentives and Squinches," page 238). The interior of the chapel contrasts markedly with the unadorned exterior, a transition seemingly designed to simulate the passage from the real world into the supernatural realm (**FIG. 7–19**). The worshiper looking from the western entrance across to the eastern bay of the chapel sees brilliant mosaics in the vaults and panels of veined marble sheathing the walls below. Bands of luxuriant floral designs and geometric patterns cover the arches and barrel vaults, and figures of standing apostles, gesturing like orators, fill the upper walls of the central space. Doves flanking a small fountain between the apostles symbolize eternal life in heaven.

In the lunette at the end of the barrel vault opposite the entrance, a mosaic depicts the third-century St. Lawrence, to whom the building was dedicated. The triumphant martyr carries a cross over his shoulder like a trophy and gestures toward the fire-engulfed metal grill on which he was literally roasted at his martyrdom. At the left stands a tall cabinet containing the Gospels, signifying the faith for which he gave his life. Opposite St. Lawrence, in a lunette over the entrance portal, is a mosaic of **THE GOOD SHEPHERD** (**FIG. 7–20**). A comparison with third- and fourth-century renderings of the same subject (see **FIGS. 7–6, 7–7**) reveals significant changes in content and design.

Jesus is no longer a boy in a simple tunic, but an adult emperor wearing purple and gold royal robes, his imperial majesty signaled by the golden halo surrounding his head and by a long golden staff that ends in a cross instead of a shepherd's crook. By the time this mosaic was made, Christianity had been the official state religion for 45 years, and nearly a century had passed since the last state persecution of Christians. The artists and patrons of this mosaic chose to assert the glory of Jesus in mosaic, the richest medium of wall decoration, in an imperial image still imbued with pagan spirit but now claiming the triumph of a new faith.

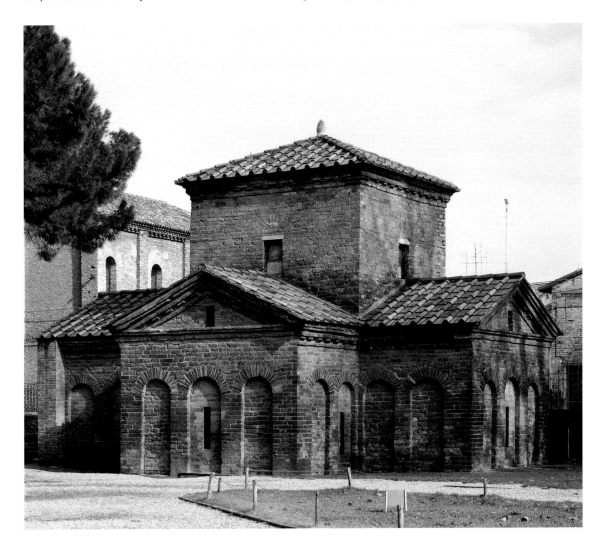

7–18 • ORATORY OF GALLA PLACIDIA, RAVENNA
c. 425–426.

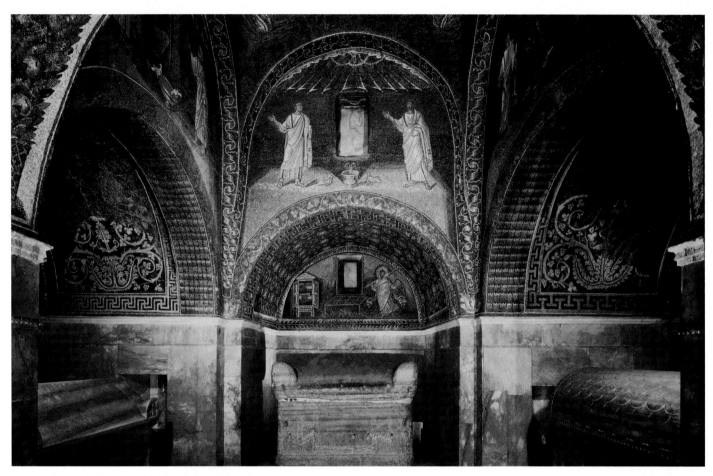

7–19 • ORATORY OF GALLA PLACIDIA
View from entrance, barrel-vaulted arms housing sarchophagi, lunette mosaic of the martyrdom of St. Lawrence. c. 425–426.

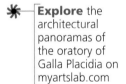

Explore the architectural panoramas of the oratory of Galla Placidia on myartslab.com

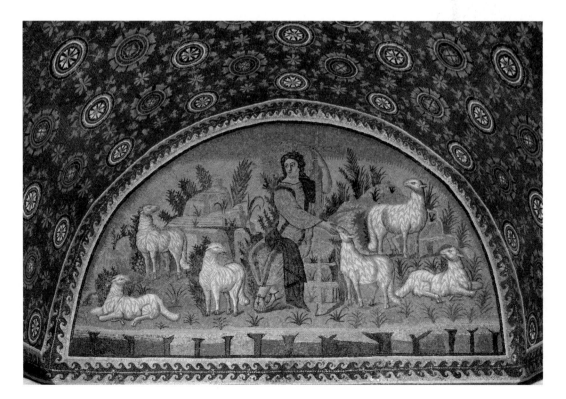

7–20 • THE GOOD SHEPHERD
Lunette over the entrance, Oratory of Galla Placidia. c. 425–426. Mosaic.

Episodes from the life of Jesus as recounted in the Gospels form the principal subject matter of Christian visual art. What follows is a list of main events in his life with parenthetical references citing their location in the Gospel texts.

Incarnation and Childhood of Jesus

Annunciation: The archangel Gabriel informs the Virgin Mary that God has chosen her to bear his Son. A dove often represents the **Incarnation**, her miraculous conception of Jesus through the Holy Spirit. (Lk 1:26–28)

Visitation: The pregnant Mary visits her older cousin Elizabeth, pregnant with the future St. John the Baptist. (Lk 1:29–45)

Nativity: Jesus is born in Bethlehem. The Holy Family—Jesus, Mary, and her husband, Joseph—is usually portrayed in a stable, or, in Byzantine art, a cave. (Lk 2:4–7)

Annunciation to and Adoration of the Shepherds: Angels announce Jesus' birth to shepherds, who hurry to Bethlehem to honor him. (Lk 2:8–20)

Adoration of the Magi: Wise men from the east follow a bright star to Bethlehem to honor Jesus as king of the Jews, presenting him with precious gifts. Eventually these Magi became identified as three kings, often differentiated through facial type as young, middle-aged, and old. (Mat 2:1–12)

Presentation in the Temple: Mary and Joseph bring the infant Jesus to the Temple in Jerusalem, where he is presented to the high priest. (Lk 2:25–35)

Massacre of the Innocents and Flight into Egypt: An angel warns Joseph that King Herod—to eliminate the threat of a newborn rival king—plans to murder all male babies in Bethlehem. The Holy Family flees to Egypt. (Mat 2:13–16)

Jesus' Ministry

Baptism: At age 30, Jesus is baptized by John the Baptist in the River Jordan. The Holy Spirit appears in the form of a dove and a heavenly voice proclaims Jesus as God's Son. (Mat 3:13–17, Mk 1:9–11, Lk 3:21–22)

Marriage at Cana: At his mother's request Jesus turns water into wine at a wedding feast, his first public miracle. (Jn 2:1–10)

Miracles of Healing: Throughout the Gospels, Jesus performs miracles of healing the blind, possessed (mentally ill), paralytic, and lepers; he also resurrects the dead.

Calling of Levi/Matthew: Jesus calls to Levi, a tax collector, "Follow me." Levi complies, becoming the disciple Matthew. (Mat 9:9, Mk 2:14)

Raising of Lazarus: Jesus brings his friend Lazarus back to life four days after his death. (Jn 11:1–44)

Transfiguration: Jesus reveals his divinity in a dazzling vision on Mount Tabor as his closest disciples—Peter, James, and John—look on. (Mat 17:1–5, Mk 9:2–6, Lk 9:28–35)

Tribute Money: Challenged to pay the temple tax, Jesus sends Peter to catch a fish, which turns out to have the required coin in its mouth. (Mat 17:24–27, Lk 20:20–25)

Jesus' Passion, Death, and Resurrection

Entry into Jerusalem: Jesus, riding an ass and accompanied by his disciples, enters Jerusalem, while crowds honor him, spreading clothes and palm fronds in his path. (Mat 21:1–11, Mk 11:1–11, Lk 19:30–44, Jn 12:12–15)

Last Supper: During the Jewish Passover seder, Jesus reveals his impending death to his disciples. Instructing them to drink wine (his blood) and eat bread (his body) in remembrance of him, he lays the foundation for the Christian Eucharist (Mass). (Mat 26:26–30, Mk 14:22–25, Lk 22:14–20)

Washing the Disciples' Feet: At the Last Supper, Jesus washes the disciples' feet, modeling humility. (Jn 13: 4–12)

Agony in the Garden: In the Garden of Gethsemane on the Mount of Olives, Jesus struggles between his human fear of pain and death and his divine strength to overcome them. The apostles sleep nearby, oblivious. (Lk 22:40–45)

Betraya/Arrest: Judas Iscariot (a disciple) has accepted a bribe to indicate Jesus to an armed band of his enemies by kissing him. (Mat 26:46–49, Mk 14:43–46, Lk 22:47–48, Jn 18:3–5)

Jesus before Pilate: Jesus is taken to Pontius Pilate, Roman governor of Judaea, and charged with treason for calling himself king of the Jews. Pilate proposes freeing Jesus but is shouted down by the mob, which demands Jesus be crucified. (Mat 27:11–25, Mk 15:4–14, Lk 23:1–24, Jn 18:28–40)

Crucifixion: Jesus is executed on a cross, often shown between two crucified criminals and accompanied by the Virgin Mary, John the Evangelist, Mary Magdalen, and other followers at the foot of the cross; Roman soldiers sometimes torment Jesus—one extending a sponge on a pole with vinegar instead of water for him to drink, another stabbing him in the side with a spear. A skull can identify the execution ground as Golgotha, "the place of the skull." (Mat 27:35–50, Mk 15:23–37, Lk 23:38–49, Jn 19:18–30)

Descent from the Cross (Deposition): Jesus' followers take his body down from the cross. (Mat 27:55–59, Mk 15:40–46, Lk 23:50–56, Jn 19:38–40)

Lamentation/Pietà and Entombment: Jesus' sorrowful followers gather around his body to mourn and then place his body in a tomb. An image of the grieving Virgin alone with Jesus across her lap is known as a **pietà** (from Latin *pietas*, "pity"). (Mat 27:60–61, Jn 19:41–42)

Resurrection/Holy Women at the Tomb: Three days after his entombment, Christ rises from the dead, and his female followers—usually including Mary Magdalen—discover his empty tomb. An angel announces Christ's resurrection. (Mat 28, Mk 16, Lk 24:1–35, Jn 20)

Descent into Limbo/Harrowing of Hell (Anastasis): The resurrected Jesus descends into limbo, or hell, to free deserving predecessors, among them Adam, Eve, David, and Moses. (Apocryphal Gospel of Nicodemus, not in the New Testament)

Noli Me Tangere ("Do Not Touch Me"): Christ appears to Mary Magdalen as she weeps at his tomb. When she reaches out to him, he warns her not to touch him. (Lk 24:34–53, Jn 20:11–31)

Ascension: Christ ascends to heaven from the Mount of Olives, disappearing in a cloud, while his mother and apostles watch. (Acts 1)

7-21 • SS. ONESIPHOROS AND PORPHYRIOS STANDING BEFORE AN ARCHITECTURAL BACKDROP

Mosaics on the interior of the dome of the church of St. George (formerly the mausoleum of Galerius). Thessaloniki, northern Greece. Rotunda 4th century; mosaics 5th century.

liturgical vestments make orant gestures of prayer, as if celebrating the liturgy in paradise concurrent with the services held here on earth. Behind them is a backdrop of elaborate architectural fantasies composed of Classical forms, decorated with gems, and inhabited by peacocks. The figures are equally Classical, with their careful modeling, lavish drapery, and most notably their air of grace, eloquence, and composure. Classicizing features such as these will continue to develop as the Early Christian art of the Eastern Roman Empire blossoms into Byzantine art, which will flourish until the fifteenth century, centered in Constantinople.

THINK ABOUT IT

7.1 Discuss the Roman foundations of Early Christian sculpture, focusing your answer on the sarcophagus of Junius Bassus (FIG. 7–17). Look back to Chapter 6 to help form your ideas.

7.2 Distinguish the "iconic" from the "narrative" in two works of late antique Jewish or Christian art discussed in this chapter. How were these two traditions used by the communities that created these works?

7.3 How does the situation of the Jewish and Christian buildings in Dura-Europos on the outskirts of the Roman Empire affect their design and decoration?

7.4 Identify the distinctive features of basilicas and central-plan churches, and discuss how the forms of these early churches were geared toward specific types of Christian worship and devotional practice.

CROSSCURRENTS

FIG. 6–7

FIG. 7–1

Both Etruscans and Early Christians often painted the interior walls of their tombs. Discuss the themes chosen for the murals in these two examples. Are the images related to life, to death, or to life after death? How are the styles and subjects related to these two cultures?

✔—⌐**Study** and review on myartslab.com

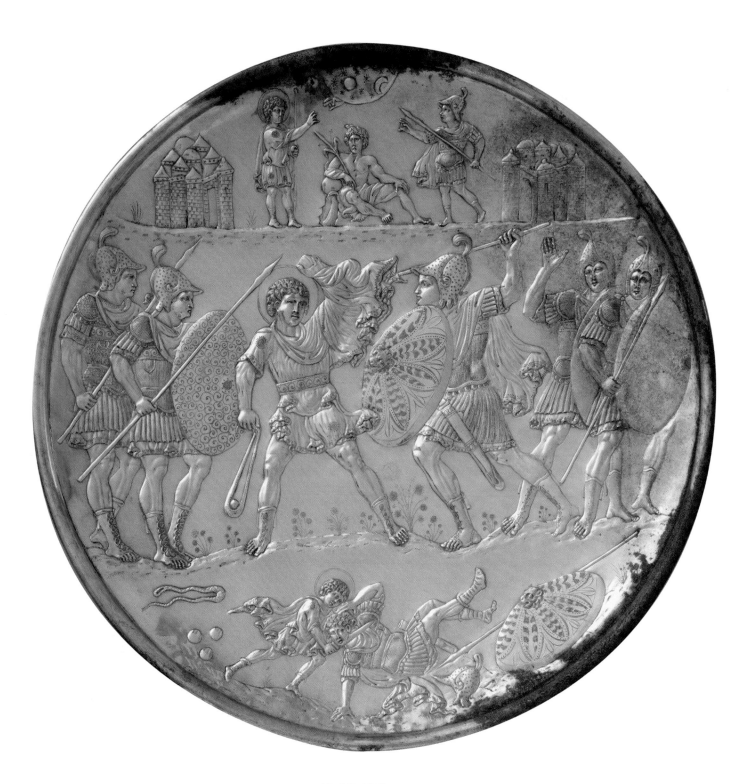

8–1 • DAVID BATTLING GOLIATH
One of the "David Plates," made in Constantinople. 629–630 CE. Silver,
diameter 19⅞" (49.4 cm). Metropolitan Museum of Art, New York.

Byzantine Art

The robust figures on this huge silver plate (**FIG. 8-1**) enact three signature episodes in the youthful hero David's combat with the Philistine giant Goliath (1 Samuel 17:41–51). In the upper register, David—easily identified not only by his youth but also by the prominent halo as the "good guy" in all three scenes—and Goliath challenge each other on either side of a seated Classical personification of the stream that will be the source of the stones David is about to use in the ensuing battle. The confrontation itself appears in the middle, in a broad figural frieze whose size signals its primary importance. Goliath is most notable here for his superior armaments—helmet, spear, sword, and an enormous protective shield. At the bottom, David, stones and slingshot flung behind him, consummates his victory by severing the head of his defeated foe, whose imposing weapons and armor are scattered uselessly behind him.

Some may be surprised to see a Judeo-Christian subject portrayed in a style that was developed for the exploits of Classical heroes, but this mixture of traditions is typical of the eclecticism characterizing the visual arts as the Christianized Roman world became the Byzantine Empire. Patrons saw no conflict between the artistic principles of the pagan past and the Christian teaching undergirding their imperial present. To them, this Jewish subject, created for a Christian patron in a pagan style, would have attracted notice only because of its sumptuousness and its artistic virtuosity.

This was one of nine "David Plates" unearthed in Cyprus in 1902. Control stamps—guaranteeing the purity of the material, much like the stamps of "sterling" that appear on silver today—date them to the reign of the Byzantine emperor Heraclius (r. 613–641 CE). Displayed in the home of their owners, they were visual proclamations of wealth, but also of education and refined taste, just like collections of art and antiques in homes today. A constellation of iconographic and historical factors, however, allows us to uncover a subtler message. For the original owners, the single combat of David and Goliath might have recalled a situation involving their own emperor and enemies.

The reign of Heraclius was marked by war with the Sasanian Persians. A decisive moment in the final campaign of 628–629 CE occurred when Heraclius himself stepped forward for single combat with the Persian general Razatis, and the emperor prevailed, presaging Byzantine victory. Some contemporaries referred to Heraclius as a new David. Is it possible that the set of David Plates was produced for the emperor to offer as a diplomatic gift to one of his aristocratic allies, who subsequently took them to Cyprus? Perhaps the owners later buried them for safekeeping—like the early silver platter from Mildenhall (see FIG. 6–68)—where they awaited discovery at the beginning of the twentieth century.

LEARN ABOUT IT

8.1 Survey the variety of stylistic sources and developments that characterize the long history of Byzantine art.

8.2 Understand the principal themes and subjects—secular as well as sacred—used by Byzantine artists.

8.3 Assess the central role of images in the devotional practices of the Byzantine world and explore the reasons for and impact of the brief interlude of iconoclasm.

8.4 Trace the growing Byzantine interest in conveying human emotions and representing human situations when visualizing sacred stories.

((•—[Listen** to the chapter audio on myartslab.com

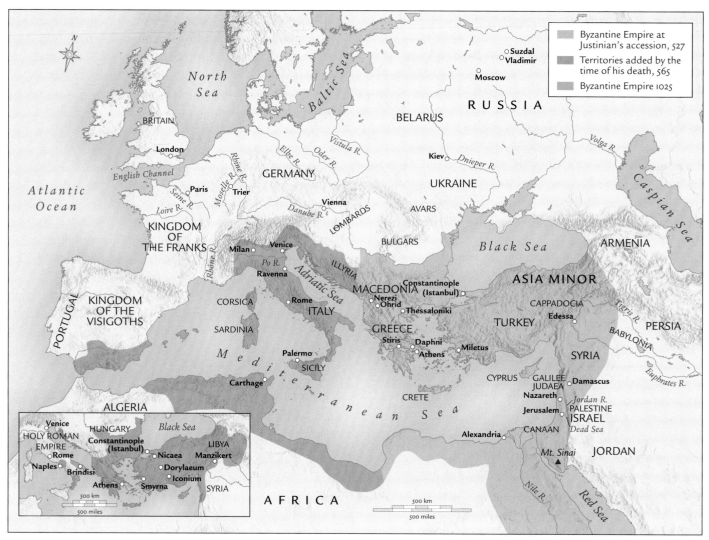

MAP 8-1 • THE LATE ROMAN AND BYZANTINE WORLD

The eastern shores of the Mediterranean, birthplace of Judaism and Christianity, were the focal point of the Byzantine Empire. The empire expanded further west under Emperor Justinian, though by 1025 CE it had contracted again to the east.

BYZANTIUM

Art historians apply the term "Byzantine" broadly to the art and architecture of Constantinople—whose ancient name, before Constantine renamed the revitalized city after himself, was Byzantium—and of the regions under its influence. Constantine had chosen well in selecting the site of his new capital city—his "New Rome." Constantinople lay at the crossroads of the overland trade routes between Asia and Europe and the sea route connecting the Black Sea and the Mediterranean. Even as the territories controlled by Byzantine rulers diminished in size and significance from century to century leading up to the fall of Constantinople in 1453, Byzantine emperors continued to conceive themselves as successors to the rulers of ancient Rome, their domain as an extension of the Roman Empire, and their capital city as an enduring manifestation of the glory that was ancient Rome.

In this chapter, we will focus on what has been considered the three "golden ages" of Byzantine art. The Early Byzantine period, most closely associated with the reign of Emperor Justinian I (r. 527–565), began in the fifth century and ended in 726, at the onset of the iconoclast controversy that led to the destruction of religious images. The Middle Byzantine period began in 843, when Empress Theodora (c. 810–867) reinstated the veneration of icons, and continued until 1204, when Christian crusaders from western Europe occupied Constantinople. The Late Byzantine period began with the restoration of Byzantine rule in 1261 and ended with the empire's fall to the Ottoman Turks in 1453, at which point Russia succeeded Constantinople as the "Third Rome" and the center of the Eastern Orthodox Church. Late Byzantine art continued to flourish into the eighteenth century in Ukraine, Russia, and much of southeastern Europe.

EARLY BYZANTINE ART

THE GOLDEN AGE OF JUSTINIAN

During the fifth and sixth centuries, while invasions and religious controversy racked the Italian peninsula, the Eastern Roman Empire prospered. In fact, during the sixth century under Emperor Justinian I and his wife, Empress Theodora (d. 548), Byzantine political power, wealth, and culture were at their peak. Imperial forces held northern Africa, Sicily, much of Italy, and part of Spain. Ravenna became the Eastern Empire's administrative capital in the west, and Rome remained under nominal Byzantine control until the eighth century.

HAGIA SOPHIA IN CONSTANTINOPLE In Constantinople, Justinian and Theodora embarked on a spectacular campaign of building and renovation, but little now remains of their architectural projects or of the old imperial capital itself. The church of Hagia Sophia, meaning "Holy Wisdom" (referring to the dedication of this church to Christ as the embodiment of divine wisdom) is a spectacular exception (**FIG. 8-2**). It replaced a fourth-century church destroyed when crowds, spurred on by Justinian's foes during the devastating urban Nika Revolt in 532, set the old church on fire and cornered the emperor within his palace. Theodora,

a brilliant and politically shrewd woman, is said to have shamed Justinian, who was plotting to escape, into not fleeing the city, saying "Purple makes a fine shroud"—a reference to purple as the imperial color. Theodora meant that she would rather remain and die an empress than flee and preserve her life. Taking up her words as a battle cry, Justinian led the imperial forces in crushing the rebels and restoring order, reputedly slaughtering 30,000 of his subjects in the process.

To design a new church that embodied imperial power and Christian glory, Justinian chose two scholar-theoreticians, Anthemius of Tralles and Isidorus of Miletus. Anthemius was a specialist in geometry and optics, and Isidorus a specialist in physics who had also studied vaulting. They developed an audacious and awe-inspiring design, executed by builders who had refined their masonry techniques by building the towers and domed rooms that were part of the city's defenses. So when Justinian ordered the construction of domed churches, and especially Hagia Sophia, master masons with a trained and experienced workforce stood ready to give permanent form to his architects' dreams.

The new Hagia Sophia was not constructed by the miraculous intervention of angels, as was rumored, but by mortal builders in only five years (532–537). Procopius of Caesarea, who chronicled Justinian's reign, claimed poetically that Hagia Sophia's gigantic

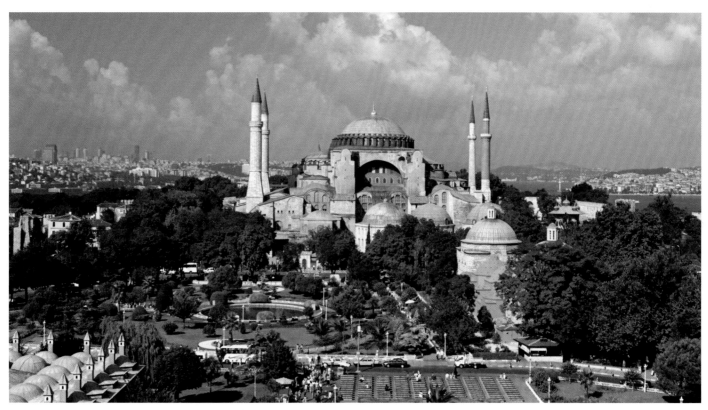

8-2 • Anthemius of Tralles and Isidorus of Miletus CHURCH OF HAGIA SOPHIA, CONSTANTINOPLE
Modern Istanbul. 532–537. View from the southwest.

The body of the original church is now surrounded by later additions, including the minarets built after 1453 by the Ottoman Turks. Today the building is a museum.

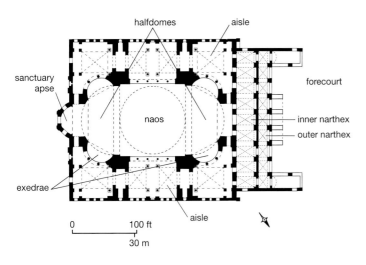

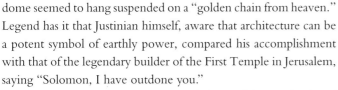

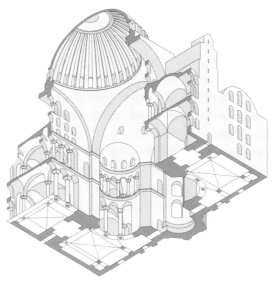

8-3 • PLAN (A) AND ISOMETRIC DRAWING (B) OF THE CHURCH OF HAGIA SOPHIA

dome seemed to hang suspended on a "golden chain from heaven." Legend has it that Justinian himself, aware that architecture can be a potent symbol of earthly power, compared his accomplishment with that of the legendary builder of the First Temple in Jerusalem, saying "Solomon, I have outdone you."

Hagia Sophia is an innovative hybrid of longitudinal and central architectural planning (**FIG. 8-3**). The building is clearly dominated by the hovering form of its gigantic dome (**FIG. 8-4**). But flanking **conches**—halfdomes—extend the central space into a longitudinal nave that expands outward from the central dome to connect with the narthex on one end and the halfdome of the sanctuary apse on the other. This processional core, called the **naos** in Byzantine architecture, is flanked by side aisles and **galleries** above them overlooking the naos.

Since its idiosyncratic mixture of basilica and rotunda precludes a ring of masonry underneath the dome to provide support around its circumference (as in the Pantheon, see FIGS. 6-50, 6-51), the main dome of Hagia Sophia rests instead on four **pendentives** (triangular curving vault sections) that connect the base of the dome with the huge supporting piers at the four corners of the square area beneath it (see "Pendentives and Squinches," page 238). And since these piers are essentially submerged back into the darkness of the aisles, rather than expressed within the main space itself (see FIG. 8-3), the dome seems to float mysteriously over a void. The miraculous, weightless effect was reinforced by the light-reflecting gold mosaic that covered the surfaces of dome and pendentives alike, as well as by the band of 40 windows that perforate the base of the dome right where it meets its support. This daring move challenges architectural logic by seeming to weaken the integrity of the masonry at the very place where it needs to be strong, but the windows created the circle of light that helps the dome appear to hover, and a reinforcement of buttressing on the exterior made the solution sound as well as shimmering. The origin of the dome on pendentives is obscure, but its large-scale use at Hagia Sophia was totally unprecedented and represents one

of the boldest experiments in the history of architecture. It was to become the preferred method of supporting domes in Byzantine architecture.

The architects and builders of Hagia Sophia clearly stretched building materials to their physical limits, denying the physicality of the building in order to emphasize its spirituality. In fact, when the first dome fell in 558, it did so because a pier and pendentive shifted and because the dome was too shallow and exerted too much outward force at its base, not because the windows weakened the support. Confident of their revised technical methods, the architects designed a steeper dome that raised the summit 20 feet higher. They also added exterior buttressing. Although repairs had to be made in 869, 989, and 1346, the church has since withstood numerous earthquakes.

The liturgy used in Hagia Sophia in the sixth century has been lost, but it presumably resembled the rites described in detail for the church in the Middle Byzantine period. The celebration of the Eucharist took place behind a screen that separated the sanctuary from the nave. The emperor was the only layperson permitted to enter the sanctuary. Other men and women stood in the aisles or in the galleries, where they witnessed the processions of clergy, moving in a circular path from the sanctuary into the nave and back five or six times during the ritual.

Hagia Sophia was thus a gigantic theater for public, imperial worship of God—whose presence was assumed within the building—created by a culture within which Church and state were inextricably intertwined. Justinian had the sanctuary embellished with 40,000 pounds of silver that he donated himself. This precious material was crafted into sumptuous decorations on the altar, a ciborium (canopy sheltering the altar), ambo (pulpit), and screen. Since there was no figural decoration on the walls of the building in Justinian's time to focus the attention of viewers in any one place, worshipers standing on the church floor must have surveyed the whole expanse of the interior, shifting their attention from one shimmering vista to the next.

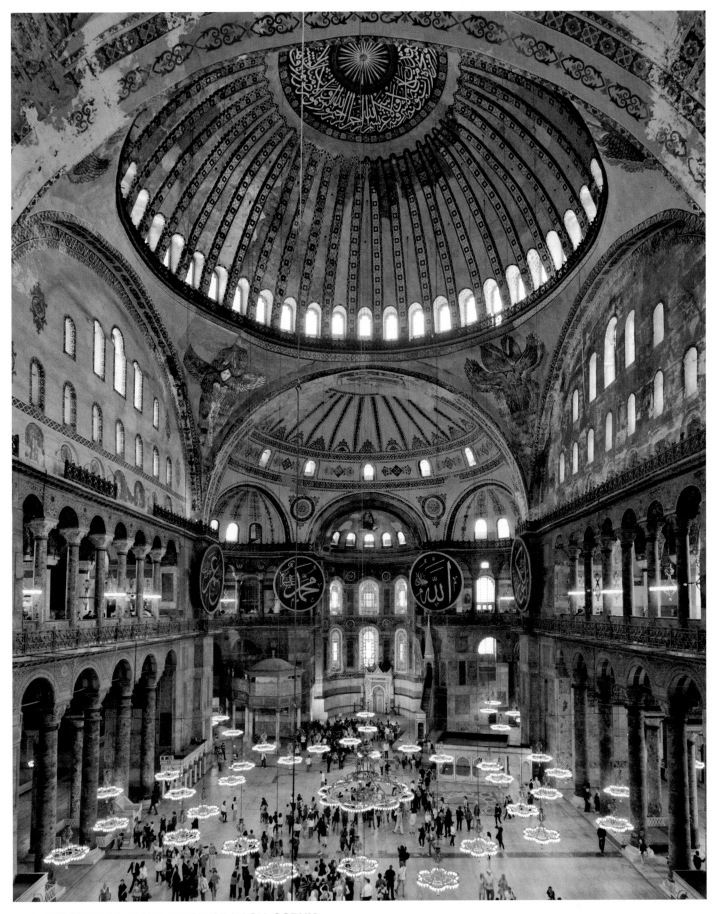

8-4 • INTERIOR OF THE CHURCH OF HAGIA SOPHIA

📖 **Read** the document related to the church of Hagia Sophia on myartslab.com

Pendentives and squinches are two methods of supporting a round dome or its drum over a square space. Pendentives are concave, triangular forms between the arches under a dome. They rise upward and inward to form a circular base of support on which the dome rests. **Squinches** are diagonal lintels placed across the upper corner of the wall and supported by an arch or a series of corbeled arches that give it a nichelike shape. Because squinches create an octagon, which is close in shape to a circle, they provide a solid base around the perimeter of a dome, usually elevated on a drum (a circular wall), whereas pendentives project the dome slightly inside the square space it covers, making it seem to float. Byzantine builders preferred pendentives (as at Hagia Sophia, see FIG. 8–4), but elaborate, squinch-supported domes became a hallmark of Islamic architecture.

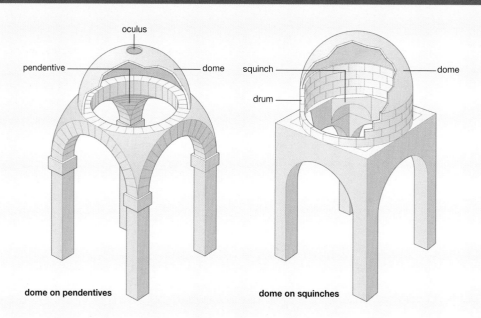

dome on pendentives　　　　**dome on squinches**

👁—|**Watch** an architectural simulation about pendentives and squinches on myartslab.com

SAN VITALE IN RAVENNA In 540, Byzantine forces captured Ravenna from the Arian Christian Ostrogoths who had themselves taken it from the Romans in 476. Much of our knowledge of the art of this turbulent period comes from the well-preserved monuments at Ravenna. In 526, Ecclesius, bishop of Ravenna, commissioned two new churches, one for the city and one for its port, Classis. In the 520s, construction began on a central-plan church, a **martyrium** (church built over the grave of a martyr) dedicated to the fourth-century Roman martyr St. Vitalis (Vitale in Italian), but it was not finished until after Justinian had

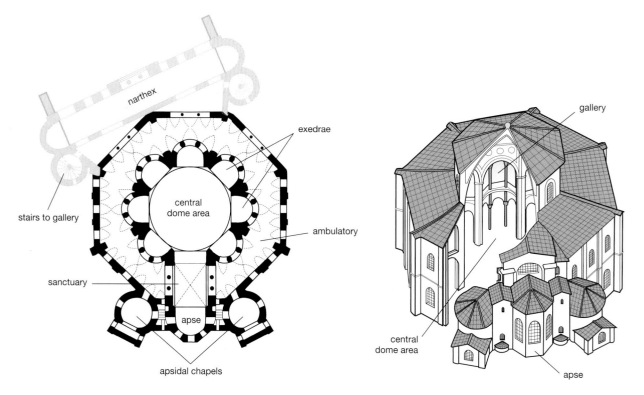

8-5 • PLAN (A) AND CUTAWAY DRAWING (B) OF THE CHURCH OF SAN VITALE, RAVENNA
Under construction from c. 520; consecrated 547.

Christian churches are identified by a three-part descriptive title combining (1) designation (or type), with (2) dedication (often to a saint), and finally (3) geographic location, cited in that order.

Designation: There are various types of churches, fulfilling a variety of liturgical and administrative objectives, and the identification of a specific church often begins with an indication of its function within the system. For example, an **abbey church** or monastery church is the place of worship within a monastery or convent; a **pilgrimage church** is a site that attracts visitors wishing to venerate **relics** (material remains or objects associated with a saint) as well as attend services. A cathedral is a bishop's primary church (the word derives from the Latin *cathedra*, meaning chair, since the chair or throne of a bishop is contained within his cathedral). A bishop's domain is called a diocese, and there can be only one church in the diocese designated as its bishop's cathedral, but a diocese has numerous parish churches where local residents attend regular services.

Dedication: Christian churches are always dedicated to Christ, the Virgin Mary, a saint, or a sacred concept or event, for example St. Peter's Basilica or the church of Hagia Sophia (Christ as the embodiment of Holy Wisdom). In short-hand identification, when we omit the church designation at the beginning, we always add an apostrophe and an *s* to a saint's name, as when using "St. Peter's" to refer to the Vatican Basilica of St. Peter in Rome.

Location: The final piece of information that clearly pinpoints the specific church indicated in a title is its geographic location, as in the church of San Vitale in Ravenna or the Cathedral of Notre-Dame (French for "Our Lady," referring to the Virgin Mary) in Paris. "Notre-Dame" alone usually refers to this Parisian cathedral, in spite of the fact that many contemporary cathedrals elsewhere (e.g. at Chartres and Reims) were also dedicated to "Notre-Dame." Similarly, "St. Peter's" usually means the Vatican church of the pope in Rome.

conquered Ravenna and established it as the administrative capital of Byzantine Italy (**FIG. 8-5**).

San Vitale was designed as a central-domed octagon surrounded by eight radiating exedrae (wall niches), surrounded in turn by an ambulatory and gallery, all covered by vaults. A rectangular sanctuary and semicircular apse project from one of the sides of the octagon, and circular rooms flank the apse. A separate oval narthex, set off-axis, joined church and palace and also led to cylindrical stair towers that gave access to the second-floor gallery.

The floor plan of San Vitale only hints at the effect of the complex, interpenetrating interior spaces of the church, an effect that was enhanced by the offset narthex, with its double sets of doors leading into the church. People entering from the right saw only arched openings, whereas those entering from the left approached on an axis with the sanctuary, which they saw straight ahead of them. The dome rests on eight large piers that frame the exedrae and the sanctuary. The undulating, two-story exedrae open through superimposed arcades into the outer aisles on the ground floor and into galleries on the second floor. They push out the circular central space and create an airy, floating sensation, reinforced by the liberal use of veined marble veneer and colored glass and gold mosaics in the surface decoration. As in Hagia Sophia, structure seems to dissolve into shimmering light and color, only here an elaborate program of figural mosaics focuses the worshiper's attention within the sanctuary (**FIG. 8-6**).

In the halfdome of the sanctuary apse (**FIG. 8-7**), St. Vitalis and Bishop Ecclesius flank an image of Christ enthroned. The other sanctuary images relate to its use for the celebration of the Eucharist. The lunette on the north wall shows an altar table set for the meal that Abraham offers to three disguised angels (Genesis 18:1–15), and next to it a portrayal of his near-sacrifice of Isaac. In the spandrels and other framed wall spaces appear prophets and evangelists, and the program is bristling with symbolic references to Jesus, but the focus of the sanctuary program is the courtly tableau in the halfdome of the apse.

A youthful, classicizing Christ appears on axis, dressed in imperial purple and enthroned on a cosmic orb in paradise, the setting indicated by the four rivers that flow from the ground underneath him. Two winged angels flank him, like imperial bodyguards or attendants. In his left hand Christ holds a scroll with seven seals that he will open at his Second Coming at the end of time, proclaiming his authority not only over this age, but over the age to come. He extends his right hand to offer a crown of martyrdom to a figure on his right (our left) labeled as St. Vitalis, the saint to whom this church is dedicated. On the other side is the only un-nimbed figure in the tableau, labeled as Bishop Ecclesius, the founder of San Vitale, who holds forward a model of the church itself, offering it to Christ. The artist has imagined a scene of courtly protocol in paradise, where Christ, as emperor, gives a gift to, and receives a gift from, members of the celestial entourage.

In separate, flanking rectangular compositions, along the curving wall of the apse underneath the scene in the halfdome appear Justinian and Theodora and their retinues (Justinian can be seen in FIG. 8-6). The royal couple did not attend the dedication ceremonies for the church of San Vitale, conducted by Archbishop Maximianus in 547. There is no evidence that they actually set foot in Ravenna, but these two large mosaic panels that face each other across its sanctuary picture their presence here in perpetuity.

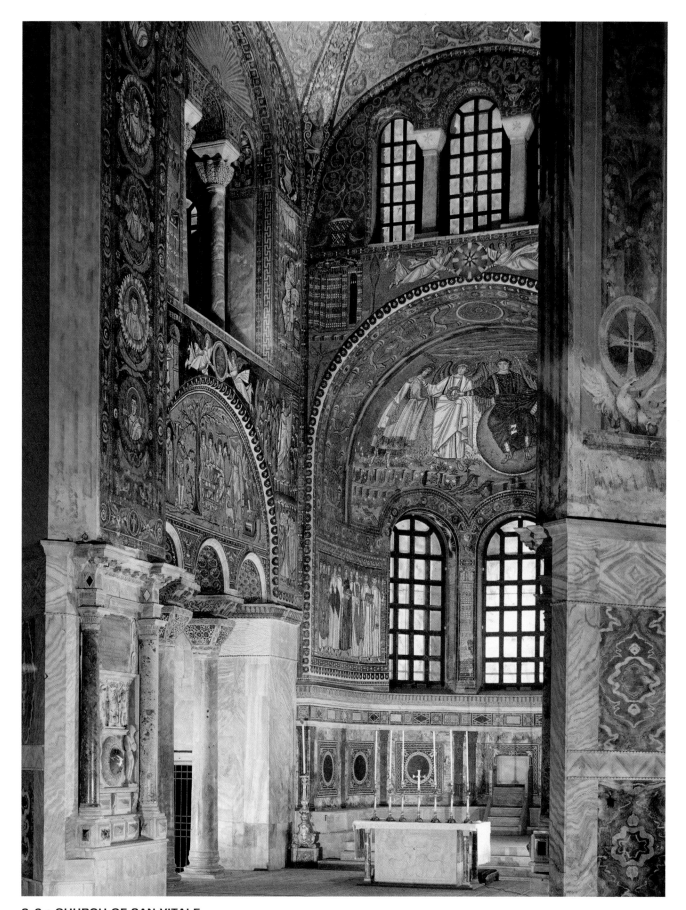

8-6 • CHURCH OF SAN VITALE
View into the sanctuary toward the northeast. c. 547.

✳ Explore the architectural panoramas of the church of San Vitale on myartslab.com

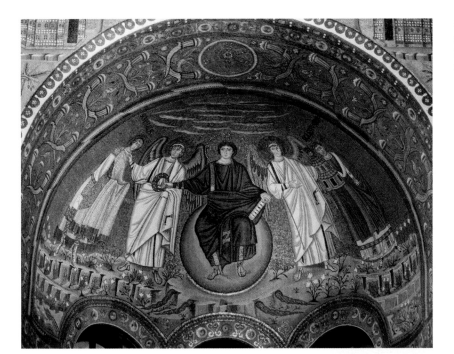

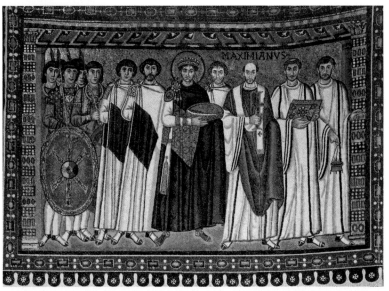

8-8 • EMPEROR JUSTINIAN AND HIS ATTENDANTS, NORTH WALL OF THE APSE

Church of San Vitale, Ravenna. Consecrated 547. Mosaic, 8′8″ × 12′ (2.64 × 3.65 m).

As head of state, the haloed Justinian wears a huge jeweled crown and a purple cloak; he carries a large golden paten that he is donating to San Vitale for the celebration of the Eucharist. Bishop Maximianus at his left holds a jeweled cross and another churchman holds a jewel-covered book. Government officials stand at Justinian's right, followed by barbarian mercenary soldiers, one of whom wears a neck torc, another a Classical cameo cloak clasp.

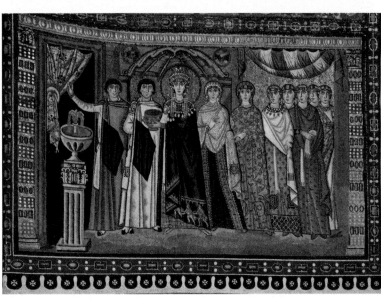

8-9 • EMPRESS THEODORA AND HER ATTENDANTS, SOUTH WALL OF THE APSE

Church of San Vitale, Ravenna. c. 547. Mosaic 8′8″ × 12′ (2.64 × 3.65 m).

Like Justinian, Theodora has a halo, wears imperial purple, and carries in her hands a liturgical vessel—the chalice that held the Eucharistic wine—that she will donate to the church. Her elaborate jewelry includes a wide collar of embroidered and jeweled cloth. A crown, hung with long strands of pearls (thought to protect the wearer from disease), frames her face. Her attendants also wear the rich textiles and jewelry of the Byzantine court.

Justinian (FIG. 8-8), on the north wall, carries a large golden paten that will be used to hold the Eucharistic bread and stands next to Maximianus, who holds a golden, jewel-encrusted cross. The priestly celebrants at the right carry the Gospels, encased in a golden, jeweled book cover, symbolizing the coming of Christ as the Word, and a censer containing burning incense to purify the altar prior to the Eucharist.

On the south wall, Theodora, standing beneath a fluted shell canopy and singled out by a golden halo and elaborate crown, carries a huge golden chalice studded with jewels (FIG. 8-9). The rulers present these gifts as precious offerings to Christ—emulating most immediately Bishop Ecclesius, who offers a model of the church to Christ in the halfdome of the apse, but also the three Magi who brought valuable gifts to the infant Jesus, depicted in "embroidery" at the bottom of Theodora's purple cloak. In fact, the paten and chalice offered by the royal couple will be used by this church to offer Eucharistic bread and wine to the local Christian community during the liturgy. In this way the entire program of mosaic decoration revolves around themes of offering, extended into the theme of the Eucharist itself.

Theodora's group stands beside a fountain, presumably in a courtyard leading to the entrance to the church. The open doorway and curtain are Classical space-creating devices, but here the mosaicists have deliberately avoided allowing their illusionistic power to overwhelm their ability also to create flat surface patterns. Notice, too, that the figures cast no shadows, and, though modeled, their outlines as silhouetted shapes are more prominent than their sense of three-dimensionality. Still, especially in Justinian's panel, a complex and carefully controlled system of overlapping allows us to see these figures clearly and logically situated within a shallow space, moving in a stately procession from left to right toward the entrance to the church and the beginning of the liturgy. So the scenes portrayed in these mosaic paintings are both flattened and three-dimensional, abstract and representational, patterned and individualized. Like Justinian and Theodora, their images are both there and not there at the same time.

THE MONASTERY OF ST. CATHERINE ON MOUNT SINAI Justinian's imperial architectural projects extended across the breadth of the Byzantine Empire, emulating the example of the great emperors of ancient Rome. Soon after the dedication of San Vitale, he sponsored the reconstruction of the monastery of St. Catherine at Mount Sinai in Egypt (FIG. 8-10). This pilgrimage destination and spiritual retreat had been founded much earlier, during the fourth century, at the place where Moses had encountered God in the burning bush (Exodus 4 and 5) and in the shadow of the peak on which he had met God to receive the Ten Commandments (Exodus 19 and 20). Justinian's reconstruction focused on two aspects of the complex. In conjunction with the installation of a frontier garrison to protect both monks and pilgrims from Bedouin attacks on this remote border outpost, Justinian had the walls of the monastery fortified. He also commissioned

a new church, dedicated to the Virgin Mary and—according to inscriptions carved into the wooden beams that support its roof—built in memory of Theodora, who died in 548.

Procopius' description of this project focuses on characterizing the lives of the monks who lived there:

> On this Mount Sinai whose life is a kind of careful rehearsal of death, and they enjoy without fear the solitude which is very precious to them. Since these monks have nothing to desire, for they are superior to all human wishes and they have no interest in owning anything or in caring for their bodies, nor do they seek pleasure in any other thing whatever, therefore the emperor Justinian built them a church which he dedicated to the Mother of God, so that they might be enabled to pass their lives within it, praying and holding services. (*Buildings*, V, viii, translated by H.B. Dewing, Loeb Library ed.)

The origins of monasticism in the eastern Christian world can be traced back to the third century, when some devout Christians began to retire into the desert to become hermits, living a secluded life of physical austerity and devoted to continual meditation and prayer. By the fourth century, groups of men and women began assembling around these hermits, ultimately forming independent secluded communities devoted to prayer and work. These monks and nuns practiced celibacy, poverty, and obedience to a spiritual leader, and they aspired to self-sufficiency so as to minimize contact with the outside world. The monastic movement grew rapidly; by 536 there were about 70 monasteries in Constantinople alone. Although they continued to function as retreats from the secular world—places where pious men and women could devote themselves almost exclusively to the contemplative life and safe havens for orphans, the poor, and the elderly—the monasteries, being tax-exempt, also amassed enormous wealth from the donations and bequests of the rich.

A local architect designed the new basilica church that Justinian commissioned for the monks and pilgrims of Mount Sinai. The building was constructed of local materials, but the sumptuous decoration of the sanctuary derives from more cosmopolitan artistic centers. The marble revetment that faces the lower walls of the apse was imported from an island quarry near Constantinople, and the artists who covered the halfdome of the apse and the end wall of the nave above it with powerful scenes in sumptuous mosaics were probably called in from Jerusalem, or even Constantinople. As at San Vitale, mosaic decoration is concentrated in the sanctuary, where the apse would have glistened with vivid color and divine light—a spotlighted destination at the end of the longitudinal axis of the processional nave (FIG. 8-11).

The mosaics integrate a series of stories and themes into a coherent program around the notion of theophany—the appearance of God to human beings. Two rectangular scenes on the end wall of the nave, above the apse (only partially visible in FIG. 8-11), picture two local theophanies—Moses before the burning bush

8-10 • THE MONASTERY OF ST. CATHERINE, SINAI
Mount Sinai, Egypt. Fortifications and church constructed under the patronage of Emperor Justinian, c. 548–566.

Founded in the fourth century, this monastery was initially associated with the burning bush, since it was built on the site where Moses was believed to have encountered this startling theophany, but in the tenth or eleventh century it was rededicated to St. Catherine of Alexandria after acquiring her relics.

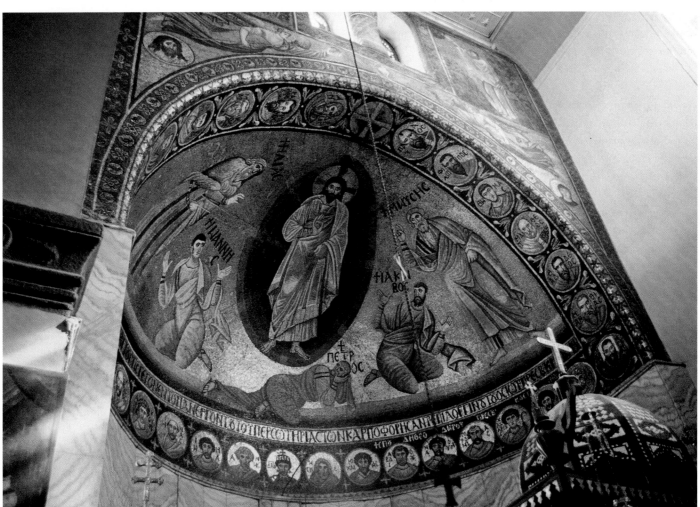

8-11 • THE TRANSFIGURATION OF CHRIST
Apse mosaic in the church of the Virgin, monastery of St. Catherine, Mount Sinai, Egypt. c. 565.

Framing the scene of the Transfiguration are medallion portraits of the 12 apostles, 2 monastic saints, and the 17 major and minor prophets. Sixth-century viewers would probably have associated David—in the medallion directly under Jesus and dressed in the robes and crown of a Byzantine emperor—with the patron, Emperor Justinian, and an inscription running above the lower row of medallions to the right identifies the monastic leaders at the time the mosaic was made and dates them to 565/6, near the time of Justinian's death.

and Moses receiving the law. The halfdome of the apse highlights the Transfiguration, an episode from the life of Jesus during which he was transformed "on a high mountain" from human to divine and set between apparitions of Moses and Elijah before the eyes of Peter, James, and John, three of his disciples (Matthew 17:1–6). The central figure of Jesus fits the description in the gospel text—"his face shone like the sun, and his clothes became dazzling white." The artists have flattened Jesus' form and set him against a contrasting deep blue mandorla (body halo), through which pass rays of light emanating from him and touching the figures around him. Unlike Jesus, the three apostles below him—who "fell to the ground and were overcome by fear"—are active rather than static, aggressively three-dimensional rather than brilliantly flattened, in a visual contrast between celestial apparition and earthly form. The entire tableau takes place against a background of golden light, with no indication of a landscape setting other than the banded lines of color at the bottom of the scene.

OBJECTS OF VENERATION AND DEVOTION

The court workshops of Constantinople excelled in the production of luxurious small-scale works in gold, ivory, and textiles. The Byzantine elite also sponsored vital **scriptoria** (writing centers for scribes—professional document writers) for the production of **manuscripts** (handwritten books), often located within monasteries.

THE ARCHANGEL MICHAEL DIPTYCH Commemorative ivory diptychs—two carved panels hinged together—originated with ancient Roman politicians elected to the post of consul. New consuls would send notices of their election to friends and colleagues by inscribing them in wax that filled a recessed rectangular area on the inner sides of a pair of ivory panels carved with elaborate decoration on the reverse. Christians adapted the practice for religious use, inscribing a diptych with the names of people to be remembered with prayers during the liturgy.

This large panel depicting the **ARCHANGEL MICHAEL**—the largest surviving Byzantine ivory—was half of such a diptych (**FIG. 8-12**). In his classicizing serenity, imposing physical presence, and elegant architectural setting, the archangel is comparable to the (supposed) priestess of Bacchus in the fourth-century pagan Symmachus diptych panel (see **FIG. 6-70**) and reminiscent of the standing saints in the dome mosaics of St. George in Thessaloniki (see **FIG. 7-21**). His relationship to the architectural space and the frame around him, however, is more complex. His heels rest on the top step of a stair that clearly lies behind the columns and pedestals, but the rest of his body projects in front of them—since it overlaps the architectural setting—creating a striking tension between this celestial figure and his terrestrial backdrop.

The angel is outfitted here as a divine messenger, holding a staff of authority in his left hand and a sphere symbolizing worldly power in his right. Within the arch is a similar cross-topped orb, framed by a wreath bound by a ribbon with long, rippling extensions,

8-12 • ARCHANGEL MICHAEL
Panel of a diptych, probably from the court workshop at Constantinople. Early 6th century. Ivory, 17″ × 5½″ (43.3 × 14 cm). British Museum, London.

Since people began to write some 5,000 years ago, they have kept records on a variety of materials, including clay or wax tablets, pieces of broken pottery, papyrus, animal skins, and paper. Books have taken two forms: scroll and codex.

Scribes made scrolls from sheets of papyrus glued end to end or from thin sheets of cleaned, scraped, and trimmed sheepskin or calfskin, a material known as **parchment** or, when softer and lighter, vellum. Each end of the scroll was attached to a rod; readers slowly unfurled the scroll from one rod to the other as they read. Scrolls could be written to be read either horizontally or vertically.

At the end of the first century CE, the more practical and manageable **codex** (plural, codices)—sheets bound together like the modern book—replaced the scroll as the primary form of recording texts. The basic unit of the codex was the eight-leaf quire, made by folding a large sheet of parchment twice, cutting the edges free, then sewing the sheets together up the center. Heavy covers kept the sheets of a codex flat. The thickness and weight of parchment and vellum made it impractical to produce a very large manuscript, such as an entire Bible, in a single volume. As a result, individual sections were made into separate books.

Until the invention of printing in the fifteenth century, all books were manuscripts—that is, they were written by hand. Manuscripts often included illustrations, called **miniatures** (from *minium*, the Latin word for a reddish lead pigment). Manuscripts decorated with gold and colors were said to be illuminated.

that is set against the background of a scallop shell. The lost half of this diptych would have completed the Greek inscription across the top, which reads: "Receive these gifts, and having learned the cause…." Perhaps the other panel contained a portrait of the emperor—many think he would be Justinian—or of another high official who presented the panels as a gift to an important colleague, acquaintance, or family member. Nonetheless, the emphasis here is on the powerfully classicized celestial messenger, who does not need to obey the laws of earthly scale or human perspective.

THE VIENNA GENESIS Byzantine manuscripts were often made with very costly materials. For example, sheets of purple-dyed **vellum** (a fine writing surface made from calfskin) and gold and silver inks were used to produce a codex now known as the Vienna Genesis. It was probably made in Syria or Palestine, and the purple vellum indicates that it may have been created for an imperial patron, since costly purple dye, made from the secretions of murex mollusks, was usually restricted to imperial use. The Vienna Genesis is written in Greek and illustrated with pictures that appear below the text at the bottom of the pages.

The story of **REBECCA AT THE WELL (FIG. 8-13)** (Genesis 24) appears here in a single composition, but the painter—clinging to the **continuous narrative** tradition that had characterized the illustration of scrolls—combines events that take place at different times in the story within a single narrative space. Rebecca, the heroine, appears at the left walking away from the walled city of Nahor with a large jug on her shoulder, going to fetch water. A colonnaded road leads toward a spring, personified by a reclining pagan water nymph who holds a flowing jar. In the foreground, Rebecca appears again, clearly identifiable by continuity of costume. Her jug now full, she encounters a thirsty camel driver and offers him water to drink. Since he is Abraham's servant, Eliezer, in search of a bride for Abraham's son Isaac, Rebecca's generosity results in her marriage to Isaac. The lifelike poses and rounded, full-bodied figures of this narrative scene conform to the conventions of traditional Roman painting. The sumptuous purple of the background and the glittering metallic letters of the text situate the book within the world of the privileged and powerful in Byzantine society.

8-13 • REBECCA AT THE WELL
Page from a codex featuring the book of Genesis (known as the Vienna Genesis). Made in Syria or Palestine. Early 6th century. Tempera, gold, and silver paint on purple-dyed vellum, 13½″ × 9⅞″ (33.7 × 25 cm). Österreichische Nationalbibliothek, Vienna.

LUXURY WORKS IN SILVER The imperial court at Constantinople had a monopoly on the production of some luxury goods, especially those made of precious metals. A seventh-century court workshop seems to have been the origin of a spectacular set of nine silver plates portraying events in the early life of the biblical King David, including the plate that we examined at the beginning of the chapter (see FIG. 8–1).

The plates would have been made by hammering a large silver ingot (the plate in FIG. 8–1 weighs 12 pounds 10 ounces) into a round shape and raising on it the rough semblance of the human figures and their environment. With finer chisels, silversmiths then refined these shapes, and at the end of their work, they punched ornamental motifs and incised fine details. The careful modeling, lifelike postures, and intricate engraving document the highly refined artistry and stunning technical virtuosity of these cosmopolitan artists at the imperial court who still practiced a classicizing art that had characterized some works of Christian art for centuries (see FIGS. 7–8, 7–21, 8–12).

ICONS AND ICONOCLASM

Christians in the Byzantine world prayed to Christ, Mary, and the saints while gazing at images of them on independent panels known as **icons**. Church doctrine toward the veneration of icons was ambivalent. Christianity inherited from Judaism an uneasiness with the power of religious images, rooted in the Mosaic prohibition of "graven images" (Exodus 20:4). The lingering effects of the early persecution of Christians because of their refusal to venerate images of Roman emperors only intensified this anxiety. But key figures of the Eastern Church, such as Basil the Great of Cappadocia (c. 329–379) and John of Damascus (c. 675–749), distinguished between idolatry—the worship of images—and the veneration of an idea or holy person depicted in a work of art. Icons were thus accepted as aids to meditation and prayer, as intermediaries between worshipers and the holy personages they depicted. Honor showed to the image was believed to transfer directly to its spiritual prototype.

Surviving early icons are rare. A few precious examples exist at the monastery of St. Catherine on Mount Sinai, among them **VIRGIN AND CHILD WITH SAINTS AND ANGELS** (FIG. **8–14**). As Theotokos (Greek for "bearer of God"), Jesus' earthly mother was viewed as a powerful, ever-forgiving intercessor, who could be counted on to appeal to her divine son for mercy on behalf of devout

8-14 • VIRGIN AND CHILD WITH SAINTS AND ANGELS

Icon. Second half of the 6th century. **Encaustic** on wood, 27″ × 18⅞″ (69 × 48 cm). Monastery of St. Catherine, Mount Sinai, Egypt.

Read the document related to painting icons on myartslab.com

Iconoclasm (literally "image breaking," from the Greek words *eikon* "image" and *klao* meaning "break" or "destroy") is the prohibition and destruction of works of visual art, usually because they are considered inappropriate in religious contexts.

During the eighth century, mounting discomfort with the place of icons in Christian devotion grew into a major controversy in the Byzantine world, and between 726 and 730, Emperor Leo III (r. 717–741) imposed iconoclasm, initiating the systematic destruction of images of saints and sacred stories on icons and in churches, as well as the persecution of those who made them and defended their use. His successor, Constantine V (r. 741–775), enforced these policies and practices with even greater fervor, but at the end of the reign of Leo IV (r. 775–780), his widow, Empress Irene, who ruled as regent for their son Constantine IV (r. 780–797), put an end to iconoclasm in 787 through a church council held in Nicea. Leo V (r. 813–820) instituted a second phase of iconoclasm in 813, and it remained imperial policy until March 11, 843, when the widowed Empress Theodora reversed her husband Theophilus' policy and reinstated the central place of images in Byzantine devotional practice.

A number of explanations have been proposed for these two interludes of Byzantine iconoclasm. Some Church leaders feared that the use of images in worship could lead to idolatry or at least distract worshipers from their spiritual exercises. Specifically, there were questions surrounding the relationship between images and the Eucharist, the latter considered by iconoclasts as sufficient representation of the presence of Christ in the church. But there was also anxiety in Byzantium about the weakening state of the empire, especially in relation to the advances of Arab armies into Byzantine territory. It was easy to pin these hard times on God's displeasure with the idolatrous use of images. Coincidentally, Leo III's success fighting the Arabs could be interpreted as divine sanction of his iconoclastic position, and its very adoption might appease the iconoclastic Islamic enemy itself. Finally, since the production and promotion of icons was centered in monasteries—at that time rivaling the state in strength and wealth—attacking the use of images might check their growing power. Perhaps all these factors played a part, but at the triumph of the **iconophiles** (literally "lovers of images") in 843, the place of images in worship was again secure: Icons proclaimed Christ as God incarnate and facilitated Christian worship by acting as intermediaries between humans and saints. Those who had suppressed icons became heretics (**FIG. 8–15**).

But iconoclasm is not restricted to Byzantine history. It reappears from time to time throughout the history of art. Protestant reformers in sixteenth-century Europe adopted what they saw as the iconoclastic position of the Hebrew Bible (Exodus 20:4), and many works of Catholic art were destroyed by zealous reformers and their followers. Even more recently, in 2001, the Taliban rulers of Afghanistan dynamited two gigantic fifth-century CE statues of the Buddha carved into the rock cliffs of the Bamiyan Valley, specifically because they believed such "idols" violated Islamic law.

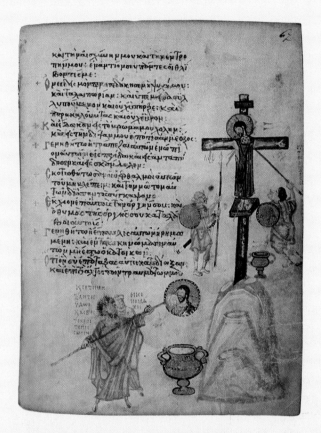

8–15 • CRUCIFIXION AND ICONOCLASTS
From the Chludov Psalter. Mid 9th century. Tempera on vellum, 7¾" × 6" (19.5 × 15 cm). State Historical Museum, Moscow. MS. D. 29, fol. 67v

This page and its illustration of Psalm 69:21—made soon after the end of the iconoclastic controversy in 843—records the iconophiles' harsh judgment of the iconoclasts. Painted in the margin at the right, a scene of the Crucifixion shows a soldier tormenting Christ with a vinegar-soaked sponge. In a striking visual parallel, two named iconoclasts—identified by inscription—in the adjacent picture along the bottom margin employ a whitewash-soaked sponge to obliterate an icon portrait of Christ, thus linking them by their actions with those who had crucified him.

and repentant worshipers. The Virgin and Child are flanked here by Christian warrior-saints Theodore (left) and George (right)—both legendary figures said to have slain dragons, representing the triumph of the Church over the "evil serpent" of paganism. Angels behind them twist their heads to look heavenward. The artist has painted the Christ Child, the Virgin, and especially the angels, with an illusionism that renders them lifelike and three-dimensional in appearance. But the warrior-saints—who look out to meet directly the worshipful gaze of viewers—are more stylized. Here the artist barely hints at bodily form beneath the richly patterned textiles

of their cloaks, and their tense faces are frozen in frontal stares of gripping intensity.

In the eighth century, the veneration of icons sparked a major controversy in the Eastern Church, and in 726 Emperor Leo III launched a campaign of **iconoclasm** ("image breaking"), banning the use of icons in Christian worship and ordering the destruction of devotional pictures (see "Iconoclasm," page 247). Only a few early icons survived in isolated places like Mount Sinai, which was no longer a part of the Byzantine Empire at this time. But iconoclasm did not last. In 787 iconoclasm was revoked at the instigation of Empress Irene, only to be reinstated in 813. Again it was an empress—Theodora, widow of Theophilus, last of the iconoclastic emperors—who reversed her husband's policy in 843, and from this moment onward icons would play an increasingly important role as the history of Byzantine art developed.

MIDDLE BYZANTINE ART

With the turmoil and destruction of iconoclasm behind them, Byzantine patrons and artists turned during the second half of the ninth century to ambitious projects of restoration and renewal, redecorating church interiors with figural images and producing new icons in a variety of media for the devotional practices of the faithful. This period also saw a renewal and expansion of the power and presence of monasteries in the Byzantine world. A new Macedonian dynasty of rulers—founded in 866 by Emperor Basil I (r. 866–886) and continuing until 1056—increased Byzantine military might, leading to an expansion of imperial territory, only checked in the mid eleventh century by the growing power of the Turks who dealt the Byzantine army a series of military setbacks that would continue to erode the empire until the fifteenth century. But after the empire stabilized under the Komnenian dynasty (1081–1185), it was not the Turks who instigated the end of the Middle Byzantine period. It ended abruptly when Christian crusaders from the west, setting out on a holy war against Islam, diverted their efforts to conquering the wealthy Christian Byzantine Empire, taking Constantinople in 1204. The crusaders looted the capital and set up a Latin dynasty of rulers to replace the Byzantine emperors, who fled into exile.

The patronage of the Macedonian dynasty stimulated a new golden age of Byzantine art, often referred to as the "Macedonian Renaissance," since it was marked by an intensified interest in the styles and themes of classical art, as well as by a general revitalization of intellectual life, including the study and emulation of the classics. As the Middle Byzantine period developed, the geography of Byzantine art changed significantly. As we have seen, early Byzantine civilization had been centered in lands along the rim of the Mediterranean Sea that had been within the Roman Empire. During the Middle Byzantine period, Constantinople's scope was reduced to present-day Turkey and other areas by the Black Sea, as well as the Balkan peninsula, including Greece, and southern Italy. The influence of Byzantine culture also extended into Russia and Ukraine, and to Venice, Constantinople's trading partner in northeastern Italy, at the head of the Adriatic Sea.

ARCHITECTURE AND WALL PAINTING IN MOSAIC AND FRESCO

Although the restitution of images within Byzantine religious life led to the creation of new mosaics in the major churches of the capital, comparatively few Middle Byzantine churches in Constantinople have survived intact. Better-preserved examples of the central-plan domed churches that were popular in the Byzantine world survive in Greece to the southwest and Ukraine to the northeast, and are reflected in Venice within the western medieval world. These structures document the Byzantine taste for a multiplicity of geometric forms, for verticality, and for rich decorative effects both inside and out.

APSE MOSAIC OF HAGIA SOPHIA The upper parts of Justinian's church of Hagia Sophia was originally encrusted with broad expanses of gold mosaic framed by strips of vegetal and geometric ornament, but figural mosaics highlighting sacred individuals or

8-16 • VIRGIN AND CHILD IN THE APSE OF HAGIA SOPHIA

Constantinople (Istanbul). Dedicated in 867. Mosaic.

sacred stories seem not to have been part of the original design. With the restitution of images at the end of iconoclasm, however, there was an urgency to assert the significance of images within Byzantine churches, and the great imperial church of the capital was an important location to proclaim the orthodoxy of icons. By 867, mosaicists had inserted an iconic rendering of the Incarnation in the form of an image of the Virgin Mary holding the child Jesus in her lap (**FIG. 8-16**), flanked by angels, and accompanied by an inscription claiming that "the images which the imposters [the iconoclast emperors] had cast down here, pious emperors have set up again." The design of Hagia Sophia—especially the disposition of the sanctuary apse perforated from top to bottom with bands of windows—provided no obvious areas to highlight a figural mosaic, and working at the extreme height of the halfdome—where the mosaic is located—required the erection of immense wooden scaffolding to accommodate the artists at work (see FIG. 8-4, where the Virgin and Child appear at the top of the central lower apse, floating above the middle of the five windows at the bottom of the halfdome). Adding this mosaic was an expensive project.

Floating on an expansive sweep of gold mosaic with neither natural nor architectural setting—like a monumental icon presented for the perpetual veneration of the faithful—the Virgin and Child in Hagia Sophia recalls the pre-iconoclastic rendering on a surviving icon from Mount Sinai (see FIG. 8-14), but their gracefully modeled faces, their elegantly attenuated bodily proportions, and the jewel-studded bench that serves as their throne, proclaim the singular importance of their placement in Constantinople's principal imperial church. Co-emperors Michael III and Basil I were present in Hagia Sophia on March 29, 867, when the patriarch Photios preached the sermon at the dedication of the apse mosaics, laying claim to the historic moment this represented and challenging the rulers to maintain the orthodoxy it represented.

MONASTERY OF HOSIOS LOUKAS Although an outpost, Greece was part of the Byzantine Empire, and the eleventh-century Katholikon (main church) of the monastery of Hosios Loukas, built a few miles from the village of Stiris in central Greece, is an excellent example of Middle Byzantine architecture (**FIG. 8-17**). It stands next to the earlier church of the Theotokos (Virgin Mary) within the courtyard of the walled enclosure that contained the life of the monks (**FIG. 8-18**). They slept in individual rooms—called "cells"—incorporated into the walls around the periphery of the complex, and they ate their meals together in a long rectangular hall, parallel to the main church.

The Katholikon has a compact central plan with a dome, supported on squinches, rising over an octagonal core (see "Pendentives and Squinches," page 238). On the exterior, the rising forms of apses, walls, and roofs disguise the vaulting roofs of the interior. The Greek builders created a polychromed decorative effect on the exterior, alternating stones with bricks set both vertically and horizontally and using diagonally set bricks to form saw-toothed moldings. Inside the churches, the high central space carries the eyes of worshipers upward into the main dome, which soars above a ring of tall arched openings.

8-17 • MONASTERY CHURCHES AT HOSIOS LOUKAS, STIRIS
Central Greece. Katholikon (left), early 11th century, and church of the Theotokos, late 10th century. View from the east.

8-18 • PLAN OF THE MONASTERY AT HOSIOS LOUKAS
Including the two churches in FIG. 8-17: Katholikon at lower right, church of the Theotokos at upper left.

Explore the architectural panoramas of the monastery at Hosios Loukas on myartslab.com

warm rooms for winter

monks' cells

old entrance

gardens

courtyard

gardens

older church of the Virgin (Theotokos)

Katholikon (main church of Hosios Loukas)

refectory

underground cistern

current entrance

chapel and clock tower

monks' cells

0 20m

Unlike Hagia Sophia, with its clear, sweeping geometric forms, the Katholikon has a complex variety of architectural shapes and spaces, including domes, groin vaults, barrel vaults, pendentives, and squinches, all built on a relatively small scale (**FIG. 8-19**). The barrel vaults and tall sanctuary apse with flanking rooms further complicate the spatial composition. Single, double, and triple windows create intricate and unusual patterns of light that illuminated a mosaic of Christ Pantokrator (now lost) looming at the center of the main dome. A mosaic of the Lamb of God surrounded by the Twelve Apostles at Pentecost fills the secondary, sanctuary dome, and the apse halfdome presents a rendering of the Virgin and Child Enthroned, reminiscent of the ninth-century mosaic in the apse halfdome of Hagia Sophia (see FIG. 8-16). Scenes of Christ's life on earth (the Nativity appears on the squinch visible in FIG. 8-19) and figures of saints fill the upper surfaces of the interior with brilliant color and dramatic images. As at Hagia Sophia, the lower walls are faced with a multicolored stone veneer. A screen with icons separates the congregation from the sanctuary.

CATHEDRAL OF SANTA SOPHIA IN KIEV During the ninth century, the rulers of Kievan Rus—Ukraine, Belarus, and Russia—adopted Orthodox Christianity and Byzantine culture. These lands had been settled by eastern Slavs in the fifth and sixth centuries, but later were ruled by Scandinavian Vikings who had sailed down the rivers from the Baltic to the Black Sea. In Constantinople, the Byzantine emperor hired the Vikings as his

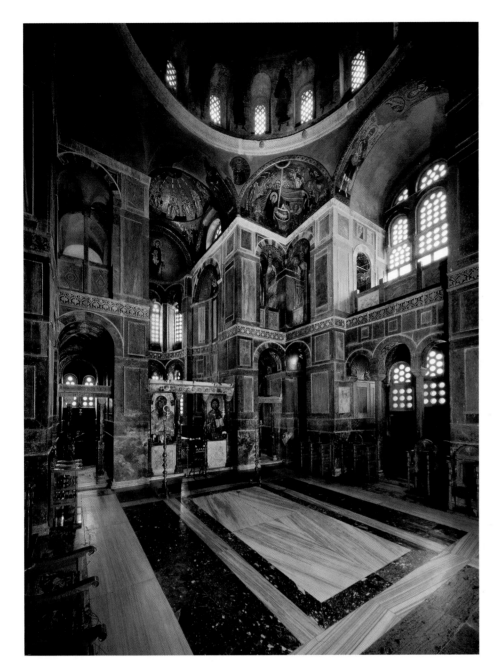

8-19 • CENTRAL DOMED SPACE AND APSE (THE NAOS), KATHOLIKON
Monastery of Hosios Loukas. Early 11th century and later.

The subjects of the mosaics in Middle Byzantine churches such as the Katholikon at Hosios Loukas were organized into three levels according to meaning. Heavenly subjects like Christ Pantokrator, the Virgin Mary, Pentecost (Acts 2:1–3), or angels, appear on the tops of domes or in apse halfdomes. Below them, in a middle register are scenes from Christ's life on earth—here the Nativity in a squinch. Below, at the lowest level of mosaics are iconic representations of saints, closer to the viewer and thus more available for individual prayerful veneration.

personal bodyguards, and Viking traders established a headquarters in the upper Volga region and in the city of Kiev, which became the capital of the area under their control.

The first Christian member of the Kievan ruling family was Princess Olga (c. 890–969), who was baptized in Constantinople by the patriarch himself, with the Byzantine emperor as her godfather. Her grandson Grand Prince Vladimir (r. 980–1015) established Orthodox Christianity as the state religion in 988 and cemented his relations with the Byzantines by accepting baptism and marrying Anna, the sister of the powerful Emperor Basil II (r. 976–1025).

Vladimir's son Grand Prince Yaroslav (r. 1036–1054) founded the **CATHEDRAL OF SANTA SOPHIA** in Kiev (**FIG. 8-20**). The church—originally designed as a typical Byzantine multiple-domed cross—was expanded with double side aisles, leading to

five apses, and incorporating a large central dome surrounded by 12 smaller domes, all of which creates a complicated and compartmentalized interior. The central domed space of the crossing, however, focuses attention on the nave and the main apse, where the walls glow with lavish decoration, including the mosaics of the central dome, the apse, and the arches of the crossing. The remaining surfaces are frescoed with scenes from the lives of Christ, the Virgin, the apostles Peter and Paul, and the archangels.

The Kievan mosaics established a standard iconographic system used in Russian Orthodox churches. A Christ Pantokrator fills the curving surface at the crest of the main dome (not visible above the window-pierced drum in FIG. 8-20). At a lower level, the apostles stand between the windows of the drum, with the four evangelists occupying the pendentives. An orant figure of the Virgin Mary seems to float in a golden heaven on the halfdome

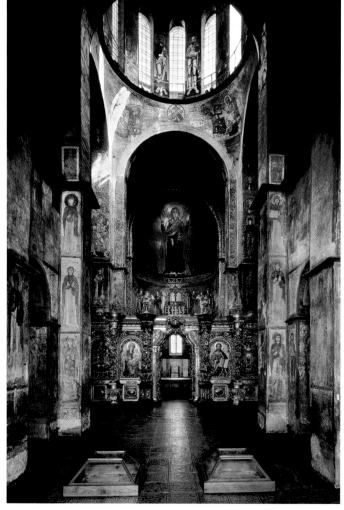

8-20 • INTERIOR, CATHEDRAL OF SANTA SOPHIA, KIEV
1037–1046. Apse mosaics: Orant Virgin and Communion of the Apostles.

other spread to clutch a massive book securely. In the squinches of the corner piers are four signal episodes from his life: Annunciation, Nativity, Baptism, and Transfiguration.

A mosaic of the **CRUCIFIXION** from the lower part of the church (**FIG. 8-22**) exemplifies the focus on emotional appeal to individuals that appears in late eleventh-century Byzantine art. The figures inhabit an otherworldly space, a golden universe anchored to the material world by a few flowers, which suggest the promise of new life. A nearly nude Jesus is shown with bowed head and gently sagging body, his eyes closed in death. The witnesses have been reduced to two isolated mourning figures, Mary and the young apostle John, to whom Jesus had just entrusted the care of his mother. The elegant cut of the contours and the eloquent restraint of the gestures only intensify the emotional power of the image. The nobility and suffering of these figures was meant to move monks and visiting worshipers toward a deeper involvement with their own meditations.

This depiction of the Crucifixion has symbolic as well as emotional power. The mound of rocks and the skull at the bottom of the cross represent Golgotha, the "place of the skull," the hill outside ancient Jerusalem where Adam was thought to be buried and where the Crucifixion was said to have taken place. The faithful saw Jesus Christ as the new Adam, whose sacrifice on the cross saved humanity from the sins brought into the world by Adam and

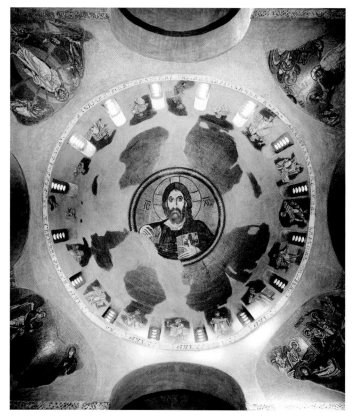

8-21 • CHRIST PANTOKRATOR WITH SCENES FROM THE LIFE OF CHRIST
Central dome and squinches, Church of the Dormition, Daphni, Greece. c. 1100. Mosaic.

and upper wall of the apse, and on the wall below her is the Communion of the Apostles. Christ appears not once, but twice, in this scene, offering the Eucharistic bread and wine to the apostles, six on each side of the altar. With such extravagant use of costly mosaic, Prince Yaroslav made a powerful political declaration of his own power and wealth—and that of the Kievan Church as well.

MONASTERY CHURCH OF THE DORMITION AT DAPHNI
The refined mosaicists who worked c. 1100 at the monastery church of the Dormition at Daphni, near Athens, seem to have conceived their compositions in relation to an intellectual ideal. They eliminated all "unnecessary" detail to focus on the essential elements of a narrative scene, conveying its mood and message in a moving but elegant style. The main dome of this church has retained its riveting image of the Pantokrator, centered at the crest of the dome like a seal of divine sanction and surveillance (**FIG. 8-21**). This imposing figure manages to be elegant and awesome at the same time. Christ blesses or addresses the assembled congregation with one hand, while the slender, attenuated fingers of the

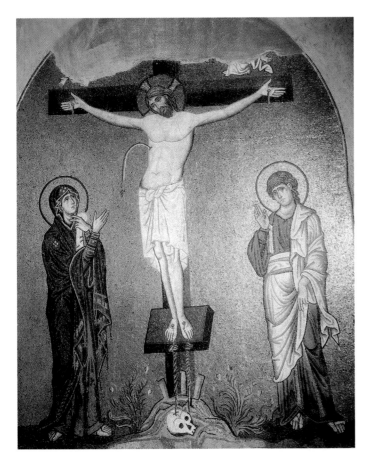

8-22 • CRUCIFIXION
Church of the Dormition, Daphni, Greece. c. 1100. Mosaic.

Eve. The arc of blood and water springing from Jesus' side refers to Eucharistic and baptismal rites. As Paul wrote in his First Letter to the Corinthians: "For just as in Adam all die, so too in Christ shall all be brought to life" (1 Corinthians 15:22). The timelessness and simplicity of this image were meant to aid the Christian worshiper seeking to achieve a mystical union with the divine through prayer and meditation, both intellectually and emotionally.

MONASTERY CHURCH OF ST. PANTELEIMON AT NEREZI Dedicated in 1164, the church of St. Panteleimon—the Katholikon of the small monastery at Nerezi in Macedonia—was built under the patronage of Alexios Komnenos, nephew of Emperor John II (r. 1118–1143). Here the wall paintings were created in fresco rather than mosaic, with a stylistic delicacy and **painterly** spontaneity characteristic of Byzantine art under the Komnenians. It represents well the growing emphasis in capturing the emotionalism of sacred narrative, already noted at Daphni. In the upper part of one wall, the scene of the **LAMENTATION** over the dead body of Christ (**FIG. 8-23**)—a non-biblical episode that seems to have been developed during the twelfth century—forges a direct link with viewers' emotions, while standing in the register below, a group of monastic saints model the unswerving postures of spiritual stability. The narrative emphasis is on the Virgin's anguish as she cradles the lifeless body of her son in the broad extension of her lap, pulling his head toward her, cheek to cheek, in a desperate final embrace. Behind her, St. John bends

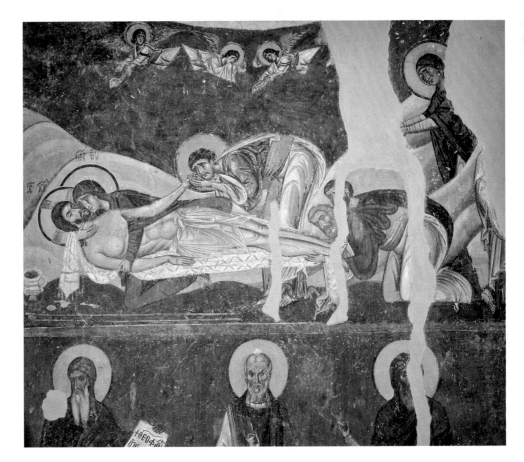

8-23 • LAMENTATION WITH STANDING MONASTIC SAINTS BELOW
North wall of the church of the monastery of St. Panteleimon, Nerezi (near Skopje), Macedonia. 1164. Fresco.

to lift Jesus' hand to his cheek, conforming to a progressively descending diagonal arrangement of mourners that tumbles from the mountainous backdrop toward resolution in the limp torso of the savior. Such emotional expressions of human grief in human terms will be taken up again in Italy by Giotto over a century later (see FIG. 18–8).

THE CATHEDRAL OF ST. MARK IN VENICE The northeastern Italian city of Venice, set on the Adriatic at the crossroads of Europe and Asia Minor, was in certain ways an outpost of Byzantine art in Italy. Venice had been subject to Byzantine rule in the sixth and seventh centuries, and up to the tenth century, the city's ruler, the doge ("duke" in Venetian dialect), had to be ratified by the Byzantine emperor. At the end of the tenth century, Constantinople granted Venice a special trade status that allowed its merchants to control much of the commerce between east and west, and the city grew enormously wealthy.

Venetian architects looked to Byzantine domed churches for inspiration in 1063, when the doge commissioned a church to replace the palace chapel that had housed the relics of St. Mark the apostle since they had been brought to Venice from Alexandria in 828/29 (FIG. **8-24**). The Cathedral of St. Mark is designed as a Greek cross, with arms of equal length. A dome covers each square unit—five great domes in all, separated by barrel vaults and supported by pendentives. Unlike Hagia Sophia in Constantinople, where the space seems to flow from the narthex up into the dome and through the nave to the apse, St. Mark's domed compartments produce a complex space in which each dome maintains its own separate vertical axis. As we have seen elsewhere, marble veneer covers the lower walls, and golden mosaics glimmer above on the vaults, pendentives, and domes. A view of the exterior of St. Mark's as it would have appeared in early modern times can be seen in a painting by the fifteenth-century Venetian artist Gentile Bellini (see FIG. 20–42).

8-24 • INTERIOR (A) AND PLAN (B) OF THE CATHEDRAL OF ST. MARK
Venice. Begun 1063. View looking toward apse.

This church is the third one built on the site. It was both the palace chapel of the doge and the burial place for the bones of the patron of Venice, St. Mark. The church was consecrated as a cathedral in 1807. The mosaics have been reworked continually to the present day.

PRECIOUS OBJECTS OF COMMEMORATION, VENERATION, AND DEVOTION

As in the Early Byzantine period, tenth-, eleventh-, and twelfth-century artists produced small, often portable, luxury items for wealthy members of the imperial court as well as for Church dignitaries. These patrons often commissioned such precious objects as official gifts for one another. They had to be portable, sturdy, and refined, representing the latest trends in style and subject. These works frequently combined exceptional beauty and technical virtuosity with religious meaning; many were icons or devotional objects. Ivory carving, gold and **enamel** work, fine books, and intricate panel paintings were especially prized.

IVORIES Standing slightly over 9 inches tall, the small ivory ensemble known as the **HARBAVILLE TRIPTYCH** (named after a nineteenth-century owner) was made as a portable devotional object with two hinged wings that could be folded shut for travel. Its privileged owner used this work as the focus for private prayer; as a luxury object it also signaled high status and wealth. When opened (**FIG. 8-25A**), the triptych features across the top of the central panel a tableau with an enthroned Christ flanked by Mary and St. John the Baptist. This is a composition known as the "Deësis" (meaning "entreaty" in Greek), which shows Mary and John interceding with Christ, presumably pleading for forgiveness and salvation for the owner of this work. St. Peter stands directly under Christ, gesturing upward toward him, and flanked by four other apostles—SS. James, John, Paul, and Andrew, all identified by inscriptions. The figures in the outer panels (both back and front) are military saints, bishop saints, and martyrs.

These holy figures stand in undefined spatial settings, given definition only by the small bases under their feet, effectively removing their gently modeled forms from the physical world. As a whole, they represent a celestial court of saints attending the enthroned Christ in paradise, categorized into thematic groups in an organization that recalls the ordered distribution of subjects in a Middle Byzantine church (see **FIGS. 8-19, 8-20**). On the back of the central panel (**FIG. 8-25B**) is a symbolic evocation of paradise itself in the form of a large stable cross surrounded by luxurious vegetation inhabited by animals, presumably an evocation of the longed-for destination of the original owner, a reminder to focus attention on devotional practice and enlist the aid of the congregation of saints to assure the attainment of salvation. An abbreviated inscription above the cross—IC XC NIKA—backs up the pictorial reminder with words—"Jesus Christ is victorious."

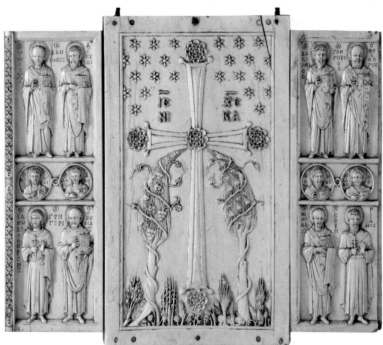

8-25 • FRONT (A) AND BACK (B) OF THE HARBAVILLE TRIPTYCH
From Constantinople. Mid 10th century. Ivory, closed 9½″ × 5⅝″ (24.2 × 14.3 cm); open 9½″ × 11″ (24.2 × 28 cm). Musée du Louvre, Paris.

Related to the Harbaville Triptych in both figure style and compositional format is an independent ivory panel portraying an emperor and empress gesturing toward and standing between an elevated figure of Christ, who reaches out to touch the crowns they wear on their heads (**FIG. 8-26**). The imperial figures are identified by inscription as Romanos and Eudokia—most likely Emperor Romanos II, son and co-emperor of Constantine VII

8-26 • CHRIST CROWNING EMPEROR ROMANOS II AND EMPRESS EUDOKIA

From Constantinople. 945–949. Ivory, 7⅜″ × 3¾″ (18.6 × 9.5 cm). Cabinet des Médailles, Bibliothèque Nationale de France, Paris.

Porphyrogenitos (r. 945–959), and Romanos's first wife Eudokia, the daughter of Hugo of Provence, King of Rome, whom Romanos married in 944 when she was only 4 years old, and who died in 949. This is not a scene of coronation but an emblem—Eudokia, for instance, is represented as an adult rather than as a child—of the fusion of imperial authority with the religious faith that sanctioned and supported it. The carefully modeled figure of Christ, whose drapery is arranged to give three-dimensionality to his bodily form, offers a striking contrast to the stiff and flattened figures of the imperial couple, all but consumed by the elaborate decoration of their royal robes.

MANUSCRIPTS Painted books were some of the most impressive products of the Middle Byzantine period, and of the Macedonian Renaissance in particular. The luxurious Paris **Psalter** (named after its current library location) is a noteworthy example.

This personal devotional book—meant to guide the prayer life of its aristocratic owner—includes the complete text of the Psalms and a series of odes or canticles drawn from the Bible that were a standard part of Byzantine psalters. The annotation of the biblical texts with passages from interpretive commentaries gives this book a scholarly dimension consistent with a revival of learning that took place under the Macedonians emperors. Indeed it seems to have been commissioned in Constantinople by the intellectual Emperor Constantine VII Porphyrogenitos as a gift for his son Romanos II, whom we have already encountered (see FIG. 8–26).

This book is best known, however, neither for its learned texts nor for its imperial patron or owner, but for its set of 14 full-page miniatures. The fresh spontaneity of these paintings and the complicated abstraction underlying their compositional structure—salient stylistic features of the Macedonian Renaissance—make this book one of the true glories of Byzantine art. Eight of these framed miniatures portray episodes from the life of Israel's King David, who as a boy had saved the people of God by killing the giant Goliath

8-27 • DAVID COMPOSING THE PSALMS

Page from the Paris Psalter. Constantinople. c. 950. Paint and gold on vellum, sheet size 14½″ × 10½″ (37 × 26.5 cm). Bibliothèque Nationale de France, Paris.

A CLOSER LOOK | Icon of St. Michael the Archangel

Made in Constantinople. 12th century. Silver-gilt on wood, cloisonné enamels, gemstones. 18⅛″ × 13¾″ (46 × 35 cm).
Treasury of the Cathedral of St. Mark, Venice.

This bust portrait of Christ, created with **cloisonné** enamel, appears directly over the head of St. Michael, sanctioning his power with a gesture of blessing or recognition. The medallions on the upper corners portray SS. Peter and Menas, but the enamels once filling comparable medallions on the lower strip of the frame are lost.

Heavily abbreviated inscriptions flanking or surmounting the saints identify them by name.

In 1834, restorers replaced the wings of St. Michael, which are now probably disproportionately large in relation to the originals. In the same restoration, the precious gemstones once set into the frame were replaced with colored glass.

Four pairs of military saints in oval compartments flank St. Michael on the lateral strips of the frame. This entourage emphasizes the military character of St. Michael himself, who is dressed and equipped for battle as the leader of a heavenly army.

Luminous enamel (glass heated to the melting point at which it bonds to the underlying or surrounding metal) completely covers the face of St. Michael to give it the appearance of human flesh.

Lavish and intricate patterns created from enamel fill the background around St. Michael. Byzantine artists were virtuosos in the *cloisonné* technique, in which gold strips or wires are soldered to the underlying metal surface to separate the different colors of enamel from each other, forming a network of delicate gold lines that delineate the decorative forms and enliven the surface with reflected light.

A series of separately fabricated forms—nimbed head, torso, legs, arms, wings, sword, and fully three-dimensional orb and sword—have been assembled to create the projecting figure of St. Michael.

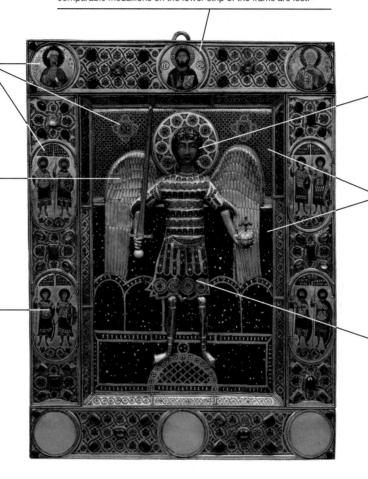

 View the Closer Look for the icon of St. Michael the Archangel on myartslab.com

(see FIG. 8–1) and who was traditionally considered the author of the Psalms. The first of these depicts David seated outdoors against a background of lush foliage while he composes the Psalms to the accompaniment of his harp (**FIG. 8-27**). Groups of animals surround him in the foreground, while his native city of Bethlehem looms through the atmospheric mist in the background.

The Macedonian Renaissance emphasis on a Classical revival is evident here in the personification of abstract ideas and landscape features: Melody, a languorous female figure, leans casually on David's shoulder to inspire his compositions, while another woman, perhaps Echo, peeks from behind a column in the right background. The swarthy reclining youth in the lower foreground is a personification of Mount Bethlehem, as we learn from his inscription. The motif of the dog watching over the sheep and goats while his master strums the harp invokes the Classical subject of Orpheus charming wild animals with music. The strongly modeled three-dimensionality of the forms, the integration of the figures into a three-dimensional space, and the use of atmospheric perspective all enhance the Classical flavor of the painting, in yet another example of the enduring vitality of pagan artistic traditions at the Christian court in Constantinople.

ICONS In the centuries after the end of iconoclasm, one of the major preoccupations of Byzantine artists was the creation of independent devotional images in a variety of media. The revered twelfth-century icon of Mary and Jesus known as the **VIRGIN**

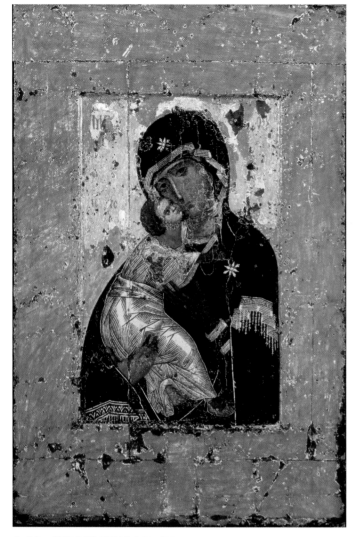

8-28 • VIRGIN OF VLADIMIR
Probably from Constantinople. Faces, 12th century; the figures have
been retouched. Tempera on panel, height approx. 31″ (78 cm).
Tretyakov Gallery, Moscow.

OF VLADIMIR (**FIG. 8-28**) was probably painted in Constan-
tinople but brought to Kiev. This distinctively humanized image
is another example of the growing desire for a more immediate
and personal religion that we have already seen in the Cruci-
fixion mosaic at Daphni, dating slightly earlier. Here the artist
used an established iconographic type, known as the "Virgin of
Compassion," showing Mary and the Christ Child pressing their
cheeks together and gazing at each other with tender affection,
that is found as early as the tenth century and was believed to have
been first painted by St. Luke, reproducing what he had seen in
a vision. The *Virgin of Vladimir* was thought to protect the people
of the city where it resided. It arrived in Kiev sometime in the
1130s, was subsequently taken to the city of Suzdal, and finally to
Vladimir in 1155. In 1480, it was moved to the Cathedral of the
Dormition in the Moscow Kremlin.

Also from the twelfth century, but made from more pre-
cious materials and presenting a saintly image more hieratic than

intimate, is a representation of the archangel Michael in silver-gilt
and enamel (see "A Closer Look," page 257), whose technical vir-
tuosity and sumptuous media suggest it may have been an imperial
commission for use within the palace complex itself. St. Michael is
dressed here as a confrontational military commander in the heav-
enly forces, a real contrast with the calmly classicizing angelic form
he takes in the large ivory panel we examined from the Early Byz-
antine period (see **FIG. 8-12**). This later St. Michael did not remain
in Constantinople. It is now in the treasury of the Cathedral of St.
Mark in Venice, one of many precious objects taken as booty by
Latin crusaders in 1204 at the fall of Constantinople during the
ill-conceived Fourth Crusade. This devastating event brought an
abrupt end to the Middle Byzantine period.

LATE BYZANTINE ART

A third great age of Byzantine art began in 1261, after the Byz-
antines expelled the Christian crusaders who had occupied Con-
stantinople for nearly 60 years. Although the empire had been
weakened and its domain decreased to small areas of the Balkans
and Greece, the arts underwent a resurgence known as the Pal-
aeologue Renaissance after the new dynasty of emperors who
regained Constantinople. The patronage of emperors, wealthy
courtiers, and the Church stimulated renewed church building as
well as the production of icons, books, and precious objects.

CONSTANTINOPLE: THE CHORA CHURCH

In Constantinople, many existing churches were renovated,
redecorated, and expanded during the Palaeologue Renaissance.
Among these is the church of the monastery of Christ in Chora.
The expansion of this church was one of several projects that
Theodore Metochites (1270–1332), a humanist poet and scientist,
and the administrator of the imperial treasury at Constantinople,
sponsored between c. 1315 and 1321. He added a two-story annex
on the north side, two narthexes on the west, and a parekklesion
(side chapel) used as a funerary chapel on the south (**FIG. 8-29**).
These structures contain the most impressive interior decorations
remaining in Constantinople from the Late Byzantine period,
rivaling in splendor and technical sophistication the works of the
age of Justinian, but on a more intimate scale. The walls and vaults
of the parekklesion are covered with frescos (see "The Funerary
Chapel of Theodore Metochites," page 260), and the narthex vaults
are encrusted with mosaics.

In the new narthexes of the Chora church, above an expanse
of traditional marble revetment on the lower walls, mosaics cover
every surface—the domical groin vaults, the wall lunettes, even
the undersides of arches—with narrative scenes and their orna-
mental framework (**FIG. 8-30**). The small-scale figures of these
mosaics seem to dance with relentless enthusiasm through the
narrative episodes they enact from the lives of Christ and his
mother. Unlike the stripped-down narrative scenes of Daphni (see
FIG. 8-22), here the artists have lavished special attention on the

8-29 • PLAN OF THE MONASTERY CHURCH OF CHRIST IN CHORA, CONSTANTINOPLE

Modern Istanbul. (Present-day Kariye Müzesi.) Original construction 1077–1081; expanded and refurbished c. 1315–1321.

✳ **Explore** the architectural panoramas of the church of Christ in Chora on myartslab.com

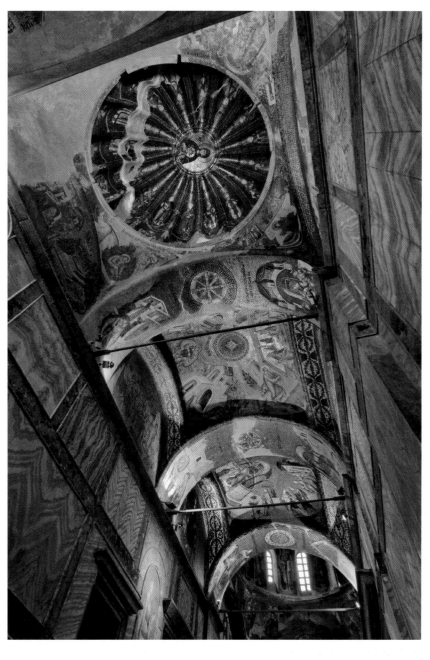

8-30 • MOSAICS IN THE VAULTING OF THE INNER NARTHEX

Church of Christ in Chora. (Present-day Kariye Müzesi.) c. 1315–1321.

settings, composing their stories against backdrops of architectural fantasies and stylized plants. The architecture of the background is presented in an innovative system of perspective, charting its three-dimensionality not in relation to a point of convergence in the background—as will be the case in the linear, **one-point perspective** of fifteenth-century Florentine art (see "Renaissance Perspective," page 610)—but projecting forward in relationship to a point in the foreground, thereby drawing attention to the figural scenes themselves.

The Chora mosaics build on the growing Byzantine interest in the expression of emotions within religious narrative, but they broach a level of human tenderness that surpasses anything we have seen in Byzantine art thus far. The artists invite viewers to see the participants in these venerable sacred stories as human beings just like themselves, only wealthier and holier. For example, an

entire narrative field in one vault is devoted to a scene where the infant Mary is cuddled between her adoring parents, Joachim and Anna (**FIG. 8-33**; part of the scene is visible in **FIG. 8-30**). Servants on either side of the family look on with gestures and expressions of admiration and approval, perhaps modeling the response that is expected from viewers within the narthex itself. The human interaction even extends to details, such as the nuzzling of Mary's head into the beard of her father as she leans back to look into his eyes, and her tentative reach toward her mother's face at the same time. In another scene, the young Jesus rides on the shoulders of Joseph, in a pose still familiar to fathers and children in our own time. The informality and believability that these anecdotal details bring to sacred narrative recalls developments as far away as Italy, where at this same time Giotto and Duccio were using similar devices to bring their stories to life (see Chapter 18).

Theodore Metochites (1270–1332) was one of the most fascinating personalities of the Late Byzantine world. Son of a disgraced intellectual cleric—condemned and exiled for championing the union of the Roman and Byzantine Churches—Metochites became a powerful intellectual figure in Constantinople. As a poet, philosopher, and astronomer who wrote scores of complicated commentaries in an intentionally cultivated, arcane, and mannered literary style, he ridiculed a rival for his prose style of "excess clarity." In 1290, Emperor Andronicus II Palaeologus (r. 1282–1328) called Metochites to court service, where the prolific young scholar became an influential senior statesman, ascending to the highest levels of the government and amassing power and wealth second only to that of the emperor himself. Metochites' political and financial status plummeted when the emperor was overthrown by his grandson in 1328. Stripped of his wealth and sent into exile, Metochites was allowed to return to the capital two years later, retiring to house arrest at the Chora monastery, where he died and was buried in 1332.

It is his association with this monastery that has become Theodore Metochites' greatest claim to enduring fame. Beginning in about 1315, at the peak of his power and wealth, he funded an expansion and restoration of the church of Christ in Chora (meaning "in the country"), part of an influential monastery on the outskirts of Constantinople. The mosaic decoration he commissioned for the church's expansive narthexes (see FIGS. 8–30, 8–33) may be the most sumptuous product of his beneficence, but the project probably revolved around a **FUNERARY CHAPEL** (or parekklesion) that he built adjacent to the main church (**FIG. 8–32**), with the intention of creating a location for his own funeral and tomb.

The extensive and highly integrative program of frescos covering every square inch of the walls and vaults of this jewel-box space focuses on funerary themes and expectations of salvation and its rewards. Above a dado of imitation marble stand a frieze of 34 military saints ready to fulfill their roles as protectors of those buried in the chapel. Above them, on the side walls of the main space, are stories from the Hebrew Bible interpreted as prefigurations of the Virgin Mary's intercessory powers. A portrayal of Jacob's ladder (Genesis 28:11–19), for example, evokes her position between heaven and earth as a bridge from death to life. In the pendentives of the dome over the main space (two of which are seen in the foreground) sit famous Byzantine hymn writers, with quotations from their work. These carefully chosen passages highlight texts associated with funerals, including one that refers to the story of Jacob's ladder.

The climax of the decorative program, however, is the powerful rendering of the **ANASTASIS** that occupies the halfdome of the apse (**FIG. 8–31**). In this popular Byzantine representation of the Resurrection—drawn not from the Bible but from the apocryphal Gospel of Nicodemus—Jesus demonstrates his powers of salvation by descending into limbo after his death on the cross to save his righteous Hebrew forebears from Satan's grasp. Here a boldly striding Christ—brilliantly outfitted in a pure white that makes him shine to prominence within the fresco program—lunges to rescue Adam and Eve from their tombs, pulling them upward with such force that they seem to float airborne under the spell of his power. Satan lies tied into a helpless bundle at his feet, and patriarchs, kings, and prophets to either side look on in admiration, perhaps waiting for their own turn to be rescued. During a funeral in this chapel, the head of the deceased would have been directed toward this engrossing tableau, closed eyes facing upward toward a painting of the Last Judgment, strategically positioned on the vault over the bier. In 1332, this was the location of Metochites' own dead body since this parekklesion was indeed the site of his funeral. He may have been buried in one of the niche tombs cut into the walls of the chapel, or even within a tomb that was placed under the floor of the sanctuary itself, directly under the painted image of the archangel Michael, guardian of souls.

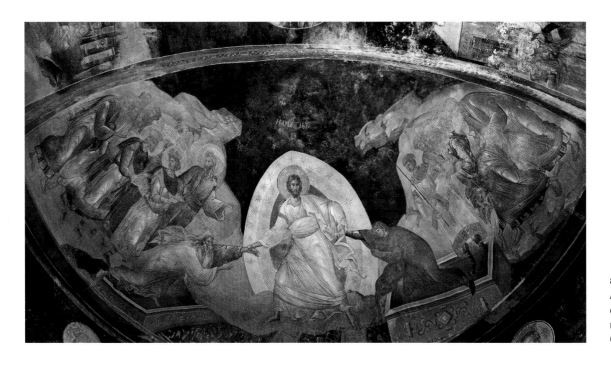

8-31 • ANASTASIS
Apse of the funerary chapel, church of the monastery of Christ in Chora. c. 1321. Fresco.

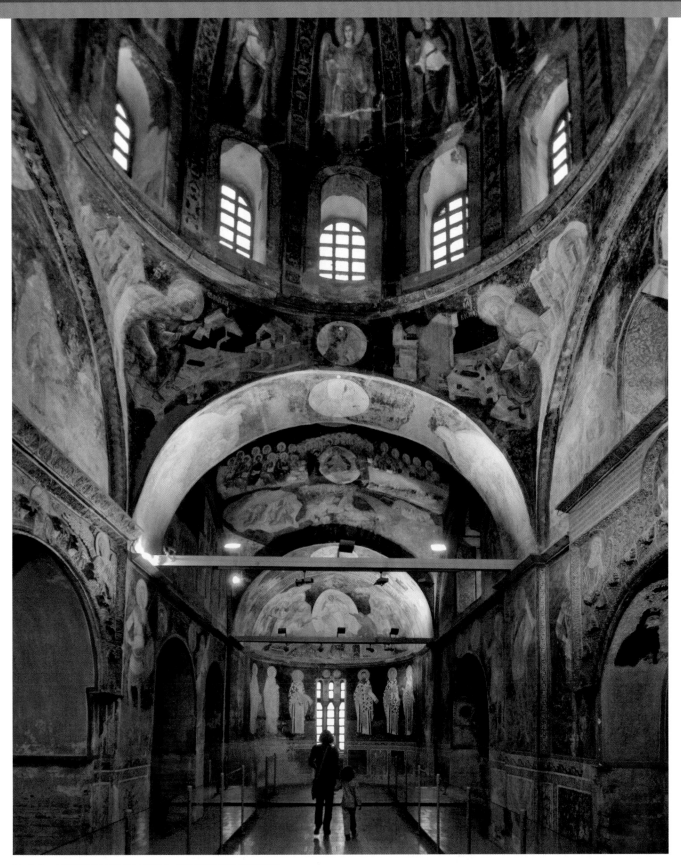

8-32 • FUNERARY CHAPEL (PAREKKLESION)
Church of the monastery of Christ in Chora. (Present-day Kariye Müzesi.) c. 1315–1321.

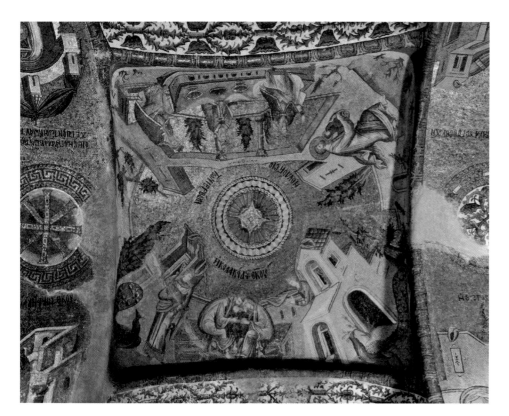

8-33 • THE INFANT VIRGIN MARY CARESSED BY HER PARENTS JOACHIM AND ANNA

Inner narthex, church of Christ in Chora. (Present-day Kariye Müzesi.) c. 1315–1321. Mosaic.

The Greek inscription placed over the family group identifies this scene as the fondling of the Theotokos (bearer of God).

ICONS

Late Byzantine artists of Constantinople created icons as well as painting murals and making mosaics on walls. Among the most dynamic and engaging is a representation of the Annunciation on one side of an early fourteenth-century double-sided icon (**FIG. 8-34**)—the other side has an image of the Virgin and Child—roughly contemporary with the redecoration of the Chora church. This icon was made in the capital, perhaps under imperial patronage, and sent from there to the archbishop of Ohrid. Over three feet tall, it was probably mounted on a pole and carried in processions, where both sides would be visible. Characteristic of Constantinopolitan art under the Palaeologues are the small heads of the figures, their inflated bodies, and the light-shot silk of their clothing; the forward projecting perspective of the architecture of background and throne, similar in concept to what we have seen in the Chora mosaics (see FIG. 8-33); as well as the fanciful caryatids perched on the tops of the columns.

The practice of venerating icons intensified in Russia during this period; regional schools of icon painting flourished, fostering the work of remarkable artists. One of these was the renowned artist-monk Andrey Rublyov who created a magnificent icon of **THE HOSPITALITY OF ABRAHAM** sometime between about 1410 and 1425 (**FIG. 8-35**). It was commissioned in honor of Abbot Sergius of the Trinity-Sergius Monastery, near Moscow. The theme is the Trinity, represented here by three identical angels. Rublyov's source for this idea was a story in the Hebrew Bible of the patriarch Abraham and his wife Sarah, who entertained three strangers who were in fact God represented by three divine beings in human form (Genesis 18). Tiny images of Abraham and Sarah's home and

8-34 • ANNUNCIATION TO THE VIRGIN

Sent from Constantinople to the church of the Virgin Peribleptos, Ohrid, Macedonia. Early 14th century. Tempera on panel, 36⅝″ × 26¾″ (93 × 68 cm). Icon Gallery, Ohrid, Macedonia.

the oak of Mamre can be seen above the angels. The food the couple offered to the strangers becomes a chalice on an altarlike table.

Rublyov's icon clearly illustrates how Late Byzantine artists—like the artists of ancient Greece—relied on mathematical conventions to create ideal figures, giving their works remarkable consistency. But unlike the Greeks, who based their formulas on close observation of nature, Byzantine artists invented an ideal geometry to evoke a spiritual realm and conformed their representations of human forms and features to it. Here the circle forms the basic underlying structure for the composition. Despite this formulaic approach, talented artists like Rublyov worked within it to create a personal, expressive style. Rublyov relied on typical Late Byzantine conventions—salient contours, small heads and long bodies, and a focus on a limited number of figures—to capture the sense of the spiritual in his work, yet he distinguished his art by imbuing it with a sweet, poetic ambience.

The Byzantine tradition continued for centuries in the art of the Eastern Orthodox Church and is carried on to this day in Greek and Russian icon painting. But in Constantinople, Byzantine art—like the empire itself—came to an end in 1453. When the forces of the Ottoman sultan Mehmed II overran the capital, the Eastern Empire became part of the Islamic world. The Turkish conquerors were so impressed with the splendor of the Byzantine art and architecture in the capital, however, that they adopted its traditions and melded them with their own rich aesthetic heritage into a new, and now Islamic, artistic efflorescence.

8-35 • Andrey Rublyov THE HOSPITALITY OF ABRAHAM
Icon. c. 1410–1425. Tempera on panel, 55½″ × 44½″ (141 × 113 cm). Tretyakov State Gallery, Moscow.

THINK ABOUT IT

8.1 Characterize the role of the Classical tradition, already notable in the Early Christian period, in the developing history of Byzantine art. When was it used? In what sorts of contexts? Develop your discussion in relation to two specific examples from two different periods of Byzantine art.

8.2 Compare the portrayals of the Byzantine rulers in the mosaics of San Vitale in Ravenna (see FIGS. 8-8, 8-9) and those on a tenth-century ivory plaque (see FIG. 8-26). Attend to the subjects of the scenes themselves as well as the way the emperor and empress are incorporated within them.

8.3 How were images used in Byzantine worship? Why were images suppressed during iconoclasm?

8.4 How do the mosaics of the Chora church in Constantinople emphasize the human dimensions of sacred stories? Consider, in particular, how the figures are represented, what kinds of stories are told, and in what way.

CROSSCURRENTS

FIG. 7–13A

FIG. 8–3A

Both of these grand churches were built under the patronage of powerful rulers and were meant to glorify them as well as serve the Christian community. What features do they share? In what ways are they fundamentally different? What functions did they serve in both Church and state?

✓—[**Study** and review on myartslab.com

9–1 • Yahya Ibn al-Wasiti THE MAQAMAT OF AL-HARIRI
From Baghdad, Iraq. 1237. Ink, pigments, and gold on paper, 13¾″ × 10¼″ (35 × 25 cm). Bibliothèque Nationale, Paris. Arabic MS. 5847, fol. 18v

Islamic Art

The *Maqamat* ("*Assemblies*"), by al-Hariri (1054–1122), belongs to a popular Islamic literary genre of cautionary tales. Al-Hariri's stories revolve around a silver-tongued scoundrel named Abu Zayd, whose cunning inevitably triumphs over other people's naivety. His exploits take place in a world of colorful settings—desert camps, ships, pilgrim caravans, apothecary shops, mosques, gardens, libraries, cemeteries, and courts of law. In such settings, these comic stories of trickery and theft would seem perfectly suited for illustration, and that is the case in this engaging manuscript, made in Baghdad during the thirteenth century. Human activity permeates the compositions—pointing fingers, arguing with adversaries, riding horses, stirring pots, and strumming musical instruments. And these vivid visualizations of Abu Zayd's adventures provide us with rare windows into ordinary Muslim life, here prayer in the congregational **mosque** (**FIG. 9–1**), a religious and social institution at the center of Islamic culture.

The congregation has gathered to hear a sermon preached by the deceitful Abu Zayd, who plans to make off with the alms collection. The men sit directly on the ground, as is customary not only in mosques, but in traditional dwellings. The listener in the front row tilts his chin upward to focus his gaze directly upon the speaker. He is framed and centered by the arch of the **mihrab** (the niche indicating the direction of Mecca) on the rear wall; his white turban contrasts noticeably with the darker gold background. Perhaps he stands in for the manuscript's reader who, perusing the illustrations of these captivating stories, pauses to project him- or herself into the scene.

The columns of the mosque's arcades have ornamental capitals from which spring half-round arches. Glass mosque lamps hang from the center of each arch. Figures wear turbans and flowing, loose-sleeved robes with epigraphic borders (*tiraz*) embroidered in gold. Abu Zayd delivers his sermon from the steps of a **minbar** (pulpit) with an arched gateway opening at the lowest level. This *minbar* and the arcades that form the backdrop of the scene are reduced in scale so the painter can describe the entire setting and still make the figures the main focus of the composition. Likewise, although in an actual mosque the *minbar* would share the same wall as the *mihrab*, here they have been separated, perhaps to keep the *minbar* from hiding the *mihrab*, and to rivet our attention on what is most important—the rapt attention Abu Zayd commands from his captive audience, a group we ourselves join as we relish the anecdotal and pictorial delights of this splendid example of Islamic visual narrative.

LEARN ABOUT IT

9.1 Explore the stylistic variety of art and architecture created in the disparate areas of the Islamic world.

9.2 Explore the use of ornament and inscription in Islamic art.

9.3 Interpret Islamic art as a reflection of both religion and secular society.

9.4 Recognize the role of political transformation in the creation of Islamic artistic eclecticism as well as its unification around a shared cultural and religious viewpoint.

((•—**Listen** to the chapter audio on myartslab.com

ISLAM AND EARLY ISLAMIC SOCIETY

Islam arose in seventh-century Arabia, a land of desert oases with no cities of great size and sparsely inhabited by tribal nomads. Yet, under the leadership of its founder, the Prophet Muhammad (c. 570–632 CE), and his successors, Islam spread rapidly throughout northern Africa, southern and eastern Europe, and into Asia, gaining territory and converts with astonishing speed. Because Islam encompassed geographical areas with a variety of long-established cultural traditions, and because it admitted diverse peoples among its converts, it absorbed and combined many different techniques and ideas about art and architecture. The result was a remarkably sophisticated artistic eclecticism.

Muslims ("those who have submitted to God") believe that in the desert outside of Mecca in 610, Muhammad received revelations that led him to found the religion called Islam ("submission to God's will"). Many powerful Meccans were hostile to the message preached by the young visionary, and in 622 he and his companions fled to Medina. There Muhammad built a house that became a gathering place for the converted and thus the first mosque. Muslims date their history as beginning with this *hijira* ("emigration").

In 630, Muhammad returned to Mecca with an army of 10,000, routed his enemies, and established the city as the spiritual capital of Islam. After his triumph, he went to the **KAABA** (**FIG. 9-2**), a cubelike, textile-draped shrine said to have been built for God by Ibrahim (Abraham) and Isma'il (Ishmael) and long the focus of pilgrimage and polytheistic worship. He emptied the shrine, repudiating its accumulated pagan idols, while preserving the enigmatic structure itself and dedicating it to God.

The Kaaba is the symbolic center of the Islamic world, the place to which all Muslim prayer is directed and the ultimate destination of Islam's obligatory pilgrimage, the *hajj*. Each year, huge numbers of Muslims from all over the world travel to Mecca to circumambulate the Kaaba during the month of pilgrimage. The exchange of ideas that occurs during the intermingling of these diverse groups of pilgrims has contributed to Islam's cultural eclecticism.

Muhammad's act of emptying the Kaaba of its pagan idols instituted the fundamental practice of avoiding figural imagery in Islamic religious architecture. This did not, however, lead to a ban

9-2 • THE KAABA, MECCA
The Kaaba represents the center of the Islamic world. Its cubelike form is draped with a black textile that is embroidered with a few Qur'anic verses in gold.

MAP 9–1 • THE ISLAMIC WORLD

Within 200 years after 622 CE, the Islamic world expanded from Mecca to India in the east, and to Morocco and Spain in the west.

on art. Figural imagery is frequent in palaces and illustrated manuscripts, and Islamic artists elaborated a rich vocabulary of nonfigural ornament, including complex geometric designs and scrolling foliate vines (that Europeans labeled **arabesques**), which were appropriate in all contexts. Islamic art revels in surface decoration, in manipulating line, color, and especially pattern, often highlighting the interplay of pure abstraction, organic form, and script.

According to tradition, the Qur'an assumed its final form during the time of the third caliph (successor to the Prophet), Uthman (r. 644–56). As the language of the Qur'an, Arabic and its script have been a powerful unifying force within Islam. From the eighth through the eleventh centuries, it was the universal language among scholars in the Islamic world and in some Christian lands as well. Inscriptions frequently ornament works of art, sometimes written clearly to provide a readable message, but in other cases written as complex patterns also to delight the eye.

The Prophet was succeeded by a series of caliphs. The accession of Ali as the fourth caliph (r. 656–61) provoked a power struggle that led to his assassination and resulted in enduring divisions within Islam. Followers of Ali, known as Shi'ites (referring to the party or *shi'a* of Ali), regard him alone as the Prophet's

rightful successor. Sunni Muslims, in contrast, recognize all of the first four caliphs as "rightly guided." Ali was succeeded by his rival Muawiya (r. 661–80), a close relative of Uthman and the founder of the first Muslim dynasty, the Umayyad (661–750).

Islam expanded dramatically. Within two decades, seemingly unstoppable Muslim armies conquered the Sasanian Persian Empire, Egypt, and the Byzantine provinces of Syria and Palestine. By the early eighth century, the Umayyads had reached India, conquered northern Africa and Spain, and penetrated France before being turned back (**MAP 9-1**). In these newly conquered lands, the treatment of Christians and Jews who did not convert to Islam was not consistent, but in general, as "People of the Book"—followers of a monotheistic religion based on a revealed scripture—they enjoyed a protected status, though they were subject to a special tax and restrictions on dress and employment.

Muslims participate in congregational worship at a mosque (*masjid*, "place of prostration"). The Prophet Muhammad himself lived simply and instructed his followers in prayer at his house, now known as the Mosque of the Prophet, where he resided in Medina. This was a square enclosure that framed a large courtyard with rooms along the east wall where he and his family lived. Along

Islamic art delights in complex ornament that sheathes surfaces, distracting the eye from the underlying structure or physical form.

ablaq masonry (*Madrasa*-Mausoleum-Mosque of Sultan Hasan, Cairo; see FIG. 9–14) juxtaposes stone of contrasting colors. The ornamental effect is enhanced here by the interlocking jigsaw shape of the blocks, called **joggled voussoirs**.

cut tile (Shah-i Zinda, Samarkand; see FIG. 9–18), made up of dozens of individually cut ceramic tile pieces fitted precisely together, emphasizes the clarity of the colored shapes.

muqarna (Palace of the Lions, Alhambra, Granada; see FIG. 9–16) consist of small nichelike components, usually stacked in multiples as successive, nonload-bearing units in arches, cornices, and domes, hiding the transition from the vertical to the horizontal plane.

wooden strapwork (Kutubiya *minbar*, Marrakesh; see FIG. 9–9) assembles finely cut wooden pieces to create the appearance of geometrically interlacing ribbons, often framing smaller panels of carved wood and inlaid ivory or mother-of-pearl (shell).

mosaic (Dome of the Rock, Jerusalem; see FIG. 9–4) is comprised of thousands of small glass or glazed ceramic *tesserae* set on a plaster ground. Here the luminous white circular shapes are mother-of-pearl.

water (Court of the Myrtles, Alhambra, Granada) as a fluid architectural element reflects surrounding architecture, adds visual dynamism and sound, and, running in channels between areas to unite disparate spaces.

chini khana (Ali Qapu Pavilion, Isfahan)—literally "china cabinet"—is a panel of niches, sometimes providing actual shelving, but used here for its contrast of material and void which reverses the typical figure-ground relationship.

the south wall, a thatched portico supported by palm-tree trunks sheltered both the faithful as they prayed and Muhammad as he spoke from a low platform. This simple arrangement inspired the design of later mosques. Without the architectural focus provided by chancels, altars, naves, or domes, the space of this prototypical hypostyle (multicolumned) mosque reflected the founding spirit of Islam in which the faithful pray as equals directly to God, led by an imam, but without the intermediary of a priesthood.

THE EARLY PERIOD: NINTH THROUGH TWELFTH CENTURIES

The caliphs of the Umayyad dynasty (661–750) ruled from Damascus in Syria, and throughout the Islamic empire they built mosques and palaces that projected the authority of the new rulers and reflected the growing acceptance of Islam. In 750 the Abbasid

clan replaced the Umayyads in a coup d'état, ruling as caliphs until 1258 from Baghdad, in Iraq. Their long and cosmopolitan reign saw achievements in medicine, mathematics, the natural sciences, philosophy, literature, music, and art. They were generally tolerant of the ethnically diverse populations in the territories they subjugated, and they admired the past achievements of Roman civilization as well as the living traditions of Byzantium, Persia, India, and China, freely borrowing artistic techniques and styles from all of them.

In the tenth century, the Islamic world split into separate kingdoms ruled by independent caliphs. In addition to the Abbasids of Iraq, there was a Fatimid Shi'ite caliph ruling Tunisia and Egypt, and a descendant of the Umayyads ruling Spain and Portugal (together then known as al-Andalus). The Islamic world did not reunite under the myriad dynasties who thereafter ruled from northern Africa to Asia, but loss in unity was gain to artistic diversity.

ARCHITECTURE

While Mecca and Medina remained the holiest Muslim cities, the political center under the Umayyads shifted to the Syrian city of Damascus in 656. In the eastern Mediterranean, inspired by Roman and Byzantine architecture, the early Muslims became enthusiastic builders of shrines, mosques, and palaces. Although tombs were officially discouraged in Islam, they proliferated from the eleventh century onward, in part due to funerary practices imported from the Turkic northeast, and in part due to the rise of Shi'ism with its emphasis on genealogy and particularly ancestry through Muhammad's daughter, Fatima.

THE DOME OF THE ROCK In the center of Jerusalem rises the Haram al-Sharif ("Noble Sanctuary"), a rocky outcrop from which Muslims believe Muhammad ascended to the presence of God on the "Night Journey" described in the Qur'an, as well as the site of the First and Second Jewish Temples. Jews and Christians variously associate this place with Solomon, the site of the creation of Adam, and the place where the patriarch Abraham prepared to sacrifice his son Isaac at the command of God. In 691–92, a domed shrine was built over the rock (**FIG. 9–3**), employing artists

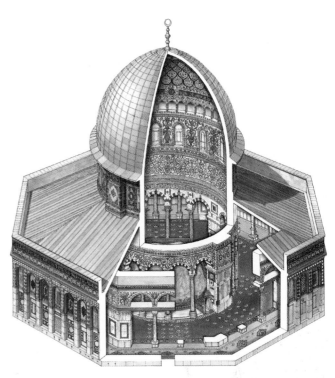

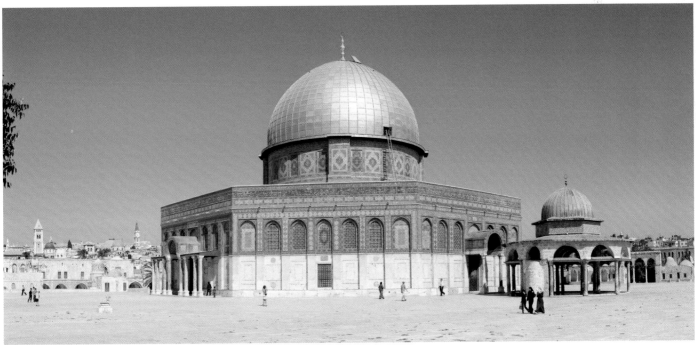

9-3 • EXTERIOR VIEW (A) AND CUTAWAY DRAWING (B) OF THE DOME OF THE ROCK, JERUSALEM
Israel. Begun 691.

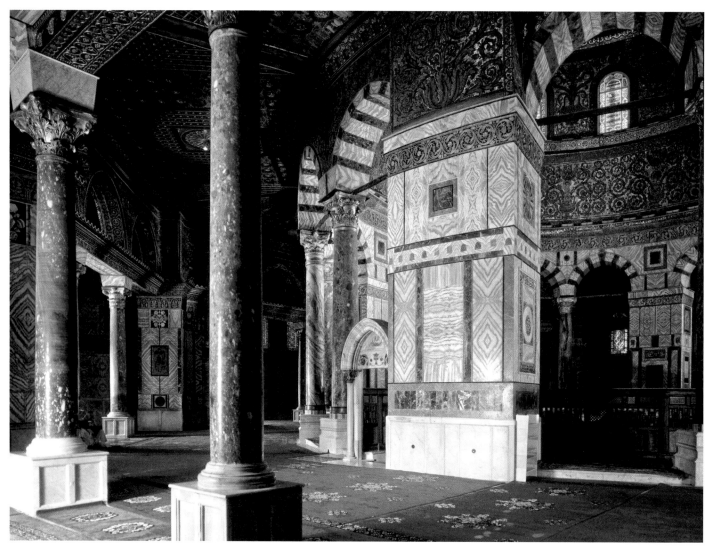

9-4 • INTERIOR, DOME OF THE ROCK
Israel. Begun 691.

The arches of the inner and outer face of the central arcade are encrusted with golden mosaics, a Byzantine technique adapted for Islamic use to create ornament and inscriptions. The pilgrim must walk around the central space first clockwise and then counterclockwise to read the inscriptions. The carpets and ceilings are modern but probably reflect the original intent.

trained in the Byzantine tradition to create the first great monument of Islamic art. By assertively appropriating a site holy to Jews and Christians, the Dome of the Rock manifested Islam's view of itself as completing and superseding the prophecies of those faiths.

Structurally, the Dome of the Rock imitates the centrally planned form of Early Christian and Byzantine martyria (see FIGS. 7–15, 8–5). However, unlike the plain exteriors of its models, it is crowned by a golden dome that dominates the skyline. The ceramic tiles on the lower portion of the exterior were added later, but the opulent marble veneer and mosaics of the interior are original (see "Ornament," page 268). The dome, surmounting a circular drum pierced with windows and supported by arcades of alternating **piers** and columns, covers the central space containing the rock (FIG. 9-4), and concentric aisles (ambulatories) permit devout visitors to circumambulate it.

Inscriptions from the Qur'an interspersed with passages from other texts, including information about the building itself, form a frieze around the inner and outer arcades. As pilgrims walk around the central space to read the inscriptions in brilliant gold mosaic on turquoise green ground, the building communicates both as a text and as a dazzling visual display. These inscriptions are especially notable because they are the oldest surviving written verses from the Qur'an and the first use of Qur'anic inscriptions in architecture. Below, walls are faced with marble—the veining of which creates abstract symmetrical patterns—and the rotunda is surrounded by columns of gray marble with gilded capitals. Above the calligraphic frieze is another mosaic frieze depicting symmetrical vine scrolls and trees in turquoise, blue, and green, embellished with imitation jewels, over a gold ground. The mosaics are variously thought to represent the gardens of Paradise and trophies of

Islam emphasizes a direct personal relationship with God. The Pillars of Islam, sometimes symbolized by an open hand with the five fingers extended, enumerate the duties required of Muslims by their faith.

- The first pillar (*shahadah*) is to proclaim that there is only one God and that Muhammad is his messenger. While monotheism is common to Judaism, Christianity, and Islam, and Muslims worship the God of Abraham, and also acknowledge Hebrew and Christian prophets such as Musa (Moses) and Isa (Jesus), Muslims deem the Christian Trinity polytheistic and assert that God was not born and did not give birth.

- The second pillar requires prayer (*salat*) to be performed by turning to face the Kaaba in Mecca five times daily: at dawn, noon, late afternoon, sunset, and nightfall. Prayer can occur almost anywhere, although the prayer on Fridays takes place in the congregational mosque. Because ritual ablutions are required for purity, mosque courtyards usually have fountains.

- The third pillar is the voluntary payment of annual tax or alms (*zakah*), equivalent to one-fortieth of one's assets. *Zakah* is used for charities such as feeding the poor, housing travelers, and paying the dowries of orphan girls. Among Shi'ites, an additional tithe is required to support the Shi'ite community specifically.

- The fourth pillar is the dawn-to-dusk fast (*sawm*) during Ramadan, the month when Muslims believe Muhammad received the revelations set down in the Qur'an. The fast of Ramadan is a communally shared sacrifice that imparts purification, self-control, and fellowship with others. The end of Ramadan is celebrated with the feast day 'Id al-Fitr (Festival of the Breaking of the Fast).

- For those physically and financially able to do so, the fifth pillar is the pilgrimage to Mecca (*hajj*), which ideally is undertaken at least once in the life of each Muslim. Among the extensive pilgrimage rites are donning simple garments to remove distinctions of class and culture; collective circumambulations of the Kaaba; kissing the Black Stone inside the Kaaba (probably a meteorite that fell in pre-Islamic times); and the sacrificing of an animal, usually a sheep, in memory of Abraham's readiness to sacrifice his son at God's command. The end of the *hajj* is celebrated by the festival 'Id al-Adha (Festival of Sacrifice).

The directness and simplicity of Islam have made the Muslim religion readily adaptable to numerous varied cultural contexts throughout history. The Five Pillars instill not only faith and a sense of belonging, but also a commitment to Islam in the form of actual practice.

Muslim victories offered to God. Though the decorative program is extraordinarily rich, the focus of the building is neither art nor architecture but the plain rock it shelters.

THE GREAT MOSQUE OF KAIROUAN Muslim congregations gather on Fridays for regular worship in a mosque. The earliest mosque type followed the model of the Prophet's own house. The **GREAT MOSQUE** of Kairouan, Tunisia (**FIG. 9–5**), built in the ninth century, reflects the early form of the mosque but is elaborated with later additions. The large rectangular space is divided between a courtyard and a flat-roofed hypostyle prayer hall oriented toward Mecca. The system of repeated bays and aisles can easily be extended as the congregation grows in size— one of the hallmarks of the hypostyle plan. New is the large

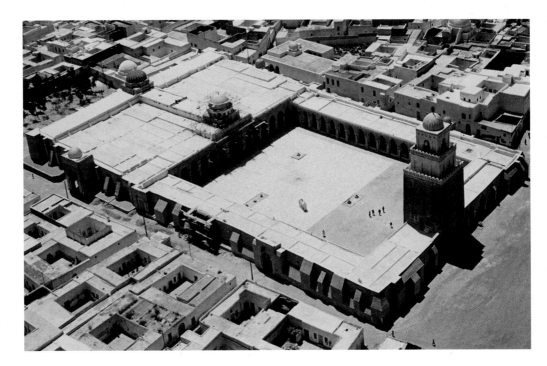

9-5 • THE GREAT MOSQUE, KAIROUAN
Tunisia. 836–875.

When the Umayyads were toppled in 750, a survivor of the dynasty, Abd al-Rahman I (r. 756–788), fled across north Africa into southern Spain (al-Andalus) where, with the support of Muslim settlers, he established himself as the provincial ruler, or emir. This newly transplanted Umayyad dynasty ruled in Spain from its capital in Cordoba (756–1031). The Hispano-Umayyads were noted patrons of the arts, and one of the finest surviving examples of Umayyad architecture is the Great Mosque of Cordoba (**FIGS. 9–6, 9–7**).

In 785, the Umayyad conquerors began building the Cordoba mosque on the site of a Christian church built by the Visigoths, the pre-Islamic rulers of Spain. The choice of site was both practical—for the Muslims had already been renting space within the church—and symbolic, an appropriation of place (similar to the Dome of the Rock) that affirmed their presence. Later rulers expanded the building three times, and today the walls enclose an area of about 620 by 460 feet, about a third of which is the courtyard. This patio was planted with fruit trees, beginning in the early ninth century; today orange trees seasonally fill the space with color and sweet scent. Inside, the proliferation of pattern in the repeated columns and double flying arches is both colorful and dramatic. The marble columns and capitals in the hypostyle prayer hall were recycled from the Christian church that had formerly occupied the site, as well as from classical buildings in the region, which had been a wealthy Roman province. The mosque's interior incorporates *spolia* (reused) columns of slightly varying heights. Two tiers of arches, one over the other, surmount these columns, the upper tier springing from rectangular

piers that rise from the columns. This double-tiered design dramatically increases the height of the interior space, inspiring a sense of monumentality and awe. The distinctively shaped **horseshoe arches**—a form known from Roman times and favored by the Visigoths—came to be closely associated with Islamic architecture in the West (see "Arches," page 274). Another distinctive feature of these arches, adopted from Roman and Byzantine precedents, is the alternation of white stone and red-brick voussoirs forming the curved arch. This mixture of materials may have helped the building withstand earthquakes.

In the final century of Umayyad rule, Cordoba emerged as a major commercial and intellectual hub and a flourishing center

for the arts, surpassing Christian European cities in science, literature, and philosophy. As a sign of this new wealth, prestige, and power, Abd al-Rahman III (r. 912–961) boldly reclaimed the title of caliph in 929. He and his son al-Hakam II (r. 961–976) made the Great Mosque a focus of patronage, commissioning costly and luxurious renovations such as a new *mihrab* with three bays in front of it (**FIG. 9–8**). These capped the **maqsura**, an enclosure in front of the *mihrab* reserved for the ruler and other dignitaries, which became a feature of congregational mosques after an assassination attempt on one of the Umayyad rulers. A *minbar* formerly stood by the *mihrab* as the place for the prayer leader and as a symbol of authority. The melon-shaped, ribbed dome

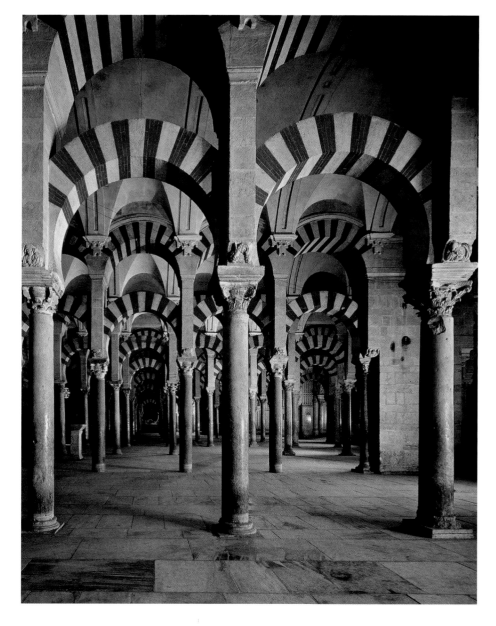

9–6 • PRAYER HALL, GREAT MOSQUE, CORDOBA
Spain. Begun 785/786.

over the central bay may be a metaphor for the celestial canopy. It seems to float upon a web of crisscrossing arches, the complexity of the design reflecting the Islamic interest in mathematics and geometry, not purely as abstract concepts but as sources for artistic inspiration. Lushly patterned mosaics with inscriptions, geometric motifs, and stylized vegetation clothe both this dome and the *mihrab* below in brilliant color and gold. These were installed by a Byzantine master sent by the emperor in Constantinople, who brought with him boxes of small glazed ceramic and glass pieces (*tesserae*). Such artistic exchange is emblematic of the interconnectedness of the medieval Mediterranean—through trade, diplomacy, and competition.

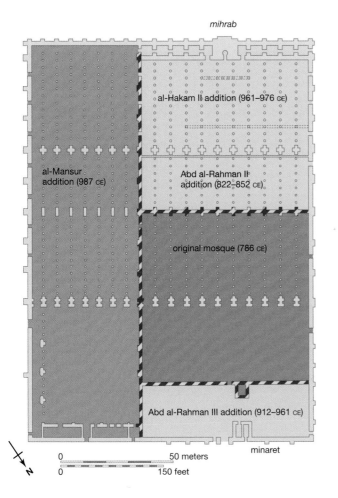

mihrab

al-Hakam II addition (961–976 CE)

al-Mansur addition (987 CE)

Abd al-Rahman II addition (822–852 CE)

original mosque (786 CE)

Abd al-Rahman III addition (912–961 CE)

minaret

0 50 meters
0 150 feet

9-7 • PLAN OF THE GREAT MOSQUE
Begun 785/786.

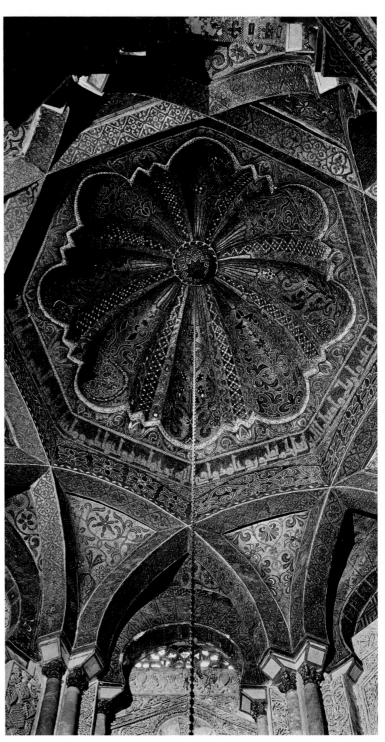

9-8 • DOME IN FRONT OF THE MIHRAB, GREAT MOSQUE
965.

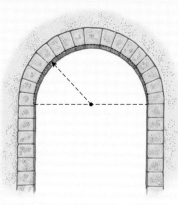
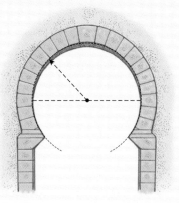
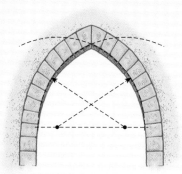

The simple **semicircular arch**, inherited from the Romans and Byzantines, has a single center point that is level with the points from which the arch springs.

The **horseshoe arch** predates Islam but became the prevalent arch form in the Maghreb (see FIG. 9–6). The center point is above the level of the arch's springing point, so that it pinches inward above the capital.

The **pointed arch**, introduced after the beginning of Islam, has two (sometimes four) center points, the points generating different circles that overlap (see FIG. 9–28).

A **keel arch** has flat sides, and slopes where other arches are curved. It culminates at a pointed apex (see "Ornament," cut tile, page 268).

👁—**Watch** an architectural simulation about Islamic arches on myartslab.com

minaret (a tower from which the faithful are called to prayer) that rises from one end of the courtyard, standing as a powerful sign of Islam's presence in the city.

The **qibla** wall, marked by a centrally positioned *mihrab* niche, is the wall of the prayer hall that is closest to Mecca. Prayer is oriented toward this wall. In the Great Mosque of Kairouan, the *qibla* wall is given heightened importance by a raised roof, a dome over the *mihrab*, and a central aisle that marks the axis that extends from the minaret to the *mihrab* (for a fourteenth-century example of a *mihrab*, see FIG. 9–17). The *mihrab* belongs to the historical tradition of niches that signify a holy place—the Torah shrine in a synagogue, the frame for sculptures of gods or ancestors in Roman architecture, the apse in a church.

THE KUTUBIYA MOSQUE In the Kutubiya Mosque, the principal mosque of Marrakesh, Morocco, survives an exceptionally exquisite, twelfth-century wooden *minbar*—made originally for the Booksellers' Mosque in Marrakesh (**FIG. 9-9**). It consists of a staircase from which the weekly sermon was delivered to the congregation (see FIG. 9-1). The sides are paneled in wooden marquetry with strapwork in a geometric pattern of eight-pointed stars and

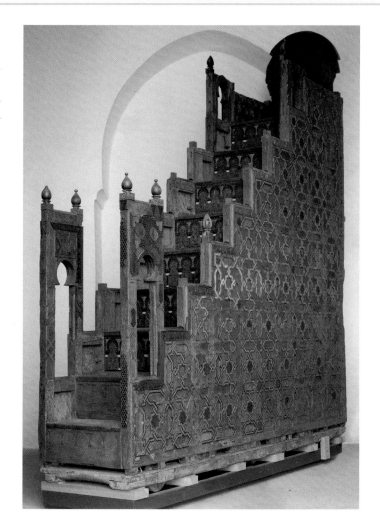

9-9 • MINBAR
From the Kutubiya Mosque, Marrakesh, Morocco. 1125–1130. Wood and ivory, 12′8″ × 11′4″ × 2′10″ (3.86 × 3.46 × 0.87 m). Badi Palace Museum, Marrakesh.

elongated hexagons inlaid with ivory (see "Ornament," page 268). The areas between the strapwork are filled with wood carved in swirling vines. Reflecting the arcades of its original architectural context, the risers of the stairs represent horseshoe arches (see "Arches," opposite) resting on columns with ivory capitals and bases. This *minbar* is much like others across the Islamic world, but those at the Kutubiya Mosque and the Great Mosque of Cordoba (see "the Great Mosque of Cordoba, page 272) were the finest, according to Ibn Marzuq (1311–1379), a distinguished preacher who had given sermons from 48 *minbars*.

CALLIGRAPHY

From the beginning, Arabic script was held in high esteem in Islamic society. Reverence for the Qur'an as the word of God extended—and continues to extend—by association to the act of writing itself, and **calligraphy** (the art of the finely written word) became one of the glories of Islamic art. Writing was not limited to books and documents but—as we have seen—was displayed on the walls of buildings and will appear on works in many media throughout the history of Islamic art. The written word played two roles: It could convey information about a building or object, describing its beauty or naming its patron, and it could delight the eye as a manifestation of beauty.

Arabic script is written from right to left, and a letter's form varies depending on its position in a word. With its rhythmic interplay between verticals and horizontals, Arabic lends itself to many variations. Calligraphers enjoyed the highest status of all artists in Islamic society. Apprentice scribes had to learn secret formulas for inks and paints, and become skilled in the proper ways to sit, breathe, and manipulate their tools. They also had to absorb the complex literary traditions and number symbolism that had developed in Islamic culture. Their training was long and arduous, but unlike other artists who were generally anonymous in the early centuries of Islam, outstanding calligraphers received public recognition.

Formal **Kufic** script (after Kufa, a city in Iraq) is blocky and angular, with strong upright strokes and long horizontals. It may have developed first for carved or woven inscriptions where clarity and practicality of execution were important. Most early Qur'ans were horizontal in orientation and had large Kufic letters creating only three to five lines per page. Visual clarity was essential because one book was often shared simultaneously by multiple readers. A page from a ninth-century Syrian Qur'an exemplifies the style common from the eighth to the tenth century (**FIG. 9-10**). Red diacritical marks (pronunciation guides) accent the dark brown ink; the surah ("chapter") title is embedded in the burnished ornament at the bottom of the sheet. Instead of page numbers, the brilliant gold of the framed words and the knoblike projection in the left-hand margin mark chapter breaks.

By the tenth century, more than 20 cursive scripts had come into use. They were standardized by Ibn Muqla (d. 940), an Abbasid official who fixed the proportions of the letters in each script and devised a method for teaching calligraphy that is still in use today. The Qur'an was usually written on parchment (treated

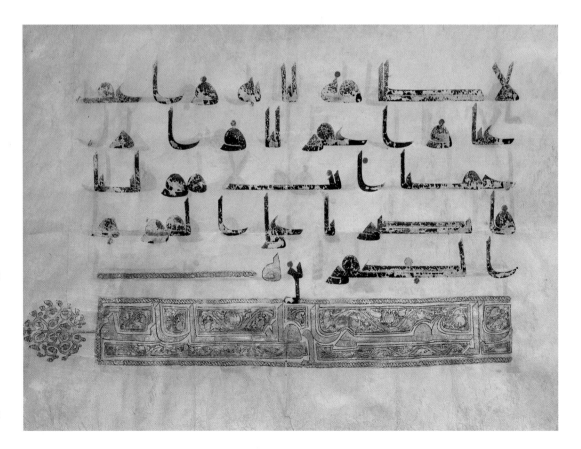

9-10 • PAGE FROM THE QUR'AN
Surah 2:286 and title of surah 3 in Kufic script. Syria. 9th century. Black ink, pigments, and gold on vellum, 8⅜" × 11⅛" (21.8 × 29.2 cm). Metropolitan Museum of Art, New York. Rogers Fund, 1937. (37.99.2)

Read the document related to the Qur'an on myartslab.com

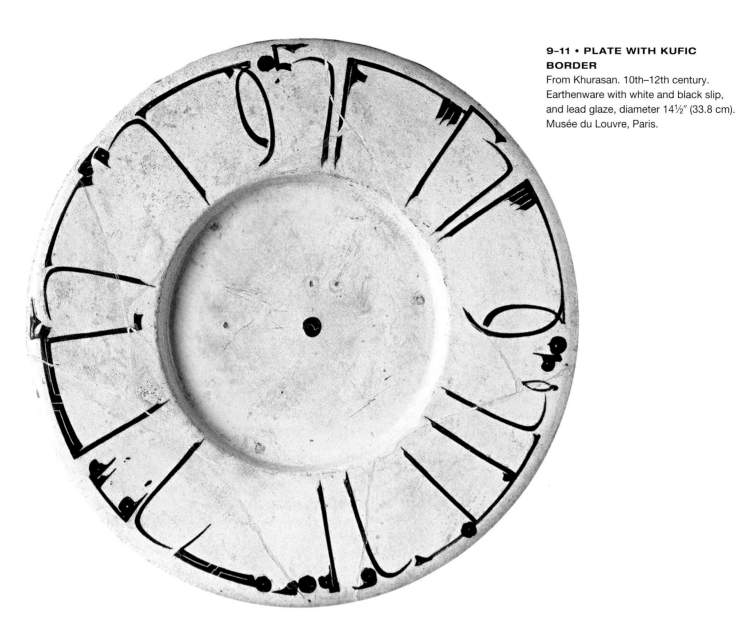

9-11 • PLATE WITH KUFIC BORDER
From Khurasan. 10th–12th century. Earthenware with white and black slip, and lead glaze, diameter 14½" (33.8 cm). Musée du Louvre, Paris.

animal skin) and vellum (calfskin or a fine parchment). Paper was first manufactured in Central Asia during the mid eighth century, having been introduced earlier by Buddhist monks. Muslims learned how to make high-quality, rag-based paper, and eventually established their own paper mills. By about 1000, paper had largely replaced the more costly parchment for everything but Qur'an manuscripts, which adopted the new medium much later. It was a change as momentous as that brought about by movable type or the Internet, affecting not only the appearance of books but also their content. The inexpensive new medium sparked a surge in book production and the proliferation of increasingly elaborate and decorative cursive scripts which had generally superseded Kufic by the thirteenth century.

Kufic script remained popular, however, in other media. It was the sole decoration on a type of white pottery made from the tenth century onward in and around the region of Nishapur (in Khurasan, in present-day Iran) and Samarkand (in present-day Uzbekistan) known as epigraphic ware. These elegant earthenware bowls and plates employ a clear lead glaze over a painted black inscription on a white slip ground (**FIG. 9-11**). Here the script's horizontals and verticals have been elongated to fill the plate's rim, stressing the letters' verticality in such a way that they seem to radiate from the bold spot at the center of the circle. The fine quality of the lettering indicates that a calligrapher furnished the model. The inscription translates: "Knowledge [or magnanimity]: the beginning of it is bitter to taste, but the end is sweeter than honey," an apt choice for tableware made to appeal to an educated patron. Inscriptions on Islamic ceramics provide a storehouse of such popular aphorisms.

LUSTERWARE

In the ninth century, Islamic potters developed a means of producing a lustrous metallic surface on their ceramics. They may have learned the technique from Islamic glassmakers in Syria and Egypt, who had produced luster-painted vessels a century earlier. First the potters applied a paint laced with silver, copper, or gold oxides to the surface of already fired and glazed tiles or vessels. In a second firing with relatively low heat and less oxygen, these oxides burned

away to produce a reflective, metallic sheen. The finished **lusterware** resembled precious metal. Lusterware tiles, dated 862/863, decorated the *mihrab* of the Great Mosque at Kairouan. At first a carefully guarded secret of Abbasid potters in Iraq, lusterware soon spread throughout the Islamic world, to North Africa, Egypt, Iran, Syria, and Spain.

Early potters covered the entire surface with luster, but soon they began to use luster to paint patterns using geometric design, foliate motifs, animals, and human figures, in brown, red, purple, and/or green. Most common was monochrome lusterware in shades of brown, as in this tenth-century jar from Iraq (**FIG. 9-12**). The form of the vessel is emphasized by the distribution of decorative motifs—the lip and neck are outlined with a framed horizontal band of scalloped motifs, the shoulder singled out with dots within circles (known as the "peacock's eye" motif), and the height emphasized by boldly ornamented vertical strips with undulating outlines moving up toward pointed tops and dividing the surface of the jar into quadrants. Emphasis, however, is placed on representations of enigmatic human figures dressed in dark, hooded garments. They stand in bended postures and hold beaded strands while looked directly out toward viewers, engaged in an activity whose meaning and significance remains a mystery.

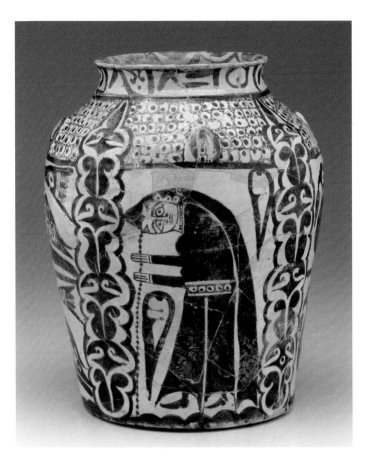

9-12 • LUSTERWARE JAR
Iraq. 10th century. Glazed earthenware with luster, 11⅛″ × 9⅛″ (28.2 × 23.2 cm). Freer Gallery of Art, Smithsonian Institution, Washington, DC.

THE LATER PERIOD: THIRTEENTH THROUGH FIFTEENTH CENTURIES

The Abbasid caliphate began a slow disintegration in the ninth century, and power in the Islamic world became distributed among more or less independent regional rulers. During the eleventh century, the Saljuqs, a Turkic people, swept from north of the Caspian Sea into Khurasan and took Baghdad in 1055, becoming the virtual rulers of the Abbasid lands. The Saljuqs united most of Iran and Iraq, establishing a dynasty that endured from 1037/38 to 1194. A branch of the dynasty, the Saljuqs of Rum, ruled much of Anatolia (Turkey) from the late eleventh to the beginning of the fourteenth century. The central and eastern Islamic world suffered a dramatic rift in the early thirteenth century when the nomadic Mongols—non-Muslims led by Genghiz Khan (r. 1206–1227) and his successors—attacked northern China, Central Asia, and ultimately Iran. The Mongols captured Baghdad in 1258 and encountered weak resistance until they reached Egypt, where they were firmly defeated by the new ruler of the Mamluk dynasty (1250–1517). In Spain, the borders of Islamic territory were gradually pushed southward by Christian forces until the rule of the last Muslim dynasty there, the Nasrids (1230–1492), was ended. Morocco was ruled by the Berber Marinids (from the mid thirteenth century until 1465).

Although the religion of Islam remained a dominant and unifying force throughout these developments, the history of later Islamic society and culture reflects largely regional phenomena. Only a few works have been selected here and in Chapter 24 to characterize Islamic art, and they by no means provide a comprehensive history.

ARCHITECTURE

The new dynasties built on a grand scale, expanding their patronage from mosques and palaces to include new functional buildings, such as tombs, **madrasas** (colleges for religious and legal studies), public fountains, and urban hostels. To encourage long-distance trade, remote caravanserais (inns) were constructed for traveling merchants. A distinguishing characteristic of architecture in the later period is its complexity. Multiple building types were now combined in large and diverse complexes, supported by perpetual endowments (called *waqf*) that funded not only the building, but its administration and maintenance. Increasingly, these complexes included the patron's own tomb, thus giving visual prominence to the act of individual patronage and expressing personal identity through commemoration. A new plan emerged, organized around a central courtyard framed by four large **iwans** (large vaulted halls with rectangular plans and monumental arched openings); this four-*iwan* plan was used for schools, palaces, and especially mosques.

THE MAMLUKS IN EGYPT Beginning in the eleventh century, Muslim rulers and wealthy individuals endowed hundreds of charitable complexes that displayed piety as well as personal

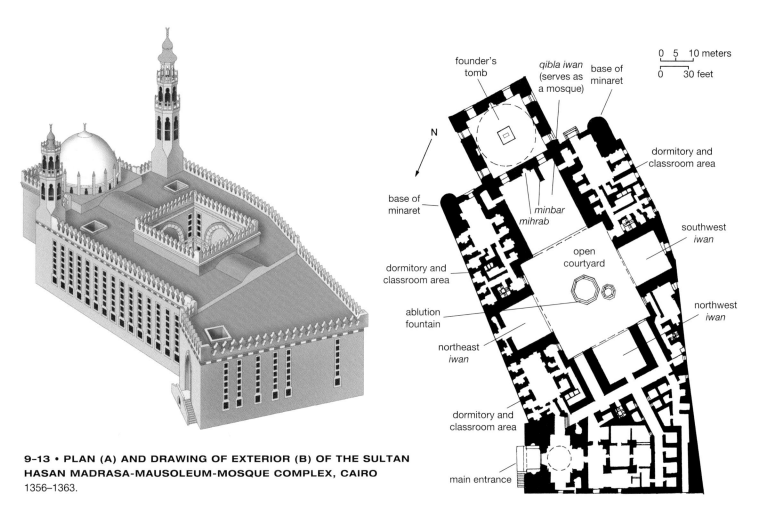

founder's tomb

qibla iwan
(serves as
a mosque)

base of
minaret

0 5 10 meters

0 30 feet

N

base of
minaret

minbar
mihrab

dormitory and
classroom area

southwest
iwan

dormitory and
classroom area

open
courtyard

northwest
iwan

ablution
fountain

northeast
iwan

dormitory and
classroom area

main entrance

**9–13 • PLAN (A) AND DRAWING OF EXTERIOR (B) OF THE SULTAN
HASAN MADRASA-MAUSOLEUM-MOSQUE COMPLEX, CAIRO**
1356–1363.

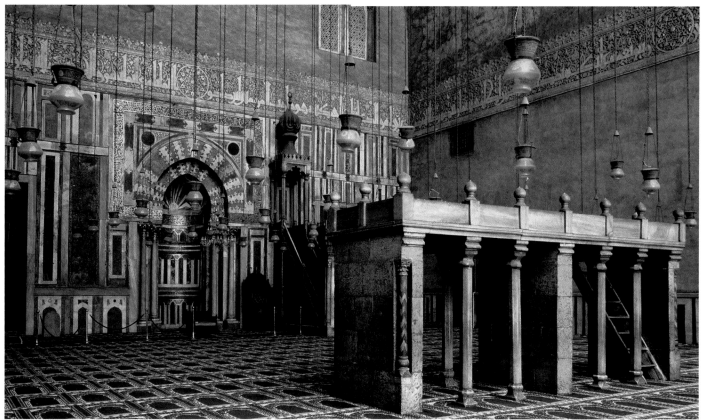

9–14 • QIBLA WALL WITH MIHRAB AND MINBAR
Sultan Hasan Madrasa-Mausoleum-Mosque Complex, Cairo. 1356–1363.

A CLOSER LOOK | A Mamluk Glass Oil Lamp

by 'Ali ibn Muhammad al-Barmaki. Cairo, Egypt. c. 1329–1335.
Blown glass, polychrome enamel, and gold. Diameter 9⅜″ (23.89 cm), height 14″ (35.56 cm).
Metropolitan Museum of Art, New York.

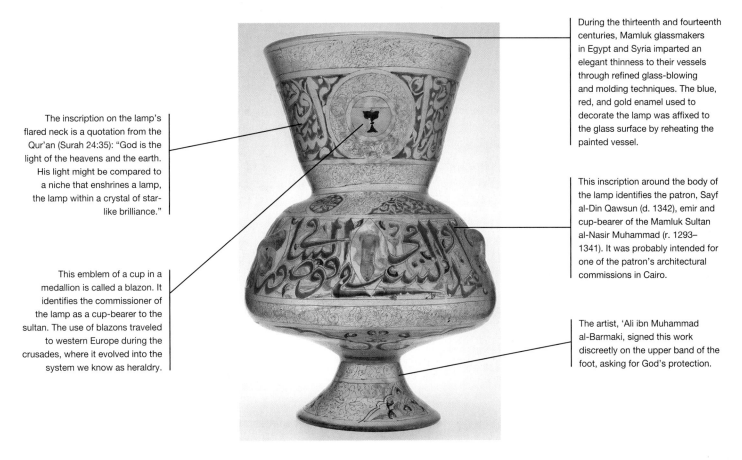

During the thirteenth and fourteenth centuries, Mamluk glassmakers in Egypt and Syria imparted an elegant thinness to their vessels through refined glass-blowing and molding techniques. The blue, red, and gold enamel used to decorate the lamp was affixed to the glass surface by reheating the painted vessel.

The inscription on the lamp's flared neck is a quotation from the Qur'an (Surah 24:35): "God is the light of the heavens and the earth. His light might be compared to a niche that enshrines a lamp, the lamp within a crystal of star-like brilliance."

This inscription around the body of the lamp identifies the patron, Sayf al-Din Qawsun (d. 1342), emir and cup-bearer of the Mamluk Sultan al-Nasir Muhammad (r. 1293–1341). It was probably intended for one of the patron's architectural commissions in Cairo.

This emblem of a cup in a medallion is called a blazon. It identifies the commissioner of the lamp as a cup-bearer to the sultan. The use of blazons traveled to western Europe during the crusades, where it evolved into the system we know as heraldry.

The artist, 'Ali ibn Muhammad al-Barmaki, signed this work discreetly on the upper band of the foot, asking for God's protection.

🔍 **View** the Closer Look for the Mamluk glass oil lamp on myartslab.com

wealth and status. The combined *madrasa*-mausoleum-mosque complex established in mid-fourteenth-century Cairo by the Mamluk Sultan Hasan (**FIG. 9-13**) is a splendid example. A deflected entrance—askew from the building's orientation—leads from the street, through a dark corridor, into a central, well-lit courtyard of majestic proportions. The complex has a classic four-*iwan* plan, each *iwan* serving as a classroom for students following a different branch of study, who are housed in a surrounding, multi-storied cluster of tiny rooms. The sumptuous *qibla iwan* served as the prayer hall for the complex (**FIG. 9-14**). Its walls are ornamented with typically Mamluk panels of sharply contrasting marbles (*ablaq* masonry, see "Ornament," page 268) that culminate in a doubly recessed *mihrab* framed by slightly pointed arches on columns. The marble blocks of the arches are ingeniously joined in interlocking pieces called joggled voussoirs. The paneling is surmounted by a wide band of Kufic script in stucco set against a background of scrolling vines, both the text and the abundant foliage referring to the paradise that is

promised to the faithful. Next to the *mihrab,* an elaborate *minbar* stands behind a platform for reading the Qur'an. Just beyond the *qibla iwan* is the patron's monumental domed tomb, ostentatiously asserting his identity with the architectural complex. The Sultan Hasan complex is vast in scale and opulent in decoration, but money was not an object: The project was financed by the estates of victims of the bubonic plague that had raged in Cairo from 1348 to 1350.

Partly because the mosque in the Sultan Hasan complex—and many smaller establishments—required hundreds of lamps, glassmaking was a booming industry in Egypt and Syria. Made of ordinary sand and ash, glass is the most ethereal of materials. The ancient Egyptians were producing glassware by the second millennium BCE (see "Glassmaking," page 76), and the tools and techniques for making it have changed little since then. Islamic artists also used glass for beakers and bottles, but lamps, lit from within by oil and wick, glowed with special brilliance (see "A Closer Look," above).

THE NASRIDS IN SPAIN Muslim patrons also spent lavishly on luxurious palaces set in gardens. The Alhambra in Granada, in southeastern Spain, is an outstanding and sumptuous example. Built on the hilltop site of an early Islamic fortress, this palace complex was the seat of the Nasrids (1232–1492), the last Spanish Muslim dynasty, by which time Islamic territory had shrunk from covering most of the Iberian peninsula to the region around Granada. To the conquering Christians at the end of the fifteenth century, the Alhambra represented the epitome of luxury. Thereafter, they preserved the complex as much to commemorate the defeat of Islam as for its beauty. Essentially a small town extending for about half a mile along the crest of a high hill overlooking Granada, it included government buildings, royal residences, gates, mosques, baths, servants' quarters, barracks, stables, a mint, workshops, and gardens. Much of what one sees at the site today was built in the fourteenth century or by Christian patrons in later centuries.

The Alhambra offered dramatic views to the settled valley and snowcapped mountains around it, while enclosing gardens within its courtyards. One of these is the Court of the Lions, which stood at the heart of the so-called Palace of the Lions, the private retreat of Sultan Muhammad V (r. 1354–1359 and 1362–1391). The **COURT OF THE LIONS** is divided into quadrants by cross-axial walkways—a garden form called a *chahar bagh*. The walkways carry channels that meet at a central marble fountain held aloft on the backs of 12 stone lions (**FIG. 9-15**). Water animates the fountain, filling the courtyard with the sound of its life-giving abundance. In an adjacent courtyard, the Court of the Myrtles, a basin's round shape responds to the naturally concentric ripples of the water that spouts from a central jet (see "Ornament," page 268). Water has a practical role in the irrigation of gardens, but here it is raised to the level of an art form.

The Court of the Lions is encircled by an arcade of stucco arches embellished with **muqarnas** (nichelike components stacked in tiers, see "Ornament," page 268) and supported on single columns or clusters of two and three. Second-floor **miradors**—windows that frame intentional views—look over the courtyard, which was originally either gardened or more likely paved, with aromatic citrus confined to corner plantings. From these windows, protected by latticework screens, the women of the court, who did not appear in public, would watch the activities of the men below. At one end of the Palace of the Lions, a particularly magnificent *mirador* looks out onto a large, lower garden and the plain below. From here, the sultan literally oversaw the fertile valley that was his kingdom.

Pavilions used for dining and musical performances open off the Court of the Lions. One of these, the so-called Hall of the Abencerrajes, in addition to having excellent acoustics, is covered by a ceiling of dazzling geometrical complexity and exquisitely carved stucco (**FIG. 9-16**). The star-shaped vault is formed by a honeycomb of clustered *muqarnas* arches that alternate with corner squinches themselves filled with more *muqarnas*. The square room thus rises to an eight-pointed star, pierced by 16 windows, that culminates in a burst of *muqarnas* floating high overhead—a dematerialized architectural form, perceived and yet ultimately unknowable, like the heavens themselves.

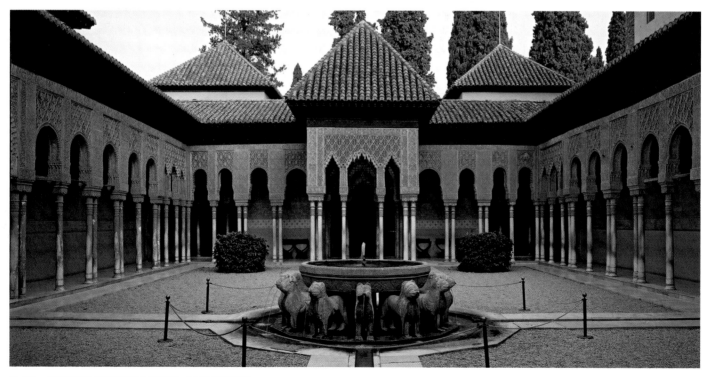

9-15 • COURT OF THE LIONS, ALHAMBRA
Granada, Spain. 1354–1391.

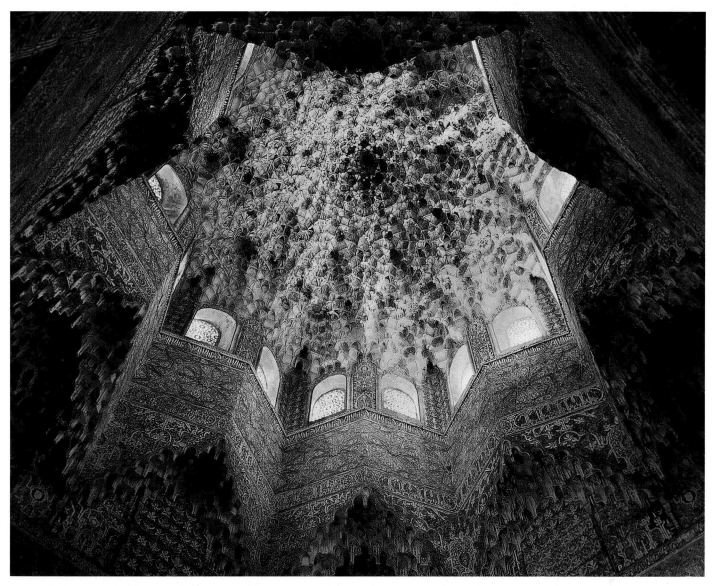

9-16 • MUQARNAS DOME, HALL OF THE ABENCERRAJES, PALACE OF THE LIONS, ALHAMBRA

Granada, Spain. 1354–1391.

The stucco *muqarnas* (stalactite) ornament does not support the dome but is actually suspended from it, composed of some 5,000 individual plaster pieces. Of mesmerizing complexity, the vault's effect can be perceived but its structure cannot be fully comprehended.

👁—⌐**Watch** a video about the Alhambra on myartslab.com

THE TIMURIDS IN IRAN, UZBEKISTAN, AND AFGHANI-STAN The Mongol invasions brought devastation and political instability but also renewal and artistic exchange that provided the foundation for successor dynasties with a decidedly eastern identity. One of the empires to emerge after the Mongols was the vast Timurid empire (1370–1506), which conquered Iran, Central Asia, and the northern part of South Asia. Its founder, Timur (known in the West as Tamerlane), was a Mongol descendant, a lineage strengthened through marriage to a descendant of Genghiz Khan. Timur made his capital at Samarkand (in present-day Uzbekistan), which he embellished by means of the forcible relocation of expert artists from the areas he conquered. Because the empire's compass was vast, Timurid art could integrate Chinese, Persian, Turkic, and Mediterranean artistic ideas into a Mongol base. Its architecture is characterized by axial symmetry, tall double-shelled domes (an inner dome capped by an outer shell of much larger proportions), modular planning with rhythmically repeated elements, and brilliant cobalt blue, turquoise, and white glazed ceramics. Although the empire itself lasted only 100 years after the death of Timur, its legacy endured in the art of the later Safavid dynasty in Iran and the Mughals of South Asia.

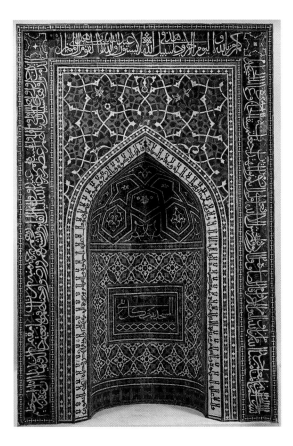

9–17 • TILE MOSAIC MIHRAB
From the Madrasa Imami, Isfahan, Iran. Founded 1354.
Glazed and cut tiles, 11′3″ × 9′5¹¹⁄₁₆″ (3.43 × 2.89 m).
Metropolitan Museum of Art, New York. Harris Brisbane Dick
Fund. (39.20)

This *mihrab* has three inscriptions: the outer inscription, in
cursive, contains Qur'anic verses (surah 9) that describe
the duties of believers and the Five Pillars of Islam.
Framing the niche's pointed arch, a Kufic inscription
contains sayings of the Prophet. In the center, a panel
with a line in Kufic and another in cursive states: "The
mosque is the house of every pious person."

Made during a period of uncertainty as Iran shifted from Mongol to Timurid rule, this *mihrab* (1354), originally from a *madrasa* in Isfahan, is one of the finest examples of architectural ceramic decoration from this era (**FIG. 9–17**). More than 11 feet tall, it was made by painstakingly cutting each individual piece of tile, including the pieces making up the letters on the curving surface of the keel-profiled niche. The color scheme—white against turquoise and cobalt blue with accents of dark yellow and green—was typical of this type of decoration, as were the harmonious, dense, contrasting patterns of organic and geometric forms. The cursive inscription of the outer frame is rendered in elegant white lettering on a blue ground, while the Kufic inscription bordering the pointed arch reverses these colors for a striking contrast.

Near Samarkand, the preexisting Shah-i Zinda ("Living King") **FUNER-ARY COMPLEX** was adopted for the tombs of Timurid family members, especially princesses, in the late fourteenth and fifteenth centuries (**FIG. 9–18**). The mausolea are arrayed along a central avenue that descends from the tomb

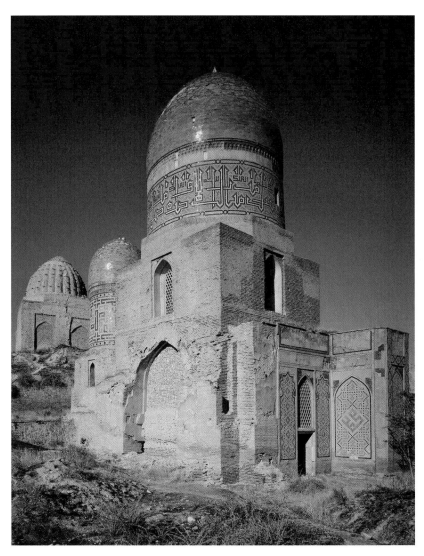

9–18 • SHAH-I ZINDA FUNERARY COMPLEX
Samarkand, Uzbekistan. Late 14th–15th century.

Timurid princesses were buried here and built many of the tombs. The lively
experimentation in varied artistic motifs indicates that women were well versed
in the arts and empowered to exercise personal taste.

of Qutham b. Abbas (a cousin of the Prophet and a saint). The women sought burial in the vicinity of the holy man in order to gain *baraka* (blessing) from his presence. Like all Timurid architecture, the tombs reflect modular planning—noticeable in the repeated dome-on-square unit—and a preference for blue glazed tiles. The domes of the individual structures were double-shelled and, for exaggerated effect, stood on high drums inscribed with Qur'anic verses in interwoven Kufic calligraphy. The ornament adorning the exterior façades consists of an unusually exuberant array of patterns and techniques, from geometry to chinoiserie, and both painted and cut tiles (see "Ornament," page 268). The tombs reflect a range of individual taste and artistic experimentation that was possible precisely because they were private commissions that served the patrons themselves, rather than the city or state (as in a congregational mosque).

LUXURY ARTS

Islamic society was cosmopolitan, with pilgrimage, trade, and a well-defined road network fostering the circulation of marketable goods. In addition to the import and export of basic and practical commodities, luxury arts brought particular pleasure and status to wealthy owners and were visible signs of cultural refinement. On objects made of ceramics, ivory, glass (see "A Closer Look," page 279), metal, and textiles, calligraphy was prominently displayed. These precious art objects were eagerly exchanged and collected from one end of the Islamic world to the other, and despite their Arabic lettering—or perhaps precisely because of its exotic artistic cachet—they were sought by European patrons as well.

CERAMICS From the beginning, Islamic civilization in Iran was characterized by the production of exceptionally sophisticated and strikingly beautiful luxury ceramic ware. During the twelfth century, Persian potters developed a technique of multicolor ceramic overglaze painting known as *mina'i* ware, the Persian word for "enamel" (**FIG. 9–19**). The decoration of *mina'i* bowls, plates, and beakers often reference or portray stories and subjects popular with potential owners. The circular scene at the bottom of this bowl is drawn from the royal life of Bahram Gur (Sasanian king Bahram V, r. 420–438), legendary in the Islamic world for his prowess in love and hunting; this episode combines both. Bahram Gur rides proudly atop a large camel next to his favorite, the ill-fated lute player Azada, who has foolishly belittled his skills as

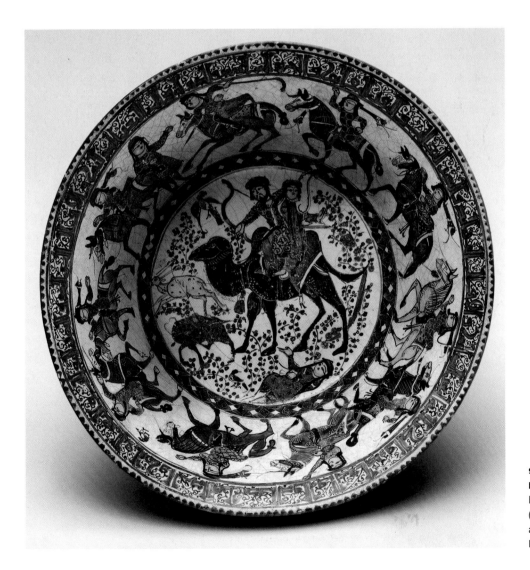

9-19 • MINA'I BOWL WITH BAHRAM GUR AND AZADA
Iran. 12th–13th century. *Mina'i* ware (stoneware with polychrome in-glaze and overglaze), diameter 8½″ (21.6 cm). Metropolitan Museum of Art, New York.

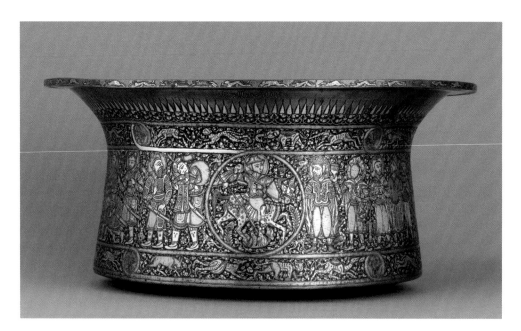

This beautifully crafted basin, with its princely themes of hunting and horsemanship, was made, judging by its emblems and coats of arms, for an unidentified, aristocratic Mamluk patron. However, it became known as the Baptistery of St. Louis, because it was acquired by the French sometime before the end of the fourteenth century (long after the era of St. Louis [king Louis IX, r. 1226–1270]) and used for royal baptisms.

a hunter. To prove his peerless marksmanship, the king pins with his arrow the hoof and ear of a gazelle who had lifted its hind leg to scratch an itch. In this continuous narrative (representing multiple scenes from the same story within a single composition), the subsequent action is also portrayed: Azada trampled to death under the camel after Bahram Gur had pushed her from her mount as punishment for mocking him.

METALWORK Islamic metalsmiths enlivened the surface of vessels with scrolls, interlacing designs, human and animal figures, and calligraphic inscriptions. A shortage of silver in the mid twelfth century prompted the development of inlaid brasswork that used the more precious metal sparingly, as in **FIGURE 9-20**. This basin, made in Mamluk Egypt in the late thirteenth or early fourteenth century by Muhammad Ibn al-Zain (who signed it in six places), is among the finest works of metal produced by a Muslim artist. The dynamic surface is crowded with overlapping figures in vigorous poses that nevertheless remain distinct by means of hatching, modeling, and framing. The exterior face is divided into three bands. The upper and lower depict running animals, and the center shows scenes of horsemen flanked by attendants, soldiers, and falcons—scenes of the princely arts of horsemanship and hunting. In later metalwork, such pictorial cycles were replaced by elegant large-scale inscriptions.

THE ARTS OF THE BOOK

The art of book production had flourished from the first century of Islam because an emphasis on the study of the Qur'an promoted a high level of literacy among both men and women. With the availability of paper, books on a wide range of religious as well as secular subjects became available, although since they were hand-copied, books always remained fairly costly. (Muslims did not adopt the printing press until the eighteenth and nineteenth centuries.)

9-21 • QUR'AN FRONTISPIECE
Cairo. c. 1368. Ink, pigments, and gold on paper, 24″ × 18″ (61 × 45.7 cm). National Library, Cairo. MS. 7

The Qur'an to which this page belonged was donated in 1369 by Sultan Shaban to the *madrasa* established by his mother. A close collaboration between illuminator and scribe can be seen here and throughout the manuscript.

Libraries, often associated with *madrasas*, were endowed by members of the educated elite. Books made for royal patrons had luxurious bindings and highly embellished pages, the result of workshop collaboration between noted calligraphers and illustrators.

The manuscript illustrators of Mamluk Egypt (1250–1517) executed intricate nonfigural designs filled with sumptuous botanical ornamentation for Qur'ans. As in architectural decoration, the exuberant ornament adheres to a strict geometric organization. In an impressive frontispiece, the design radiates on each page from a 16-pointed starburst, filling the central square (**FIG. 9-21**). The surrounding frames contain interlacing foliage and stylized flowers that embellish the holy scripture. The page's resemblance to court carpets was not coincidental. Designers often worked in more than one medium, leaving the execution of their efforts to specialized artisans. In addition to religious works, scribes copied and recopied famous secular texts—scientific treatises, manuals of all kinds, stories, and especially poetry. Painters supplied illustrations for these books and also created individual small-scale paintings—miniatures—that were collected by the wealthy and placed in albums.

BIHZAD One of the great royal centers of Islamic miniature painting was at Herat in western Afghanistan, where a Persian **school of painting** and calligraphy was founded in the early fifteenth century under the highly cultured patronage of the Timurid dynasty (1370–1507). In the second half of the fifteenth century, the most famous painter of the Herat School was Kamal al-Din Bihzad (c. 1450–1536/37), who worked under the patronage of Sultan Husayn Bayqara (r. 1470–1506). When the Safavids supplanted the Timurids in 1506/07 and established their capital at Tabriz in northwestern Iran, Bihzad moved to Tabriz, where he headed the Safavid royal workshop.

Bihzad's key paintings, including his only signed works, appear in a manuscript

9-22 • Kamal al-Din Bihzad YUSUF FLEEING ZULAYHKA
From a copy of the *Bustan* of Sa'di. Herat, Afghanistan. 1488. Ink and pigments on paper, approx. 12″ × 8½″ (30.5 × 21.5 cm). Cairo, National Library. (MS Adab Farsi 908, f. 52v)

of the thirteenth-century Persian poet Sa'di's *Bustan* ("Orchard"), made for the royal library in 1488. Sa'di's narrative anthology in verse includes the story of Yusuf and Zulayhka—the biblical Joseph whose virtue was proven by resisting seduction by his master Potiphar's wife, named Zulayhka in the Islamic tradition (Genesis 39:6–12; Qur'an 12:23–25). Bihzad's vizualization of this event (**FIG. 9-22**) is one of the masterpieces of Persian narrative painting. The dazzling and elaborate architectural setting is inspired not by Sa'di's account, but visualizes Timurid poet Jami's more mystical version of the story (quoted in an architectural frame around the central *iwan* under the two figures), written only five years before Bihzad's painting. Jami sets his story in a seduction palace that Zulayhka had built specifically for this encounter, and into which

she leads Joseph ever inward from room to room, with entrance doors locked as they pass from one room to the next. As the scarlet-garbed Zulayhka lunges to possess him, the fire-haloed Joseph flees her advances as the doors miraculously open in front of him.

The brilliant, jewel-like color of Bihzad's architectural forms, and the exquisite detail with which each is rendered are salient characteristics of his style, as is the dramatic lunge of Zulayhka and Yusuf's balletic escape. The asymmetrical composition depends on a delicately balanced placement of flat screens of colorful ornament and two emphatically three-dimensional architectural features—a projecting balcony to the right and a zigzagging staircase to the left. Bihzad signed this work in a calligraphic panel over a window at upper left.

ART AND ARCHITECTURE OF LATER EMPIRES

In the pre-modern era, three great powers emerged in the Islamic world. The introduction of gunpowder for use in cannons and guns caused a shift in military strategy; isolated lords in lone castles could not withstand gunpowder sieges. Power lay not in thick walls but in strong centralized governments that could invest in firepower and train armies in its use. To the west was the Ottoman Empire (1342–1918), which grew from a small principality in Asia Minor. In spite of setbacks inflicted by the Mongols, the Ottomans ultimately controlled Anatolia, western Iran, Iraq, Syria, Palestine, western Arabia (including Mecca and Medina), northern Africa (excepting Morocco), and part of eastern Europe. In 1453, their stunning capture of Constantinople (ultimately renamed Istanbul) brought the Byzantine Empire to an end. To the east of the Ottomans, Iran was ruled by the Safavid dynasty (1501–1732), distinguished for their Shi'ite branch of Islam. Their patronage of art and architecture brought a new refinement to artistic ideas and techniques drawn from the Timurid period. The other heirs to the Timurids were the Mughals of South Asia (1526–1858). The first Mughal emperor, Babur, invaded Hindustan (India and Pakistan) from Afghanistan, bringing with him a taste for Timurid gardens, architectural symmetry, and modular planning. The Mughals will be discussed in Chapter 24. Here we will focus on the Ottomans and the Safavids.

THE OTTOMAN EMPIRE

Imperial Ottoman mosques were strongly influenced by Byzantine church plans. Prayer-hall interiors are dominated by ever-larger domed spaces uninterrupted by structural supports. Worship is directed, as in other mosques, toward a *qibla* wall and *mihrab* opposite the entrance.

Upon conquering Constantinople, Ottoman rulers converted the great Byzantine church of Hagia Sophia into a mosque, framing it with two graceful Turkish-style minarets in the fifteenth century and two more in the sixteenth century (see FIG. 8-2). In conformance with Islamic practice, the church's figural mosaics were destroyed or whitewashed. Huge calligraphic disks with the names of God (Allah), Muhammad, and the early caliphs were added to the interior in the mid nineteenth century (see FIG. 8-4). At present, Hagia Sophia is neither a church nor a mosque but a state museum.

SINAN Ottoman architects had already developed the domed, centrally planned mosque, but the vast open interior and structural clarity of Hagia Sophia inspired them to strive for a more ambitious scale. For the architect Sinan (c. 1489–1588) the development of a monumental, centrally planned mosque was a personal quest. Sinan began his career in the army, serving as engineer in the Ottoman campaigns at Belgrade, Vienna, and Baghdad. He rose through the ranks to become, in 1528, chief architect for Suleyman "the Magnificent," the tenth Ottoman sultan (r. 1520–1566). Suleyman's reign marked the height of Ottoman power, and the sultan sponsored an ambitious building program on a scale not seen since the days of the Roman Empire. Serving Suleyman and his successor, Sinan is credited with more than 300 imperial commissions, including palaces, *madrasas* and Qur'an schools, tombs, public kitchens, hospitals, caravanserais, treasure houses, baths, bridges, viaducts, and 124 large and small mosques.

Sinan's crowning accomplishment, completed about 1579, when he was over 80, was a mosque he designed in the provincial capital of Edirne for Suleyman's son, Selim II (r. 1566–1574) (FIG. 9-23). The gigantic hemispheric dome that tops the Selimiye Mosque is more than 102 feet in diameter—larger than the dome of Hagia Sophia, as Sinan proudly pointed out. It crowns a building of extraordinary architectural coherence. The transition from square base to the central dome is accomplished by corner half-domes that enhance the spatial plasticity and openness of the prayer hall's airy interior (FIG. 9-24). The eight massive piers that bear the dome's weight are visible both within and without—on the exterior they resolve in pointed towers that encircle the main dome—revealing the structural logic of the building and clarifying its form. In the arches that support the dome and span from one pier to the next—indeed at every level—light pours through windows into the interior, a space at once soaring and serene.

The interior was clearly influenced by Hagia Sophia—an open expanse under a vast dome floating on a ring of light—but it rejects Hagia Sophia's longitudinal pull from entrance to sanctuary. The Selimiye Mosque is truly a centrally planned structure. In addition to the mosque, the complex housed a *madrasa* and other educational buildings, a cemetery, a hospital, and charity kitchens, as well as the income-producing covered market and baths. Framed by the vertical lines of four minarets and raised on a platform at the city's edge, the Selimiye Mosque dominates the skyline.

The Topkapi, the Ottomans' enormous palace in Istanbul, was a city unto itself. Built and inhabited from 1473 to 1853, it

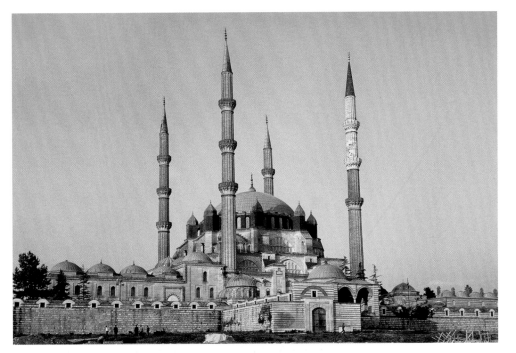

9-23 • PLAN (A) AND EXTERIOR VIEW (B) OF THE MOSQUE OF SULTAN SELIM, EDIRNE

Western Turkey. 1568–1575.

The minarets that pierce the sky around the prayer hall of this mosque, their sleek, fluted walls and needle-nosed spires soaring to more than 295 feet, are only 12½ feet in diameter at the base, an impressive feat of engineering. Only royal Ottoman mosques were permitted multiple minarets, and having more than two was unusual.

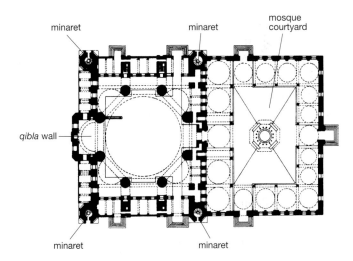

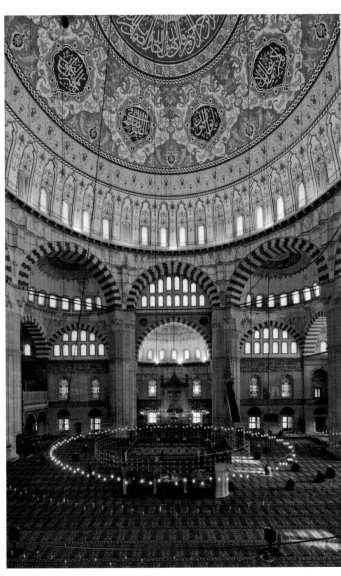

9-24 • INTERIOR, MOSQUE OF SULTAN SELIM

consisted of enclosures within walled enclosures, mirroring the immense political bureaucracy of the state. Inside, the sultan was removed from virtually all contact with the public. At the end of the inner palace, a free-standing pavilion, the Baghdad Kiosk (1638), provided him with a sumptuous retreat (**FIG. 9-25**). The kiosk consists of a low dome set above a cruciform hall with four alcoves. Each recess contains a low sofa (a Turkish word) laid with cushions and flanked by cabinets of wood inlaid with ivory and shell. Alternating with the cabinets are niches with ornate profiles: When stacked in profusion such niches—called *chini khana*—form decorative panels. On the walls, the blue and turquoise glazed tiles contain an inscription of the Throne Verse (Qur'an 2:255) which proclaims God's dominion "over the heavens and the earth," a reference to divine power that appears in many throne rooms and places associated with Muslim sovereigns. Sparkling light glows in the **stained glass** above.

9-25 • BAGHDAD KIOSK ALCOVE
Topkapi Palace, Istanbul. 1638.

TUGRAS Following a practice begun by the Saljuqs and Mamluks, the Ottomans put calligraphy to political use, developing the design of imperial ciphers—**tugras**—into a specialized art form. Ottoman *tugras* combined the ruler's name and title with the motto "Eternally Victorious" into a monogram denoting the authority of the sultan and of those select officials who were also granted an emblem. *Tugras* appeared on seals, coins, and buildings, as well as on official documents called *firmans*, imperial edicts supplementing Muslim law. Suleyman issued hundreds of edicts, and a high court official supervised specialist calligraphers and illuminators who produced the documents with fancy *tugras* (**FIG. 9-26**).

Tugras were drawn in black or blue with three long, vertical strokes to the right of two concentric horizontal teardrops. Decorative foliage patterns fill the area within the script. By the 1550s, this fill decoration became more naturalistic, and in later centuries it spilled outside the emblems' boundary lines. This rare, oversized *tugra* has a sweeping, fluid but controlled line, drawn to set proportions. The color scheme of delicate floral interlace enclosed in the body of the *tugra* may have been inspired by Chinese blue-and-white porcelain; similar designs appear on Ottoman ceramics and textiles.

9-26 • ILLUMINATED TUGRA OF SULTAN SULEYMAN
From Istanbul, Turkey. c. 1555–1560. Ink, paint, and gold on paper, removed from a *firman* and trimmed to 20½″ × 25⅜″ (52 × 64.5 cm). Metropolitan Museum of Art, New York. Rogers Fund, 1938. (38.149.1)

The *tugra* shown here is from a document endowing an institution in Jerusalem that had been established by Suleyman's powerful wife, Hurrem.

THE SAFAVID DYNASTY

When Shah Isma'il (r. 1501–1524) solidified Safavid rule over the land of the Timurids in the early years of the sixteenth century, he called Bihzad, the most distinguished member of the Herat School, to the capital city of Tabriz to supervise the Safavid royal workshop that established a new golden age of book production by blending the Herat style with that of other regional Persian traditions. But it was Isma'il's son and successor Shah Tahmasp (r. 1524–1576) who emerged as the most important early patron.

SULTAN MUHAMMAD As a child, Tahmasp was trained in the art of calligraphy and drawing in Herat, where Shah Isma'il had dispatched him to serve as titular governor. Shortly after succeeding his father, the youthful Tahmasp commissioned from the royal workshop in Tabriz a spectacular manuscript copy of the *Shahnama* ("Book of Kings"), Firdawsi's poetic history of Persian rulers written in the late tenth and early eleventh centuries. Tahmasp's monumental volume—with pages 18½ inches tall, larger than any book produced during the Timurid period—consists of 742 folios whose margins are embellished with pure gold; 258 full-page pictures highlight the important kings and heroes of Persian royal history. The paintings were produced by a series of artists over an extended period during the 1520s and into the 1530s. This was the most important royal artistic project of the early Safavid period.

Among the most impressive paintings—indeed, a work many consider the greatest of all Persian manuscript paintings—is a rendering of **THE "COURT OF GAYUMARS"** (**FIG. 9-27**) painted by Sultan Muhammad, the most renowned artist in the royal workshop. This assessment is not only modern. In 1544, Dust Muhammad—painter, chronicler, and **connoisseur**—cited this painting in particular when singling out Sultan Muhammad as the premier painter participating in the project, claiming that "although it has a thousand eyes, the celestial sphere has not seen his like" (Blair and Bloom, page 168). Sultan Muhammad portrayed the idyllic reign of the legendary first Shah, Gayumars, who ruled from a mountaintop over a people who were the first to make clothing from leopard skins and develop the skill of cooking. The elevated and central figure of the king is surrounded by the members of his family and court, each rendered with individual facial features and varying body proportions to add a sense of naturalism to the unleashed fantasy characterizing the surrounding world. The landscape sparkles with brilliant color, encompassing the detailed delineation of lavish plant life as well as melting renderings of pastel rock formations, into which are tucked the faces of the spirits and demons animating this primitive paradise. This is a painting meant to be savored slowly by an intimate, elite audience within the Safavid court. It is packed with surprises and unexpected delights.

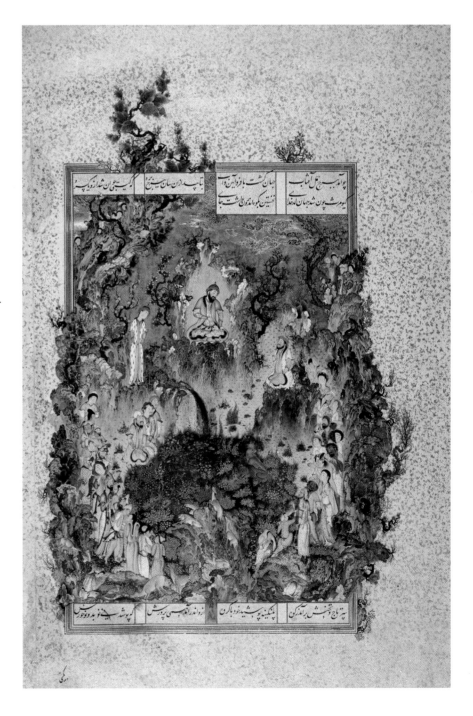

9-27 • Sultan Muhammad **THE "COURT OF GAYUMARS"**

From the Shahnama of Shah Tahmasp (fol. 20v). Tabriz, Iran. c. 1525–1535. Ink, pigments, and gold on paper, page size 18½″ × 12½″ (47 × 31.8 cm). Aga Khan Museum, Toronto. (AKM165)

ARCHITECTURE Whereas the Ottomans took their inspiration from works of the Byzantine Empire, the Safavids looked to Timurid architecture with its tall, double-shell domes, sheathed in blue tiles. In the later Safavid capital of Isfahan, the typically Timurid taste for modular construction re-emerged on a grand scale that extended well beyond buildings to include avenues, bridges, public plazas, and gardens. To the preexisting city of Isfahan, Safavid Shah Abbas I (1588–1629) added an entirely new extension, planned around an immense central plaza (*maydan*) and a broad avenue, called the Chahar Bagh, that ran through a zone of imperial palace pavilions and gardens down to the river. The city's prosperity and beauty so amazed visitors who flocked from around the world to conduct trade and diplomacy that it led to the popular saying, "Isfahan is half the world."

With Isfahan's **MASJID-I SHAH** or Royal Mosque (1611–1638), the four-*iwan* mosque plan reached its apogee (**FIG. 9-28**). Stately and huge, it anchors the south end of the city's *maydan*. Its 90-foot portal and the passageway through it aligns with the *maydan*, which is oriented astrologically, but the entrance corridor soon turns to conform to the prayer hall's orientation to

Mecca. The portal's great *iwan* is framed by a *pishtaq* (a rectangular panel framing an *iwan*) that rises above the surrounding walls and is enhanced by the soaring verticality of its minarets. The *iwan*'s profile is reflected in the repeated, double-tiered *iwans* that parade across the façade of the mosque courtyard and around the *maydan* as a whole. Achieving unity through the regular replication of a single element—here the arch—is a hallmark of Safavid architecture, inherited from Timurid aesthetics, but achieved on an unprecedented scale and integrated within a well-planned urban setting.

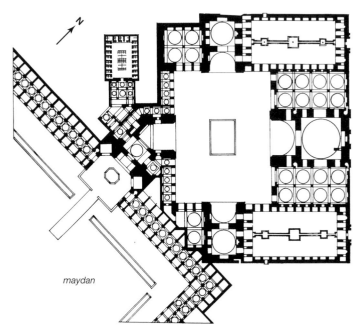

maydan

9-28 • PLAN (A) AND EXTERIOR VIEW (B) OF THE MASJID-I SHAH, ISFAHAN
Iran. 1611–1638.

The tall bulbous dome behind the *qibla iwan* and the large *pishtaqs* with minarets are pronounced vertical elements that made royal patronage visible not only from the far end of the *maydan* but throughout the city and beyond.

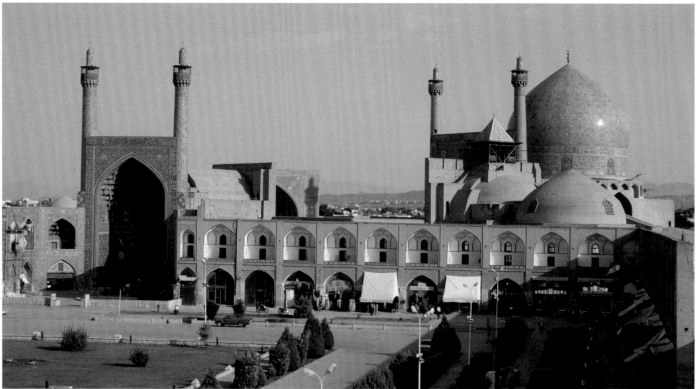

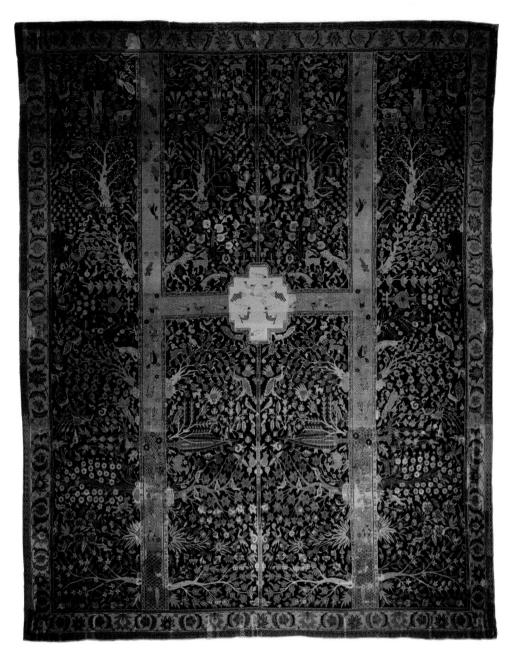

CARPETS The Safavid period was a golden age of carpet making (see "Carpet Making," page 292). Shah Abbas built workshops in Isfahan and Kashan that produced large, costly carpets that were often signed—indicating the weaver's growing prestige. Among the types produced were medallion carpets, centered around a sun or star, and garden carpets, representing Paradise as a shady garden with four rivers. The seventeenth-century **GARDEN CARPET** in **FIGURE 9-29** represents a dense field of trees (including cypresses) and flowers, populated with birds, animals, and even fish, and traversed by three large water channels that form an H with a central pool at the center. Laid out on the floor of an open-air hall, and perhaps set with bowls of ripe fruit and other delicacies, such carpets brought the beauty of nature indoors.

Rugs have long been used for Muslim prayer, which involves repeatedly kneeling and touching the forehead to the floor before God. While individuals often had their own small prayer rugs, with representations of mihrab niches to orient them in prayer, many mosques were furnished with wool-pile rugs received as pious donations. In Islamic houses, people sat and slept on cushions, carpets, and thick mats laid directly on the floor, so cushions took the place of the fixed furnishings of Western domestic environments. Historically, rugs from Iran, Turkey, and elsewhere were highly valued by Westerners, who often displayed them on tables rather than floors. They remain one of the predominant forms of Islamic art known in the West.

THE MODERN ERA

Islamic art is not restricted to the distant past. But with the dissolution of the great Islamic empires and the formation of smaller nation-states during the twentieth century, questions of identity and its expression in art changed significantly. Muslim artists and

Because textiles are made of organic materials that are destroyed through use, very few carpets from before the sixteenth century have survived. Carpets fall into two basic types: flat-weave carpets and pile, or knotted, carpets. Both can be made on either vertical or horizontal looms.

The best-known flat-weaves today are kilims, which are typically woven in wool with bold, geometric patterns and sometimes with brocaded details. Kilim weaving is done with a **tapestry** technique called slit tapestry (see A).

Knotted carpets are an ancient invention. The oldest known example, excavated in Siberia and dating to the fourth or fifth century BCE, has designs evocative of Achaemenid art, suggesting that the technique may have originated in Central Asia. In knotted carpets, the pile—the plush, thickly tufted surface—is made by tying colored strands of yarn, usually wool but occasionally silk for deluxe carpets, onto the vertical elements

(the **warp**) of a yarn grid (see B and C). These knotted loops are later trimmed and sheared to form the plush pile surface of the carpet. The **weft** strands (crosswise threads) are shot horizontally, usually twice, after each row of knots is tied, to hold the knots in place and to form the horizontal element common to all woven structures. The weft is usually an undyed yarn and is hidden by the colored knots of the warp. Two common knot tying techniques are the asymmetrical knot, used in many carpets from Iran, Egypt, and Central Asia (formerly termed the Sehna knot), and the symmetrical knot (formerly called the Gördes knot) more commonly used in Anatolian Turkish carpet weaving. The greater the number of knots, the shorter the pile. The finest carpets can have as many as 2,400 knots per square inch, each one tied separately by hand.

Although royal workshops produced luxurious carpets (see FIG. 9–29), most knotted rugs have traditionally been made in tents and homes, woven, depending on local custom, either by women or by men.

A Kilim weaving pattern used in flat-weaving

B Symmetrical knot, used extensively in Turkey

C Asymmetrical knot, used extensively in Iran

9-30 • Hasan Fathy MOSQUE AT NEW GOURNA
Luxor, Egypt. 1945–1947. Gouache on paper, 22½″ × 17⅞″ (52.8 × 45.2 cm). Collection of the Aga Khan Award for Architecture, Geneva, Switzerland.

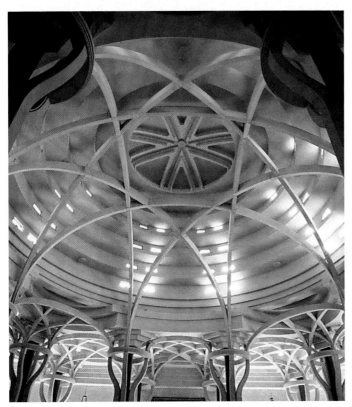

9-31 • Paolo Portoghesi, Vittorio Gigliotti, and Sami Mousawi
ISLAMIC MOSQUE AND CULTURAL CENTER, ROME
1984–1992.

The prayer hall, 197′ × 131′ (60 × 40 m), which has an ablution area on the floor below, can accommodate a congregation of 2,500 on its main floor and balconies. The large central dome (65½′; 20 m in diameter) is surrounded by 16 smaller domes, all similarly articulated with concrete ribs.

architects began to participate in international movements that swept away many of the visible signs that formerly expressed their cultural character and difference. When architects in Islamic countries were debating whether modernity promised opportunities for new expression or simply another form of Western domination, the Egyptian Hasan Fathy (1900–1989) questioned whether abstraction could serve the cause of social justice. He revived traditional, inexpensive, and locally obtainable materials such as mud brick and forms such as wind scoops (an inexpensive means of catching breezes to cool a building's interior) to build affordable housing for the poor. Fathy's New Gourna Village (designed 1945–1947) in Luxor, Egypt, became a model of environmental sustainability realized in pure geometric forms that resonated with references to Egypt's architectural past (**FIG. 9–30**). In their simplicity, his watercolor paintings are as beautiful as his buildings.

More recently, Islamic architects have sought to reconcile modernity with an Islamic cultural identity distinct from the West. In this spirit Iraqi architect Sami Mousawi and the Italian firm of Portoghesi-Gigliotti designed the **ISLAMIC CULTURAL CENTER** in Rome (completed 1992) with clean modern lines, exposing the structure while at the same time taking full advantage of opportunities for ornament (**FIG. 9–31**). The structural logic appears in the prayer hall's concrete columns that rise to meet abstract capitals in the form of plain rings, then spring upward to make a geometrically dazzling eight-pointed star supporting a dome of concentric circles. There are references here to the interlacing ribs of the *mihrab* dome in the Great Mosque of Cordoba, to the great domed spans of Sinan's prayer halls, and to the simple palm-tree trunks that supported the roof of the Mosque of the Prophet in Medina.

THINK ABOUT IT

9.1 Explain how the design of the mosque varies across the Islamic world with reference to three examples. Despite the differences, what features do mosques typically have in common?

9.2 Images of people are not allowed in Islamic religious contexts, but mosques and other religious buildings are lavishly decorated. What artistic motifs and techniques are used and why?

9.3 Compare the painted pages from sumptuous manuscripts in FIGURES 9–21 and 9–27. How does the comparison reveal the distinctive aspirations of religious and secular art in Islamic society? How are they different, and what features do they share?

9.4 Select an Islamic structure that is influenced by Roman or Byzantine architecture. Which forms are borrowed? Why and how, in their new Islamic context, are they transformed?

CROSSCURRENTS

FIG. 7–13B

FIG. 9–5

These buildings were constructed for worship during the formative years of Christianity and Islam. Explain why they appear similar and discuss the ways in which their designs are consistent with the religious and cultural contexts.

✓—**Study** and review on myartslab.com

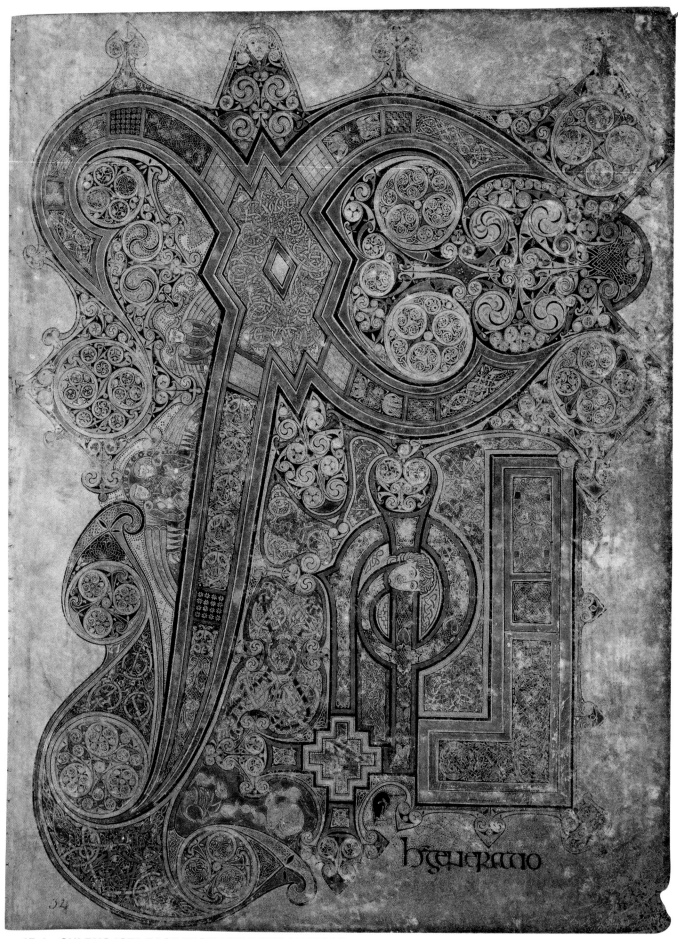

15–1 • CHI RHO IOTA PAGE FROM THE BOOK OF KELLS
Probably made at Iona, Scotland. Late 8th or early 9th century. Oxgall inks and pigments on vellum, 12¾″ × 9½″ (32.5 × 24 cm).
The Board of Trinity College, Dublin. MS. 58, fol. 34r

Early Medieval Art in Europe

The explosion of ornament surrounding—almost suffocating—the words on this page from an early medieval manuscript clearly indicates the importance of what is being expressed (**FIG. 15–1**). The large Greek letters *chi rho iota* (*XPI*) abbreviate the word *Christi* that starts the Latin phrase *Christi autem generatio*. The last word is written out fully and legibly at bottom right, clear of the decorative expanse. These words begin Matthew 1:18: "Now the birth of Jesus the Messiah took place in this way." So what is signaled here—not with a picture of the event but with an ornamental celebration of its initial mention in the text—is Christ's first appearance within this Gospel book. The book itself not only contains the four biblical accounts of Christ's life; it would also evoke Christ's presence on the altar of the monastery church where this lavish volume was once housed. It is precisely the sort of ceremonial book that we have already seen carried in the hands of a deacon in Justinian's procession into San Vitale in Ravenna to begin the liturgy (see FIG. 8–8).

There is nothing explicitly Christian about the ornamental motifs celebrating the first mention of the birth of Christ in this manuscript, known as the Book of Kells and produced in Ireland or Scotland sometime around the year 800. The swirling spirals and interlaced tangles of stylized animal forms have their roots in jewelry created by the migrating, so-called barbarian tribes that formed the "other" of the Greco-Roman world. But by this time, this ornamental repertory had been subsumed into the flourishing art of Irish monasteries. Irish monks became as famous for writing and copying books as for their intense spirituality and missionary fervor.

Wealthy, isolated, and undefended, Irish monasteries were easy victims to Viking attacks. In 806, fleeing Viking raids on the island of Iona (off the coast of modern Scotland), its monks established a refuge at Kells on the Irish mainland. They probably brought the Book of Kells with them. It was precious. Producing this illustrated version of the Gospels entailed lavish expenditure: Four scribes and three major painters worked on it (modern scribes take about a month to complete such a page), 185 calves were slaughtered to make the vellum, and colors for some of its paintings came from as far away as Afghanistan.

Throughout the Middle Ages and across Europe, monasteries were principal centers of art and learning. While prayer and acts of mercy represented their primary vocation, some talented monks and nuns also worked as painters, jewelers, carvers, weavers, and embroiderers. Few, however, could claim a work of art as spectacular as this one.

LEARN ABOUT IT

15.1 Identify and investigate the rich variety of early medieval artistic and architectural styles across Europe, as well as the religious and secular contexts in which they were developed.

15.2 Appreciate and understand the themes and subjects used to illustrate early medieval sacred books.

15.3 Assess the Carolingian and Ottonian revival of Roman artistic traditions in relation to the political position of the rulers as emperors sanctioned by the pope.

15.4 Recognize and evaluate the "barbarian" and Islamic sources that were adopted and transformed by Christian artists during the early Middle Ages.

((•—[**Listen** to the chapter audio on myartslab.com

THE EARLY MIDDLE AGES

As Roman authority crumbled at the dissolution of the Western Empire in the fifth century, it was replaced by rule of people from outside of the Roman Empire and cultural orbit of the Romans, people whom the Romans—like the Greeks before them—called "barbarians," since they could only "barble" the Greek or Latin language (**MAP 15-1**). Thus far we have seen these "barbarians" as adversaries viewed through Greek and Roman eyes—the defeated Gauls at Pergamon (see FIG. 5-60), the captives on the Gemma Augustea (see FIG. 6-23), or the enemy beyond the Danube River on Trajan's Column (see FIG. 6-48). But by the fourth century many Germanic tribes were allies of Rome. In fact, most of Constantine's troops in the decisive battle with Maxentius at the Milvian Bridge were Germanic "barbarians."

A century later the situation was entirely different. The adventures of the Roman princess Galla Placidia, whom we have already met as a patron of the arts (see "The Oratory of Galla Placidia in Ravenna," page 228), bring the situation to life. She had the misfortune to be in Rome when Alaric and the Visigoths sacked the city in 410 (the emperor and pope were living safely in Ravenna). Carried off as a prize of war by the Goths, Galla Placidia had to join their migrations through France and Spain and eventually married the Gothic king, who was soon murdered. Back in Italy, married and widowed yet again, Galla Placidia ruled the Western Empire as regent for her son from 425 to 437/38. She died in 450, thus escaping yet another sack of Rome, this time by the Vandals, in 455. The fall of Rome shocked the Christian world, although the wounds were more psychological than physical. Bishop Augustine of Hippo (St. Augustine, d. 430) was inspired to write *The City of God*, a cornerstone of Christian philosophy, as an answer to people who claimed that the Goths represented the vengeance of the pagan gods on people who had abandoned them for Christianity.

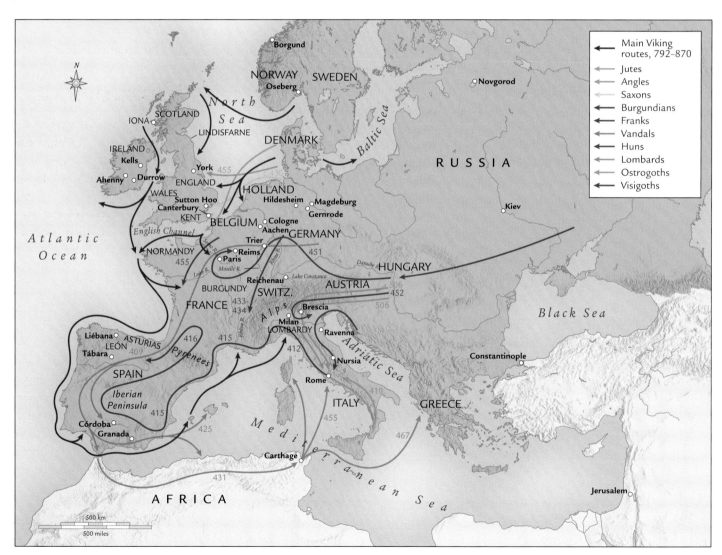

MAP 15-1 • EUROPE OF THE EARLY MIDDLE AGES

This map shows the routes taken by the groups of people who migrated into and through the western Roman world at the dawn of the Middle Ages. Modern country names have been used here for convenience, but at this time, these countries, as we know them, did not yet exist.

The roughly 1,000 years of European history between the dissolution of the Western Roman Empire during the fifth century and the Florentine Renaissance in the fifteenth century are generally referred to as the Middle Ages, or the medieval period. These terms reflect the view of Renaissance humanists who regarded the period that preceded theirs as a "dark age" of ignorance, decline, and barbarism, standing in the middle and separating their own "golden age" from the golden ages of ancient Greece and Rome. Although scholars now acknowledge the ridiculousness of this self-serving formulation and recognize the millennium of the "Middle Ages" as a period of

great richness, complexity, creativity, and innovation, the term has endured.

Art historians commonly divide the Middle Ages into three periods: early medieval (ending c. 1000), Romanesque (eleventh and twelfth centuries), and Gothic (beginning in the mid twelfth and extending into the fifteenth century). In this chapter we can look at only a few of the many cultures that flourished during the early medieval period. For convenience, we will use modern geographic names as familiar points of reference (see MAP 15–1), but, in fact, European nations as we know them today did not yet exist.

Who were these people living outside of the Mediterranean orbit? Their wooden architecture is lost to fire and decay, but their metalwork and its animal and geometric ornament has survived. They were hunters and fishermen, shepherds and farmers living in villages with a social organization based on extended families and tribal loyalties. They engaged in pottery, weaving, and woodwork, and they fashioned metals into weapons, tools, and jewelry.

The Celts controlled most of western Europe (see "The Celts," page 150), and the Germanic people—Goths and others— lived around the Baltic Sea. Increasing population evidently forced the Goths to begin to move south, into better lands and climate around the Mediterranean and Black Sea, but the Romans had extended the borders of their empire across the Rhine and Danube rivers. Seeking the relative security and higher standard of living they saw in the Roman Empire, the Germanic people crossed the borders and settled within the Roman world.

The tempo of migration speeded up in the fifth century when the Huns from Central Asia swept down on western Europe; the Ostrogoths (Eastern Goths) moved into Italy and deposed the last Western Roman emperor in 476; the Visigoths (Western Goths) ended their wanderings in Spain; the Burgundians settled in Switzerland and eastern France; the Franks in Germany, France, and Belgium; and the Vandals crossed over into Africa, making Carthage their headquarters before circling back to Italy, sacking Rome in 455.

As these "barbarian" groups gradually converted to Christianity, the Church served to unify Europe's heterogeneous population. As early as 345, the Goths adopted Arian Christianity, beliefs considered heretical by the Church in Rome. (Arian Christians did not believe that Christ was divine or co-equal with God the Father.) Not until 589 did they accept Roman Christianity. But the Franks under Clovis (r. 481–511), influenced by his Burgundian wife Clotilda, converted to Roman Christianity in 496, beginning a fruitful alliance between French rulers and the popes. Kings and nobles defended the claims of the Roman Church, and the pope, in turn, validated their authority. As its wealth and influence increased throughout Europe, the Church emerged as the principal patron of the arts, commissioning buildings and liturgical

equipment, including altars, altar vessels, crosses, candlesticks, containers for the remains of saints (reliquaries), vestments (ritual garments), images of Christian symbols and stories, and copies of sacred texts such as the Gospels. (See "Defining the Middle Ages," above.)

THE ART OF THE "BARBARIANS" IN EUROPE

Weaving a rich fabric of themes and styles originating from inside and out of the empire, from pagan and Christian beliefs, from urban and rural settlements, brilliant new artistic styles were born across Europe as people migrated from the east to settle within the former Western Roman Empire. Many of the "barbarian" groups were superb metalworkers and created magnificent colorful jewelry, both with precious metals and with inlays of gems. Most of the motifs were geometric or highly abstract natural forms.

THE MEROVINGIANS

Among the "barbarian" people who moved into the Western Roman world during the fifth century were the Franks, migrating westward from what is now Belgium and settling in the northern part of Roman Gaul (modern France). There they were soon ruled by a succession of leaders from a dynasty named "Merovingian" after its legendary founder, Merovech. The Merovingians established a powerful kingdom during the reigns of Childeric I (c. 457–481) and his son Clovis I (481–511), whose conversion to Christianity in 496 connected the Franks to the larger European world through an ecclesiastical network of communication and affiliation.

Some early **illuminated** books (books that include not only text but pictures and decoration in color and gold) have been associated with the dynasty, but our knowledge of Merovingian art is based primarily on the jewelry that has been uncovered in the graves of kings, queens, and aristocrats, indicating that both men and women expressed their wealth (in death, as presumably in life) by wearing earrings, necklaces, finger rings, bracelets, and weighty

15-2 • JEWELRY OF QUEEN ARNEGUNDE
Discovered in her tomb, excavated at the Abbey of Saint-Denis, Paris. Burial c. 580–590. Gold, silver, garnets, and glass beads; length of pin 10⅜″ (26.4 cm). Musée des Antiquités Nationales, Saint-Germain-en-Laye, France.

leather belts, from which they suspended even more ornamental metalwork. One of the most spectacular royal tombs was that of Queen Arnegunde, unearthed during excavations in 1959 at the Abbey of Saint-Denis, near Paris, which was a significant center of Merovingian patronage.

Arnegunde was discovered within a stone sarcophagus—undisturbed since her burial in c. 580–590. From her bodily remains, archaeologists determined that she was slight and blond, 5 feet tall, and about 70 years old at the time of her death. The inscription of her name on a gold ring on her left thumb provided the first clue to her identity, and her royal pedigree was confirmed by the sumptuousness of her clothing. She was outfitted in a short purple silk tunic, cinched at the waist by a substantial leather belt from which hung ornamental metalwork. The stockings that

covered her legs were supported by leather garters with silver strap tongues and dangling ornaments. Over this ensemble was a dark red gown embroidered in gold thread. This overgarment was open at the front, but clasped at neck and waist by round brooches and a massive buckle (**FIG. 15-2**). These impressive objects were made by casting their general shape in two-piece molds, refining and **chasing** them with tools, and inlaying within reserved and framed areas carefully cut garnets to provide color and sparkle. Not long after Arnegunde's interment, Merovingian royalty ceased the practice of burying such precious items with the dead—encouraged by the Church to donate them instead to religious institutions in honor of the saints—but we are fortunate to have a few early examples that presumably document the way these royal figures presented themselves on state occasions.

THE NORSE

In Scandinavia (present-day Denmark, Norway, and Sweden), which was never part of the Roman Empire, people spoke variants of the Norse language and shared a rich mythology with other Germanic peoples. Scandinavian artists had exhibited a fondness for abstract patterning from early prehistoric times. During the first millennium BCE, trade, warfare, and migration had brought a variety of jewelry, coins, textiles, and other portable objects into northern Europe, where artists incorporated the solar disks and stylized animals on these objects into their already rich artistic vocabulary.

By the fifth century CE, the so-called **animal style** dominated the arts, displaying an impressive array of serpents, four-legged beasts, and squat human figures. The **GUMMERSMARK BROOCH** (**FIG. 15-3**), for example, is a large silver-gilt pin dating from the sixth century in Denmark. Its elegant ornament consists of a large, rectangular panel and a medallionlike plate covering the safety pin's catch, connected by an arched bow. The surface of the pin seethes with human, animal, and geometric forms. An eye-and-beak motif frames the rectangular panel, a man is compressed between dragons just below the bow, and a pair of monster heads and crouching dogs with spiraling tongues frame the covering of the catch.

Certain underlying principles govern works with animal-style design: The compositions are generally symmetrical, and artists depict animals in their entirety either in profile or from above. Ribs and spinal columns are exposed as if they had been x-rayed; hip and shoulder joints are pear-shape; tongues and jaws extend and curl; and legs end in large claws.

The northern jewelers carefully crafted their molds to produce a glittering surface on the cast metal, turning a process intended to speed production into an art form of great refinement.

THE CELTS AND ANGLO-SAXONS IN BRITAIN

After the Romans departed Britain at the beginning of the fifth century, Angles and Saxons from Germany and the Low Countries (present-day Belgium and Holland), and Jutes from Denmark, crossed the sea to occupy southeastern Britain. Gradually they extended their control northwest across the island. Over the next 200 years, the arts experienced a spectacular efflorescence. A fusion of Celtic, Roman, Germanic, and Norse cultures generated a new style of art, sometimes known as Hiberno-Saxon (from the Roman name for Ireland, Hibernia). Anglo-Saxon literature is filled with references to sumptuous jewelry and weapons made of or decorated with gold and silver. Fortunately, some of these objects have survived.

The Anglo-Saxon epic *Beowulf*, composed perhaps as early as the seventh century, describes its hero's burial with a hoard of treasure in a grave mound near the sea. Such a burial site was discovered near the North Sea coast in Suffolk at a site called Sutton Hoo (*hoo* means "hill"). The grave's occupant had been buried in a ship—90 feet long and designed for rowing, not sailing—whose

15-3 • GUMMERSMARK BROOCH
Denmark. 6th century. Silver gilt, height 5¾″ (14.6 cm). Nationalmuseet, Copenhagen.

traces in the earth were recovered by careful excavators. The wood—and the hero's body—had disintegrated, and no inscriptions record his name. He has sometimes been identified with the ruler Raedwald, who died about 625. Whoever he was, the treasures buried with him prove that he was a wealthy and powerful man. They include weapons, armor, other equipment to provide for the ruler's afterlife, and many luxury items. The objects from Sutton Hoo represent the broad multicultural heritage characterizing the British Isles at this time: Celtic, Scandinavian, and classical Roman, as well as Anglo-Saxon. There was even a Byzantine silver bowl at Sutton Hoo.

One of the most exquisite finds was a clasp of pure gold that once secured over his shoulder the leather body armor of

The story of the excavation of Sutton Hoo—unquestionably one of the most important archaeological discoveries in Britain—begins with Edith May Pretty, who decided late in her life to explore the burial mounds that were located on her estate in southeast Suffolk, securing the services of a local amateur archaeologist, Basil Brown. Excavations began in 1938 as a collaborative effort between the two of them, and in the following year they encountered the famous ship burial. As rumors spread of the importance of the find, its excavation was gradually taken over by renowned experts and archaeologists who moved from the remains of the ship to the treasures of the burial chamber for which Sutton Hoo is most famous. Police officers were posted to guard the site, and the treasures were sent for safekeeping to the British Museum in London, although, since Sutton Hoo was determined not to be "Treasure Trove" (buried objects meant to be retrieved by their original owners and now considered property of the Crown—see "The Mildenhall Treasure," page 212), it was Pretty's legal property. She, however, decided to donate the entire contents of the burial mound to the British Museum.

Excavation of Sutton Hoo was interrupted by World War II, but in 1945 Rupert Bruce-Mitford of the British Museum began a scholarly study of its treasures that would become his life work. He not only subjected each piece to detailed scrutiny; he proposed reconstructions of objects that were only partially preserved, such as the harp, helmet, and drinking horns. Using the evidence that had been gathered in a famous murder case, he proposed that Sutton Hoo was actually a burial, even though no evidence of human remains were ever found, since they could have disappeared completely in the notably acidic soil of the mound. Other scholars used radiocarbon dating of timber fragments and close analysis of coins to focus the dating of the burial to c. 625, which happened to coincide with the death date of King Raedwald of East Anglia, the most popular candidate for the identity of the person buried at Sutton Hoo.

After heated discussions and considerable controversy, new excavations were carried out in the area of Sutton Hoo during the 1980s and 1990s. These revealed a series of other discoveries in what emerged as an important early medieval burial ground and proved that the area had been inhabited since the Neolithic period, but they uncovered nothing to rival the collection of treasures that were preserved at Sutton Hoo.

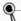 **View** the Closer Look for the pursue cover from the Sutton Hoo burial ship on myartslab.com

its distinguished owner (**FIG. 15–4**). The two sides of the clasp—essentially identical in design—were connected when a long gold pin, attached to one half by a delicate but strong gold chain, was inserted through a series of aligned channels on the back side of the inner edge of each. The superb decoration of this work is created by thin pieces of garnet and blue-checkered glass (known as **millefiori**, from the Italian for "a thousand flowers") cut into precisely stepped geometric shapes or to follow the sinuous contours of stylized animal forms. The cut shapes were then inserted into channels and supplemented by granulation (the use of minute granules of gold fused to the surface; see also "Aegean Metalwork," page 90). Under the stepped geometric pieces that form a rectangular patterned field on each side, jewelers placed gold foil stamped with incised motifs that reflect light back up through the transparent garnet to spectacular effect. Around these carpetlike rectangles are borders of interlacing snakes, and in the curving compartments to the outside stand pairs of semitransparent, overlapping boars stylized in ways that reflect the traditions of Scandinavian jewelry. Their curly pig's tails overlap their strong rumps at the outer edges on each side of the clasp, and following the visible vertebrae along

15-4 • HINGED CLASP, FROM THE SUTTON HOO BURIAL SHIP

Suffolk, England. First half of 7th century. Gold plaques with granulation and inlays of garnet and checked millefiori glass, length 5″ (12.7 cm). British Museum, London.

the arched forms of their backs, we arrive at their heads, with floppy ears and extended tusks. Boars represented strength and bravery, important virtues in warlike Anglo-Saxon society.

THE EARLY CHRISTIAN ART OF THE BRITISH ISLES

Although the Anglo-Saxons who settled in Britain had their own gods and myths, Christianity survived. Monasteries flourished in the Celtic north and west, and Christians from Ireland founded influential missions in Scotland and northern England. Cut off from Rome, these Celtic Christians developed their own liturgical practices, calendar, and distinctive artistic traditions. Then, in 597, Pope Gregory the Great (pontificate 590–604) dispatched missionaries from Rome to the Anglo-Saxon king Ethelbert of Kent, whose Christian wife, Bertha, was sympathetic to their cause. The head of this successful mission, the monk Augustine (St. Augustine of Canterbury, d. 604), became the first archbishop of Canterbury in 601. The Roman Christian authorities and the Irish monasteries, although allied in the effort to Christianize Britain, came into conflict over their divergent practices. The Roman Church eventually triumphed and brought British Christians under its authority. Local traditions, however, continued to influence their art.

ILLUSTRATED BOOKS

Among the richest surviving artworks of the period are lavishly decorated Gospel books, not only essential for spiritual and liturgical life within established monasteries, but also critical for the missionary activities of the Church, since a Gospel book was required in each new foundation. Often bound in gold and jeweled covers, they were placed on the altars of churches, carried in processions, and even thought to protect parishioners from enemies, predators, diseases, and all kinds of misfortune. Such sumptuous books were produced by monks in local monastic workshops called scriptoria (see "The Medieval Scriptorium," page 438).

THE BOOK OF DURROW One of the earliest surviving decorated Gospels of the period is the **BOOK OF DURROW**, dating to the second half of the seventh century (**FIG. 15-5**). The book's format reflects Roman Christian models, but its paintings are an encyclopedia of Hiberno-Saxon design. Each of the four Gospels is introduced by a three-part decorative sequence: a page with the symbol of its evangelist author, followed by a page of pure ornament, and finally elaborate decoration highlighting the initial words of the text (the *incipit*).

The Gospel of Matthew is preceded by his symbol, the man, but what a difference there is from the way humans were represented in the Greco-Roman tradition. The armless body is formed by a colorful checkered pattern recalling the rectangular panels of the Sutton Hoo clasp (see FIG. 15-4). Set on the body's rounded shoulders, a schematic, symmetrical, frontal face stares directly out at the viewer, and the tiny feet that emerge at its other end are

15-5 • SYMBOL OF THE EVANGELIST MATTHEW, GOSPEL BOOK OF DURROW
Page from the Gospel of Matthew. Probably made at Iona, Scotland, or in northern England. Second half of 7th century. Ink and tempera on parchment, 9⅝″ × 6⅛″ (24.4 × 15.5 cm). The Board of Trinity College, Dublin. MS. 57, fol. 21v

seen from a contrasting profile view, as if to deny any hint of lifelike form or earth-based spatial placement. Equally prominent is the bold band of complicated but coherent interlacing ornament that borders the figure's field.

THE BOOK OF KELLS The monastic scribes and artists of England, Scotland, and Ireland developed and expanded this artistic tradition in works of breathtaking virtuosity like the Lindisfarne Gospels (see "The Lindisfarne Gospels," page 436) and the Book of Kells. This chapter began with a close look at the most celebrated page in the Book of Kells—the page introducing Matthew's account of Jesus' birth (see FIG. 15-1). At first this appears to be a dense thicket of spiral and interlace patterns derived from metalworking traditions embellishing—in fact practically overwhelming—the Chi Rho monogram of Christ. The illuminators

The **LINDISFARNE GOSPEL BOOK** is one of the most extraordinary manuscripts ever created, admired for the astonishing beauty of its words and pictures (**FIGS. 15–6, 15–7**; see also "A Closer Look," page xxx, FIG. A), but also notable for the wealth of information we have about its history. Two and a half centuries after it was made, a priest named Aldred added a colophon to the book, outlining with rare precision its history, as he knew it—that it was written by Eadfrith, bishop of Lindisfarne (698–721), and bound by Ethelwald, his successor. Producing this stupendous work of art was an expensive and laborious proposition—requiring 300 calfskins to make the vellum and using pigments imported from as far away as the Himalayas for the decoration. Preliminary outlines were made for each of the pictures, using compasses, dividers, and straight edges to produce precise under-drawings with a sharp point of silver or lead, forerunner to our pencils.

The full pages of ornament set within cross-shape frameworks (see example in the Introduction) are breathtakingly complex, like visual puzzles that require patient and extended viewing. Hybrid animal forms tangle in acrobatic interlacing, disciplined by strict symmetry and sharp framing. Some have speculated that members of the religious community at Lindisfarne might have deciphered the patterns as a spiritual exercise. But principally the book was carried in processions and displayed on the altar, not shelved in the library to be consulted as a part of intellectual life. The text is heavily ornamented and abbreviated, difficult to read. The words that begin the Gospel of Matthew (see FIG. 15–6)—*Liber generationis ihu xpi filii david filii abraham* ("The book of the generation of Jesus Christ, son of David, son of Abraham")—are jammed together, even stacked on top of each other. They are

also framed, subsumed, and surrounded by a proliferation of the decorative forms, ultimately deriving from barbarian visual traditions, that we have already seen moving from jewelry into books in the Durrow Gospels (see FIG. 15–5) and the Book of Kells (see FIG. 15–1).

But the paintings in the Lindisfarne Gospels document more than the developing sophistication of an abstract artistic tradition. Roman influence is evident here as well. Instead of beginning each Gospel with a symbol of its author, the designer of this book

introduced portraits of the evangelists writing their texts, drawing on a Roman tradition (see FIG. 15–7). The monastic library at Wearmouth-Jarrow, not far from Lindisfarne, is known to have had a collection of Roman books, and an author portrait in one of them seems to have provided the model for an artist there, who portrayed **EZRA RESTORING THE SACRED SCRIPTURES** within a huge Bible (**FIG. 15–8**). This painter worked to emulate the illusionistic traditions of the Greco-Roman world. Ezra is a modeled, three-dimensional form, sitting on a

15–6 • PAGE WITH THE BEGINNING OF THE TEXT OF MATTHEW'S GOSPEL, LINDISFARNE GOSPEL BOOK
Lindisfarne. c. 715–720. Ink and tempera on vellum, 13⅜″ × 9⁷⁄₁₆″ (34 × 24 cm). The British Library, London. Cotton MS. Nero D.IV, fol. 27r

The words written in the right margin, just beside the frame, are an Old English gloss translating the Latin text, added here in the middle of the tenth century by the same Aldred who added the colophon. They represent the earliest surviving English text of the Gospels.

15–7 • MATTHEW WRITING HIS GOSPEL, LINDISFARNE GOSPEL BOOK

Lindisfarne. c. 715–720. Ink and tempera on vellum, 13⅜″ × 9⁷⁄₁₆″ (34 × 24 cm). The British Library, London. Cotton MS. Nero D.IV, fol. 25v

The identity of the haloed figure peeking from behind the curtain is still a topic of debate. Some see him as Christ confronting us directly around the veil that separated the holy of holies from worshipers in the Jewish Temple; others think he is Moses, holding the closed book of the law that was meant to be seen in contrast to the open book into which Matthew writes his Gospel. Also curious here is the Greek form of "saint" in Matthew's title ("O Agios" or "the holy"), written, however, with letters from the Latin alphabet.

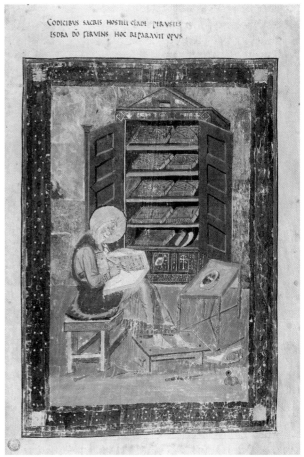

15–8 • EZRA RESTORING THE SACRED SCRIPTURES, IN THE BIBLE KNOWN AS THE CODEX AMIATINUS

Wearmouth-Jarrow. c. 700–715. Ink and tempera on vellum, 20″ × 13½″ (50.5 × 34.3 cm). Biblioteca Medicea Laurenziana, Florence. Cod. Amiat. I, fol. 5r

This huge manuscript (at over 2,000 pages, it weighs more than 75 pounds) is the earliest surviving complete text of the Bible in the Latin Vulgate translation of St. Jerome.

foreshortened bench and stool, both drawn in perspective to make them appear to recede into the distance. In the background, the obliquely placed books on the shelves of a cabinet seem to occupy the depth of its interior space.

Interestingly, the artist of the Matthew portrait in the Lindisfarne Gospels worked with the same Roman prototype, judging from the number of details these two portraits share, especially the figures' poses. But instead of striving to capture the lifelike features of his Roman model, the Lindisfarne artist sought to undermine them. Matthew appears against a blank background. All indications of modeling have been stripped from his clothing to foreground the decorative pattern and contrasting color created by the drapery "folds." By carefully arranging the ornament on the legs of Matthew's bench, the three-dimensional shading and perspective evident in the portrait of Ezra have been successfully suppressed. The footstool has been liberated from its support to float freely on the surface, while still resting under the evangelist's silhouetted feet. Playing freely with an acknowledged and clearly understood alien tradition, the painter situates an enigmatic figure in the "background" at upper right behind a gathered drape—suspended from a curtain rod hanging from a screw eye sunk into the upper frame—that is not long enough to conceal the rest of his figure. Clearly there were important cultural reasons for such divergent reactions to a Mediterranean model—Wearmouth-Jarrow seeking to emphasize its Roman connections and Lindisfarne its indigenous roots. We are extremely fortunate to have two surviving works of art that embody the contrast so clearly.

Today books are made with the aid of computer software that can lay out pages, set type, and insert and prepare illustrations. Modern presses can produce hundreds of thousands of identical copies in full color. In medieval Europe, however, before the invention of printing from movable type in the mid 1400s, books were made by hand, one at a time, with parchment or vellum, pen and brush, ink and paint. Each one was a time-consuming and expensive undertaking. No two were exactly the same.

At first, medieval books were usually made by monks and nuns in a workshop called a scriptorium (plural, scriptoria) within the monastery. As the demand for books increased, rulers set up palace workshops employing both religious and lay scribes and artists, supervised by scholars. Books were written on carefully prepared animal skin—either vellum, which was fine and soft, or parchment, which was heavier and shinier. Ink and water-based paints also required time and experience to prepare, and many pigments—particularly blues and greens—were derived from costly semiprecious stones. In very rich books, artists also used gold leaf or gold paint.

Work on a book was often divided between scribes, who copied the text, and artists, who painted or drew illustrations, large initials, and other decorations. Occasionally, scribes and artists signed and dated their work on the last page, in what was called the **colophon**. One scribe even took the opportunity to warn: "O reader, turn the leaves gently, and keep your fingers away from the letters, for, as the hailstorm ruins the harvest of the land, so does the injurious reader destroy the book and the writing" (cited in Dodwell, p. 247).

outlined each letter in the Chi Rho monogram, and then they subdivided the letters into panels filled with interlaced animals and snakes, as well as extraordinary spiral and knot motifs. The spaces between the letters form a whirling ornamental field, dominated by spirals.

In the midst of these abstractions, the painters inserted numerous pictorial and symbolic references to Christ—a fish (the Greek word for "fish," *ichthus*, comprises in its spelling the first letters of Jesus Christ, Son of God, Savior), moths (symbols of rebirth), the cross-inscribed wafer of the Eucharist, and numerous chalices and goblets. In a particularly intriguing image at bottom left, two cats pounce on a pair of mice nibbling the Eucharistic wafer, and two more mice torment the vigilant cats. Is this a metaphor for the struggle between good (cats) and evil (mice), or an acknowledgment of the perennial problem of keeping the sacred Host safe from rodents? Perhaps it is both.

IRISH HIGH CROSSES Metalworking traditions influenced not only manuscript decoration, but also the monumental stone crosses erected in Ireland during the eighth century. The **SOUTH CROSS** of Ahenny, in County Tipperary, is an especially well-preserved example (**FIG. 15-9**). It seems to have been modeled on metal ceremonial or reliquary crosses, that is, cross-shape containers for holy relics. It is outlined with ropelike, convex moldings and covered with spirals and interlace. The large bosses (brooch-like projections), which form a cross within this cross, resemble the jewels that were similarly placed on metal crosses. The circle enclosing the arms of such Irish high crosses—so called because of their size—has been interpreted as a ring of heavenly light or as a purely practical means of supporting the projecting arms.

15-9 • SOUTH CROSS, AHENNY
County Tipperary, Ireland. 8th century. Sandstone.

MOZARABIC ART IN SPAIN

In 711, Islamic invaders conquered Spain, ending Visigothic rule. Bypassing the small Christian kingdom of Asturias on the north coast, they crossed the Pyrenees Mountains into France, but in 732 Charles Martel and the Frankish army stopped them before they reached Paris. Islamic rulers remained in the Iberian peninsula (Spain and Portugal) for nearly 800 years, until the fall of Granada to the Christians in 1492.

With some exceptions, Christians and Jews who acknowledged the authority of the Islamic rulers and paid higher taxes because they were non-Muslims were left free to follow their own religious practices. The Iberian peninsula became a melting pot of cultures in which Muslims, Christians, and Jews lived and worked together, all the while officially and firmly separated. Christians in the Muslim territories were called Mozarabs (from the Arabic *mustarib*, meaning "would-be Arab"). In a rich exchange of artistic influences, Christian artists incorporated some features of Islamic art into a colorful new style known as **Mozarabic**. When the Mozarabic communities migrated to northern Spain, which

returned to Christian rule not long after the initial Islamic invasion, they took this Mozarabic style with them.

BEATUS MANUSCRIPTS

One of the most influential books of the early Middle Ages was a Commentary on the Apocalypse, compiled during the eighth century by Beatus, abbot of the monastery of San Martín at Liébana in the northern kingdom of Asturias. Beatus described the end of the world and the Last Judgment of the Apocalypse, rooted in the Revelation to John at the end of the New Testament, which vividly describes Christ's final, fiery triumph.

A lavishly illustrated copy of Beatus' Commentary called the Morgan Beatus was produced c. 940–945, probably at the monastery of San Salvador at Tábara, by an artist named Maius (d. 968), who both wrote the text and painted the illustrations. His gripping portrayal of the **WOMAN CLOTHED WITH THE SUN**, based on the biblical text of Apocalypse (Revelation) 12:1–18, extends over two pages to cover an entire opening of the book (**FIG. 15–10**). Maius has stayed close to the text in composing his tableau, which is dominated

15–10 • Maius WOMAN CLOTHED WITH THE SUN, THE MORGAN BEATUS
Monastery of San Salvador at Tábara, León, Spain. 940–945. Tempera on vellum, 15⅛″ × 22⅛″ (38.5 × 56 cm). The Morgan Library and Museum, New York. MS. M644, fols. 152v–153r

When the modern abstract French painter Fernand Léger (1881–1955; see FIG. 32–21) was visiting the great art historian Meyer Schapiro (1904–1996) in New York during World War II, the artist asked the scholar to suggest the single work of art that was most important for him to see while there. Schapiro took him to the Morgan Library to leaf through this manuscript, and the strong impact it had on Léger can be clearly seen in the boldness of his later paintings.

by the long, seven-headed, red dragon that slithers across practically the entire width of the picture to threaten at top left the "woman clothed with the sun, with the moon under her feet, and on her head a crown of twelve stars" (12:1). With his tail, at upper right, he sweeps a third of heaven's stars toward Earth while the woman's male child appears before the throne of God. Maius presents this complex allegory of the triumph of the Church over its enemies with a forceful, abstract, ornamental style that accentuates the dramatic, nightmarish qualities of the events outlined in the text. The background has been distilled into horizontal strips of color; the figures become striped bundles of drapery capped with faces dominated by staring eyes and silhouetted, framing haloes. Momentous apocalyptic events have been transformed by Maius into exotic abstractions that still maintain their power to captivate our attention.

Another copy of Beatus' Commentary was produced about 30 years later for Abbot Dominicus of San Salvador at Tábara. A colophon identifies Senior as the scribe for this project. Emeterius and a woman named Ende (or simply En), who signed herself "painter and servant of God," shared the task of illustration. For the first time in the West, a woman artist is identified by name with a specific surviving work of art. In an allegory of the triumph of Christ over Satan (FIG. 15–11), the painters show a peacock grasping a red-and-orange snake in its beak. The text explains that a bird with a powerful beak and beautiful plumage (Christ) covers itself with mud to trick the snake (Satan). Just when the snake decides the bird is harmless, the bird swiftly attacks and kills it. "So Christ in his Incarnation clothed himself in the impurity of our [human] flesh that through a pious trick he might fool the evil deceiver....

15–11 • Emeterius and Ende, with the scribe Senior BATTLE OF THE BIRD AND THE SERPENT, COMMENTARY ON THE APOCALYPSE BY BEATUS AND COMMENTARY ON DANIEL BY JEROME Made for Abbot Dominicus, probably at the monastery of San Salvador at Tábara, León, Spain. Completed July 6, 975. Tempera on parchment, 15¾″ × 10¼″ (40 × 26 cm). Cathedral Library, Gerona, Spain. MS. 7[11], fol. 18v

[W]ith the word of his mouth [he] slew the venomous killer, the devil" (cited in Williams, page 95).

THE VIKING ERA

During the eighth century, seafaring bands of Norsemen known as Vikings (*viken*, "people from the coves") descended on the rest of Europe. Setting off in flotillas of as many as 350 ships, they explored, plundered, traded with, and colonized a vast area during the ninth and tenth centuries. The earliest recorded Viking incursions were two devastating attacks on wealthy isolated Christian monasteries: one in 793, on the religious community on Lindisfarne, an island off the northeast coast of England; and another in 795, at Iona, off Scotland's west coast.

Norwegian and Danish Vikings raided a vast territory stretching from Iceland and Greenland—where they settled in 870 and 985, respectively—to Ireland, England, Scotland, and France. The Viking Leif Eriksson reached North America in 1000. In good weather a Viking ship could sail 200 miles in a day. In the early tenth century, the rulers of France bought off Scandinavian raiders (the Normans, or "northmen") with a large grant of land that became the duchy of Normandy. Swedish Vikings turned eastward and traveled down the Russian rivers to the Black Sea and Constantinople, where the Byzantine emperor recruited them to form an elite personal guard. Others, known as Rus, established settlements around Novgorod, one of the earliest cities in what would become Russia. They settled in Kiev in the tenth century and by 988 had become became Orthodox Christians (see Chapter 8).

THE OSEBERG SHIP

Since prehistoric times northerners had represented their ships as sleek sea serpents, and, as we saw at Sutton Hoo, they used them for burials as well as sea journeys. The ship of a dead warrior symbolized his passage to Valhalla (a legendary great hall that welcomed fallen warriors), and Viking chiefs were sometimes cremated in a ship in the belief that this hastened their journey. Women as well as men were honored by ship burials. A 75-foot-long ship, discovered in Oseberg, Norway, and dated c. 815–820, served as the vessel for two women on their journey to eternity in 834, a queen and her companion or servant. Although the burial chamber was long ago looted of jewelry and precious objects, the ship itself and its equipment attest to the wealth and prominence of the ship's owner. A cart and four sleds, all made of wood with beautifully carved decorations, were stored on board. At least 12 horses, several dogs, and an ox had been sacrificed to accompany these women on their last journey.

The Oseberg ship itself, propelled by both sail and oars, was designed for travel in the relatively calm waters of fjords (narrow coastal inlets), not for voyages in the open sea. The rising prow spirals into a serpent's head, and bands of interlaced animals carved

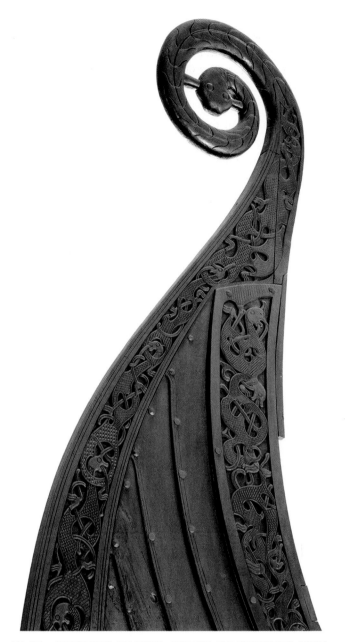

15-12 • GRIPPING BEASTS, DETAIL OF OSEBERG SHIP
c. 815–820. Wood. Vikingskiphuset, Universitets Oldsaksamling, Oslo, Norway.

in low relief run along the edges (**FIG. 15-12**). Viking beasts are grotesque, broad-bodied creatures with bulging eyes, short muzzles, snarling mouths, and large teeth which clutch each other with sharp claws. Images of such gripping beasts adorned all sorts of Viking belongings—jewelry, houses, tent poles, beds, wagons, and sleds. Traces of color—black, white, red, brown, and yellow—indicate that the carved wood of this ship was originally painted.

All women, including the most elite, worked in the fiber arts. The Oseberg queen took her spindles, a frame for sprang (braiding), and tablets for tablet-weaving, as well as two upright looms, with her to the grave. Her cabin walls had been hung with tapestries, fragments of which survive. Women not only produced clothing and embroidered garments and wall hangings, but also

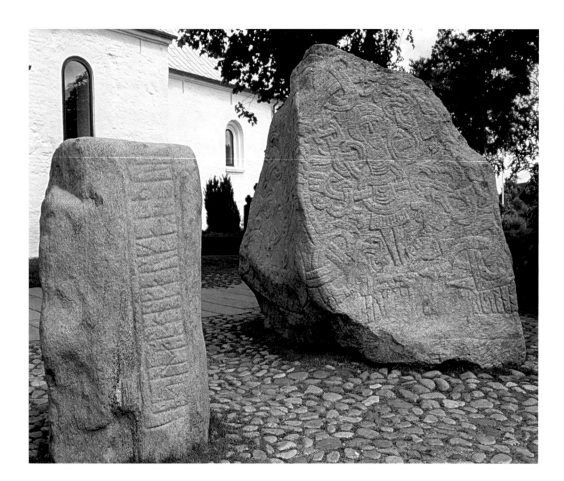

wove the huge sails of waterproof unwashed wool that gave the ships a long-distance capability. The entire community—men and women—worked to create these ships, which represent the Vikings' most important surviving contribution to world architecture.

PICTURE STONES AT JELLING

Both at home and abroad, the Vikings erected large memorial stones. Those covered mostly with inscriptions are called **rune stones** (runes are twiglike letters of an early Germanic alphabet). Those with figural decoration are called picture stones. Traces of pigments suggest that the memorial stones were originally painted in bright colors.

About 980, the Danish king Harald Bluetooth (c. 940–987) ordered a picture stone to be placed near an old, smaller rune stone and the family burial mounds at Jelling (**FIG. 15-13**). Carved in runes on a boulder 8 feet high is the inscription "King Harald had this memorial made for Gorm his father and Thyra his mother: that Harald who won for himself all Denmark and Norway and made the Danes Christians." Harald and the Danes had accepted Christianity in c. 960, but Norway did not become Christian until 1015.

During the tenth century, a new style emerged in Scandinavia and the British Isles, one that combined interlacing foliage and ribbons with animals that are more recognizable than the gripping beasts of the Oseberg ship. On one face of the larger Jelling stone the sculptor carved the image of Christ robed in the Byzantine manner, with arms outstretched as if crucified. He is entangled in a double-ribbon interlace instead of nailed to a cross. A second side holds runic inscriptions, and a third, a striding creature resembling a lion fighting a snake. The loosely twisting double-ribbon interlace covering the surface of the stone could have been inspired by Hiberno-Saxon art.

TIMBER ARCHITECTURE

The vast forests of Scandinavia provided the materials for timber buildings of many kinds. Two forms of timber construction evolved: one that stacked horizontal logs, notched at the ends, to form a rectangular building (the still-popular log cabin); and the other that stood the wood on end to form a palisade or vertical plank wall, with timbers set directly in the ground or into a sill (a horizontal beam). More modest buildings consisted of wooden frames filled with wattle-and-daub (see "Early Construction Methods," page 19). Typical buildings had a turf or thatched roof supported on interior posts. The same basic structure was used for almost all building types—feasting and assembly halls, family homes (which were usually shared with domestic animals), workshops, barns, and sheds. The great hall had a central open hearth (smoke escaped through a louver in the roof) and an off-center door designed to reduce drafts. People secured their residences and trading centers by building massive circular earthworks topped with wooden palisades.

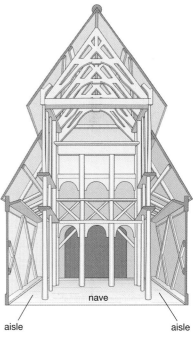

aisle nave aisle

15-14 • EXTERIOR (A) AND CUTAWAY DRAWING (B) OF STAVE CHURCH, BORGUND, NORWAY
c. 1125–1150.

👁 **Watch** an architectural simulation about stave church construction on myartslab.com

THE BORGUND STAVE CHURCH Subject to decay and fire, early timber buildings have largely disappeared, leaving only postholes and other traces in the soil. In rural Norway, however, a few later **stave churches** survive—named for the four huge timbers (staves) that form their structural core. Borgund church, from about 1125–1150 (**FIG. 15-14**), has four corner staves supporting the central roof, with additional interior posts that create the effect of a nave and side aisles, narthex, and choir. A rounded apse covered with a timber tower is attached to the choir. Steeply pitched roofs covered with wooden shingles protect the walls—planks slotted into the sills—from the rain and snow. Openwork timber stages set on the roof ridge create a tower and

give the church a steep pyramidal shape. On all the gables either crosses or dragon heads protect the church and its congregation from trolls and demons.

The Vikings were not always victorious. Their colonies in Iceland and the Faeroe Islands survived, but in North America their trading posts eventually had to be abandoned. In Europe, south of the Baltic Sea, a new German dynasty challenged and then defeated the Vikings. By the end of the eleventh century the Viking era had come to an end.

THE CAROLINGIAN EMPIRE

During the second half of the eighth century, a new force emerged on the Continent. Charlemagne (the French form of *Carolus Magnus*, Latin for "Charles the Great") established a dynasty and an empire known today as the Carolingian. He descended from a family that had succeeded the Merovingians in the late seventh century as rulers of the Franks in northern Gaul (parts of present-day France and Germany). Under Charlemagne (r. 768–814), the Carolingian realm reached its greatest extent, encompassing western Germany, France, the Lombard kingdom in Italy, and the Low Countries. Charlemagne imposed Christianity throughout this territory, and in 800, Pope Leo III (pontificate 795–816) crowned Charlemagne emperor in a ceremony in St. Peter's Basilica in Rome, declaring him the rightful successor to Constantine, the first Christian emperor. This endorsement reinforced Charlemagne's authority and strengthened the bonds between the papacy and secular government in the West.

The Carolingian rulers' ascent to the Roman imperium, and the political pretensions it implied, are clearly signaled in a small bronze equestrian statue—once thought to be a portrait of Charlemagne himself but now usually identified with his grandson **CHARLES THE BALD** (FIG. 15-15). The idea of representing an emperor as a proud equestrian figure recalls the much larger image of Marcus Aurelius (see FIG. 6-57) that was believed during the Middle Ages to portray Constantine, the first Christian emperor and an ideal prototype for the ruler of the Franks, newly legitimized by the pope. But unlike the bearded Roman, this Carolingian king sports a mustache, a Frankish sign of nobility that had also been common among the Celts (see FIG. 5-60). Works of art such as this are not the result of a slavish mimicking of Roman prototypes, but of a creative appropriation of Roman imperial typology to glorify manifestly Carolingian rulers.

Charlemagne sought to restore the Western Empire as a Christian state and to revive the arts and learning. As inscribed on his official seal, Charlemagne's ambition was "the Renewal of the Roman Empire." To lead this revival, Charlemagne turned to Benedictine monks and nuns. By the early Middle Ages, monastic communities had spread across Europe. In the early sixth century, Benedict of Nursia (c. 480–547) wrote his *Rule for Monasteries*, and this set of guidelines for a secluded life of monastic work and prayer became the model for Benedictine monasticism, soon the

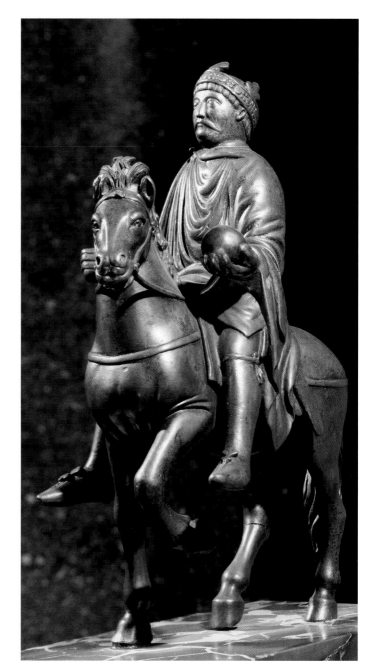

15-15 • EQUESTRIAN PORTRAIT OF CHARLES THE BALD (?)
9th century. Bronze, height 9½″ (24.4 cm). Musée du Louvre, Paris.

dominant form throughout Europe. The Benedictines became Charlemagne's "cultural army," and the imperial court at Aachen, Germany, one of the leading intellectual centers of western Europe.

CAROLINGIAN ARCHITECTURE

To proclaim the glory of the new empire in monumental form, Charlemagne's architects turned to two former Western imperial capitals, Rome and Ravenna, for inspiration. Charlemagne's biographer Einhard reported that the ruler, "beyond all sacred and venerable places… loved the church of the holy apostle Peter in Rome." Not surprisingly, Constantine's basilica of St. Peter, with

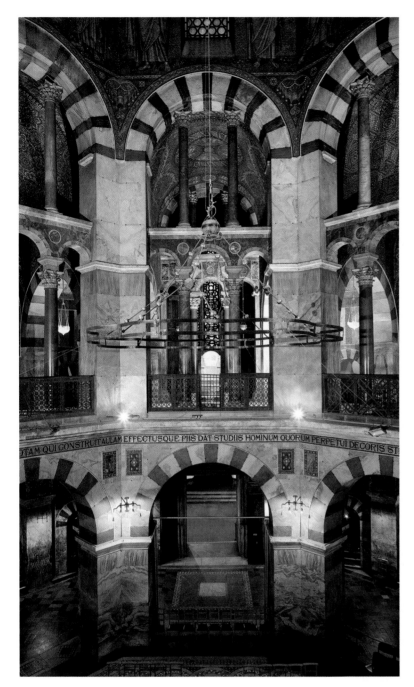

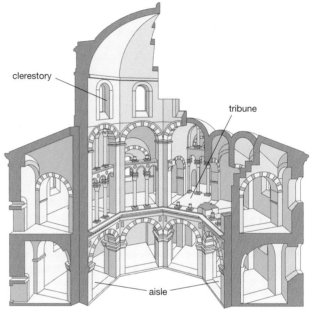

15–16 • INTERIOR VIEW (A) AND SECTION DRAWING (B), PALACE CHAPEL OF CHARLEMAGNE

Aachen (Aix-la-Chapelle), Germany. 792–805.

Extensive renovations took place here in the nineteenth century, when the chapel was reconsecrated as the cathedral of Aachen, and in the twentieth century, after it was damaged in World War II.

👁 **Watch** a video about the palace chapel of Charlemagne on myartslab.com

its long nave and side aisles ending in a transept and projecting apse (see page 653, left-hand plan), served as a model for many important churches in Charlemagne's empire. The basilican plan, which had fallen out of favor since the Early Christian period, emerged again as the principal arrangement of large congregational churches and would remain so throughout the Middle Ages and beyond.

CHARLEMAGNE'S PALACE AT AACHEN Charlemagne's palace complex provides an example of the Carolingian synthesis of Roman, Early Christian, and northern styles. Charlemagne, who enjoyed hunting and swimming, built a headquarters and palace complex amid the forests and natural hot springs of Aachen in the northern part of his empire and installed his court there in

about 794. The palace complex included a large masonry audience hall and chapel facing each other across a large square (reminiscent of a Roman forum), and a monumental gateway supporting a hall of judgment. Other administrative buildings, a palace school, homes for his circle of advisors and his large family, and workshops supplying all the needs of Church and state, were mostly constructed using the wooden building traditions indigenous to this part of Europe.

The **PALACE CHAPEL** (FIG. 15-16) functioned as Charlemagne's private place of worship, the church of his imperial court, a place for precious relics, and, after the emperor's death, the imperial mausoleum. The central, octagonal plan recalls the church of San Vitale in Ravenna (see FIG. 8-5), but the Carolingian

architects added a monumental western entrance block. Known as a **westwork**, this structure combined a ground-floor narthex (vestibule) and an upper-story throne room which opened onto the chapel interior, allowing the emperor an unobstructed view of the liturgy at the high altar, and at the same time assuring his privacy and safety. The room also opened outside into a large walled forecourt where the emperor could make public appearances and speak to the assembled crowd.

The soaring core of the chapel is an octagon, surrounded at the ground level by an ambulatory (curving aisle passageway) and on the second floor by a gallery (upper-story passageway overlooking the main space), and rising to a clerestory above the gallery level and under the octagonal dome. Two tiers of paired Corinthian columns and railings at the gallery level form a screen that re-emphasizes the flat, pierced walls of the octagon and enhances the clarity and planar geometry of its design. The effect is quite

15–17 • WESTWORK, ABBEY CHURCH OF CORVEY
Westphalia, Germany. Late 9th century (upper stories mid 12th century).

different from the dynamic spatial play and undulating exedrae of San Vitale, but the veneer of richly patterned and multicolored stone—some imported from Italy—on the walls and the mosaics covering the dome at Aachen were clearly inspired by Byzantine architecture.

THE WESTWORK AT CORVEY Originally designed to answer practical requirements of protection and display in buildings such as Charlemagne's palace chapel, the soaring multi-towered westwork came to function symbolically as the outward and very visible sign of an important building and is one of the hallmarks of Carolingian architecture. A particularly well-preserved example is the late ninth-century westwork at the **ABBEY CHURCH OF CORVEY** (**FIG. 15-17**). Even discounting the pierced upper story and towers that were added in the middle of the twelfth century, this is a broad and imposing block of masonry construction. The strong, austere exterior is a symmetrical arrangement of towers flanking a central core punched with a regular pattern of windows and doors, free of elaborate carving or decoration. In addition to providing private spaces for local or visiting dignitaries, the interiors of westworks may have been used for choirs—medieval musical graffiti have been discovered in the interior of this westwork—and they were the starting point for important liturgical processions.

THE SAINT GALL PLAN Monastic life centered on prayer and work, and since it also demanded seclusion, it required a special type of architectural planning. While contemplating how best to house a monastic community, Abbot Haito of Reichenau developed, at the request of his colleague Abbot Gozbert of Saint Gall, a conceptual plan for the layout of monasteries. This extraordinary ninth-century drawing survives in the library of the Abbey of Saint Gall in modern Switzerland and is known as the **SAINT GALL PLAN** (**FIG. 15-18**). This is not a "blueprint" in the modern sense, prepared to guide the construction of an actual monastery, but an intellectual record of Carolingian meditations on the nature of monastic life. It does, however, reflect the basic design used in the layout of medieval monasteries, an efficient and functional arrangement that continues to be used by Benedictine monasteries to this day.

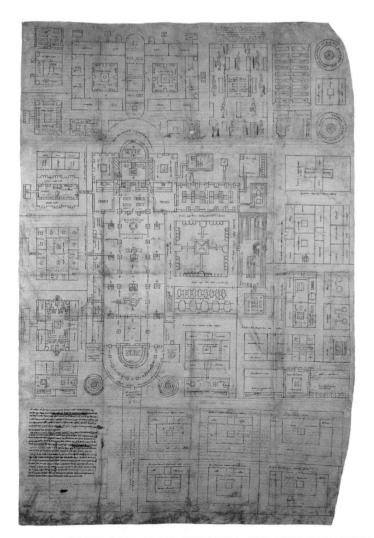
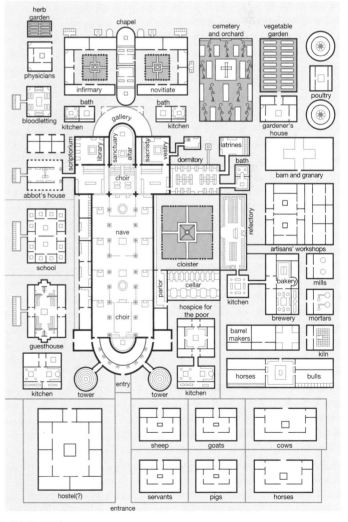

15-18 • SAINT GALL PLAN (ORIGINAL AND REDRAWN WITH CAPTIONS)
c. 817. Original in red ink on parchment, 28″ × 44⅛″ (71.1 × 112.1 cm). Stiftsbibliothek, Saint Gall, Switzerland. Cod. Sang. 1092

At the center of the Saint Gall plan is the **cloister**, an enclosed courtyard around which open all the buildings that are central to the lives of monks. Most prominent is a large basilican church north of the cloister, with towers and multiple altars in nave and aisles as well as in the sanctuary at the east end, where monks would gather for communal prayer throughout the day and night. On the north side of the church were public buildings such as the abbot's house, the school, and the guesthouse. The monks' living quarters lie off the southern and eastern sides of the cloister, with dormitory, refectory (dining room), and work rooms. For night services the monks could enter the church directly from their dormitory. The kitchen, brewery, and bakery were attached to the refectory, and a huge cellar (indicated on the plan by giant barrels) was on the west side. Along the east edge of the plan are the cemetery, hospital, and an educational center for novices (monks in training).

The Saint Gall plan indicates beds for 77 monks in the dormitory. Practical considerations for group living include latrines attached to every unit—dormitory, guesthouse, and abbot's house. Six beds and places in the refectory were reserved for visiting monks. In the surrounding buildings were special spaces for scribes and painters, who spent much of their day in the scriptorium studying and copying books, and teachers who staffed the monastery's schools and library. St. Benedict had directed that monks extend hospitality to all visitors, and the plan includes a hospice for the poor. South and west of the central core were the workshops, farm buildings, and housing for the lay support staff.

ILLUSTRATED BOOKS

Books played a central role in the efforts of Carolingian rulers to promote learning, propagate Christianity, and standardize church law and practice. Imperial workshops produced authoritative copies of key religious texts, weeding out the errors that had inevitably crept into books over centuries of copying them by hand. The scrupulously edited versions of ancient and biblical texts that emerged are among the lasting achievements of the Carolingian period. For example, the Anglo-Saxon scholar Alcuin of York, whom Charlemagne called to his court, spent the last eight years of his life producing a corrected copy of the Latin Vulgate Bible. His revision served as the standard text of the Bible for the remainder of the medieval period and is still in use.

Carolingian scribes also worked on standardizing script. Capitals (majuscules) based on ancient Roman inscriptions continued to be used for very formal writing, titles and headings, and luxury

15–19 • PAGE WITH ST. MATTHEW THE EVANGELIST, CORONATION GOSPELS

Gospel of Matthew. Early 9th century. 12¾″ × 9⅞″ (36.3 × 25 cm). Kunsthistorische Museum, Vienna.

Tradition holds that this Gospel book was buried with Charlemagne in 814, and that in the year 1000 Emperor Otto III removed it from his tomb. Its title derives from its use in the coronation ceremonies of later German emperors.

manuscripts. But they also developed a new, clear script called Carolingian minuscule, based on Roman forms but with a uniform lowercase alphabet that increased legibility and streamlined production. So like those who transformed revived Roman types—such as basilicas, central-plan churches, or equestrian Roman portraits—into creative new works, scribes and illuminators revived, reformed, and revitalized established traditions of book production. Notably, they returned the representation of lifelike human figures to a central position. For example, portraits of the evangelists (the authors of the Gospels)—as opposed to the symbols used to represent them in the Book of Durrow (see FIG. 15–5)—began to look like pictures of Roman authors.

THE CORONATION GOSPELS The portrait of Matthew (**FIG. 15–19**) in the early ninth-century Coronation Gospels of Charlemagne conforms to principles of idealized, lifelike representation quite consistent with the Greco-Roman Classical tradition. The full-bodied, white-robed figure is modeled in brilliant white and subtle shading and seated on the cushion of a folding chair set within a freely painted landscape. The way his foot lifts up to rest on the solid base of his writing desk emphasizes his three-dimensional placement within an outdoor setting, and the frame enhances the Classical effect of a view seen through a window. Conventions for creating the illusion of solid figures in space may have been learned from Byzantine manuscripts in a monastic library, or from artists fleeing Byzantium as a result of the iconoclastic controversy (see "Iconoclasm," page 247).

THE EBBO GOSPELS The incorporation of the Roman tradition in manuscript painting was not an exercise in slavish copying. It became the basis for a series of creative Carolingian variations. One of the most innovative and engaging is a Gospel book made for Archbishop Ebbo of Reims (archbishop 816–835, 840–841) at the nearby Abbey of Hautvillers (**FIG. 15–20**). The calm, carefully painted grandeur characterizing Matthew's portrait in the Coronation Gospels (see FIG. 15–19) has given way here to spontaneous, calligraphic painting suffused with energetic abandon. The passion may be most immediately apparent in the intensity of Matthew's gaze, but the whole composition is charged with energy, from the evangelist's wiry hairdo and rippling drapery, to the rapidly sketched landscape, and even extending into the windblown acanthus leaves of the frame. These forms are related

15-20 • PAGE WITH ST. MATTHEW THE EVANGELIST, EBBO GOSPELS
Gospel of Matthew. Second quarter of 9th century. Ink, gold, and colors on vellum, 10¼″ × 8¾″ (26 × 22.2 cm). Médiathèque d'Épernay, France. MS. 1, fol. 18v

A CLOSER LOOK | Psalm 23 in the Utrecht Psalter

c. 816–835. Ink on parchment, 13″ × 9⅞″ (33 × 25 cm).
Utrecht University Library. MS. 32, fol. 13r

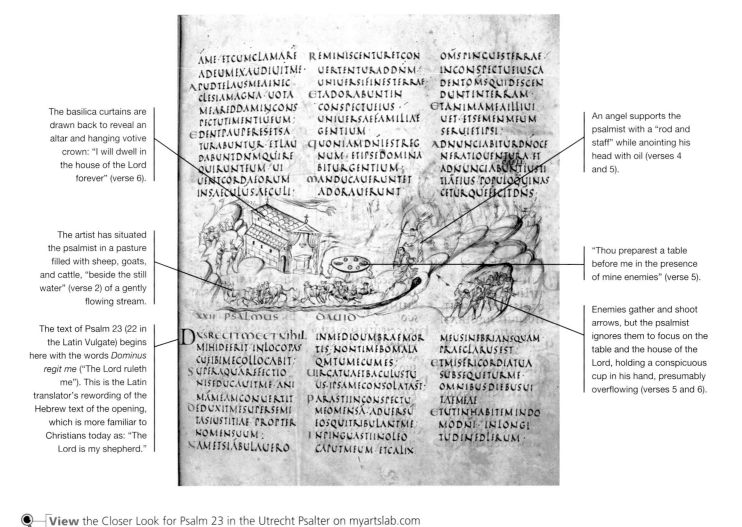

The basilica curtains are drawn back to reveal an altar and hanging votive crown: "I will dwell in the house of the Lord forever" (verse 6).

The artist has situated the psalmist in a pasture filled with sheep, goats, and cattle, "beside the still water" (verse 2) of a gently flowing stream.

The text of Psalm 23 (22 in the Latin Vulgate) begins here with the words *Dominus regit me* ("The Lord ruleth me"). This is the Latin translator's rewording of the Hebrew text of the opening, which is more familiar to Christians today as: "The Lord is my shepherd."

An angel supports the psalmist with a "rod and staff" while anointing his head with oil (verses 4 and 5).

"Thou preparest a table before me in the presence of mine enemies" (verse 5).

Enemies gather and shoot arrows, but the psalmist ignores them to focus on the table and the house of the Lord, holding a conspicuous cup in his hand, presumably overflowing (verses 5 and 6).

View the Closer Look for Psalm 23 in the Utrecht Psalter on myartslab.com

to content since the marked expressionism evokes the evangelist's spiritual excitement as he hastens to transcribe the Word of God delivered by the angel (also serving as Matthew's symbol), who is almost lost in the upper right corner. As if swept up in the saint's turbulent emotions, the footstool tilts precariously, and the top of the desk seems about to detach itself from the pedestal.

THE UTRECHT PSALTER One of the most famous Carolingian manuscripts, the Utrecht Psalter, is illustrated with ink drawings that match the nervous linear vitality encountered in Ebbo's Gospel book. Psalms do not tell straightforward stories but use metaphor and allegory in poems of prayer; they are exceptionally difficult to illustrate. Some psalters bypass this situation by illustrating scenes from the life of the presumed author (see FIG. 8–27), but the artists of the Utrecht Psalter decided to interpret the words and images of individual psalms literally (see "A Closer Look," above). Sometimes the words are acted out, as in a game of charades.

CAROLINGIAN METALWORK

The sumptuously illustrated manuscripts of the medieval period represented an enormous investment of time, talent, and materials, so it is not surprising that they were often protected with equally sumptuous covers. But because these covers were themselves made of valuable materials—ivory, enamelwork, precious metals, and jewels—they were frequently recycled or stolen. The elaborate book cover of gold and jewels, now on the Carolingian manuscript known as the **LINDAU GOSPELS** (FIG. 15–21), was probably made between 870 and 880 at one of the monastic workshops of Charlemagne's grandson, Charles the Bald (r. 840–877), but not for this book. Sometime before the sixteenth century it was reused on a late ninth-century manuscript from the monastery of Saint Gall.

15–21 • CRUCIFIXION WITH ANGELS AND MOURNING FIGURES, LINDAU GOSPELS

Outer cover. c. 870–880. Gold, pearls, sapphires, garnets, and emeralds, 13¾″ × 10⅜″ (36.9 × 26.7 cm).

The Morgan Library and Museum, New York. MS. 1

15-22 • OTTO I PRESENTING MAGDEBURG CATHEDRAL TO CHRIST
One of a series of 17 ivory plaques known as the Magdeburg Ivories, possibly carved in Milan. c. 962–968. Ivory, 5″ × 4½″ (12.7 × 11.4 cm). Metropolitan Museum of Art, New York. Gift of George Blumenthal, 1941 (41.100.157)

The cross and the Crucifixion were common themes for medieval book covers. This one is crafted in pure gold with figures in repoussé (low relief produced by pushing or hammering up from the back of a panel of metal to produce raised forms on the front) surrounded by heavily jeweled frames. The jewels are raised on miniature arcades to allow reflected light to pass through them from beneath, imparting a lustrous glow, and also to allow light traveling in the other direction to reflect from the shiny surface of the gold.

Grieving angels hover above the arms of the cross, and earthbound mourners twist in agony below. Over Jesus' head personifications of the sun and the moon hide their faces in anguish. The gracefully animated poses of these figures, who seem to float around the jeweled bosses in the compartments framed by the arms of the cross, extend the expressive style of the Utrecht Psalter illustrations into another medium and a later moment. Jesus, on the other hand, has been modeled in a more rounded and calmer Classical style. He seems almost to be standing in front of the cross—straight, wide-eyed, with outstretched arms, as if to prefigure his ultimate triumph over death. The flourishes of blood that emerge

from his wounds are almost decorative. There is little, if any, sense of his suffering.

OTTONIAN EUROPE

In 843, the Carolingian Empire was divided into three parts, ruled by three grandsons of Charlemagne. One of them was Charles the Bald, whom we have already encountered (see FIG. 15-15). Another, Louis the German, took the eastern portion, and when his family died out at the beginning of the tenth century, a new Saxon dynasty came to power in lands corresponding roughly to present-day Germany and Austria. We call this dynasty Ottonian after its three principal rulers—Otto I (r. 936–973), Otto II (r. 973–983), and Otto III (r. 983–1002; queens Adelaide and Theophanu ruled as regents for him, 983–994). After the Ottonian armies defeated the Vikings in the north and the Magyars (Hungarians) on the eastern frontiers, the resulting peace permitted increased trade and the growth of towns, making the tenth century a period of economic recovery. Then, in 951, Otto I added northern Italy to his domain by marrying the widowed Lombard queen, Adelaide. He also re-established Charlemagne's Christian Roman Empire when he was crowned emperor by the pope in 962. The Ottonians and their successors so dominated the papacy and appointments to other high offices of the Church that in the twelfth century this union of Germany and Italy under a German ruler came to be known as the Holy Roman Empire. The empire survived in modified form as the Habsburg empire into the early twentieth century.

The Ottonian ideology, rooted in unity of Church and state, takes visual form on an ivory plaque, one of several that may once have been part of the decoration of an altar or pulpit presented to Magdeburg Cathedral at the time of its dedication in 968 (**FIG. 15-22**). Otto I presents a model of the cathedral to Christ and St. Peter. Hierarchic scale demands that the mighty emperor be represented as the smallest figure, and that the saints and angels, in turn, be taller than Otto but smaller than Christ. Otto is embraced by the patron saint of this church, St. Maurice, who was a third-century military commander martyred for refusing to worship pagan gods. The cathedral Otto holds is a basilica with prominent clerestory windows and a rounded apse that, like the character of the Carolingian basilicas before it, was intended to recall the Early Christian churches of Rome.

OTTONIAN ARCHITECTURE

As we have just seen, Ottonian rulers, in keeping with their imperial status, sought to replicate the splendors both of the Christian architecture of Rome and of the Christian empire of their Carolingian predecessors. German officials knew Roman basilicas well, since the German court in Rome was located near the Early

Christian church of Santa Sabina (see FIGS. 7–10, 7–11). The buildings of Byzantium were another important influence, especially after Otto II married a Byzantine princess, cementing a tie with the East. But large timber-roofed basilicas were terribly vulnerable to fire. Magdeburg Cathedral burned down in 1008, only 40 years after its dedication; it was rebuilt in 1049, burned down again in 1207, and was rebuilt yet again. In 1009, the Cathedral of Mainz burned down on the day of its consecration. The church of St. Michael at Hildesheim was destroyed in World War II. Luckily the convent church of St. Cyriakus at Gernrode, Germany, still survives.

THE CONVENT CHURCH OF ST. CYRIAKUS IN GERN-RODE During the Ottonian Empire, aristocratic women often held positions of authority, especially as leaders of religious communities. When, in 961, the provincial military governor Gero founded the convent and **CHURCH OF ST. CYRIAKUS**, he installed his widowed daughter-in-law as the convent's first abbess. The church was designed as a basilica with a westwork flanked by circular towers (**FIG. 15–23**). At the eastern end, a transept with chapels led to a choir with an apse built over a crypt.

Like an Early Christian or Carolingian basilica, the interior of St. Cyriakus (see FIG. 15–23B) has a nave flanked by side aisles. But the design of the three-level wall elevation—nave arcade, gallery, and clerestory—creates a rhythmic effect distinct from the uniformity that had characterized earlier basilicas. Rectangular piers alternate with round columns in the two levels of arcades, and at gallery level, pairs of openings are framed by larger arches and then grouped in threes. The central rectangular piers, aligned on the two

15-23 • PLAN (A) AND INTERIOR (B), CHURCH OF ST. CYRIAKUS, GERNRODE

Harz, Saxony-Anhalt, Germany. Begun 961; consecrated 973.

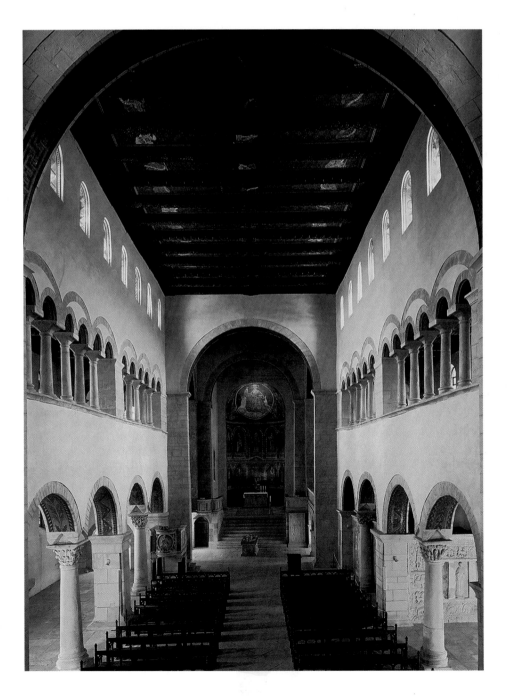

levels, bisect the walls vertically into two units, each composed of two broad arches of the nave arcade surmounted by three pairs of arches at the gallery level. This seemingly simple design, with its rhythmic alternation of heavy and light supports, its balance of rectangular and rounded forms, and its combination of horizontal and vertical movements, seems to prefigure the aesthetic exploration of wall design that will characterize the Romanesque architecture of the next two centuries.

OTTONIAN SCULPTURE

Ottonian sculptors worked in ivory, bronze, wood, and other materials rather than stone. Like their Early Christian and Byzantine predecessors, they and their patrons focused on church furnishings and portable art rather than architectural sculpture. Drawing on Roman, Early Christian, Byzantine, and Carolingian models, they created large works in wood and bronze that would have a significant influence on later medieval art.

THE GERO CRUCIFIX The **GERO CRUCIFIX** is one of the few large works of carved wood to survive from the early Middle Ages (**FIG. 15-24**). Archbishop Gero of Cologne (archbishop 969–976) commissioned the sculpture for his cathedral about 970. The life-size figure of Christ is made of painted and gilded oak. The focus here is on Jesus' human suffering. He is shown as a tortured martyr, not as the triumphant hero of the Lindau Gospels cover (see **FIG. 15-21**). His broken body sags on the cross and his head falls forward, eyes closed. The straight, linear fall of his golden drapery heightens the impact of his drawn face, emaciated arms and legs, sagging torso, and limp, bloodied hands. This is a poignant image of distilled anguish, meant to inspire pity and awe in the empathetic responses of its viewers.

THE HILDESHEIM DOORS Under the last of the Ottonian rulers, Henry II and Queen Kunigunde (r. 1002–1024), Bishop Bernward of Hildesheim emerged as an important patron. His biographer, the monk Thangmar, described Bernward as a skillful goldsmith who closely supervised the artists working for him. Bronze doors made under his direction for the abbey church of St. Michael in Hildesheim—and installed by him, according to the inscription on them, in 1015—represented the most ambitious and complex bronze-casting project undertaken since antiquity (**FIG. 15-25**). Each door, including the impressive lion heads holding the ring handle, was cast as a single piece in the lost-wax process (see page 418) and later detailed and reworked with chisels and fine tools. Rounded and animated figures populate spacious backgrounds. Architectural elements and features of the landscape are depicted in lower relief, so that the figures stand out prominently, with their heads fully modeled in three dimensions. The result is lively, visually stimulating, and remarkably spontaneous for so monumental an undertaking.

15-24 • GERO CRUCIFIX
Cologne Cathedral, Germany. c. 970. Painted and gilded wood, height of figure 6′2″ (1.88 m).

This life-size sculpture is both a crucifix to be suspended over an altar and a special kind of reliquary. A cavity in the back of the head was made to hold a piece of the Host, or Communion bread, already consecrated by the priest. Consequently, the figure not only represents the body of the dying Jesus but also contains a "relic" of the Eucharistic body of Christ. In fact, the Ottonian chronicle of Thietmar of Meresburg (written 1012–1018) claims that Gero himself placed a consecrated Host, as well as a fragment of the true cross, in a crack that formed within the head of this crucifix and prayed that it be closed, which it was.

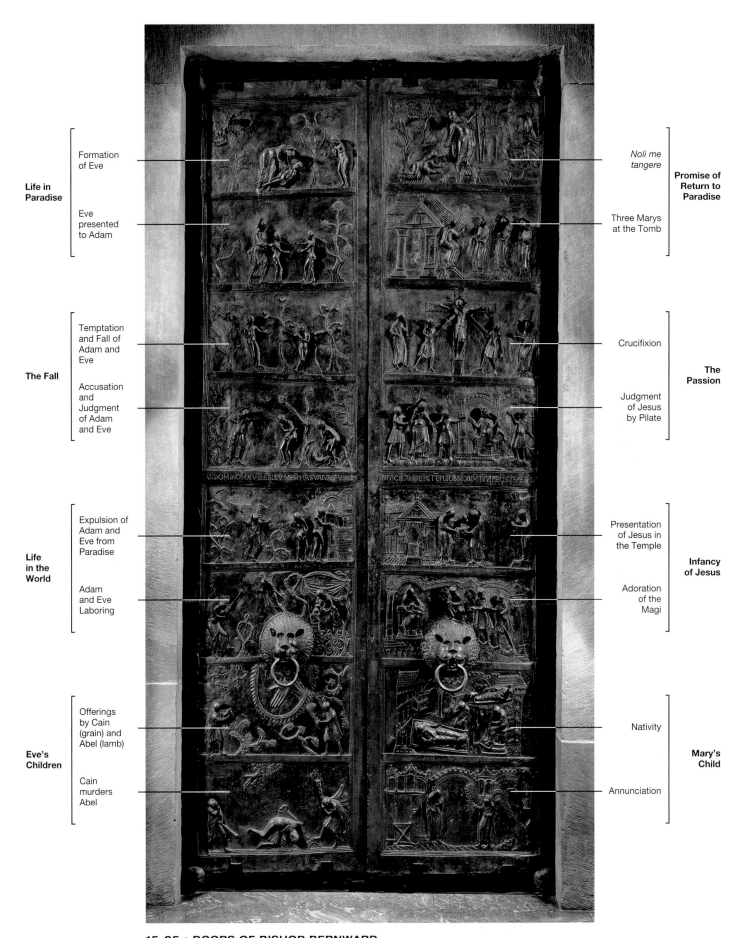

Life in Paradise
- Formation of Eve
- Eve presented to Adam

The Fall
- Temptation and Fall of Adam and Eve
- Accusation and Judgment of Adam and Eve

Life in the World
- Expulsion of Adam and Eve from Paradise
- Adam and Eve Laboring

Eve's Children
- Offerings by Cain (grain) and Abel (lamb)
- Cain murders Abel

Promise of Return to Paradise
- *Noli me tangere*
- Three Marys at the Tomb

The Passion
- Crucifixion
- Judgment of Jesus by Pilate

Infancy of Jesus
- Presentation of Jesus in the Temple
- Adoration of the Magi

Mary's Child
- Nativity
- Annunciation

15-25 • DOORS OF BISHOP BERNWARD
Made for the abbey church of St. Michael, Hildesheim, Germany. 1015. Bronze, height 16′6″ (5 m).

The doors, standing more than 16 feet tall, portray events from the Hebrew Bible on the left (reading down from the creation of Eve at the top to Cain's murder of Abel at the bottom) and from the New Testament on the right (reading upward from the Annunciation at the bottom to the *Noli me tangere* at the top). In each pair of scenes across from each other, the Hebrew Bible event is meant to present a prefiguration of or complement to the adjacent New Testament event. For instance, the third panel down on the left shows Adam and Eve picking the forbidden fruit in the Garden of Eden, believed by Christians to be the source of human sin, suffering, and death. The paired scene on the right shows the Crucifixion of Jesus, whose sacrifice was believed to have atoned for Adam and Eve's original sin, bringing the promise of eternal life. At the center of the doors, six panels down—between the door pulls—Eve (left) and Mary (right) sit side by side, holding their sons. Cain (who murdered his brother) and Jesus (who was unjustly executed) signify the opposition of evil and good, damnation and salvation. Other telling pairs are the murder of Abel (the first sin) with the Annunciation (the advent of salvation) at the bottom, and, fourth from the top, the passing of blame from Adam and Eve to the serpent paired with Pilate washing his hands of any responsibility in the execution of Jesus.

ILLUSTRATED BOOKS

Like their Carolingian predecessors, Ottonian monks and nuns created richly illuminated manuscripts, often funded by secular rulers. Styles varied from place to place, depending on the traditions of the particular scriptorium, the models available in its library, and the creativity of its artists.

THE HITDA GOSPELS The presentation page of a Gospel book made in the early eleventh century for Abbess Hitda (d. 1041) of Meschede, near Cologne (**FIG. 15–26**) represents one of the most distinctive local styles. The abbess herself appears here, offering the book to St. Walpurga,

her convent's patron saint. The artist has angled the buildings of the sprawling convent in the background to frame the figures and draw attention to their interaction. The size of the architectural complex underscores the abbess's position of authority. The foreground setting—a rocky, undulating strip of landscape—is meant to be understood as holy ground, separated from the rest of the world by golden trees and the huge arch-shape aura that silhouettes St. Walpurga. The energetic spontaneity of the painting style suffuses the scene with a sense of religious fervor appropriate to the visionary saintly encounter.

THE GOSPELS OF OTTO III This Gospel book, made in a German monastery near Reichenau about 1000, shows another Ottonian painting style, in this case inspired by Byzantine art

15-26 • PRESENTATION PAGE WITH ABBESS HITDA AND ST. WALPURGA, HITDA GOSPELS
Early 11th century. Ink and colors on vellum, 11⅜″ × 5⅝″ (29 × 14.2 cm). Universitäts- und Landesbibliothek, Darmstadt.

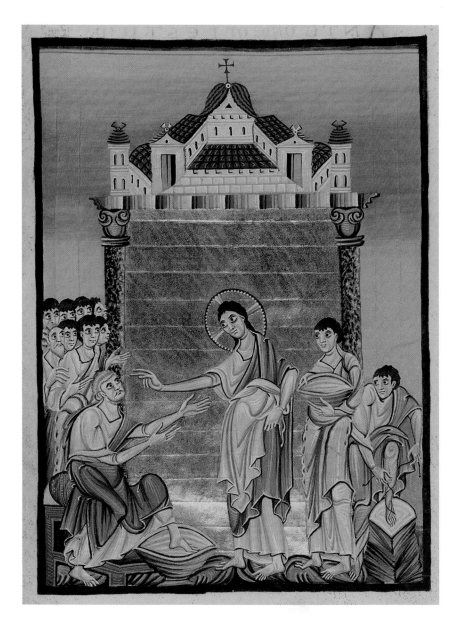

15-27 • PAGE WITH CHRIST WASHING THE FEET OF HIS DISCIPLES, GOSPELS OF OTTO III

c. 1000. Ink, gold, and colors on vellum, approx. 8″ × 6″ (20.5 × 14.5 cm). Bayerische Staatsbibliothek, Munich. Clm 4453, fol. 237r

in the use of sharply outlined drawing and lavish fields of gold (**FIG. 15-27**). Backed by a more controlled and balanced architectural canopy than that sheltering Hitda and St. Walpurga, these tall, slender men gesture dramatically with long, thin fingers. The scene captures the moment when Jesus washes the feet of his disciples during their final meal together (John 13:1–17). Peter, who had tried to stop his Savior from performing this ancient ritual of hospitality, appears at left, one leg reluctantly poised over the basin, while a centrally silhouetted and hierarchically scaled Jesus gestures emphatically to underscore the necessity and significance of the act. Another disciple, at far right, enthusiastically raises his leg to untie his sandals so he can be next in line. Selective stylization has allowed the artist of this picture to transform the received Classical tradition into a style of stunning expressiveness and narrative power, features that will also characterize the figural styles associated with Romanesque art.

THINK ABOUT IT

15.1 Characterize the styles of painting that developed in Spain for the illustration of commentaries on the Apocalypse and in the Ottonian world for visualizing sacred narrative. Focus your answer on specific examples discussed in this chapter.

15.2 Discuss the themes and subjects used for the paintings in early medieval Gospel books by comparing two specific examples from different parts of Europe.

15.3 Explain the references to early Christian Roman traditions in Carolingian architecture. How did Carolingian builders transform their models?

15.4 Compare the renderings of the crucified Christ on the cover of the Lindau Gospels (FIG. 15-21) and the Gero Crucifix (FIG. 15-24). Consider the differences in media and expressive effect, as well as in style and scale.

CROSSCURRENTS

FIG. 6–57 FIG. 15–15

The equestrian portrait on the right consciously emulates the Roman tradition represented by the work on the left. For the early Middle Ages, this sort of creative appropriation was common artistic practice. Discuss what it tells us about the Carolingians, grounding your answer in a discussion of these two works.

✔—⎡**Study** and review on myartslab.com

16-1 • CHRIST AND DISCIPLES ON THE ROAD TO EMMAUS
Cloister of the abbey of Santo Domingo, Silos, Castile, Spain. c. 1100. Pier relief, figures nearly life-size.

Romanesque Art

The three men seem to glide forward on tiptoe as their leader turns back, reversing their forward movement (**FIG. 16–1**). Their bodies are sleek; legs cross in gentle angles rather than vigorous strides; their shoulders, elbows, and finger joints melt into languid curves; draperies delicately delineate shallow contours; bearded faces stare out with large, wide eyes under strong, arched brows. The figures interrelate and interlock, pushing against the limits of the architectural frame.

Medieval viewers would have quickly identified the leader as Christ, not only by his commanding size, but specifically by his cruciform halo. The sanctity of his companions is signified by their own haloes. The scene recalls to faithful Christians the story of the resurrected Christ and two of his disciples on the road from Jerusalem to Emmaus (Luke 24:13–35). Christ has the distinctive attributes of a medieval pilgrim—a hat, a satchel, and a walking stick. Even the scallop shell on his satchel is the badge worn by pilgrims to a specific site: the shrine of St. James at Santiago de Compostela. Early pilgrims reaching this destination in the far northwestern corner of the Iberian peninsula continued to the coast to pick up a shell as evidence of their journey. Soon shells were gathered (or fabricated from metal as brooches) and sold to the pilgrims—a lucrative business for both the sellers and the church. On the return journey home, the shell became the pilgrims' passport, a badge attesting to their piety and accomplishment. Other distinctive badges were adopted at other pilgrimage sites.

This relief was carved on a corner pier in the cloister of the monastery of Santo Domingo in Silos, a major eleventh- and twelfth-century center of religious and artistic life south of the pilgrimage road across Spain (see "The Pilgrim's Journey to Santiago," page 464). It engaged an audience of monks—who were well versed in the meaning of Christian images—through a sculptural style that we call Romanesque. Not since the art of ancient Rome half a millennium earlier had sculptors carved monumental figures in stone within an architectural fabric. During the early Middle Ages, sculpture was small-scale, independent, and created from precious materials—a highlighted object within a sacred space rather than a part of its architectural envelope. But during the Romanesque period, narrative and iconic figural imagery in deeply carved ornamental frameworks would collect around the entrances to churches, focusing attention on their compelling portal complexes. These public displays of Christian doctrine and moral teaching would have been part of the cultural landscape surveyed by pilgrims journeying along the road to Santiago. Travel as a pilgrim opened the mind to a world beyond the familiar towns and agricultural villages of home, signaling a new era in the social, economic, and artistic life of Europe.

LEARN ABOUT IT

16.1 Explore the emergence of Romanesque architecture—with its emphasis on the aesthetic qualities of a sculptural wall—out of early masonry construction techniques.

16.2 Investigate the integration of painting and sculpture within the Romanesque building, and consider the themes and subjects that were emphasized.

16.3 Assess the cultural and social impact of monasticism and pilgrimage on the design and embellishment of church architecture.

16.4 Explore the eleventh- and twelfth-century interest in telling stories of human frailty and sanctity in sculpture, textiles, and manuscript painting—stories that were meant to appeal to the feelings as well as to the minds of viewers.

((•—[**Listen** to the chapter audio on myartslab.com

EUROPE IN THE ROMANESQUE PERIOD

At the beginning of the eleventh century, Europe was still divided into many small political and economic units ruled by powerful families, such as the Ottonians in Germany (**MAP 16–1**). The nations we know today did not exist, although for convenience we shall use present-day names of countries. The king of France ruled only a small area around Paris known as the Île-de-France. The southern part of modern France had close linguistic and cultural ties to northern Spain; in the north the duke of Normandy (heir of the Vikings) and in the east the duke of Burgundy paid the French king only token homage.

When in 1066 Duke William II of Normandy (r. 1035–1087) invaded England and, as William the Conqueror, became that country's new king, Norman nobles replaced the Anglo-Saxon nobility there, and England became politically and culturally allied with Normandy. As astute and skillful administrators, the Normans formed a close alliance with the Church, supporting it with grants of land and gaining in return the allegiance of abbots and bishops. Normandy became one of Europe's most powerful domains. During this period, the Holy Roman Empire, re-established by the Ottonians, encompassed much of Germany and northern Italy, while the Iberian peninsula remained divided between Muslim rulers in the south and Christian rulers in the north. By 1085, Alfonso VI of Castile and León (r. 1065–1109) had conquered the Muslim stronghold of Toledo, a center of Islamic and Jewish culture in the kingdom of Castile. Catalunya (Catalonia) emerged as a power along the Mediterranean coast.

By the end of the twelfth century, however, a few exceptionally intelligent and aggressive rulers had begun to create national states. The Capetians in France and the Plantagenets in England were especially successful. In Germany and northern Italy, the power of local rulers and towns prevailed, and Germany and Italy remained politically fragmented until the nineteenth century.

POLITICAL, ECONOMIC, AND SOCIAL LIFE

Although towns and cities with artisans and merchants grew in importance, Europe remained an agricultural society, and developing agricultural practices in this period led to expanded food supplies and population growth. Land was the primary source of wealth and power for a hereditary aristocracy. Allegiances, obligations, and social relations among members of the upper echelons of society, as well as between them and the peasants who lived and worked on their land, were not static, but were subject to long- and short-term changes in power and wealth. Patterns of political and social dependencies, expectations, and obligations varied extensively from place to place, and from community to community. Life was often difficult, and people from all levels of society were vulnerable to the violence of warfare—both local and general—as well as recurrent famine and disease.

THE CHURCH

In the early Middle Ages, Church and state had forged some fruitful alliances. Christian rulers helped ensure the spread of Christianity throughout Europe and supported monastic communities with grants of land. Bishops and abbots were often royal relatives, younger brothers and cousins, who supplied crucial social and spiritual support and a cadre of educated administrators. As a result, secular and religious authority became tightly intertwined, and this continued through the Romanesque period. Monasteries continued to sit at the center of European culture, but there were two new cultural forces fostered by the Church: pilgrimages and crusades.

MONASTICISM Although the first universities were established in the eleventh and twelfth centuries in the growing cities of Bologna, Paris, Oxford, and Cambridge, monastic communities continued to play a major role in intellectual life. As in the early Middle Ages, monks and nuns also provided valuable social services, including caring for the sick and destitute, housing travelers, and educating the elite. Because monasteries were major landholders, abbots and priors were part of the political power structure. The children of aristocratic families continued to join religious orders, strengthening links between monastic communities and the ruling elite.

As life in Benedictine communities grew increasingly comfortable and intertwined with the secular world, reform movements sought a return to earlier monastic austerity and spirituality. The most important groups of reformers for the arts were the Burgundian congregation of Cluny, established in the tenth century, and later the Cistercians, who sought reform of what they saw as Cluniac decadence and corruption of monastic values.

PILGRIMAGES Pilgrimages to three of the holiest places of Christendom—Jerusalem, Rome, and Santiago de Compostela—increased (see "The Pilgrim's Journey to Santiago," page 464), although the majority of pilgrimages were probably more local. Rewards awaited courageous travelers along the routes, both long and short. Pilgrims on long journeys could venerate the relics of local saints along the route, and artists and architects were commissioned to create spectacular and enticing new buildings and works of art to capture their attention.

CRUSADES In the eleventh and twelfth centuries, Christian Europe, previously on the defensive against the expanding forces of Islam, became the aggressor. In Spain, Christian armies of the north were increasingly successful against Islamic kingdoms in the south. At the same time, the Byzantine emperor asked the pope for help in his war with the Muslims surrounding his domain. The Western Church responded in 1095 by launching a series of holy wars, military offensives against Islamic powers known collectively as the crusades (from the Latin *crux*, referring to the cross crusaders wore).

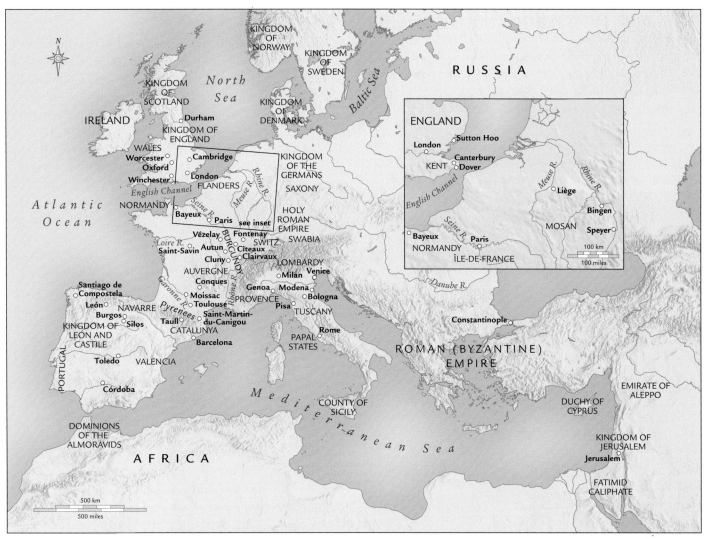

MAP 16–1 • EUROPE IN THE ROMANESQUE PERIOD

Although a few large political entities began to emerge in places like England and Normandy, Burgundy, and León/Castile, Europe remained a land of small economic entities. Pilgrimages, monasticism, and crusades acted as unifying international forces.

This First Crusade was preached by Pope Urban II (pontificate 1088–1099) and fought by the lesser nobility of France, who had economic and political as well as spiritual objectives. The crusaders captured Jerusalem in 1099 and established a short-lived kingdom. The Second Crusade in 1147, preached by St. Bernard and led by France and Germany, accomplished nothing. The Muslim leader Saladin united the Muslim forces and captured Jerusalem in 1187, inspiring the Third Crusade, led by German, French, and English kings. The Europeans recaptured some territory, but not Jerusalem, and in 1192 they concluded a truce with the Muslims, permitting the Christians access to the shrines in Jerusalem. Although the crusades were brutal military failures, the movement had far-reaching cultural and economic consequences, providing western Europeans with direct encounters with the more sophisticated material culture of the Islamic world and the Byzantine Empire. This in turn helped stimulate trade, and with trade came the development of an increasingly urban society during the eleventh and twelfth centuries.

ROMANESQUE ART

The word "Romanesque," meaning "in the Roman manner," was coined in the early nineteenth century to describe early medieval European church architecture, which often displayed the solid masonry walls and rounded arches and vaults characteristic of imperial Roman buildings. Soon the term was applied to all the arts of the period from roughly the mid-eleventh century to the second half of the twelfth century, even though that art derives from a variety of sources and reflects a multitude of influences, not just Roman.

This was a period of great building activity in Europe. New castles, manor houses, churches, and monasteries arose everywhere. One eleventh-century monk claimed that the Christian faithful were so relieved to have passed through the apocalyptic anxiety that had gripped their world at the millennial change around the year 1000, that, in gratitude, "Each people of Christendom rivaled with the other, to see which should worship in the finest buildings.

The world shook herself, clothed everywhere in a white garment of churches" (Radulphus Glaber, cited in Holt, vol. I, p. 18) (see FIG. 16–2). The desire to glorify the house of the Lord and his saints (whose earthly remains in the form of relics kept their presence alive in the minds of the people) increased throughout Christendom. There was a veritable building boom.

ARCHITECTURE

Romanesque architecture and art is a trans-European phenomenon, but it was inflected regionally, and the style varied in character from place to place. Although timber remained common in construction, Romanesque builders used stone masonry extensively. Masonry vaults were stronger and more durable, and they enhanced the acoustical effect of Gregorian chant (plainsong, named after Pope Gregory the Great, pontificate 590–604). Stone

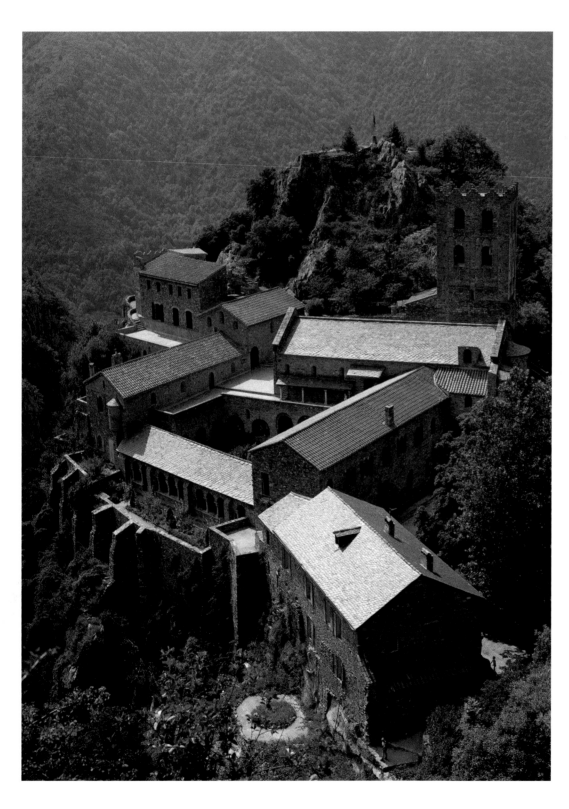

16-2 • SAINT-MARTIN-DU-CANIGOU
French Pyrenees. 1001–1026.

towers sometimes marked the church as the most important building in the community. Portals were often encrusted with sculpture that broadcast the moral and theological messages of the Church to a wide public.

"FIRST ROMANESQUE"

Soon after the year 1000, patrons and builders in Catalunya (northeast Spain), southern France, and northern Italy were already constructing all-masonry churches, employing the methods of late Roman builders. The picturesque Benedictine monastery of **SAINT-MARTIN-DU-CANIGOU**, nestled into the Pyrenees on a building platform stabilized by strongly buttressed retaining walls, is a typical example (**FIG. 16-2**). Patronized by the local Count Guifred, who took refuge in the monastery and died here in 1049, the complex is capped by a massive stone tower sitting next to the sanctuary of the two-story church. Art historians call such early stone-vaulted buildings "First Romanesque," employing the term that Catalan architect and theorist Josep Puig I Cadafalch first associated with them in 1928.

THE CHURCH OF SANT VINCENC, CARDONA Another fine example of "First Romanesque" is the **CHURCH OF SANT VINCENC** (St. Vincent) in the Catalan castle of Cardona (**FIG. 16-3**). Begun in the 1020s, it was consecrated in 1040. Castle residents entered the church through a two-story narthex into a nave with low narrow side aisles that permitted clerestory windows in the nave wall. The sanctuary was raised dramatically over an aisled crypt. The Catalan masons used local materials—small split stones, bricks, even river pebbles, and very strong mortar—to raise plain walls and round barrel or groin vaults. Today we can admire their skillful stonework both inside and out, but the builders originally covered their masonry with a facing of stucco.

To strengthen the exterior walls, and to enrich their sculptural presence, the masons added vertical bands of projecting masonry (called strip buttresses) joined by arches and additional courses of masonry to counter the weight and outward thrust of the vault. On the interior these masonry strips project from the piers and continue up and over the vault, creating a series of **transverse arches**. Additional projecting bands line the underside of the arches of the nave arcade. The result is a compound, sculptural pier that works in concert with the transverse arches to divide the nave into a series of bays. This system of bay division became standard in Romanesque architecture. It is a marked contrast to the flat-wall continuity and undivided space within a pre-Romanesque church like Gernrode (see FIG. 15-23).

PILGRIMAGE CHURCHES

The growth of a cult of relics and the desire to visit holy shrines such as St. Peter's in Rome or St. James's in Spain, as well as the shrines of local saints, increasingly inspired Christians in western Europe to travel on pilgrimages (see "The Pilgrim's Journey to Santiago," page 464). To accommodate the faithful and

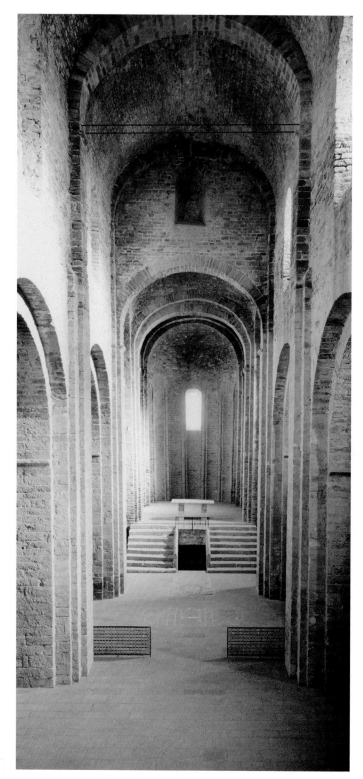

16-3 • INTERIOR, CHURCH OF SANT VINCENC, CARDONA
1020s–1030s.

proclaim Church doctrine, many monasteries—including those on the major pilgrimage routes—built large new churches, filled them with sumptuous altars and reliquaries, and encrusted them with elaborate stone sculpture on the exterior, especially around entrances.

Western Europe in the eleventh and twelfth centuries saw the growing popularity of religious pilgrimage—much of it local, but some of it international. The rough roads that led to the holiest destinations—the tomb of St. Peter and other martyrs in Rome, the church of the Holy Sepulcher in Jerusalem, and the cathedral of St. James in Santiago de Compostela in the northwest corner of Spain—were often crowded with pilgrims. Their journeys could last a year or more; church officials going to Compostela were given 16 weeks' leave of absence. Along the way the pilgrims had to contend with bad food and poisoned water, as well as bandits and dishonest innkeepers and merchants.

In the twelfth century, the priest Aymery Picaud wrote a guidebook for pilgrims on their way to Santiago through what is now France. Like travel guides today, Picaud's book provided advice on local customs, comments on food and the safety of drinking water, and a list of useful words in the Basque language. In Picaud's time, four main pilgrimage routes to Santiago crossed France, merging into a single road in Spain at Puente la Reina and leading on from there through Burgos and León to Compostela (MAP 16-2). Conveniently spaced monasteries and churches offered food and lodging, as well as relics to venerate. Roads and bridges were maintained by a guild of bridge builders and guarded by the Knights of Santiago.

Picaud described the best-traveled routes and most important shrines to visit along the way. Chartres, for example, housed the tunic that the Virgin was said to have worn when she gave birth to Jesus. The monks of Vézelay had the bones of St. Mary Magdalen, and at Conques,

the skull of Sainte Foy was to be found. Churches associated with miraculous cures—Autun, for example, which claimed to house the relics of Lazarus, raised by Jesus from the dead—were filled with the sick and injured praying to be healed.

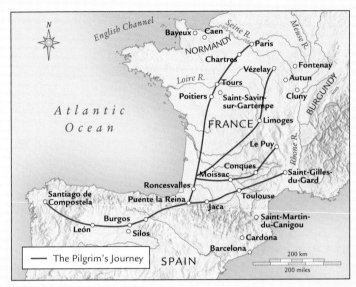

MAP 16-2 • THE PILGRIMAGE ROUTES TO SANTIAGO DE COMPOSTELA

THE CATHEDRAL OF ST. JAMES IN SANTIAGO DE COMPOSTELA One major goal of pilgrimage was the **CATHEDRAL OF ST. JAMES** in Santiago de Compostela (**FIG. 16-4**), which held the body of St. James, the apostle to the Iberian peninsula. Builders of this and several other major churches along the roads leading through France to the shrine developed a distinctive plan designed to accommodate the crowds of pilgrims and allow them to move easily from chapel to chapel in their desire to venerate relics (see "Relics and Reliquaries," page 467). This "pilgrimage plan" is a model of functional planning and traffic control. To the aisled nave the builders added aisled transepts with eastern chapels leading to an ambulatory (curving walkway) with additional radiating chapels around the apse. This expansion of the basilican plan allowed worshipers to circulate freely around the church's perimeter, visiting chapels and venerating relics without disrupting services within the main space.

At Santiago, pilgrims entered the church through the large double doors at the ends of the transepts rather than through the western portal, which served ceremonial processions. Pilgrims from France entered the north transept portal; the approach from the town was through the south portal. All found themselves in a transept in which the design exactly mirrored the nave in height and structure (**FIG. 16-5**). Both nave and transept have two stories—an arcade and a gallery. Compound piers with attached halfcolumns

on all four sides support the immense barrel vault and are projected over it vertically through a rhythmic series of transverse arches. They give sculptural form to the interior walls and also mark off individual vaulted bays in which the sequence is as clear and regular as the ambulatory chapels of the choir. Three different kinds of vaults are used here: barrel vaults with transverse arches cover the nave, groin vaults span the side aisles, and halfbarrel or quadrant vaults cover the galleries and strengthen the building by countering the outward thrust of the high nave vaults and transferring it to the outer walls and buttresses. Without a clerestory, light enters the nave and transept only indirectly, through windows in the outer walls of the aisles and upper-level galleries. Light from the choir clerestory and the large windows of an octagonal **lantern** tower (a structure built above the height of the main ceiling with windows that illuminate the space below) over the crossing would therefore spotlight the glittering gold and jeweled shrine of the principal relic at the high altar.

In its own time, Santiago was admired for the excellence of its construction—"not a single crack is to be found," according to the twelfth-century pilgrims' guide—"admirable and beautiful in execution…large, spacious, well-lighted, of fitting size, harmonious in width, length, and height…." Pilgrims arrived at Santiago de Compostela weary after weeks or months of difficult travel through dense woods and mountains. Grateful to St. James for his

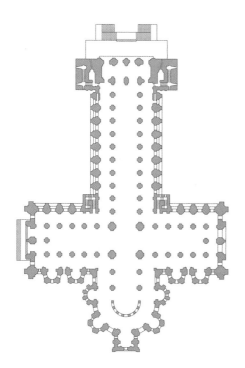

16-4 • PLAN (A) AND RECONSTRUCTION DRAWING (B) OF THE CATHEDRAL OF ST. JAMES, SANTIAGO DE COMPOSTELA
Galicia, Spain. 1078–1122; western portions later. View from the east.

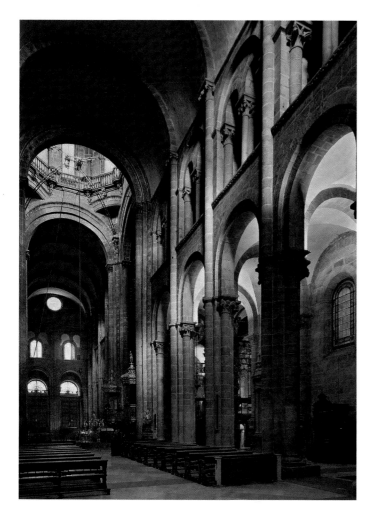

protection along the way, they entered a church that welcomed them with open portals, encrusted with the dynamic moralizing sculpture that characterized Romanesque churches. The cathedral had no doors to close—it was open day and night.

CLUNY

In 909, the duke of Burgundy gave land for a monastery to Benedictine monks intent on strict adherence to the original rules of St. Benedict. They established the reformed congregation of Cluny. From its foundation, Cluny had an independent status; its abbot answered directly to the pope in Rome rather than to the local bishop or lord. This freedom, jealously safeguarded by a series of long-lived and astute abbots, enabled Cluny to keep the profits from extensive gifts of land and treasure. Independent, wealthy, and a center of culture and learning, Cluny and its affiliates became important patrons of architecture and art.

16-5 • TRANSEPT INTERIOR, CATHEDRAL OF ST. JAMES, SANTIAGO DE COMPOSTELA
1078–1122. View toward the crossing.

Read the documents related to the cathedral of St. James, Santiago de Compostela on myartslab.com

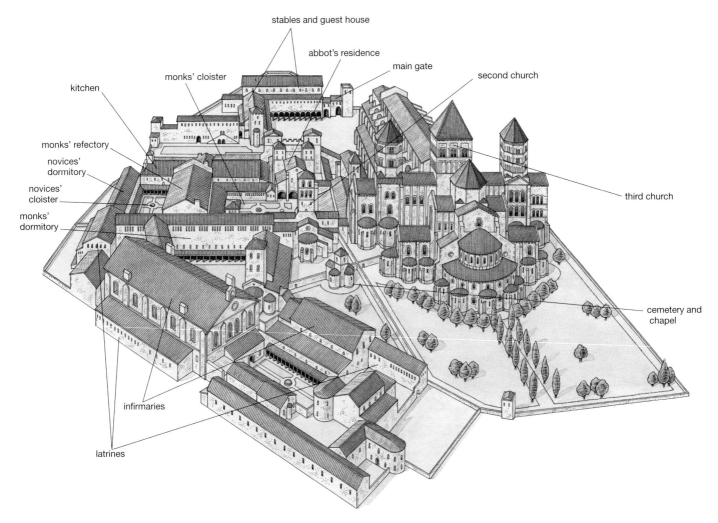

16-6 • RECONSTRUCTION DRAWING OF THE ABBEY OF CLUNY
Burgundy, France. 1088–1130. View from the east.

Read the document related to the abbey at Cluny on myartslab.com

The monastery of Cluny was a city unto itself. By the second half of the eleventh century, there were some 200 monks in residence, supplemented by many laymen on whom they depended for material support. Just as in the Saint Gall plan of the Carolingian period (see FIG. 15–18), the cloister lay at the center of this monastic community, joining the church with domestic buildings and workshops (FIG. 16–6). In wealthy monasteries such as Cluny, the arcaded galleries of the cloister had elaborate carved capitals as well as relief sculpture on piers (see FIG. 16–1). The capitals may have served as memory devices or visualized theology to direct and inspire the monks' thoughts and prayers.

Cluniac monks observed the traditional eight Benedictine Hours of the Divine Office (including prayers, scripture readings, psalms, and hymns) spread over the course of each day and night. Mass was celebrated after the third hour (terce), and the Cluniac liturgy was especially elaborate. During the height of its power, plainsong, or Gregorian chant, filled the church with music 24 hours a day. And the elegant and extravagant design of the church at Cluny—as well as many of the churches of its

host of dependent monasteries—was conceived largely as an elaborate setting for the performance of this liturgy. Cluniac churches were notable for their fine stone masonry with rich sculptured and painted decoration. In Burgundy, the churches were distinguished by their use of classicizing elements drawn from Roman art, such as fluted pilasters and Corinthian capitals. Cluniac monasteries elsewhere, however, were free—perhaps even encouraged—to follow regional traditions and styles.

THE THIRD CHURCH AT CLUNY The original church at Cluny, a small barnlike building, was soon replaced by a basilica with two towers and narthex at the west and a choir with tower and chapels at the east. Hugh de Semur, abbot of Cluny for 60 years (1049–1109), began rebuilding the abbey church for the third time in 1088 (FIG. 16–8). Money paid in tribute by Muslims to victorious Christians in Spain financed the building. When King Alfonso VI of León and Castile captured Toledo in 1085, he sent 10,000 pieces of gold to Cluny; German rulers were also generous donors. The church (known to art historians as Cluny

Christians turned to the heroes of the Church, especially martyrs who had died for their faith, to answer their prayers and to intercede with Christ on their behalf, and prayers offered to saints while in close proximity to their relics were considered especially effective. Bodies of saints, parts of bodies, and things associated with the Holy Family or the saints were kept in richly decorated containers called reliquaries. Reliquaries could be simple boxes, but they might also be created in more elaborate shapes, sometimes in the form of body parts such as arms, ribs, or heads. By the eleventh century, many different arrangements of crypts, chapels, and passageways gave people access to the relics kept in churches. When the Church decided that every altar required a relic, the saints' bodies and possessions were subdivided. In this way relics were multiplied; for example, hundreds of churches held relics of the true cross.

Owning and displaying these relics so enhanced the prestige and wealth of a community that people went to great lengths to acquire them, not only by purchase but also by theft. In the ninth century, for example, the monks of Conques stole the relics of the child martyr Sainte Foy (St. Faith) from her shrine at Agen. Such a theft was called "holy robbery," for the new owners insisted that it had been sanctioned by the saint who had communicated to them her desire to move. In the late ninth or tenth century, the monks of Conques encased their new relic—the skull of Sainte Foy—in a gold and jeweled statue whose unusually large head was made from a reused late Roman work. During the eleventh century, they added the crown and more jeweled banding, and, over subsequent centuries, jewels, cameos, and other gifts added by pilgrims continued to enhance the statue's splendor (**FIG. 16–7**).

This type of reliquary—taking the form of a statue of the saint—was quite popular in the region around Conques, but not everyone was comfortable with the way these works functioned as cult images. Early in the eleventh century, the learned Bernard of Angers prefaces his tendentious account of miracles associated with the cult of Sainte Foy by confessing his initial misgivings about such reliquaries, specifically the way simple folks adored them. Bernard thought it smacked of idolatry: "To learned people this may seem to be full of superstition, if not unlawful, for it seems as if the rites of the gods of ancient cultures, or that the rites of demons, are being observed" (*The Book of Sainte Foy*, p. 77). But when he witnessed firsthand the interaction of the reliquary statue with the faithful, he altered his position: "For the holy image is consulted not as an idol that requires sacrifices, but because it commemorates a martyr. Since reverence to her honors God on high, it was despicable of me to compare her statue to statues of Venus or Diana. Afterwards I was very sorry that I had acted so foolishly toward God's saint." (ibid., p. 78)

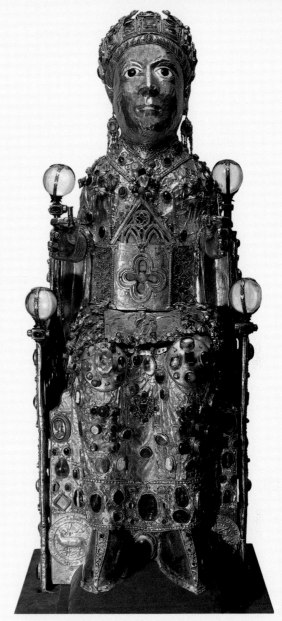

16-7 • RELIQUARY STATUE OF SAINTE FOY (ST. FAITH)
Abbey church, Conques, France. Late 9th or 10th century with later additions. Silver gilt over a wood core, with gems and cameos of various dates. Height 33″ (85 cm). Church Treasury, Conques.

III because it was the third building at the site) was the largest in Europe when it was completed in 1130: 550 feet long, with five aisles like Old St. Peter's in Rome. Built with superbly cut masonry, and richly carved, painted, and furnished, Cluny III was a worthy home for the relics of St. Peter and St. Paul, which the monks had acquired from the church of St. Paul's Outside the Walls in Rome. It was also a fitting headquarters for a monastic

order that eventually became so powerful within Europe that popes were chosen from its ranks.

In simple terms, the church was a basilica with five aisles, double transepts with chapels, and an ambulatory and radiating chapels around the high altar. The large number of chapels was necessary so that each monk-priest had an altar at which to perform daily Mass. Octagonal towers over the two crossings and additional towers

over the transept arms created a dramatic pyramidal design at the east end. The nave had a three-part elevation. A nave arcade with tall compound piers, faced by pilasters to the inside and engaged columns at the sides, supported pointed arches lined by Classical ornament. At the next level a blind arcade and pilasters created a continuous sculptural strip that could have been modeled on an imperial Roman triumphal monument. Finally, triple clerestory windows in each bay let sunlight directly into the church around its perimeter. The pointed barrel vault with transverse arches rose to a daring height of 98 feet with a span of about 40 feet, made possible by giving the vaults a steep profile, rather than the weaker rounded profile used at Santiago de Compostela.

Cluny III was consecrated in 1130, but it no longer exists. The monastery was suppressed during the French Revolution, and this grandest of French Romanesque churches was sold stone by stone, transformed into a quarry for building materials. Today the site is an archaeological park, with only one transept arm from the original church still standing.

THE CISTERCIANS

New religious orders devoted to an austere spirituality arose in the late eleventh and early twelfth centuries. Among these were the Cistercians, who spurned Cluny's elaborate liturgical practices and aspects of their arts, especially figural sculpture in cloisters (see "St. Bernard and Theophilus: The Monastic Controversy over the Visual Arts," page 470). The Cistercian reform began in 1098 with the founding of the abbey of Cîteaux (Cistercium in Latin, hence the order's name). Led in the twelfth century by the commanding figure of Abbot (later St.) Bernard of Clairvaux, the Cistercians advocated strict mental and physical discipline and a life devoted to prayer and intellectual pursuits combined with shared manual labor. Like the Cluniacs, however, Cistercians depended on the work of laypeople. To seclude themselves as much as possible from the outside world, they settled in reclaimed swamps and wild forests, where they then farmed and raised sheep. In time, their monasteries extended from Russia to Ireland.

FONTENAY Cistercian architecture embodies the ideals of the order—simplicity, austerity, and purity. Always practical, the Cistercians made a significant change to the already very efficient monastery plan. They placed key buildings such as the refectory at right angles to the cloister walk so they could easily be extended should the community grow. The cloister fountain was relocated from the center to the side, conveniently in front of the refectory, where the monks could wash when coming from their work in the fields for communal meals. For easy access to the sanctuary during their prayers at night, monks entered the church directly from the cloister into the south transept or from the dormitory by way of the "night stairs."

The **ABBEY OF FONTENAY** in Burgundy is among the best-preserved early Cistercian monasteries. The abbey church, begun in 1139, has a regular geometric plan (**FIG. 16–9**) with a long bay-divided nave, rectangular chapels off the square-ended transept arms, and a shallow choir with a straight east wall. One of its characteristic features is the use of

16-8 • RECONSTRUCTION DRAWING OF THE INTERIOR LOOKING EAST, THIRD ABBEY CHURCH AT CLUNY
1088–1130.

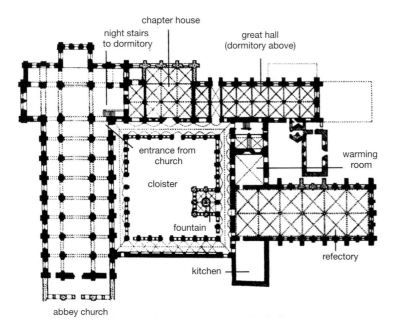

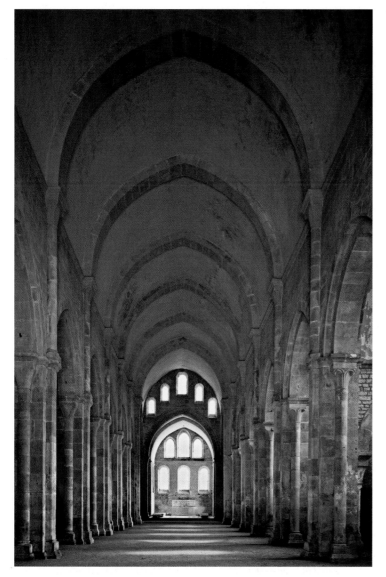

16-9 • PLAN (A) AND CHURCH INTERIOR (B) OF THE ABBEY OF NOTRE-DAME, FONTENAY
Burgundy, France. 1139–1147.

pointed barrel vaults over the nave and pointed arches in the nave arcade and side-aisle bays. Although pointed arches are usually associated with Gothic architecture, they are actually common in the Romanesque buildings of some regions, including Burgundy—we have already seen them at Cluny. Pointed arches are structurally more stable than round ones, directing more weight down into the floor instead of outward against the walls. Consequently, they can span greater distances at greater heights without collapsing.

Although Fontenay and other early Cistercian monasteries fully reflect the architectural developments of their time in masonry construction, vaulting, and planning, the Cistercians concentrated on harmonious proportions, superbly refined stonework, and elegantly carved foliate and ornamental decoration, to achieve beauty in their architecture. The figural scenes and monstrous animals found on many Romanesque churches are avoided here. The large windows in the end wall, rather than a clerestory, provided light, concentrated here as at Santiago, on the sanctuary. The sets of triple windows may have reminded the monks of the Trinity. Some scholars have suggested that the numerical and proportional systems guiding the design of such seemingly simple buildings are saturated with the sacred numerical systems outlined by such eminent early theologians as St. Augustine of Hippo. The streamlined but sophisticated architecture favored by the Cistercians spread from their homeland in Burgundy to become an international style. From Scotland and Poland to Spain and Italy, Cistercian designs and building techniques varied only slightly in relation to local building traditions. Cistercian experiments with masonry vaulting and harmonious proportions influenced the development of the French Gothic style in the middle of the twelfth century.

REGIONAL STYLES IN ROMANESQUE ARCHITECTURE

The cathedral of Santiago de Compostela and the abbey church at Cluny reflect the cultural exchanges and international connections fostered by powerful monastic orders, and to a certain extent by travel along the pilgrimage roads, but Europe remained a land divided by competing kingdoms, regions, and factions. Romanesque architecture reflects this regionalism in the wide variety of its styles, traditions, and building techniques. Only a few examples can be examined here.

THE CATHEDRAL OF ST. MARY OF THE ASSUMPTION IN PISA Throughout Italy artists looked to the still-standing remains of imperial Rome and early Christianity. The influence remained especially strong in Pisa, on the west coast of Tuscany. Pisa became a maritime power, competing with Barcelona and Genoa as well as the Muslims for control of trade in the western Mediterranean. In 1063, after a decisive victory over the Muslims, the jubilant Pisans began

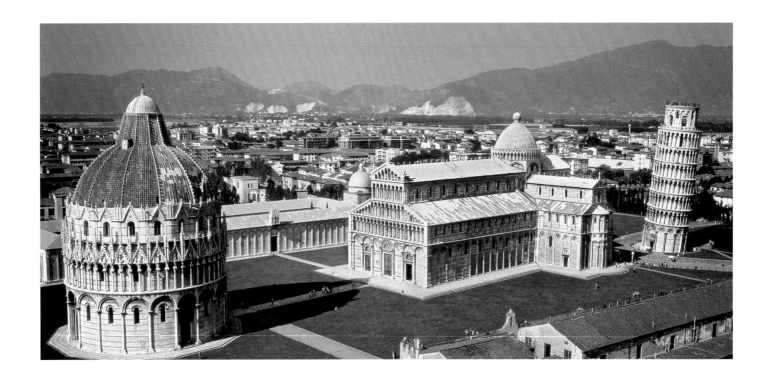

ART AND ITS CONTEXTS | St. Bernard and Theophilus: The Monastic Controversy over the Visual Arts

The twelfth century saw a heated controversy over the place and appropriateness of lavish art in monasteries. In a letter to William of Saint-Thierry, Bernard of Clairvaux wrote:

> ...in the cloisters, before the eyes of the brothers while they read—what is that ridiculous monstrosity doing, an amazing kind of deformed beauty and yet a beautiful deformity? What are the filthy apes doing there? The fierce lions? The monstrous centaurs? The creatures part man and part beast? The striped tigers? The fighting soldiers? The hunters blowing horns? You may see many bodies under one head, and conversely many heads on one body. On one side the tail of a serpent is seen on a quadruped, on the other side the head of a quadruped is on the body of a fish. Over there an animal has a horse for the front half and a goat for the back; here a creature which is horned in front is equine behind. In short, everywhere so plentiful and astonishing a variety of contradictory forms is seen that one would rather read in the marble than in books, and spend the whole day wondering at every single one of them than in meditating on the law of God. Good God! If one is not ashamed of the absurdity, why is one not at least troubled at the expense?
>
> (Rudolph, *Things of Greater Importance*, pp. 11–12)

"Theophilus" is the pseudonym used by a monk who wrote a book during the first half of the twelfth century on the practice of artistic craft, voiced as a defense of the place of the visual arts within the monastic traditions of work and prayer. The book gives detailed instructions for panel painting, stained glass (colored glass assembled into ornamental or pictorial windows), and goldsmithing. In contrast to the stern warnings of Bernard, perhaps even in response to them, "Theophilus" assured artists that "God delights in embellishments" and that artists worked "under the direction and authority of the Holy Spirit."

He wrote:

> Therefore, most beloved son, you should not doubt but should believe in full faith that the Spirit of God has filled your heart when you have embellished His house with such great beauty and variety of workmanship …
>
> … do not hide away the talent given to you by God, but, working and teaching openly and with humility, you faithfully reveal it to those who desire to learn.
>
> … if a faithful soul should see a representation of the Lord's crucifixion expressed in the strokes of an artist, it is itself pierced; if it sees how great are the tortures that the saints have endured in their bodies and how great the rewards of eternal life that they have received, it grasps at the observance of a better life; if it contemplates how great are the joys in heaven and how great are the torments in the flames of hell, it is inspired with hope because of its good deeds and shaken with fear on considering its sins.
>
> (Theophilus, *On Divers Arts*, pp. 78–79)

As we will see in the next chapter, Abbot Suger of Saint-Denis shared the position of Theophilus, rather than that of Bernard, and from this standpoint would sponsor a reconstruction of his abbey church that gave birth to the Gothic style.

16-10 • CATHEDRAL COMPLEX, PISA

Tuscany, Italy. Cathedral, begun 1063; baptistery, begun 1153; campanile, begun 1174; Campo Santo, 13th century.

When finished in 1350, the Leaning Tower of Pisa stood 179 feet high. The campanile had begun to tilt while still under construction, and today it leans about 13 feet off the perpendicular. In the latest effort to keep it from toppling, engineers filled the base with tons of lead.

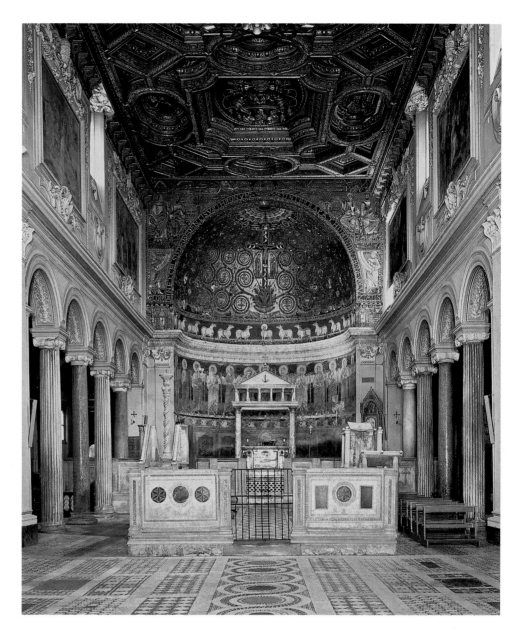

16-11 • INTERIOR, CHURCH OF SAN CLEMENTE, ROME

Consecrated 1128.

San Clemente contains one of the finest surviving collections of early church furniture: choir stalls, pulpit, lectern, candlestick, and also the twelfth-century inlaid pavement. Ninth-century choir-screen panels were reused from the earlier church on the site. The upper wall and ceiling decoration date from the eighteenth century.

an imposing new cathedral dedicated to the Virgin Mary (**FIG. 16-10**). The cathedral was designed as a cruciform basilica by the master builder Busketos. A long nave with double side aisles (usually an homage to Old St. Peter's) is crossed by projecting transepts, designed like basilicas with their own aisles and apses. The builders added galleries above the side aisles, and a dome covers the crossing. Unlike Early Christian basilicas, the exteriors of Tuscan churches were richly decorated with marble—either panels of green and white marble or arcades. At Pisa, pilasters, applied arcades, and narrow galleries in white marble adorn the five-story façade.

In addition to the cathedral itself, the complex eventually included a baptistery, a campanile, and the later Gothic Campo Santo, a walled burial ground. The baptistery, begun in 1153, has arcading and galleries on the lower levels of its exterior that match those on the cathedral (the baptistery's present exterior dome and ornate upper levels were built later). The campanile (a free-standing bell tower—now known for obvious reasons as "the Leaning Tower of Pisa") was begun in 1174 by master builder Bonanno Pisano. Built on inadequate foundations, it began to lean almost immediately. The cylindrical tower is encased in tier upon tier of marble columns. This creative reuse of the Classical theme of the colonnade, turning it into a decorative arcade, is characteristic of Tuscan Romanesque art.

THE BENEDICTINE CHURCH OF SAN CLEMENTE IN ROME The Benedictine church of San Clemente in Rome was rebuilt beginning in the eleventh century (it was consecrated in 1128) on top of the previous church (which had itself been built over a Roman sanctuary of Mithras). The architecture and decoration reflect a conscious effort to reclaim the artistic and spiritual legacy of the early church (**FIG. 16-11**). As with the columns of Santa Sabina (see FIG. 7-10), the columns in San Clemente are **spolia**: that is, they were reused from ancient Roman buildings. The

16-12 • STAGS DRINKING FROM STREAMS FLOWING UNDER THE CRUCIFIED CHRIST
Detail of mosaics in the apse of the church of San Clemente, Rome. Consecrated 1128.

church originally had a timber roof (now disguised by an ornate eighteenth-century ceiling). Even given the Romanesque emphasis on stone vaulting, the construction of timber-roofed buildings continued throughout the Middle Ages.

At San Clemente, the nave ends in a semicircular apse opening directly off the rectangular hall without a sanctuary extension or transept crossing. To accommodate the increased number of participants in the twelfth-century liturgy, the liturgical choir for the monks was extended into the nave itself, defined by a low barrier made up of ninth-century relief panels reused from the earlier church. In Early Christian basilicas, the area in front of the altar had been similarly enclosed by a low stone parapet (see FIG. 7–10), and the Romanesque builders may have wanted to revive what they considered a glorious Early Christian tradition. A **baldachin** (a canopy suspended over a sacred space, also called a ciborium), symbolizing the Holy Sepulcher, covers the main altar in the apse.

The apse of San Clemente is richly decorated with marble revetment on the curving walls and mosaic in the semidome, in a system familiar from the Early Christian and Byzantine world (see FIGS. 7–19, 8–6). The mosaics recapture this past glory, portraying the trees and rivers of paradise, a lavish vine scroll inhabited by figures, in the midst of which emerges the crucified Christ flanked by Mary and St. John. Twelve doves on the cross and the 12 sheep that march in single file below represent the apostles. Stags drink from streams flowing from the base of the cross, an evocation of the tree of life in paradise (**FIG. 16–12**). An inscription running along the base of the apse explains, "We liken the Church of Christ to this vine that the law causes to wither and the Cross causes to bloom," a statement that recalls Jesus' reference to himself as the true vine and his followers as the branches (John 15:1–11). The learned monks of San Clemente would have been prepared to derive these and other meanings from the evocative symbols within this elaborate, glowing composition.

Although the subject of the mosaic recalls Early Christian art, the style and technique are clearly Romanesque. The artists have suppressed the sense of lifelike illusionism that characterized earlier mosaics in favor of ornamental patterns and schemas typical of the twelfth century. The doves silhouetted on the dark blue cross, the symmetrical repetition of circular vine scrolls, even the animals, birds, and humans among their leaves conform to an overriding formal design. By an irregular setting of mosaic tesserae in visibly rough plaster, the artists are able to heighten color and increase the glitter of the pervasive gold field, allowing the mosaic to sparkle.

As we see at San Clemente in Rome and at Saint-Savin-sur-Gartempe (see FIGS. 16–14, 16–15), Romanesque church interiors were not bare expanses of stone, but were often covered with images that glowed in flickering candlelight amid clouds of incense. Outside Rome during the Romanesque period, murals largely replaced mosaics on the walls of churches. Wall painting was subject to the same influences as the other visual arts: that is, the mural painters could be inspired by illuminated manuscripts, or ivories, or enamels in their treasuries or libraries. Some artists must have seen examples of Byzantine art; others had Carolingian or even Early Christian models.

Artists in Catalunya brilliantly combined the Byzantine style with their own Mozarabic and Classical heritage in the apse paintings of the church of San Climent in the mountain village of Taull (Tahull), consecrated in 1123, just a few years before the church of San Clemente in Rome. The curve of the semidome of the apse contains a magnificently expressive **CHRIST IN MAJESTY** (FIG. 16–13) holding an open book inscribed *Ego sum lux mundi* ("I am the light of the world," John 8:12)—recalling in his commanding presence the imposing Byzantine depictions of Christ Pantokrator, ruler and judge of the world, in Middle Byzantine churches (see FIG. 8–21). The San Climent artist was one of the finest painters of the Romanesque period, but where he came from and where he learned his art is unknown. His use of elongated oval faces, large staring eyes, and long noses, as well as the placement of figures against flat bands of color and his use of heavy outlines, reflect the Mozarabic past (see FIG. 15–10). At the same time his work betrays the influence of Byzantine art in his painting technique of modeling from light to dark through repeated colored lines of varying width in three shades—dark, medium, and light. Instead of blending the colors, he delights in the striped effect, as well as in the potential for pattern in details of faces, hair, hands, and muscles.

16–13 • CHRIST IN MAJESTY
Detail of apse fresco, church of San Climent, Taull, Catalunya, Spain. Consecrated 1123. © MNAC—Museu Nacional d'Art de Catalunya, Barcelona.

THE ABBEY CHURCH OF SAINT-SAVIN-SUR-GARTEMPE

At the Benedictine abbey church of Saint-Savin-sur-Gartempe in western France, a tunnel-like barrel vault runs the length of the nave and choir (FIG. 16–14). Without galleries or clerestory windows, the nave at Saint-Savin approaches the form of a "hall church," where the nave and aisles rise to an equal height. And unlike other churches we have seen (for example, FIG. 16–5), at Saint-Savin the barrel vault is unbroken by projecting transverse arches, making it ideally suited for paintings.

The paintings on the high vaults of Saint-Savin survive almost intact, presenting scenes from the Hebrew Bible and New Testament. The nave was built c. 1095–1115, and the painters seem to have followed the masons immediately, probably using the same scaffolding. Perhaps their intimate involvement with the building process accounts for the vividness with which they portrayed the biblical story of the **TOWER OF BABEL** (FIG. 16–15).

According to the account in Genesis (11:1–9), God (represented here by a striding figure of Christ on the left) punished the prideful people who had tried to reach heaven by means of their own architectural ingenuity by scattering them and making their languages mutually unintelligible. The tower in the painting is Romanesque in style, reflecting the medieval practice of visualizing all stories in contemporary settings, thereby underlining their relevance for the contemporary audience. Workers haul heavy stone blocks toward the tower, presumably intending to lift them to masons on the top with the same hoist that has been used to haul up a bucket of mortar. The giant Nimrod, on the far right,

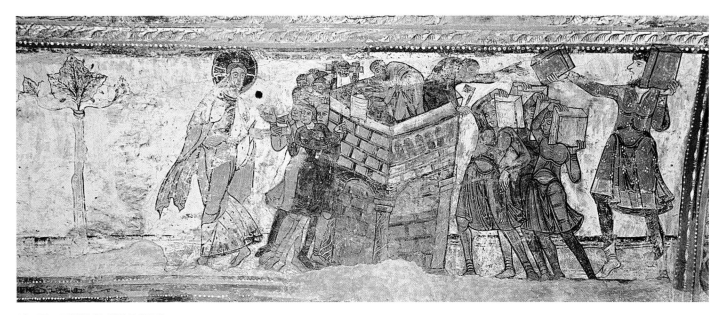

16–15 • TOWER OF BABEL
Detail of painting in nave vault, abbey church of Saint-Savin-sur-Gartempe, Poitou, France. c. 1115.

simply hands over the blocks. These paintings embody the energy and narrative vigor that characterizes Romanesque art. A dynamic figure of God confronts the wayward people, stepping away from them even as he turns back, presumably to scold them. The dramatic movement, monumental figures, bold outlines, broad areas of color, and patterned drapery all promote the legibility of these pictures to viewers looking up in the dim light from far below. The team of painters working here did not use the *buon fresco* technique favored in Italy for its durability, but they did moisten the walls before painting, which allowed some absorption of pigments into the plaster, making them more permanent than paint applied to a dry surface.

THE CATHEDRAL OF THE VIRGIN AND ST. STEPHEN AT SPEYER The imperial cathedral at Speyer in the Rhine River Valley was a colossal structure. An Ottonian, wooden-roofed church built between 1030 and 1060 was given a masonry vault c. 1080–1106 (**FIG. 16–16**). Massive compound piers mark each nave bay and support the transverse ribs of a groin vault that

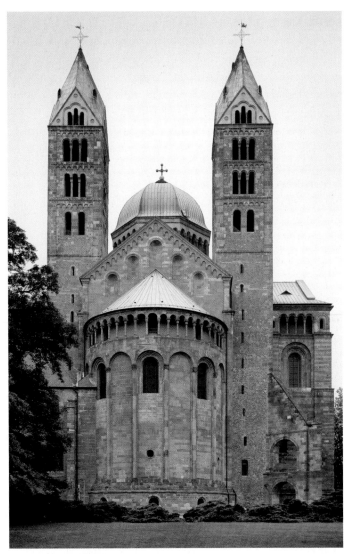

16-17 • EXTERIOR, SPEYER CATHEDRAL
c. 1080–1106 and second half of the 12th century.

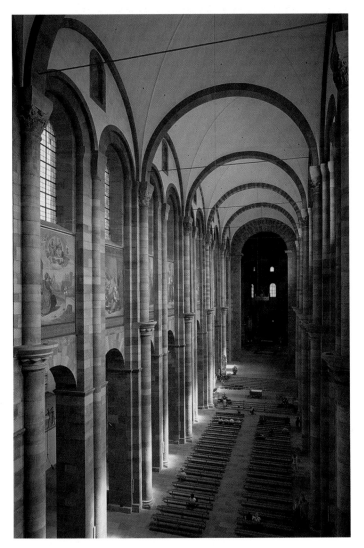

16-16 • INTERIOR, SPEYER CATHEDRAL
Rhineland-Palatinate, Germany. As remodeled c. 1080–1106.

rises to a height of over 100 feet. These compound piers alternate with smaller piers supporting the vaults of the aisle bays. This rhythmic, alternating pattern of heavy and light elements, first suggested in Ottonian wooden-roofed architecture (see FIG. 15–23), became an important design element in Speyer. Since groin vaults concentrate the weight and thrust of the vault on the four corners of the bay, they relieve the stress on the side walls of the building. Large windows can be safely inserted in each bay to flood the building with light.

The exterior of Speyer Cathedral emphasizes its Ottonian and Carolingian background. Soaring towers and wide transepts mark both ends of the building, although a narthex, not an apse, stands at the west. A large apse housing the high altar abuts the flat wall of the choir; transept arms project at each side; a large octagonal tower rises over the crossing; and a pair of tall slender towers flanks the choir (**FIG. 16–17**). A horizontal arcade forms an exterior gallery at the top of the apse and transept wall, recalling the Italian practice we saw at Pisa (see FIG. 16–10).

DURHAM CATHEDRAL In Durham, an English military outpost near the Scottish border, a prince-bishop held both secular and religious authority. For his headquarters he chose a defensive site where the bend in the River Wear formed a natural moat. Durham grew into a powerful fortified complex including a castle, a monastery, and a cathedral. The great tower of the castle defended against attack from the land, and an open space between buildings served as the courtyard of the castle and the cathedral green.

DURHAM CATHEDRAL, begun in 1087 and vaulted starting in 1093, is an impressive example of Norman Romanesque, but like most buildings that have been in continuous use, it has been altered several times (**FIG. 16-18**). The nave retains its Norman character, but the huge circular window lighting the choir is a later Gothic addition. The cathedral's size and décor are ambitious. Enormous compound piers and robust columnar piers form the nave arcade and establish a rhythmic alternation. The columnar piers are carved with chevrons, spiral fluting, and diamond patterns, and some have scalloped, cushion-shape capitals. The richly carved arches that sit on them have multiple round moldings and chevron ornaments. All this carved ornamentation was originally painted.

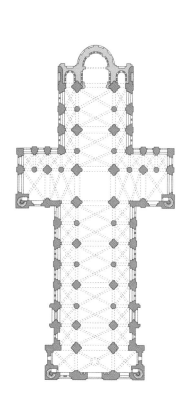

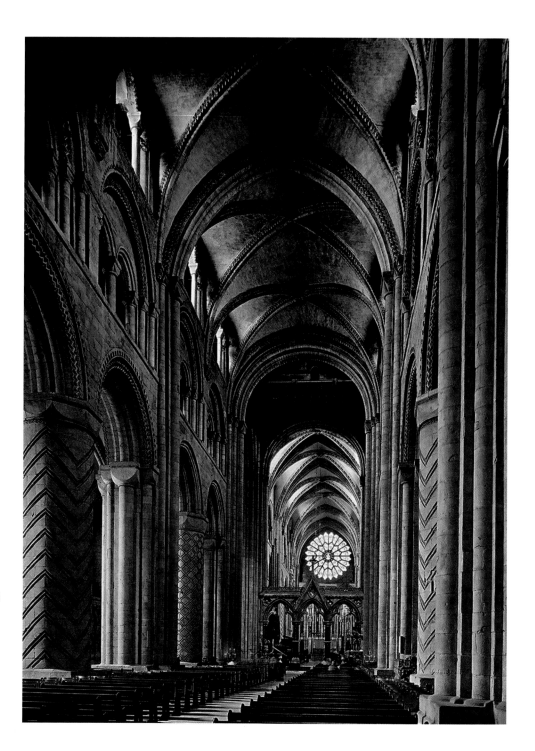

16-18 • PLAN (A) AND INTERIOR (B) OF DURHAM CATHEDRAL
Northern England. 1087–1133. Original east end replaced by a Gothic choir, 1242–c. 1280. Vault height about 73′ (22.2 m).

Explore the architectural panoramas of Durham Cathedral on myartslab.com

Above the cathedral's massive piers and walls rises a new system of ribbed groin vaults. Romanesque masons in Santiago de Compostela, Cluny, Fontenay, Speyer, and Durham were all experimenting with stone vaulting—and adopted different solutions. The Durham builders divided each bay with two pairs of diagonal crisscrossing rounded ribs and so kept the crowns of the vaults close in height to the keystones of the pointed transverse arches. Although this allows the eye to run smoothly down the length of the vault, and from vault to vault down the expanse of the nave, the richly carved zigzagging moldings on the ribs themselves invite us to linger over each bay, acknowledging traditional Romanesque bay division. This new system of ribbed groin vaulting will become a hallmark of Gothic architecture, though there it will create a very different aesthetic effect.

SECULAR ARCHITECTURE: DOVER CASTLE, ENGLAND

The need to provide for personal security in a time of periodic local warfare and political upheaval, as well as the desire to glorify the house of Christ and his saints, meant that communities used much of their resources to build castles and churches. Fully garrisoned, castles were sometimes as large as cities. In the twelfth century, **DOVER CASTLE**, safeguarding the southeastern coast of England from invasion, was a bold manifestation of military power (**FIG. 16–19**). It illustrates the way in which a key defensive position developed over the centuries.

The Romans had built a lighthouse on the point where the English Channel separating England and France narrows. The Anglo-Saxons added a church (both lighthouse and church can be seen in FIGURE 16–19 behind the tower, surrounded by the remains of earthen walls). In the early Middle Ages, earthworks topped by wooden walls provided a measure of security, and a wooden tower signified an important administrative building and residence. The advantage of fire-resistant walls was obvious, and in the twelfth and thirteenth centuries, military engineers replaced the timber tower and palisades with stone walls. They added the massive stone towers we see today.

The Great Tower, as it was called in the Middle Ages (but later known as a **keep** in England, and donjon in France), stood in a courtyard (called the bailey) surrounded by additional walls. Ditches outside the walls added to their height. In some castles, ditches were filled with water to form moats. A gatehouse—perhaps

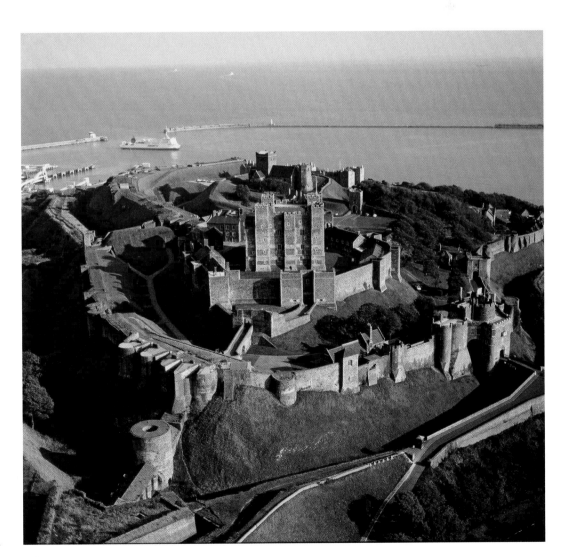

16–19 • DOVER CASTLE
Southern England.

Aerial view overlooking the harbor and the English Channel. Center distance: Roman lighthouse tower, rebuilt Anglo-Saxon church, earthworks. Center: Norman Great Tower, surrounding earthworks and wall, twelfth century. Outer walls, thirteenth century. Modern buildings have red tiled roofs. The castle was used in World War II and is now a museum.

The most important imagery on a Romanesque portal appears on the semicircular **tympanum** directly over the door—often a hierarchically scaled image of abstract grandeur such as Christ in Majesty or Christ presiding over the Last Judgment—as well as on the lintel beneath it. **Archivolts**—curved moldings composed of the wedge-shaped stone voussoirs of the arch—frame the tympanum. On both sides of the doors, the **jambs** (vertical elements) and occasionally a central pier (called the **trumeau**), support the lintel and archivolts, providing further fields for figures, columns, or narrative friezes. The jambs can extend forward to form a porch.

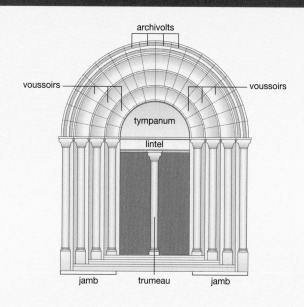

Watch an architectural simulation about the Romanesque church portal on myartslab.com

with a drawbridge—controlled the entrance. In all castles, the bailey was filled with buildings, the most important of which was the lord's hall; it was used to hold court and for feasts and ceremonial occasions. Timber buildings housed troops, servants, and animals. Barns and workshops, ovens and wells were also needed—the castle had to be self-sufficient.

If enemies broke through the outer walls, the castle's defenders retreated to the Great Tower. In the thirteenth century, the builders at Dover doubled the walls and strengthened them with towers, even though the castle's position on cliffs overlooking the sea made scaling the walls nearly impossible. The garrison could be forced to surrender only by starving its occupants.

During Dover Castle's heyday, improvements in farming and growing prosperity provided the resources for increased building activity across Europe. Churches, castles, halls, houses, barns, and monasteries proliferated. The buildings that still stand—despite the ravages of weather, vandalism, neglect, and war—testify to the technical skills and creative ingenuity of the builders and the power, local pride, and faith of the patrons.

ARCHITECTURAL SCULPTURE

Architecture dominated the arts in the Romanesque period—not only because it required the material and human resources of entire communities, but because it provided the physical context for a revival of the art of monumental stone sculpture, an art that had been almost dormant in Europe for 500 years. The "mute" façades used in early medieval buildings (see FIG. 15–17) were transformed by Romanesque sculptors into "speaking" façades with richly carved portals projecting bold symbolic and didactic programs to

the outside world (see FIG. 16–21). Christ Enthroned in Majesty might be carved over the entrance, and increasing importance is accorded to the Virgin Mary. The prophets, kings, and queens of the Hebrew Bible were seen by medieval Christians as precursors of people and events in the New Testament, so these were depicted, and we can also find representations of contemporary bishops, abbots, other noble patrons, and even ordinary folk. A profusion of monsters, animals, plants, geometric ornament, allegorical figures such as Lust and Greed, and depictions of real and imagined buildings surround the sculpture within its architectural setting. The elect rejoice in heaven with the angels; the damned suffer in hell, tormented by demons; biblical and historical tales come alive. All these events seem to take place in a contemporary medieval setting, and they are juxtaposed with scenes drawn from the viewer's everyday life.

These innovative portals are among the greatest artistic achievements of Romanesque art, taking the central messages of the Christian Church out of the sanctuary (see FIGS. 8–6, 8–11) and into the public spaces of medieval towns. And figural sculpture appeared not only at entrances, but on the capitals of interior as well as exterior piers and columns, and occasionally spread all over the building in friezes, on corbels, even peeking around cornices or from behind moldings. There was plenty of work for stone sculptors on Romanesque building sites.

WILIGELMO AT THE CATHEDRAL OF MODENA

The spirit of ancient Rome pervades the sculpture of Romanesque Italy, and the sculptor Wiligelmo may have been inspired by Roman sarcophagi still visible in cemeteries when he carved horizontal reliefs across the west façade of Modena Cathedral,

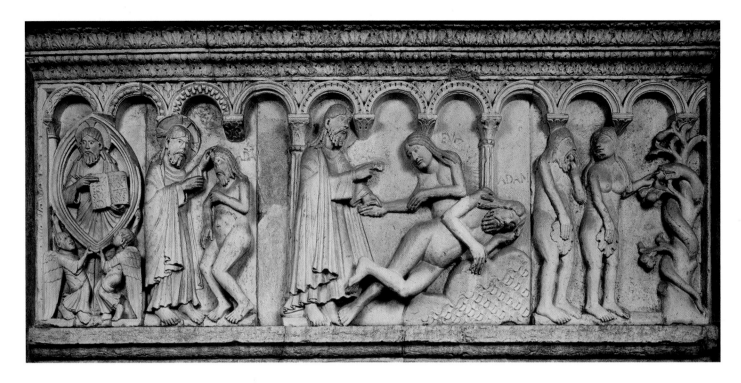

16-20 • Wiligelmo CREATION AND FALL OF ADAM AND EVE, WEST FAÇADE, MODENA CATHEDRAL
Emilia, Italy. Building begun 1099; sculpture c. 1099. Height approx. 3′ (92 cm).

c. 1099. Wiligelmo took his subjects here from Genesis, focusing on events from the **CREATION AND FALL OF ADAM AND EVE** (**FIG. 16-20**). On the far left, God, in a **mandorla** (body halo) supported by angels, appears in two persons as both Creator and Christ, identified by a cruciform halo. Following this iconic image, the narrative of creation unfolds in three scenes, from left to right: God brings Adam to life, then brings forth Eve from Adam's side, and finally Adam and Eve cover their genitals in shame as they greedily eat fruit from the forbidden tree, around which the wily serpent twists.

Wiligelmo's deft carving gives these figures a strong three-dimensionality. The framing arcade establishes a stagelike setting, with the rocks on which Adam lies and the tempting tree of paradise serving as stage props. Wiligelmo's figures exude life and personality. They convey an emotional connection with the narrative they enact, and bright paint, now almost all lost, must have increased their lifelike impact still further. An inscription at Modena proclaims, "Among sculptors, your work shines forth, Wiligelmo." This self-confidence turned out to be justified. Wiligelmo's influence can be traced throughout Italy and as far away as Lincoln Cathedral in England.

THE PRIORY CHURCH OF SAINT-PIERRE AT MOISSAC

The Cluniac priory of Saint-Pierre at Moissac was a major stop on the pilgrimage route to Santiago de Compostela. The shrine at the site dates back to the Carolingian period, and after affiliating with Cluny in 1047, the monastery prospered from the donations of pilgrims and local nobility, as well as from its control of shipping on the nearby Garonne River. During the twelfth century, Moissac's monks launched an ambitious building campaign, and much of the sculpture from the cloister (c. 1100, under Abbot Ansquetil) and the church portal and porch (1100–1130, under Abbot Roger) has survived. The quantity and quality of the carving here are outstanding.

A flattened figure of **CHRIST IN MAJESTY** dominates the huge tympanum (**FIG. 16-21**), visualizing a description of the Second Coming in Chapters 4 and 5 of Revelation. This gigantic Christ is an imposing, iconic image of enduring grandeur. He is enclosed by a mandorla; a cruciform halo rings his head. Although Christ is stable, even static, in this apocalyptic appearance, the four winged creatures symbolizing the evangelists—Matthew the man (upper left), Mark the lion (lower left), Luke the ox (lower right), and John the eagle (upper right)—who frame him on either side move with dynamic force, as if activated by the power of his unchanging majesty. Rippling bands extending across the tympanum at Christ's sides and under him—perhaps representing waves in the "sea of glass like crystal" (Revelation 4:6)—delineate three registers in which 24 elders with "gold crowns on their heads" and either a harp or a gold bowl of incense (Revelation 4:4 and 5:8) twist nervously to catch a glimpse of Christ's majestic arrival. Each of them takes an individually conceived pose and gesture, as if the sculptors were demonstrating their ability to represent three-dimensional human figures turning in space in a variety of postures, some quite challengingly contorted. Foliate and geometric ornament covers every surface surrounding this tableau. Monstrous

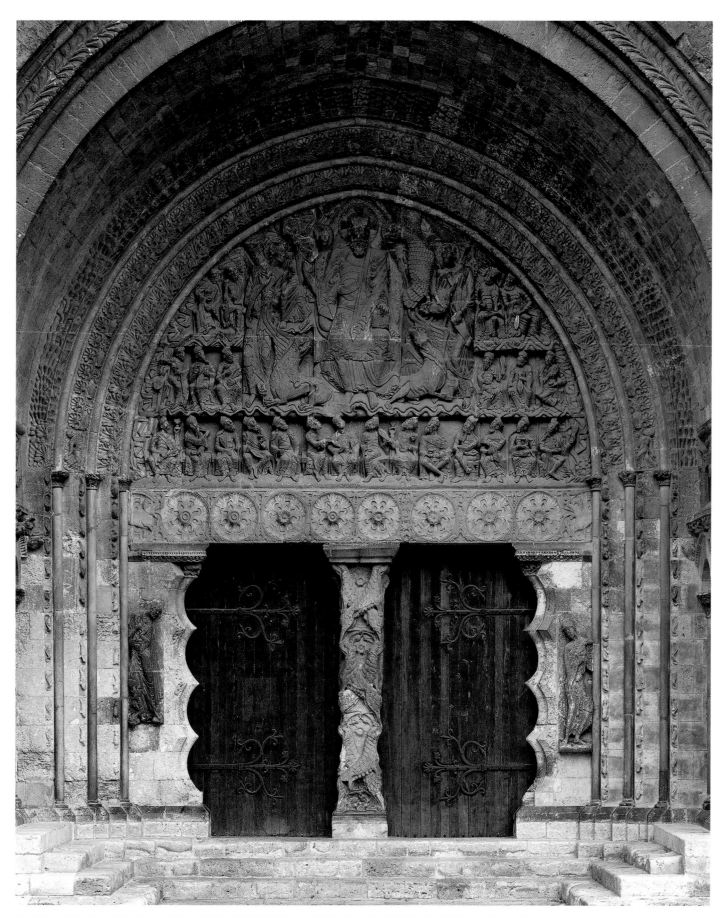

16–21 • SOUTH PORTAL, TYMPANUM SHOWING CHRIST IN MAJESTY, PRIORY CHURCH OF SAINT-PIERRE, MOISSAC

Tarn-et-Garonne, France. c. 1115.

heads in the lower corners of the tympanum spew ribbon scrolls, and other creatures appear at each end of the lintel, their tongues growing into ropes encircling acanthus rosettes.

Two side jambs and a trumeau (central portal pier) support the weight of the lintel and tympanum. These elements have scalloped profiles that playfully undermine the ability of the colonettes on the door jambs to perform their architectural function and give a sense of instability to the lower part of the portal, as if to underline the ability of the stable figure of Christ in Majesty to provide his own means of support. St. Peter and the prophet Isaiah flank the doorway on the jambs. Peter, a tall, thin saint, steps away from the door but twists back to look through it.

16-22 • TRUMEAU, SOUTH PORTAL, PRIORY CHURCH OF SAINT-PIERRE, MOISSAC

c. 1115.

The **TRUMEAU** (**FIG. 16-22**) is faced by a crisscrossing pair of lions. On the side visible here, a prophet, usually identified as Jeremiah, twists toward the viewer, with legs crossed in a pose that would challenge his ability to stand, much less move. The sculptors placed him in skillful conformity with the constraints of the scalloped trumeau; his head, pelvis, knees, and feet moving into the pointed cusps. This decorative scalloping, as well as the trumeau lions and lintel rosettes, may reveal influence from Islamic art. Moissac was under construction shortly after the First Crusade, when many Europeans first encountered the Islamic art and architecture of the Holy Land. People from the region around Moissac participated in the crusade; perhaps they brought Islamic objects and ideas home with them.

A porch covering the area in front of the portal at Moissac provided a sheltered space for pilgrims to congregate and view the sculpture. The side walls of this porch are filled with yet more figural sculptures (**FIG. 16-23**), but the style of presentation changes here with the nature of the subject matter and the response that was sought from the audience. Instead of the stylized and agitated figures on the tympanum and its supports, here sculptors have substituted more lifelike and approachable human beings. Rather than embodying unchanging theological notions or awe-inspiring apocalyptic appearances, these figures convey human frailties and torments in order to persuade viewers to follow the Church's moral teachings.

Behind the double arcade framework of the lower part of the wall are hair-raising portrayals of the torments of those who fall prey to the two sins that particularly preoccupied twelfth-century moralists: avarice (greed and the hoarding of money) and lust (sexual misconduct). At bottom left, a greedy man is attacked by demons while the money bags around his neck weigh him down, strangling him. On the other side of the column, his counterpart, the female personification of lust (*luxuria*), is confronted by a pot-bellied devil while snakes bite at her breasts and another predator attacks her pubic area. In the scene that extends behind the column and across the wall above them, *luxuria* reappears, kneeling beside the deathbed of the miser, as devils make off with his money and conspire to make his final moments miserable. These scenes are made as graphic as possible so that medieval viewers could identify with these situations, perhaps even feel the pain in their own bodies as a warning to avoid the behaviors that lead to such gruesome consequences.

In the strip of relief running across the top of the wall, the mood is calmer, but the moral message remains strong and clear, at least for those who know the story. The sculpture recounts the tale of Lazarus and Dives (Luke 16:19–31), the most popular parable of Jesus in Romanesque art. The broad scene to the right shows the greedy, rich Dives, relishing the feast that is being laid before him by his servants and refusing even to give his table scraps to the leprous beggar Lazarus, spread out at lower left. Under the table, dogs—unsatisfied by leftovers from Dives' feast—turn to lick the pus from Lazarus' sores as the poor man draws his last breath. The

The parable of Lazarus and Dives that runs across the top of this wall retains its moral power to our own day. This was the text of Martin Luther King's last Sunday sermon, preached only a few days before his assassination in Memphis, where he was supporting a strike by sanitation workers. Perhaps he saw the parable's image of the table scraps of the rich and greedy as particularly appropriate to his context. Just as in this portal, in Dr. King's sermon the story is juxtaposed with other stories and ideas to craft its interpretive message in a way that is clear and compelling for the audience addressed.

angel above Lazarus, however, transfers his soul (represented as a naked baby, now missing) to the lap of Abraham (a common image of paradise), where he is cuddled by the patriarch, the eternal reward for a pious life. The fate of Dives is not portrayed here, but it is certainly evoked on the lower section of this very wall in the torments of the greedy man, whom we can now identify with Dives himself. Clearly some knowledge is necessary to recognize the characters and story of this sculpture, and a "guide" may have been present to aid those viewers who did not readily understand, as is the case with many modern tourists. Nonetheless, the moral

of sin and its consequences can be read easily and directly from the narrative presentation. This is not scripture for an ignorant illiterate population. It is a sermon sculpted in stone.

THE CHURCH OF SAINT-LAZARE AT AUTUN

A different sculptural style and another subject appear at Autun on the portal of the church of Saint-Lazare (see "A Closer Look," opposite), which was built in the first half of the twelfth century as part of the cathedral complex at Autun to house the relics of St. Lazarus, becoming the cathedral of Autun itself only in 1195. The

A CLOSER LOOK | The Last Judgment Tympanum at Autun

by Gislebertus (?), west portal, cathedral of Saint-Lazare.
Autun, Burgundy, France. c. 1120–1130 or 1130–1145.

In one of the most endearing vignettes, an angel pushes one of the saved up through an open archway and into the glorious architectural vision of heaven. Another figure at the angel's side reaches up, impatient for his turn to be hoisted up into paradise.

Christ's mother, Mary, is enthroned as queen of heaven. Below, St. Peter—identified by the large keys slung over his shoulder—performs his duties as heavenly gatekeeper, clasping the hands of someone waiting to gain entrance.

This inscription proclaims "I alone dispose of all things and crown the just. Those who follow crime I judge and punish." Clearly, some of the viewers could read Latin.

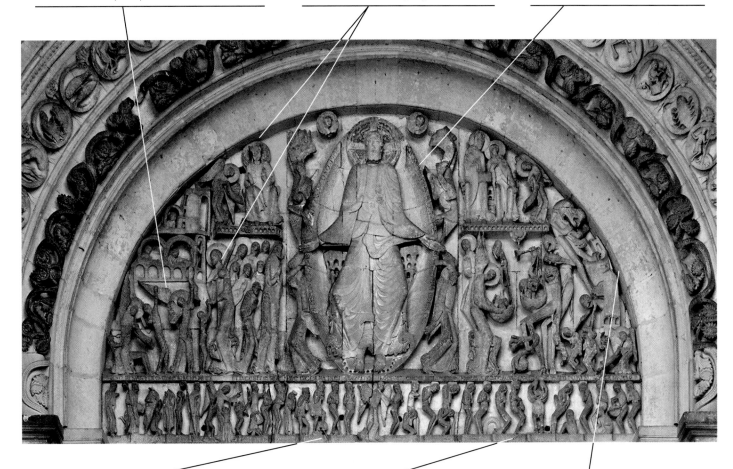

The cross (a badge of Jerusalem) and scallop shell (a badge of Santiago de Compostela) identify these two figures as former pilgrims. The clear message is that participation in pilgrimage will be a factor in their favor at the Last Judgment.

The incised ornament on these sarcophagi is quite similar to that on ancient Roman sarcophagi, one of many indications that the Autun sculptors and masons knew the ancient art created when Autun was a Roman city.

Interestingly, hell is represented here as a basilica, with a devil emerging from the toothy maw that serves as a side entrance, capturing sinners for eternal torment. The devil uses a sharp hook to grab *luxuria*, the female personification of lust.

 View the Closer Look for the Last Judgment tympanum at Autun on myartslab.com

tympanum portrays the Last Judgment, in which Christ—enclosed in a mandorla held by two svelte angels—has returned at the end of time to judge the cowering, naked humans whose bodies rise from their sarcophagi along the lintel at his feet. The damned writhe in torment at Christ's left (our right), while on the opposite side the saved savor serene bliss. The inscribed message on the side of the damned reads: "Here let fear strike those whom earthly error binds, for their fate is shown by the horror of these figures," and under the blessed: "Thus shall rise again everyone who does not

lead an impious life, and endless light of day shall shine for him" (translations from Grivot and Zarnecki).

Another text, right under the feet of Christ, ascribes the Autun tympanum to a man named Gislebertus—*Gislebertus hoc fecit* ("Gislebertus made this"). Traditionally, art historians have interpreted this inscription as a rare instance of a twelfth-century artist's signature, assigning this façade and related sculpture to an individual named Gislebertus, who was at the head of a large workshop of sculptors. Recently, however, art historian Linda Seidel

has challenged this reading, arguing that Gislebertus was actually a late Carolingian count who had made significant donations to local churches. Like the names inscribed on many academic buildings of American universities, this legendary donor's name would have been evoked here as a reminder of the long and rich history of secular financial support in Autun, and perhaps also as a challenge to those currently in power to respect and continue that venerable tradition of patronage themselves.

Thinner and taller than their counterparts at Moissac, stretched out and bent at sharp angles, the stylized figures at Autun are powerfully expressive and hauntingly beautiful. As at Moissac, a huge, **hieratic** figure of Christ dominates the composition at the center of the tympanum, but the surrounding figures are not arranged here in regular compartmentalized tiers. Their posture and placement conform to their involvement in the story they enact. Since that story is filled with human interest and anecdotal narrative detail, viewers can easily project themselves into what is going on. On the lintel, angels physically assist the resurrected bodies rising from their tombs, guiding them to line up and await their turn at being judged. Ominously, a pair of giant, pincerlike hands descends aggressively to snatch one of the damned on the right side of the lintel (as we look at it). Above these hands, the archangel Michael competes with devils over the fate of someone whose judgment is being weighed on the scales of good and evil. The man himself perches on the top of the scale, hands cupped to his mouth to project his pleas for help toward the Savior. Another man hides nervously in the folds of Michael's robe, perhaps hoping to escape judgment or cowering from the prospect of possible damnation.

By far the most riveting players in this drama are the frenzied, grotesque, screaming demons who grab and torment the damned and even try, in vain, to cheat by yanking the scales to favor damnation. The fear they inspire, as well as the poignant portrayal of the psychological state of those whom they torment, would have been moving reminders to medieval viewers to examine the way they were leading their own lives, or perhaps to seek the benefits of entering the doors in front of them to participate in the community of the Church.

The creation of lively narrative scenes within the geometric confines of capitals (called **historiated capitals**) was an important Romanesque innovation in architectural sculpture. The same sculptors who worked on the Autun tympanum carved historiated capitals for pier pilasters inside the church. Two capitals (**FIG. 16-24**) depict scenes from the childhood of Jesus drawn from Matthew 2:1–18. In one capital, the Magi—who have previously adored and offered gifts to the child Jesus—are interrupted in their sleep by an angel who warns them not to inform King Herod of the location of the newborn king of the Jews. In an ingenious compositional device, the sculptor has shown the reclining Magi and the head of their bed as if viewed from above, whereas the angel and the foot of the bed are viewed from the side. This allows us to see clearly the angel—who is appearing to them in a dream—as he touches the hand of the upper Magus, whose eyes

have suddenly popped open. As on the façade, the sculptor has conceived this scene in ways that emphasize the human qualities of its story, not its deep theological significance. With its charming, doll-like figures, the other capital shows an event that occurred just

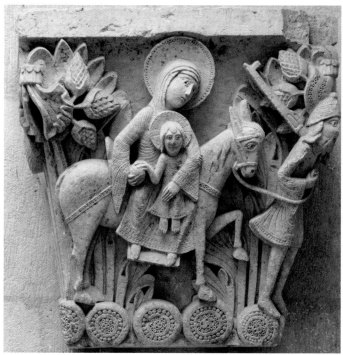

16-24 • THE MAGI ASLEEP (A) AND THE FLIGHT INTO EGYPT (B)
Capitals from the choir pier pilasters, Cathedral of Saint-Lazare, Autun, Burgundy, France. c. 1125.

after the Magi's dream: Joseph, Mary, and Jesus are journeying toward Egypt to escape King Herod's order to murder all young boys so as to eliminate the newborn royal rival the Magi had journeyed to venerate.

SCULPTURE IN WOOD AND BRONZE

Painted wood was commonly used when abbey and parish churches of limited means commissioned statues. Wood was not only cheap; it was lightweight, a significant consideration since these devotional images were frequently carried in processions. Whereas wood seems to have been a sculptural medium that spread across Europe, three geographic areas—the Rhineland, the Meuse River Valley, and German Saxony—were the principal metalworking centers. Bronze sculpture was produced only for wealthy aristocratic and ecclesiastical patrons. It drew on a variety of stylistic sources, including the work of contemporary Byzantine and Italian artists, as well as Classical precedents as reinterpreted by the sculptors' Carolingian and Ottonian forebears.

CHRIST ON THE CROSS (MAJESTAT BATLLÓ)

This mid-twelfth-century painted wooden crucifix from Catalunya, known as the **MAJESTAT BATLLÓ** (**FIG. 16-25**), presents a clothed, triumphant Christ, rather than the seminude figure we have seen at Byzantine Daphni (see FIG. 8-22) or on the Ottonian Gero Crucifix (see FIG. 15-24). This Christ's royal robes emphasize his kingship, although his bowed head, downturned mouth, and heavy-lidded eyes convey a quiet sense of sadness or introspection. The hem of his long, medallion-patterned tunic has pseudo-kufic inscriptions—designs meant to resemble Arabic script—a reminder that silks from Islamic Spain were highly prized in Europe at this time.

MARY AS THE THRONE OF WISDOM

Any Romanesque image of Mary seated on a throne and holding the Christ Child on her lap is known as "The Throne of Wisdom." In a well-preserved example in painted wood dating from the second half of the twelfth century (**FIG. 16-26**), Mother and Child are frontal and regal. Mary's thronelike bench symbolized the lion-throne of Solomon, the Hebrew Bible king who represented earthly wisdom in the Middle Ages. Mary, as Mother and

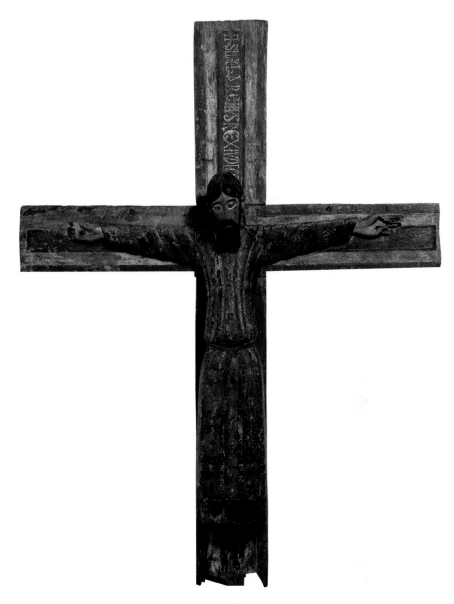

16-25 • CRUCIFIX (MAJESTAT BATLLÓ)
Catalunya, Spain. Mid-12th century. Polychromed wood, height approx. 37¾″ (96 cm).
© MNAC—Museu Nacional d'Art de Catalunya, Barcelona.

"God-bearer" (the Byzantine *Theotokos*), gave Jesus his human nature. She forms a throne on which he sits in majesty, but she also represents the Church. Although the Child's hands are missing, we can assume that the young Jesus held a book—the Word of God—in his left hand and raised his right hand in blessing.

Such statues of the Virgin and Child served as cult objects on the altars of many churches during the twelfth century. They also sometimes took part in the liturgical dramas becoming popular in church services at this time. At the feast of the Epiphany, celebrating the arrival of the Magi to pay homage to the young Jesus, townspeople representing the Magi acted out their journey by searching through the church for the newborn king. The roles of Mary and Jesus were "acted" by such sculptures, which the "Magi" discovered on the altar. On one of the capitals from Autun

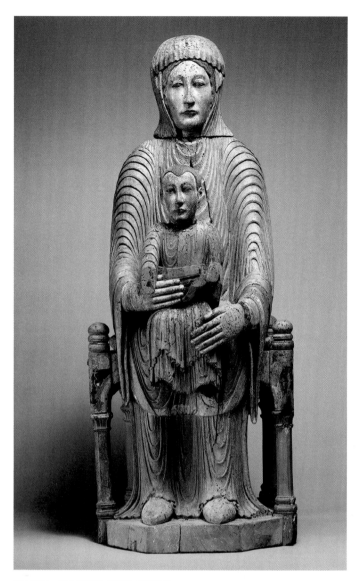

16-26 • VIRGIN AND CHILD
Auvergne region, France. Late 12th century. Oak with polychromy, height 31″ (78.7 cm). Metropolitan Museum of Art, New York. Gift of J. Pierpont Morgan, 1916 (16.32.194)

in FIGURE 16-24, the Virgin and Child who sit on the donkey in the Flight into Egypt may record the theatrical use of a wooden statue, strapped to the back of a wooden donkey, that would have been rolled into the church on wheels, possibly referenced by the round forms at the base of the capital.

TOMB OF RUDOLF OF SWABIA

The oldest-known bronze tomb effigy (recumbent portraits of the deceased) is that of **KING RUDOLF OF SWABIA** (**FIG. 16-27**), who died in battle in 1080. The spurs on his oversized feet identify him as a heroic warrior, and he holds a scepter and cross-surmounted orb, emblems of Christian kingship. Although the tomb is in the cathedral of Merseburg, in Saxony, the effigy has been attributed to an artist originally from the Rhine Valley. Nearly life-size, it was cast in one piece and gilt, though few traces of the

gilding survive. The inscription around the frame was incised after casting, and glass paste or semiprecious stones may have originally been set into the eyes and crown. We know that during the battle that ultimately led to Rudolph's death he lost a hand—which was mummified separately and kept in a leather case—but the sculptor of his effigy presents him idealized and whole.

16-27 • TOMB COVER WITH EFFIGY OF KING RUDOLF OF SWABIA
Saxony, Germany. c. 1080. Bronze with niello, approx. 6′5½″ × 2′2½″ (1.97 × 0.68 m). Cathedral of Merseburg, Germany.

16-28 • Renier of Huy BAPTISMAL FONT, NOTRE-DAME-AUX-FONTS
Liège, France. 1107–1118. Bronze, height 23⅝″ (60 cm); diameter 31¼″ (79 cm).
Now in the church of Saint-Barthélémy, Liège.

RENIER OF HUY

Bronze sculptor Renier of Huy (Huy is near Liège in present-day Belgium) worked in the Mosan region under the profound influence of classicizing early medieval works of art, as well as the humanistic learning of Church scholars. Hellinus of Notre-Dame-aux-Fonts in Liège (abbot 1107–1118) commissioned a bronze **BAPTISMAL FONT** from Renier (**FIG. 16-28**) that was inspired by the basin carried by 12 oxen in Solomon's Temple in Jerusalem (I Kings 7:23–24). Christian commentators identified the 12 oxen as the 12 apostles and the basin as the baptismal font, and this interpretation is given visual form in Renier's work. On the sides of the font are images of St. John the Baptist preaching and baptizing Christ, St. Peter baptizing the Roman soldier Cornelius, and St. John the Evangelist baptizing the philosopher Crato. Renier models sturdy but idealized bodies—nude or with clinging drapery—that move and gesture with lifelike conviction, infused with dignity, simplicity, and harmony. His understanding of human anatomy and movement must derive from his close observation of the people around him. He placed these figures within defined landscape settings, standing on an undulating ground line, and separated into scenes by miniature trees. Water rises in a mound of rippling waves (in Byzantine fashion) to cover nude figures discreetly.

TEXTILES AND BOOKS

Among the most admired arts during the Middle Ages are those that later critics patronized as the "minor" or "decorative" arts. Although small in scale, these works are often produced with technical virtuosity from very precious materials, and they were vital to the Christian mission and devotion of the institutions that housed them.

Artists in the eleventh and twelfth centuries were still often monks and nuns. They labored within monasteries as calligraphers and painters in the scriptorium to produce books and as metalworkers to craft the enamel- and jewel-encrusted works used in liturgical services. They also embroidered the vestments, altar coverings, and wall hangings that clothed both celebrants and settings in the Mass. Increasingly, however, secular urban workshops supplied the aristocratic and royal courts with textiles, tableware, books, and weapons, for their own use or as donations to religious institutions.

CHRONICLING HISTORY

Romanesque artists were commissioned not only to illustrate engaging stories and embody important theological ideas within the context of sacred buildings and sacred books. They also created visual accounts of secular history, where moralizing was one of the principal objectives of pictorial narrative.

THE BAYEUX EMBROIDERY Elaborate textiles, including embroideries and tapestries, enhanced a noble's status and were thus necessary features in castles and palaces. The Bayeux Embroidery (see page 488) is one of the earliest examples to have survived. This extended narrative strip chronicles the events leading to Duke William of Normandy's conquest of England in 1066. The images depicted on the long embroidered band of linen may have been drawn by a Norman designer since there is a clear Norman bias in the telling of the story, but style suggests that it may have been Anglo-Saxons who did the actual needlework. This represents the kind of secular art that must once have been part of most royal courts. It could be rolled up and transported from residence to residence as the noble Norman owner traveled throughout his domain, and some have speculated that it may have been the backdrop at banquets for stories sung by professional performers who could have received their cues from the identifying descriptions that accompany most scenes. Eventually the embroidery was given to Bayeux Cathedral, perhaps by Bishop Odo, William's half-brother; we know it was displayed around the walls of the cathedral on the feast of the relics.

Rarely has art spoken more vividly than in the Bayeux Embroidery, a strip of embroidered linen that recounts the history of the Norman Conquest of England. Its designer was a skillful storyteller who used a staggering number of images to chronicle this history. In the 50 surviving scenes there are more than 600 human figures, 700 horses, dogs, and other creatures, and 2,000 inch-high letters.

On October 14, 1066, William, Duke of Normandy, after a hard day of fighting, became William the Conqueror, king of England. The story told in embroidery seeks to justify his action, with the intensity of an eyewitness account: The Anglo-Saxon nobleman Harold initially swears his allegiance to William, but later betrays his vows, accepting the crown of England for himself. Unworthy to be king, he dies in battle at the hands of William and the Normans.

Harold is a heroic figure at the beginning of the story, but then events overtake him. After his coronation, cheering crowds celebrate—until Halley's Comet crosses the sky (**FIGS. 16-29, 16-30, 16-31**). The Anglo-Saxons, seeing the comet as a portent of disaster, cringe and point at this brilliant ball of fire with a flaming tail, and a man rushes to inform the new king. Harold slumps on his throne in the Palace of Westminster. He foresees what is to come: Below his feet is his vision of a ghostly

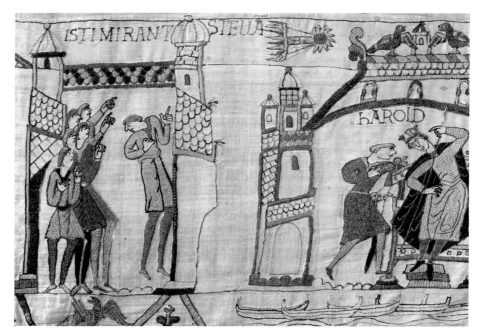

16-29 • MESSENGERS SIGNAL THE APPEARANCE OF HALLEY'S COMET, THE BAYEUX EMBROIDERY
Norman–Anglo-Saxon, perhaps from Canterbury, Kent, England. c. 1066–1082. Linen with wool embroidery, height 20″ (50.8 cm). Centre Guillaume le Conquérant, Bayeux, France.

fleet of Norman ships already riding the waves. Duke William has assembled the last great Viking flotilla on the Normandy coast.

The tragedy of this drama has spoken movingly to audiences over the centuries.

It is the story of a good man who, like Shakespeare's Macbeth, is overcome by his lust for power and so betrays his lord. The images of this Norman invasion also spoke to people during the darkest days of World War II.

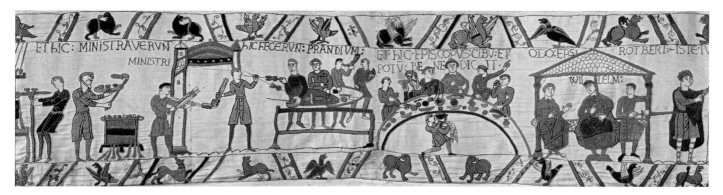

16-30 • BISHOP ODO BLESSING THE FEAST, THE BAYEUX EMBROIDERY
Norman–Anglo-Saxon, perhaps from Canterbury, Kent, England. c. 1066–1082. Linen with wool embroidery, height 20″ (50.8 cm). Centre Guillaume le Conquérant, Bayeux, France.

Odo and William are feasting before the battle. Attendants bring in roasted birds on skewers, placing them on a makeshift table made of the knights' shields set on trestles. The diners, summoned by the blowing of a horn, gather at a curved table laden with food and drink. Bishop Odo—seated at the center, head and shoulders above William to his right—blesses the meal while others eat. The kneeling servant in the middle proffers a basin and towel so that the diners may wash their hands. The man on Odo's left points impatiently to the next event, a council of war between William (now the central and tallest figure), Odo, and a third man labeled "Rotbert," probably Robert of Mortain, another of William's halfbrothers. Translation of text: "and here the servants (*ministra*) perform their duty. / Here they prepare the meal (*prandium*) / and here the bishop blesses the food and drink (*cibu et potu*). Bishop Odo. William. Robert."

 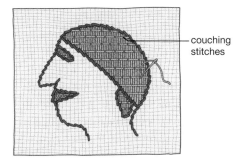

stem stitching

crosswise stitches

laid threads

couching stitches

When the Allies invaded Nazi-occupied Europe in June 1944, they took the same route in reverse from England to beaches on the coast of Normandy. The Bayeux Embroidery still speaks to us of the folly of human greed and ambition and of two battles that changed the course of history.

Although traditionally referred to as the "Bayeux Tapestry," this work is really an embroidery. In tapestry, the colored threads that create images or patterns are woven together during the process of production, completely covering the canvas ground that serves as their support; in embroidery, stitches are applied on top of a tightly woven fabric that serves as their support, as well as the ground behind the patterns they create. The embroiderers, probably Anglo-Saxon women, worked in tightly twisted wool that was dyed in eight colors. They used only two stitches: the quick, overlapping stem stitch that produced a slightly jagged line or outline, and the time-consuming laid-and-couched work used to form blocks of color. For the latter, the embroiderer first "laid" a series of long, parallel covering threads; then anchored them with a second layer of regularly spaced crosswise stitches; and finally tacked all the strands down with tiny "couching" stitches. Some of the laid-and-couched work was done in contrasting colors to achieve particular effects. The creative coloring is often fanciful: for example, some horses have legs in four different colors. Skin and other light-toned areas are represented by the bare linen cloth that formed the ground of the work.

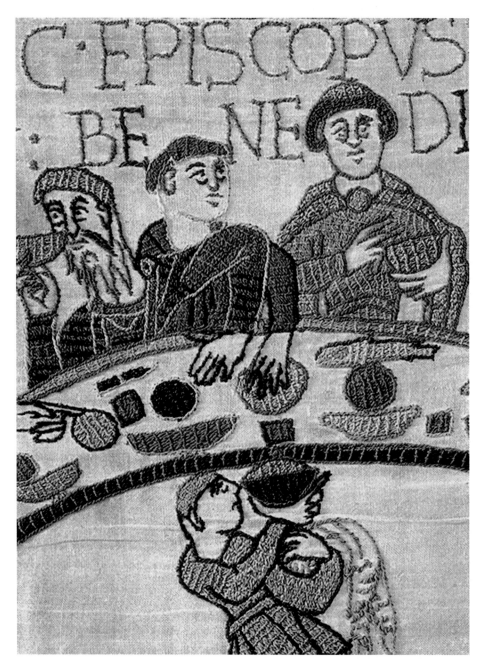

16–31 • DETAIL OF BISHOP ODO BLESSING THE FEAST (FIG. 16–30)

View the Closer Look for the Bayeux Embroidery on myartslab.com

THE WORCESTER CHRONICLE Another Romanesque chronicle is the earliest-known illustrated history book: the **WORCESTER CHRONICLE** (**FIG. 16–32**), written in the twelfth century by a monk named John. The pages shown here concern Henry I (r. 1100–1135), the second of William the Conqueror's sons to sit on the English throne. The text relates a series of nightmares the king had in 1130, in which his subjects demanded tax relief. The artist depicts the dreams with energetic directness. On the first night, angry farmers confront the sleeping king; on the second, armed knights surround his bed; and on the third, monks, abbots, and bishops present their case. In the fourth illustration, the king travels in a storm-tossed ship and saves himself by promising God that he will rescind the tax increase for seven years. The author of the Worcester Chronicle assured his readers that this story came from a reliable source, the royal physician Grimbald, who appears in the margins next to three of the scenes. The angry farmers capture our attention today because we seldom see working men with their equipment and simple clothing depicted in painting from this time.

SACRED BOOKS

Monastic scriptoria continued to be the centers of illustrated book production, which increased dramatically during the twelfth century. But the scriptoria sometimes employed lay scribes and artists who traveled from place to place. In addition to the books needed for the church services, scribes produced copies of sacred texts, scholarly commentaries, visionary devotional works, lives of saints, and collections of letters and sermons.

THE CODEX COLBERTINUS The portrait of **ST. MAT-THEW** from the Codex Colbertinus (**FIG. 16–33**) is an entirely Romanesque conception, quite different from Hiberno-Saxon and Carolingian author portraits. Like the sculptured pier figures of Silos (see **FIG. 16–1**), the evangelist stands within an architectural frame that completely surrounds him. He blesses and holds his book—rather than writing it—within the compact silhouette of his body. His dangling feet bear no weight, and his body has little sense of three-dimensionality, with solid blocks of color filling its strong outlines.

16–32 • John of Worcester **THOSE WHO WORK; THOSE WHO FIGHT; THOSE WHO PRAY—THE DREAM OF HENRY I, WORCESTER CHRONICLE**

Worcester, England. c. 1140. Ink and tempera on vellum, each page 12¾″ × 9⅜″ (32.5 × 23.7 cm). Corpus Christi College, Oxford. CCC MS. 157, pp. 382–383

16-33 • ST. MATTHEW FROM THE CODEX COLBERTINUS
c. 1100. Tempera on vellum, 7½″ × 4″ (19 × 10.16 cm).
Bibliothèque Nationale, Paris. MS lat. 254, fol. 10r

The text of Matthew's Gospel begins with a complementary block of ornament to the left of Matthew's portrait. The "L" of *Liber generationis* ("The book of the generation") is a framed picture formed of plants and animals—what art historians call a historiated initial. Dogs or catlike creatures and long-necked birds twist, claw, and bite each other and themselves while, in the center, two humans—one dressed and one nude—clamber up the letter. This manuscript was made in the region of Moissac at about the same time that sculptors were working on the

abbey church, and the stacking of intertwined animals here recalls the outer face of the Moissac trumeau (see FIGS. 16–21, 16–22).

THE GERMAN NUN GUDA In another historiated initial, this one from Westphalia in Germany, the nun Guda has a more modest presentation. In a **BOOK OF HOMILIES** (sermons), she inserted her self-portrait into the letter *D* and signed it as scribe and painter, "Guda, the sinful woman, wrote and illuminated this book" (**FIG. 16–34**). This is a simple colored drawing with darker blocks of color in the background, but Guda and her monastic sisters played an important role in the production of books in the twelfth century, and not all of them remain anonymous. Guda's image is the earliest signed self-portrait by a woman in western Europe. Throughout the Middle Ages, women were involved in the production of books as authors, scribes, painters, and patrons (see "Hildegard of Bingen," page 492).

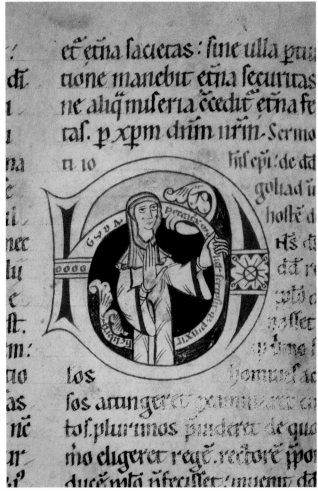

16-34 • The Nun Guda BOOK OF HOMILIES
Westphalia, Germany. Early 12th century. Ink on parchment.
Universitätsbibliothek Johann Christian Senckenberg, Frankfurt am Main, Germany. MS. Barth. 42, fol. 110v

We might expect women to have a subordinate position in the hierarchical and militaristic society of the twelfth century. On the contrary, aristocratic women took responsibility for managing estates during their male relatives' frequent absences in wars or while serving at court. And women also achieved positions of authority and influence as the heads of religious communities. Notable among them was Hildegard of Bingen (1098–1179).

Born into an aristocratic German family, Hildegard transcended the barriers that limited most medieval women. She began serving as leader of her convent in 1136, and about 1147 she founded a new convent near Bingen. Hildegard also wrote important treatises on medicine and natural science, invented an alternate alphabet, and was one of the most gifted and innovative composers of her age, writing not only motets and liturgical settings, but also a musical drama that is considered by many to be the first opera. Clearly a major, multitalented figure in the intellectual and artistic life of her time —comparison with the later Leonardo da Vinci comes to mind— she also corresponded with emperors, popes, and the powerful abbots Bernard of Clairvaux and Suger of Saint-Denis.

Following a command she claimed to have received from God in 1141, and with the assistance of her nuns and the monk Volmar, Hildegard began to record the mystical visions she had been experiencing since she was 5 years old. The resulting book, called the *Scivias* (from the Latin *scite vias lucis*, "know the ways of the light"), is filled not only with words but with striking images of the strange and wonderful visions themselves (**FIG. 16–35**). The opening page (**FIG. 16–36**) shows Hildegard receiving a flash of divine insight, represented by the tongues of flame encircling her head—she said, "a fiery light, flashing intensely, came from the open vault of heaven and poured through my whole brain"—while her scribe Volmar writes to her dictation. But was she also responsible for the arresting pictures that accompany the text in this book? Art historian Madeline Caviness thinks so, both because of their unconventional nature and because they conform in several ways to the "visionary" effects experienced by many people during migraines, which plagued Hildegard throughout her life but especially during her forties while she was composing the *Scivias*. She said of her visions, "My outward eyes are open. So I have never fallen prey to ecstacy in the visions, but I see them wide awake, day and night. And I am constantly fettered by sickness, and often in the grip of pain so intense that it threatens to kill me." (Translated in Newman, p. 16.)

Perhaps in this miniature Hildegard is using the large stylus to sketch on the wax tablets in her lap the pictures of her visions that were meant to accompany the verbal descriptions she dictates to Volmar, who sits at the right with a book in his hand, ready to write them down.

16–35 • Hildegard of Bingen
THE UNIVERSE
1927–1933 facsimile of Part I, Vision 3 of the *Liber Scivias* of Hildegard of Bingen. Original, 1150–1175.

Hildegard begins her description of this vision with these words: "After this I saw a vast instrument, round and shadowed, in the shape of an egg, small at the top, large in the middle, and narrowed at the bottom; outside it, surrounding its circumference, there was a bright fire with, as it were, a shadowy zone under it. And in that fire there was a globe of sparkling flame so great that the whole instrument was illuminated by it."

16–36 • HILDEGARD AND VOLMAR
1927–1933 facsimile of the frontispiece of the *Liber Scivias* of Hildegard of Bingen. Original, 1150–1175.

This author portrait was once part of a manuscript of Hildegard's *Scivias* that many believe was made in her own lifetime, but it was lost in World War II. Today we can study its images only from prewar black-and-white photographs or from a full-color facsimile that was lovingly hand-painted by the nuns of the abbey of St. Hildegard in Eigingen under the direction of Joesepha Krips between 1927 and 1933, the source of both pictures reproduced here.

16-37 • PAGE WITH THE TREE OF JESSE, EXPLANATIO IN ISAIAM (ST. JEROME'S COMMENTARY ON ISAIAH)

Abbey of Cîteaux, Burgundy, France. c. 1125. Ink and tempera on vellum, 15″ × 4¾″ (38 × 12 cm). Bibliothèque Municipale, Dijon, France. MS. 129, fol. 4v

A CISTERCIAN TREE OF JESSE The Cistercians were particularly devoted to the Virgin Mary and are also credited with popularizing themes such as the Tree of Jesse as a device for showing her position as the last link in the genealogy connecting Jesus to King David. (Jesse, the father of King David, was an ancestor of Mary and, through her, of Jesus.) A manuscript of St. Jerome's Commentary on Isaiah, made in the scriptorium of the Cistercian mother house of Cîteaux in Burgundy about 1125, contains an image of an abbreviated **TREE OF JESSE** (**FIG. 16–37**).

A monumental Mary, with the Christ Child sitting on her veiled arm, stands over the forking branches of the tree, dwarfing the sleeping patriarch, Jesse, from whose body a small tree trunk grows. The long, vertical folds of Mary's voluminous drapery—especially the flourish at lower right, where a piece of her garment billows up, as if caught in an updraft—recall the treatment of drapery in the portal at Autun (see "A Closer Look," page 483), also from Burgundy. The artist has drawn, rather than painted, with soft colors, using subtle tints that seem somehow in keeping with Cistercian restraint. Christ embraces his mother's neck, pressing his cheek against hers in a display of tender affection that recalls Byzantine icons of the period, like the Virgin of Vladimir (see FIG. 8–28). The foliate form Mary holds in her hands could be a flowering sprig from the Jesse Tree, or it could be a lily symbolizing her purity.

The building held by the angel on the left equates Mary with the Church, and the crown held by the angel on the right is hers as queen of heaven. The dove above her halo represents the Holy Spirit; Jesse Trees often have doves sitting in the uppermost branches. In the early decades of the twelfth century, Church doctrine came increasingly to stress the role of the Virgin Mary and the saints as intercessors who could plead for mercy on behalf of repentant sinners, and devotional images of Mary became increasingly popular during the later Romanesque period. As we will see, this popularity would continue into the Gothic period, not only in books but on the sculpted portals and within the stained-glass windows of cathedrals.

THINK ABOUT IT

16.1 Discuss what is meant by the term "Romanesque" and distinguish some of the key stylistic features associated with architecture in this style.

16.2 Discuss the sculpture that was integrated into the exteriors of Romanesque churches. Why was it there? Whom did it address? What were the prominent messages? Make reference to at least one church discussed in this chapter.

16.3 What is a pilgrimage site? How did pilgrimage sites function for medieval Christians? Ground your answer in a discussion of Santiago de Compostela, focusing on specific features that were geared toward pilgrims.

16.4 Analyze one example of a Romanesque work of art in this chapter that tells a story of human frailty. Who was the intended audience? How does its style relate to the intended moral message?

CROSSCURRENTS

FIG. 15–6

FIG. 16–33

These two pages served as the beginning of the Gospel of Matthew in two medieval manuscripts, one Hiberno-Saxon and the other Romanesque. Compare the designs of these two pages and the relationship that is established between words and images. How does the work of these two artists relate to work in other media during the period in which each was made?

✓—Study and review on myartslab.com

17–1 • SCENES FROM GENESIS
Detail of the Good Samaritan Window, south aisle of nave, Cathedral of Notre-Dame, Chartres, France. c. 1200–1210. Stained and painted glass.

Gothic Art of the Twelfth and Thirteenth Centuries

The Gothic style—originating in the powerful monasteries of the Paris region—dominated much of European art and architecture for 400 years. By the mid twelfth century, advances in building technology, increasing financial resources, and new intellectual and spiritual aspirations led to the development of a new art and architecture that expressed the religious and political values of monastic communities. Soon bishops and rulers, as well as abbots, vied to build the largest and most elaborate churches. Just as residents of twentieth-century American cities raced to erect higher and higher skyscrapers, so too the patrons of western Europe competed during the Middle Ages in the building of cathedrals and churches with ever-taller naves and towers, diaphanous walls of glowing glass, and breathtakingly airy interiors that seemed to open in all directions.

The light captured in stained-glass windows created luminous pictures that must have captivated a faithful population whose everyday existence included little color, outside the glories of the natural world. And the light that passed through these windows transformed interior spaces into a many-colored haze. Truly, Gothic churches became the glorious jeweled houses of God, evocations of the heavenly Jerusalem. They were also glowing manifestations of Christian doctrine, and invitations to faithful living, encouraging worshipers to follow in the footsteps of the saints whose lives were frequently featured in the windows of Gothic churches. Stained glass soon became the major medium of monumental painting.

This detail from the Good Samaritan Window at Chartres Cathedral (**FIG. 17–1**), created in the early years of the thirteenth century, well into the development of French Gothic architecture, includes scenes from Genesis, the first book of the Bible. The window portrays God's creation of Adam and Eve, and continues with their subsequent temptation, fall into sin, and expulsion from the paradise of the Garden of Eden to lead a life of work and woe. Adam and Eve's story is used here to interpret the meaning of the parable of the Good Samaritan for medieval viewers, reminding them that Christ saves them from the original sin of Adam and Eve just as the Good Samaritan saves the injured and abused traveler (see FIG. 17–10). The stained-glass windows of Gothic cathedrals were more than glowing walls activated by color and light; they were also luminous sermons, preached with pictures rather than with words. These radiant pictures were directed at a diverse audience of worshipers, drawn from a broad spectrum of medieval society, who derived multiple meanings from gloriously complicated works of art.

LEARN ABOUT IT

17.1 Investigate the ideas, events, and technical innovations that led to the development of Gothic architecture in France.

17.2 Understand how artists communicated complex theological ideas, moralizing stories, and socio-political concerns, in stained glass, sculpture, and illustrated books.

17.3 Analyze the relationship between the Franciscan ideals of empathy and the emotional appeals of sacred narrative painting and sculpture in Italy.

17.4 Explore and characterize English and German Gothic art and architecture in relation to French prototypes.

((•—[Listen to the chapter audio on myartslab.com

THE EMERGENCE OF THE GOTHIC STYLE

In the middle of the twelfth century, a distinctive new architecture known today as Gothic emerged in the Île-de-France, the French royal domain around Paris (**MAP 17-1**). The appearance there of a new style and technique of building coincided with the emergence of the monarchy as a powerful centralizing force. Within 100 years, an estimated 2,700 Gothic churches, shimmering with stained glass and encrusted with sculpture, were built in the Île-de-France region alone.

Advances in building technology allowed progressively larger windows and ever loftier vaults supported by more and more streamlined skeletal exterior buttressing. Soon, the Gothic style spread throughout western Europe, gradually displacing Romanesque forms while taking on regional characteristics inspired by them. Gothic prevailed until about 1400, lingering even longer in some regions. It was adapted to all types of structures, including town halls and residences, as well as Christian churches and synagogues.

The term "Gothic" was popularized by the sixteenth-century Italian artist and historian Giorgio Vasari, who disparagingly attributed the by-then-old-fashioned style to the Goths, Germanic invaders who had "destroyed" the Classical civilization of the Roman Empire that Vasari preferred. In its own day the Gothic style was simply called "modern art" or the "French style."

THE RISE OF URBAN AND INTELLECTUAL LIFE

The Gothic period was an era of both communal achievement and social change. Although Europe remained rural, towns gained increasing prominence. They became important centers of artistic patronage, fostering strong communal identity by public projects and ceremonies. Intellectual life was also stimulated by the interaction of so many people living side by side. Universities in Bologna, Padua, Paris, Cambridge, and Oxford supplanted monastic

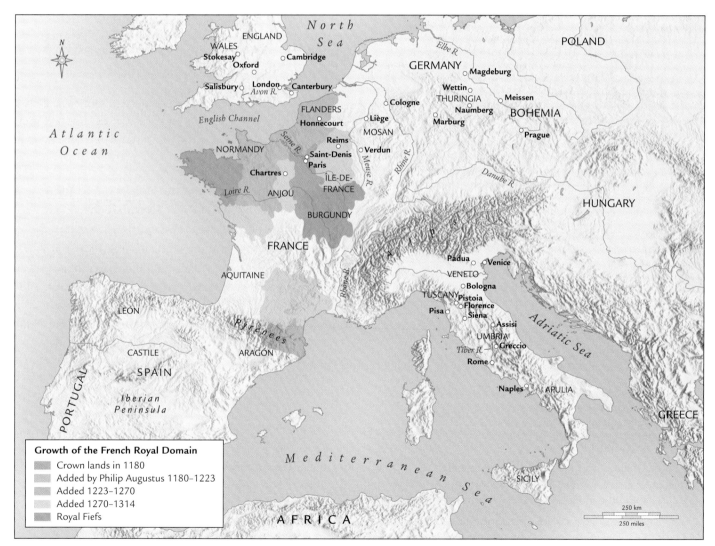

MAP 17-1 • EUROPE IN THE GOTHIC ERA

The color changes on this map chart the gradual expansion of territory ruled by the king of France during the period when Gothic was developing as a modern French style.

Suger, who masterminded the reconstruction of the abbey church at Saint-Denis while he was its abbot (1122–1151), weighed in on the twelfth-century monastic debate concerning the appropriateness of elaborate art in monasteries (see "St. Bernard and Theophilus," page 470) both through the magnificence of the new church he built and by the way he described and discussed the project in the account he wrote of his administration of the abbey.

These are his comments on the bronze doors (destroyed in 1794):

Bronze casters having been summoned and sculptors chosen, we set up the main doors on which are represented the Passion of the Saviour and His Resurrection, or rather Ascension, with great cost and much expenditure for their gilding as was fitting for the noble porch…

The verses on the door are these:

Whoever thou art, if thou seekest to extol the glory of these doors,
Marvel not at the gold and the expense but at the craftsmanship
 of the work,
Bright is the noble work; but being nobly bright, the work
Should lighten the minds, so that they may travel, through the true
 lights,
To the True Light where Christ is the true door,
In what manner it be inherent in this world the golden door
 defines:
The dull mind rises to truth through that which is material
And, in seeing this light, is resurrected from its former subversion.

On the lintel, just under the large figure of Christ at the Last Judgment on the tympanum, Suger had inscribed:

Receive, O stern Judge, the prayers of Thy Suger; grant that I be mercifully numbered among Thy own sheep.

(Translations from Panofsky, pp. 47, 49)

[○]─[Read the documents related to Abbot Suger on myartslab.com

and cathedral schools as centers of learning. Brilliant teachers like Peter Abelard (1079–1142) drew crowds of students, and in the thirteenth century an Italian theologian, Thomas Aquinas (1225–1274), made Paris the intellectual center of Europe.

A system of reasoned analysis known as scholasticism emerged from these universities, intent on reconciling Christian theology with Classical philosophy. Scholastic thinkers used a question-and-answer method of argument and arranged their ideas into logical outlines. Thomas Aquinas, the foremost Scholastic, applied Aristotelian logic to comprehend religion's supernatural aspects, setting up the foundation on which Catholic thought rests to this day. Some have seen a relationship between the development of these new ways of thinking and the geometrical order that permeates the design of Gothic cathedrals, as well as with the new interest in describing the appearance of the natural world in sculpture and painting.

THE AGE OF CATHEDRALS

Urban cathedrals, the seats of the ruling bishops, superseded rural monasteries as centers of religious culture and patronage. So many cathedrals were rebuilt between 1150 and 1400—often to replace earlier churches destroyed in the fires that were an unfortunate byproduct of population growth and housing density within cities—that some have dubbed the period the "Age of Cathedrals." Cathedral precincts functioned almost as towns within towns—containing a palace for the bishop, housing for the clergy, and workshops for the multitude of artists and laborers necessary to support building campaigns. These gigantic churches certainly dominated their urban surroundings. But even if their grandeur inspired admiration, their enormous expense and some bishops' intrusive displays of power inspired resentment, even urban rioting.

GOTHIC ART IN FRANCE

The development and initial flowering of the Gothic style in France took place against the backdrop of the growing power of the Capetian monarchy. Louis VII (r. 1137–1180) and Philip Augustus (r. 1180–1223) consolidated royal authority in the Île-de-France and began to exert more control over powerful nobles in other regions. Louis VII's queen, Eleanor of Aquitaine, brought southwestern France into the royal domain, but when their marriage was annulled, Eleanor reclaimed her lands and married Henry Plantagenet—count of Anjou, duke of Normandy—who became King Henry II of England. The resulting tangle of conflicting claims kept France and England at odds for centuries.

As French kings continued to consolidate royal authority and to increase their domains and privileges, they also sparked a building boom with the growing centralization of their government in Paris, which developed from a small provincial town into a thriving urban center beginning in the middle of the twelfth century. Concentrated architectural activity in the capital may have provided the impetus—or perhaps simply the opportunity—for the developments in architectural technology and the new ways of planning and thinking about buildings that ultimately led to the birth of a new style.

THE BIRTH OF GOTHIC AT THE ABBEY CHURCH OF SAINT-DENIS

Many consider the church of the Benedictine abbey of Saint-Denis, just north of Paris, to be the first Gothic building. This monastery had been founded in the fifth century over the tomb of St. Denis, the Early Christian martyr who had been sent from Rome to convert the local pagan population, becoming the first bishop of Paris. Early on, the abbey developed special royal significance. It housed tombs of the kings of France, the regalia of the French crown, and the relics of St. Denis, patron saint of France.

Construction began in the 1130s of a new church that was to replace the early medieval church at the abbey, under the supervision of Abbot Suger (abbot 1122–1151). In a written account of his administration of the abbey, Suger discusses the building of the church, a rare firsthand chronicle and justification of a medieval building program. Suger prized magnificence, precious materials, and especially fine workmanship (see "Abbot Suger on the Value of Art in Monasteries," page 497). He invited an international team of masons, sculptors, metalworkers, and glass painters, making this building site a major center of artistic exchange. Such a massive undertaking was extraordinarily expensive. The abbey received substantial annual revenues from the town's inhabitants, and Suger was not above forging documents to increase the abbey's landholdings, which constituted its principal source of income.

Suger began building c. 1135, with a new west façade and narthex attached to the old church, but it was in the new choir—completed in three years and three months between July

14, 1140 and its consecration on June 11, 1144—where the fully formed Gothic architectural style may first have appeared. In his account of the reconstruction, Suger argues that the older building was inadequate to accommodate the crowds of pilgrims who arrived on feast days to venerate the body of St. Denis, and too modest to express the importance of the saint himself. In working with builders to conceive a radically new church design, he turned for inspiration to texts that were attributed erroneously to a follower of St. Paul named Dionysius (the Greek form of Denis), who considered radiant light a physical manifestation of God. Since through the centuries, this Pseudo-Dionysius also became

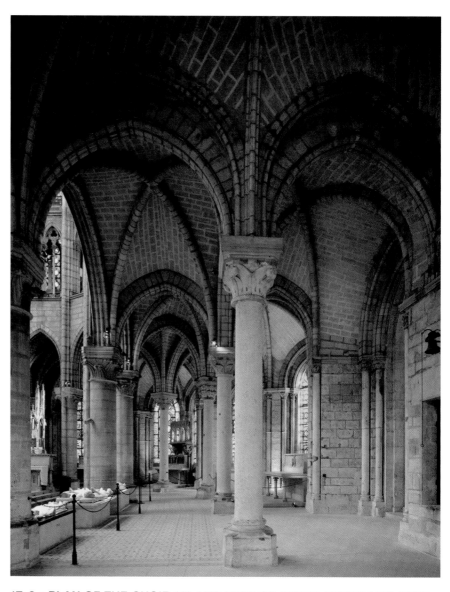

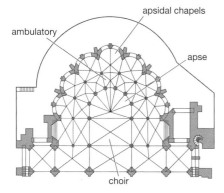

17-2 • PLAN OF THE CHOIR (A) AND VIEW OF AMBULATORY AND APSE CHAPELS (B) OF THE ABBEY CHURCH OF SAINT-DENIS
France. 1140–1144.

Envisioning the completion of the abbey church with a transept, and presumably also a nave, Abbot Suger had the following inscription placed in the church to commemorate the 1144 dedication of the choir: "Once the new rear part is joined to the part in front, the church shines with its middle part brightened. For bright is that which is brightly coupled with the bright, and bright is the noble edifice which is pervaded by the new light." (Panofsky, p. 51).

An important innovation of Romanesque and Gothic builders was **rib vaulting**. Rib vaults are a form of groin vault (see "Roman Vaulting," page 187), in which the diagonal ridges (groins) rest on and are covered by curved moldings called ribs. After the walls and piers of the building reached the desired height, timber scaffolding to support these masonry ribs was constructed. When the mortar of the ribs was set, the web of the vault was then laid on forms built on the ribs themselves. After all the temporary forms were removed, the ribs may have provided strength at the intersections of the webbing to channel the vaults' thrust outward and downward to the foundations; they certainly add decorative interest. In short, ribs formed the "skeleton" of the vault; the webbing, a lighter masonry "skin." In Late Gothic buildings, additional decorative ribs give vaults a lacelike appearance.

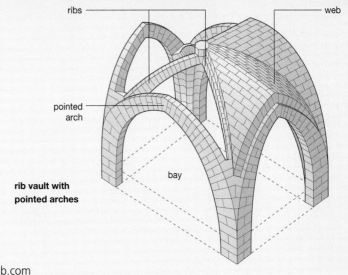

rib vault with pointed arches

⊙—[**Watch** an architectural simulation about rib vaulting on myartslab.com

identified with the martyred Denis whose body was venerated at the abbey, Suger was adapting what he believed was the patron saint's concept of divine luminosity in designing the new abbey church with walls composed essentially of stained-glass windows. In inscriptions he composed for the bronze doors (now lost), he was specific about the motivations for the church's new architectural style: "being nobly bright, the work should lighten the minds, so that they may travel, through the true lights, to the True Light where Christ is the true door" (Panofsky, p. 49).

The **PLAN OF THE CHOIR** (FIG. 17–2A) retains key features of the Romanesque pilgrimage plan (see FIG. 16–4A), with a semicircular apse surrounded by an ambulatory, around which radiate seven chapels of uniform size. And the structural elements of the choir had already appeared in Romanesque buildings, including pointed arches, ribbed groin vaults, and external buttressing to relieve stress on the walls. The dramatic achievement of Suger's builders was the coordinated use of these features to create an architectural whole that emphasized open, flowing space, enclosed by nonload-bearing walls of glowing stained glass (FIG. 17–2B). In Suger's words, the church becomes "a circular string of chapels by virtue of which the whole would shine with the wonderful and uninterrupted light of most luminous windows, pervading the interior beauty" (Panofsky, p. 101). And since Suger saw the contemplation of light as a means of illuminating the soul and uniting it with God, he was providing his monks with an environment especially conducive to their primary vocation of prayer and meditation.

The revolutionary stained-glass windows of Suger's Saint-Denis were almost lost in the wake of the French Revolution, when this royal abbey represented everything the new leaders were intent on suppressing. Thanks to an enterprising antiquarian named Alexandre Lenoir, however, the twelfth-century windows, though

removed from their architectural setting, were saved from destruction. During the nineteenth century, some stained glass returned to the abbey, but many panels are now in museums. One of the best-preserved—from a window that narrated Jesus' childhood—portrays **THE FLIGHT INTO EGYPT** (FIG. 17–3). The crisp elegance of the delineation of faces, foliage, and drapery—painted with vitreous enamel on the vibrantly colored pieces of glass that make up the panel (see "Stained-Glass Windows," page 501)—is almost as clear today as it was when the windows were new. One unusual detail—the Virgin reaching to pick a date from a palm tree that has bent down at the infant Jesus' command to accommodate her hungry grasp—is based on an apocryphal Gospel that was not included in the canonical Christian scriptures but remained a popular source for twelfth-century artists.

Louis VII and Eleanor of Aquitaine attended the consecration of the new choir in June 1144, along with a constellation of secular and sacred dignitaries. Since the bishops and archbishops of France were assembled at the consecration—celebrating Mass simultaneously at altars throughout the choir and crypt—they had the opportunity to experience firsthand this new Gothic style of building. The history of French architecture over the next few centuries indicates that they were quite impressed.

GOTHIC CATHEDRALS

The abbey church of Saint-Denis became the prototype for a new architecture of space and light based on a highly adaptable skeletal framework that supported rib vaulting on the points of slender piers—rather than along massive Romanesque walls—reinforced by external buttress systems. It initiated a period of competitive experimentation in France that resulted in ever-larger churches—principally cathedrals—enclosing increasingly taller interior spaces, walled with ever-greater expanses of stained glass.

17–3 • THE FLIGHT INTO EGYPT

Detail of the Incarnation (Infancy of Christ) Window, axial choir chapel, abbey church of Saint-Denis. c. 1140–1144. The Glencairn Museum, Bryn Athyn, Pennsylvania.

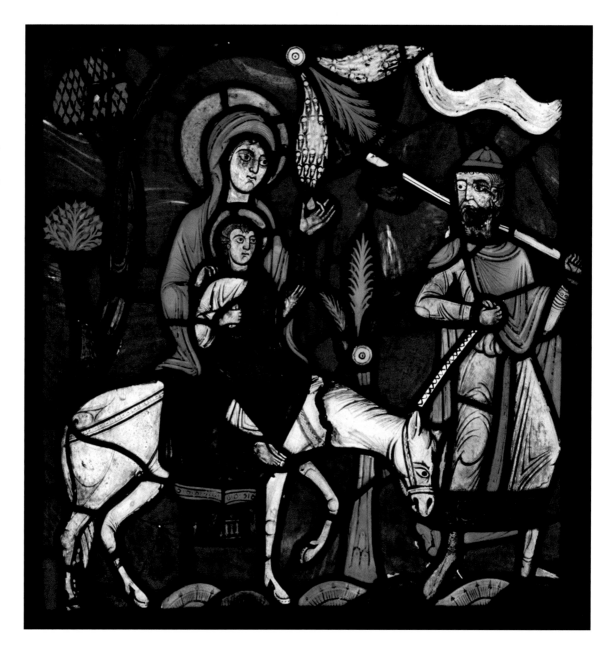

THE CATHEDRAL OF NOTRE-DAME AT CHARTRES
The new Gothic conceptions of space and wall, and the structural techniques that made them possible, were developed further at Chartres. The great cathedral dominates this town southwest of Paris and, for many people, is a near-perfect embodiment of the Gothic style in stone and glass. Constructed in several stages beginning in the mid twelfth century and extending into the mid thirteenth, with additions such as the north spire as late as the sixteenth century, Chartres Cathedral reflects the transition from an experimental twelfth-century architecture to a mature thirteenth-century style.

Chartres was the site of a pre-Christian virgin-goddess cult, and later, dedicated to the Virgin Mary, it became one of the oldest and most important Christian shrines in France. Its main treasure was a piece of linen believed to have been worn by the Virgin Mary when she gave birth to Jesus. This relic was a gift from the

Byzantine empress Irene to Charlemagne, whose grandson Charles the Bald donated it to Chartres in 876. It was kept below the high altar in a huge basement crypt. The healing powers attributed to the cloth made Chartres a major pilgrimage destination, especially as the cult of the Virgin grew in popularity in the twelfth and thirteenth centuries. Its association with important market fairs—especially cloth markets—held at Chartres on the feast days of the Virgin put the textile relic at the intersection of local prestige and the local economy, increasing the income of the cathedral not only through pilgrimage but also through tax revenue it received from the markets.

The **WEST FAÇADE** of Chartres (**FIG. 17–4**) preserves an early sculptural program created within a decade of the reconstruction of Saint-Denis. Surrounding these three doors—the so-called Royal Portal, used not by the general public but only for important ceremonial entrances of the bishop and his retinue—sculpted

The "wonderful and uninterrupted light" that Suger sought in the reconstruction of the choir of Saint-Denis in the 1140s was provided by stained-glass artists that—as he tells us—he called in from many nations to create glowing walls for the radiating chapels, perhaps the clerestory as well. As a result of their exquisite work, this influential building program not only constituted a new architectural style; it catapulted what had been a minor curiosity among pictorial techniques into the major medium of monumental European painting. For several centuries, stained glass would be integral to architectural design, not decoration added subsequently to a completed building. Windows were produced at the same time as masons were building walls and carving capitals and moldings.

Our knowledge about the medieval art of stained glass is based on a precious twelfth-century text—*De Diversis Artibus* (*On Divers Arts*)—written by a German monk who called himself Theophilus Presbyter (see "St. Bernard and Theophilus," page 470). In fact, the basic procedures of producing a stained-glass window have changed little since the Middle Ages. It is not a lost art, but it is a complex and costly process. The glass itself was made by bringing sand and ash to the molten state under intense heat, and "staining" it with color through the addition of metallic oxides. This molten material was then blown and flattened into sheets.

Using a **cartoon** (full-scale drawing) painted on a whitewashed board as a guide, the glass painter would cut from these sheets the individual shapes of color that would make up a figural scene or ornamental passage. This was done with a hot iron that would crack the glass into a rough approximation that could be refined by chipping away at the edges carefully with an iron tool—a process called **grozing**—to achieve the precise shape needed in the composition.

The artists used a vitreous paint (made, Theophilus tells us, of iron filings and ground glass suspended in wine or urine) at full strength to block light and delineate features such as facial expressions or drapery folds. It could also be diluted to create modeling washes. Once painted, the pieces of glass would be fired in a kiln to fuse the painting with the glass surface. Only then did the artists assemble these shapes of color—like pieces of a complex compositional puzzle—with strips of lead (called **cames**), and subsequently mount a series of these individual panels on an iron framework within the architectural opening to form an ensemble we call a stained-glass window. Lead was used in the assembly process because it was strong enough to hold the glass pieces together but flexible enough to bend around their complex shapes and—perhaps more critically—to absorb the impact from gusts of wind and prevent the glass itself from cracking under pressure.

figures calmly and comfortably fill their architectural settings. On the central tympanum, Christ is enthroned in majesty, returning at the end of time surrounded by the four evangelists (**FIG. 17-5**). Although imposing, he seems more serene and more human than in the hieratic and stylized portrayal of the same subject at Moissac (see **FIG. 16-21**). The apostles, organized into four groups of three fill the lintel, and the 24 elders of the Apocalypse line the archivolts.

The right portal is dedicated to the Incarnation (God's first earthly appearance), highlighting the role of Mary in the early life of Christ, from the Annunciation to the Presentation in the Temple. On the left portal is the Ascension (the Incarnate God's return from earth to heaven). Jesus floats heavenward in a cloud, supported by angels. Running across all three portals, historiated capitals, on the top of the jambs just underneath the level of the lintels, depict Jesus' life on Earth in a series of small, lively narrative scenes.

17-4 • WEST FAÇADE, CHARTRES CATHEDRAL (CATHEDRAL OF NOTRE-DAME)

France. West façade begun c. 1134; cathedral rebuilt after a fire in 1194; building continued to 1260; north spire 1507–1513.

❋ **Explore** the architectural panoramas of Chartres Cathedral on myartslab.com

17-5 • ROYAL PORTAL, WEST FAÇADE, CHARTRES CATHEDRAL
c. 1145–1155.

[□]—[**Read** the document related to the building of Chartres Cathedral on myartslab.com

Flanking all three openings on the jambs are serenely calm column statues (**FIG. 17–6**)—kings, queens, and prophets from the Hebrew Bible, evocations of Christ's royal and spiritual ancestry, as well as a reminder of the close ties between the Church and the French royal house. The prominence of kings and queens here is what has given the Royal Portal its name. The elegantly elongated proportions and linear, but lifelike, drapery of these column statues echo the cylindrical shafts behind them. Their meticulously carved, idealized heads radiate a sense of beatified calm. In fact, tranquility and order prevail in the overall design as well as in the individual components of this portal, a striking contrast to the dynamic configurations and energized figures on the portals of Romanesque churches.

17-6 • ROYAL PORTAL, WEST FAÇADE, CHARTRES CATHEDRAL
Detail of prophets and ancestors of Christ (kings and queens of Judea), right side, central portal. c. 1145–1155.

Most large Gothic churches in western Europe were built on the Latin cross plan, with a projecting transept marking the transition from nave to choir, an arrangement that derives ultimately from the fourth-century Constantinian basilica of Old St. Peter's (see FIG. 7–13). The main entrance portal was generally on the west, with the choir and its apse on the east. A western narthex could precede the entrance to the nave and side aisles. An ambulatory with radiating chapels circled the apse and facilitated the movement of worshipers through the church. Many Gothic churches have a three-story elevation, with a triforium sandwiched between the nave arcade and a glazed clerestory. Rib vaulting usually covered all spaces. **Flying buttresses** helped support the soaring nave vaults by transferring their outward thrust over the aisles to massive, free-standing, upright external buttresses. Church walls were decorated inside and out with arcades of round or pointed arches, engaged columns and colonnettes, an applied filigree of **tracery**, and horizontal moldings called **stringcourses**. The pitched roofs above the vaults—necessary to evacuate rainwater from the building—were supported by wooden frameworks. A spire or crossing tower above the junction of the transept and nave was usually planned, though often never finished. Portal façades were also customarily marked by high, flanking towers or gabled porches ornamented with **pinnacles** and finials. Architectural sculpture proliferated on each portal's tympanum, archivolts, and jambs (**FIG. 17–7**), and in France a magnificent rose window typically formed the centerpiece of the flat portal façades.

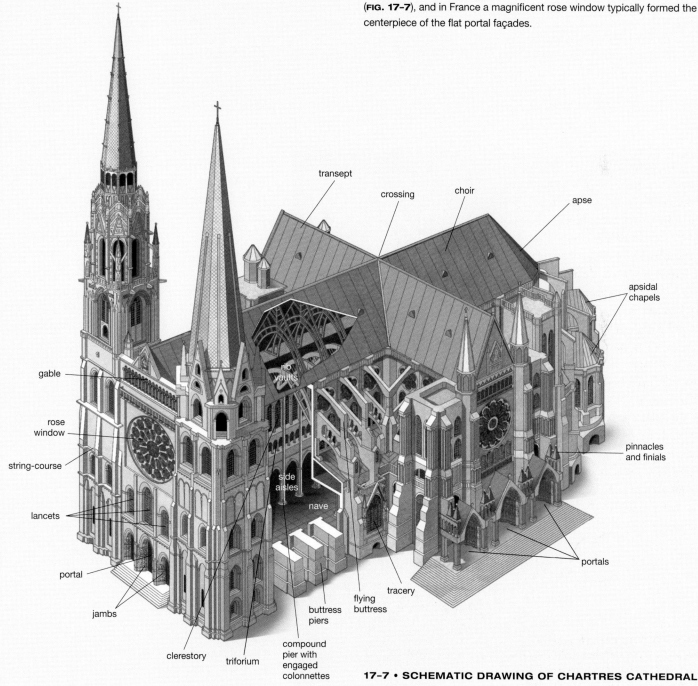

17-7 • SCHEMATIC DRAWING OF CHARTRES CATHEDRAL

Master masons oversaw all aspects of church construction in the Middle Ages, from design and structural engineering to construction and decoration. The master mason at Chartres coordinated the work of roughly 400 people scattered, with their equipment and supplies, across many locations, from distant stone quarries to high scaffolding. It has been estimated that this workforce set in place some 200 blocks of stone each day.

Funding shortages and technical delays, such as the need to let mortar harden for three to six months, made construction sporadic, so master masons and their crews moved constantly from job to job, with several masters and many teams of masons often contributing to the construction of a single building. Fewer than 100 master builders are estimated to have been responsible for all the major architectural projects around Paris during the century-long building boom there, some of them working on parts of as many as 40 churches. This was dangerous work. Masons were always at risk of injury, which could cut

short a career in its prime. King Louis IX of France actually provided sick pay to a mason injured in the construction of Royaumont Abbey in 1234, but not all workers were this lucky. Master mason William of Sens, who supervised construction at Canterbury Cathedral, fell from a scaffold. His grave injuries forced him to return to France in 1178 because of his inability to work. Evidence suggests that some medieval contracts had pension arrangements or provisions that took potential injury or illness into account, but some did not.

Today, the names of more than 3,000 master masons are known to us, and the close study of differences in construction techniques often discloses the participation of specific masters. Master masons gained in prestige during the thirteenth century as they increasingly differentiated themselves from the laborers they supervised. In some cases their names were prominently inscribed in the labyrinths on cathedral floors. From the thirteenth century on, in what was then an exceptional honor, masters were buried, along with patrons and bishops, in the cathedrals they built.

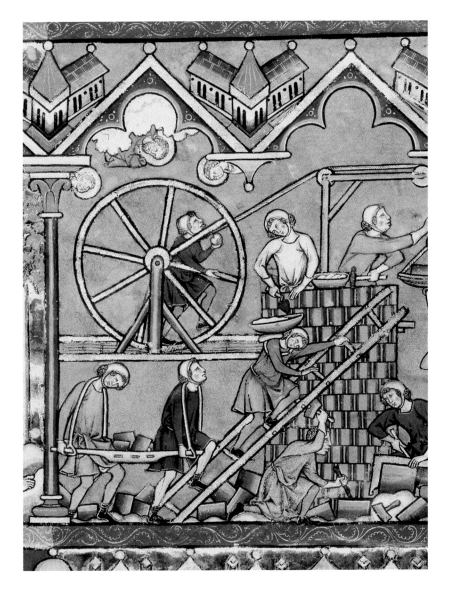

The bulk of Chartres Cathedral was constructed after a fire in 1194 destroyed an earlier Romanesque church but spared the Royal Portal, the windows above it, and the crypt with its precious relics. A papal representative convinced reluctant local church officials to rebuild. He argued that the Virgin had permitted the fire because she wanted a new and more beautiful church to be built in her honor. Between 1194 and about 1260 that new cathedral was built (see "The Gothic Church," page 503).

Such a project required vast resources—money, raw materials, and skilled labor (see "Master Masons," above). A contemporary painting shows a building site with the **MASONS AT WORK** (**FIG. 17–8**). Carpenters have built scaffolds, platforms, and a lifting machine. Master stonecutters measure and cut the stones; workers carry and hoist the blocks by hand or with a lifting wheel. Thousands of stones had to be cut accurately and placed carefully. Here a laborer carries mortar up a ladder to men working on the top of the wall, where the lifting wheel delivers cut stones. To fund this work,

17-8 • MASONS AT WORK
Detail of a miniature from a Picture Bible made in Paris. 1240s. The Morgan Library and Museum, New York. MS. M638, fol. 3r

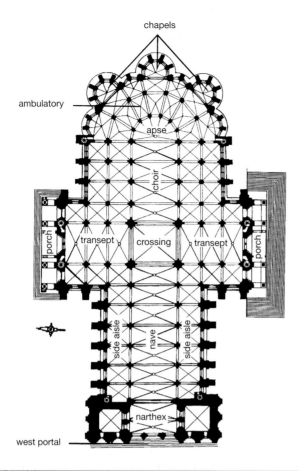

chapels

ambulatory

apse

choir

porch | transept | crossing | transept | porch

side aisle | nave | side aisle

narthex

west portal

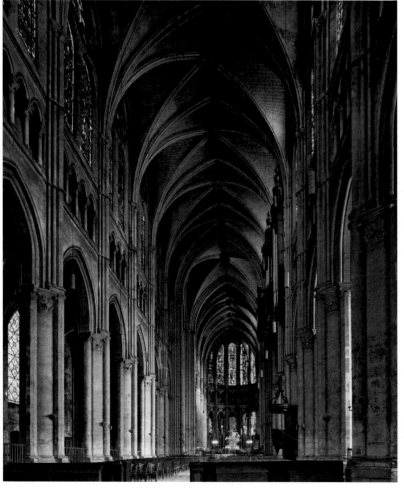

bishops and cathedral officials usually pledged all or part of their incomes for three to five, even ten years. Royal and aristocratic patrons joined in the effort. In an ingenious scheme that seems very modern, the churchmen at Chartres solicited contributions by sending the cathedral relics, including the Virgin's tunic, on tour as far away as England.

As the new structure rose higher during the 1220s, the work grew more costly and funds dwindled. But when the bishop and the cathedral clergy tried to make up the deficit by raising taxes, the townspeople drove them into exile for four years. This action in Chartres was not unique; people often opposed the building of cathedrals because of the burden of new taxes. The economic privileges claimed by the Church for the cathedral sparked intermittent uprisings by townspeople and the local nobility throughout the thirteenth century.

Building on the principles pioneered at Saint-Denis—a glass-filled masonry skeleton enclosing a large open space—the masons at Chartres erected a church over 45 feet wide with vaults that soar approximately 120 feet above the floor. As at Saint-Denis, the plan is rooted in the Romanesque pilgrimage plan, but with a significantly enlarged sanctuary occupying a full third of the building (**FIG. 17-9A**). The Chartres builders codified what were to become the typical Gothic structural devices: pointed arches and ribbed groin vaults rising from compound piers over rectangular bays. The vaults were supported externally by the recently developed flying buttress system (see **FIG. 17-7**) in which gracefully arched exterior supports countered the lateral thrust of the nave vault and transferred its weight outward, over the side aisles, where it is resolved into and supported by a buttressing pier, rising from the ground. Flying buttresses permitted larger and more luminous clerestory windows, nearly equal in height to the nave arcade (**FIG. 17-9B**). Paired **lancets** (tall openings with pointed tops), surmounted by small circular **rose windows**, are created in a technique known as **plate tracery**—holes are cut into the stone wall and nearly half the wall surface is filled with stained glass. The band between the clerestory and nave arcade was now occupied by a **triforium** (arcaded wall passageway) rather than a tall gallery.

17-9 • PLAN (A) AND INTERIOR LOOKING EAST (B), CHARTRES CATHEDRAL
1194–c. 1220.

Chartres is distinctive among French Gothic buildings in that most of its stained-glass windows have survived. Stained glass is an enormously expensive and complicated medium of painting, but its effect on the senses and emotions made the effort worthwhile for medieval patrons and builders. By 1260, glass painters had installed about 22,000 square feet of stained glass in 176 windows (see "Stained-Glass Windows," page 501). Most of the glass dates from between about 1200 and 1250, but a few earlier windows, from the 1150s—comparable in style to the windows of Suger's Saint-Denis—survived the fire of 1194 and remain in the west wall above the Royal Portal.

In the aisles and chapels, where the windows were low enough to be easily seen, there were elaborate multi-scene narratives, with small figures composed into individual episodes within the irregularly shaped compartments of windows designed as stacked medallions set against dense, multicolored fields of ornament. Art historians refer to these as cluster medallion windows. The **GOOD SAMARITAN WINDOW** of c. 1200–1210 in the south aisle of the nave is a typical example of the design (**FIG. 17-10**). Its learned allegory on sin and salvation also typifies the complexity of Gothic narrative art.

The principal subject is a parable Jesus told his followers to teach a moral truth (Luke 10:25–37). The protagonist is a traveling Samaritan who cares for a stranger, beaten, robbed, and left for dead by thieves on the side of a road. Jesus' parable is an allegory for his imminent redemption of humanity's sins, and within this window a story from Genesis is juxtaposed with the parable to underscore that association (see **FIG. 17-1**). Adam and Eve's fall introduced sin into the world, but Christ (the Good Samaritan) rescues humanity (the traveler) from sin (the thieves) and ministers to them within the Church, just as the Good Samaritan takes the wounded traveler for refuge and healing to an inn (bottom scene, **FIG. 17-1**). Stylistically, these willowy, expressive figures avoid the classicizing stockiness in Wiligelmo's folksy Romanesque rendering of the Genesis narrative at Modena (see **FIG. 16-20**). Instead they take the dancelike postures that will come to characterize Gothic figures as the style spreads across Europe in ensuing centuries.

In the clerestory windows, the Chartres glass-painters mainly used not multi-scene narratives, but large-scale single figures that could be seen at a distance because of their size, bold drawing, and strong colors. Iconic ensembles were easier to "read" in lofty openings more removed from viewers, such as the huge north transept **ROSE WINDOW** (over 42 feet in diameter) surmounting five lancets (**FIG. 17-11**), an ensemble which proclaims the royal and priestly heritage of Mary and Jesus, and through them of the Church itself. In the central lancet, St. Anne holds her

17-10 • GOOD SAMARITAN WINDOW
South aisle of nave, Chartres Cathedral. c. 1200–1210. Stained and painted glass.

17–11 • ROSE WINDOW AND LANCETS, NORTH TRANSEPT, CHARTRES CATHEDRAL
c. 1230–1235. Stained and painted glass.

View the Closer Look for the rose window and lancets in the north transept of
Chartres Cathedral on myartslab.com

infant daughter Mary, flanked left to right by statuesque figures of Hebrew Bible leaders Melchizedek, David, Solomon, and Aaron. Above, in the very center of the rose window itself, Mary and Jesus are enthroned, surrounded by a radiating array of doves, angels, and Hebrew Bible kings and prophets.

This vast wall of glass was a gift from the young King Louis IX (r. 1226–1270), perhaps arranged by his powerful mother, Queen Blanche of Castile (1188–1252), who ruled as regent (1226–1234) during Louis's minority. Royal heraldic emblems secure the window's association with the king. The arms of France—golden *fleurs-de-lis* on a blue ground—fill a prominent shield under St. Anne at the bottom of the central lancet. *Fleurs-de-lis* also appear in the graduated lancets bracketing the base of the rose window

and in a series of **quatrefoils** (four-lobed designs) within the rose itself. But also prominent is the Castilian device of golden castles on a red ground, a reference to the royal lineage of Louis's powerful mother. Light radiating from the deep blues and reds creates a hazy purple atmosphere in the soft light of the north side of the building. On a sunny day the masonry may seem to dissolve in color, but the bold theological and political messages of the rose window remain clear.

THE CATHEDRAL OF NOTRE-DAME IN REIMS Reims Cathedral, northeast of Paris in the region of Champagne, was the coronation church of the kings of France and, like Saint-Denis, had been a cultural and educational center since Carolin-

17-12 • PLAN OF CATHEDRAL OF NOTRE-DAME, REIMS
France. Begun in 1211.

✳ ⸢Explore the architectural panoramas of Reims Cathedral on myartslab.com⸥

17-13 • WEST FAÇADE, CATHEDRAL OF NOTRE-DAME, REIMS
Rebuilding begun 1211; façade begun c. 1225; to the height of rose window by 1260; finished for the coronation of Philip the Fair in 1286; towers left unfinished 1311; additional work 1406–1428.

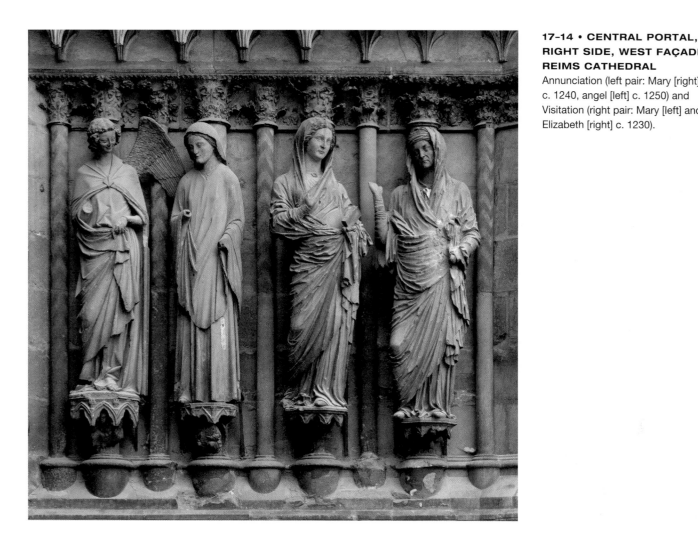

gian times. When, in 1210, fire destroyed this historic building, the community at Reims began to erect a new Gothic structure, planned as a large basilica (**FIG. 17-12**) similar to the model set earlier at Chartres (see FIG. 17-9A), only at Reims priority is given to an extended nave rather than an expanded choir, perhaps a reference to the processional emphasis of the coronation ceremony. The cornerstone of the cathedral was laid in 1211, and work continued throughout the century. The expense of the project sparked such local opposition that twice in the 1230s revolts drove the archbishop and canons into exile. At Reims, five master masons directed the work on the cathedral over the course of a century—Jean d'Orbais, Jean le Loup, Gaucher de Reims, Bernard de Soissons, and Robert de Coucy.

The west front of the Cathedral of Reims is a magnificent ensemble, in which almost every square inch of stone surface seems encrusted with sculptural decoration (**FIG. 17-13**). Its tall gabled portals form a broad horizontal base and project forward to display an expanse of sculpture, while the tympana they enclose are filled with stained-glass windows rather than stone carvings. Their soaring peaks—the middle one reaching to the center of the dominating rose window—unify the façade vertically. In a departure from tradition, Mary rather than Christ is featured in the central portal, a reflection of the growing popularity of her cult. Christ crowns

her as queen of heaven in the central gable. The towers were later additions, as was the row of carved figures that runs from the base of one tower to the other above the rose window. This "gallery of kings" is the only strictly horizontal element of the façade.

The sheer quantity of sculpture envisioned for this elaborate cathedral front required the skills of many sculptors, working in an impressive variety of styles over several decades. Four figures from the right jamb of the **CENTRAL PORTAL** illustrate the rich stylistic diversity (**FIG. 17-14**). The pair on the right portrays the Visitation, in which Mary (left), pregnant with Jesus, visits her older cousin, Elizabeth (right), pregnant with St. John the Baptist. The sculptor of these figures, active in Reims about 1230–1235, drew heavily on ancient sources. Reims had been a major Roman city, and there were remaining Roman works at the disposal of medieval sculptors. The bulky bodies show the same solidity seen in Roman sculpture (see FIG. 6-14), and the women's full faces, wavy hair, and heavy mantles recall imperial portrait statuary, even in their use of the two imperial facial ideals of unblemished youth (Mary) and aged accomplishment (Elizabeth) (compare FIGS. 6-40, 6-41). The figures shift their weight to one leg in contrapposto as they turn toward each other in conversation.

The pair to the left of the Visitation enacts the Annunciation, in which the archangel Gabriel announces to Mary that she will

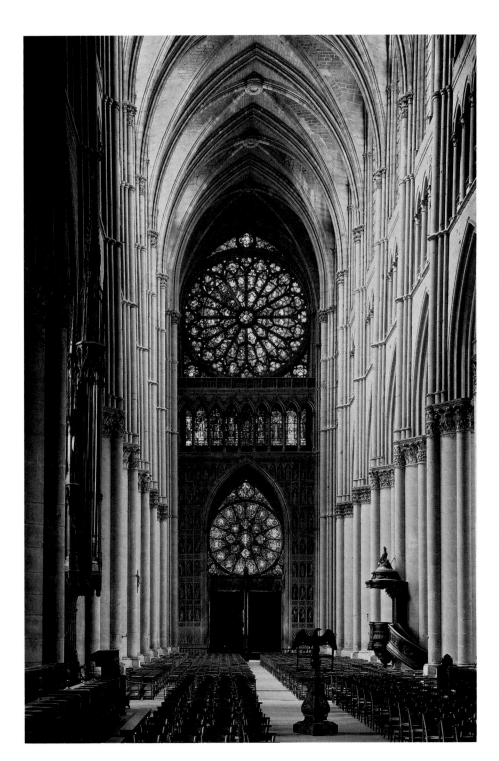

basis for what is called the International Gothic Style, fashionable across Europe well into the fifteenth century.

Inside the church (**FIG. 17–15**), the wall is designed, as at Chartres, as a three-story elevation with nave arcade and clerestory of equal height divided by the continuous arcade of a narrow triforium passageway. The designer at Reims gives a subtle emphasis to the center of each bay in the wall elevation, coordinating the central division of the clerestory into two lancets with a slightly enlarged colonnette at the middle of the triforium. This design feature was certainly noticed by one contemporary viewer, since it is (over)emphasized in the drawings Villard de Honnecourt made during a visit to Reims Cathedral c. 1230 (see FIG. 17–17). Villard also highlighted one of the principal innovations at Reims: the development of **bar tracery**, in which thin stone bars, called **mullions**, are inserted into an expansive opening in the wall to form a lacy framework for the stained glass (see rose window in FIG. 17–15). Bar tracery replaced the older plate tracery—still used at Chartres (see FIG. 17–11)—and made possible even larger areas of stained glass in relation to wall surface.

bear Jesus. This Mary's slight body, broad planes of simple drapery, restrained gesture, inward focus, and delicate features contrast markedly with the bold tangibility of the Mary in the Visitation next to her. She is clearly the work of a second sculptor. The archangel Gabriel (at the far left) represents a third artist, active at the middle of the century. This sculptor created tall, gracefully swaying figures with small, fine-featured heads, whose precious expressions, carefully crafted hairdos, and mannered poses of aristocratic refinement grew increasingly to characterize the figural arts in later Gothic sculpture and painting. These characteristics became the

A remarkable ensemble of sculpture and stained glass fills the interior west wall at Reims. A great rose window fills the clerestory level; a row of lancets illuminates the triforium; and a smaller rose window replaces the stone of the portal tympanum. The lower level is anchored visually by an expanse of sculpture covering the inner wall of the façade. Here ranks of carved prophets and royal ancestors represent moral guides for the newly crowned monarchs who faced them while processing down the elongated nave and out of the cathedral following the coronation ceremony as they began the job of ruling France.

One of the most fascinating and enigmatic works surviving from Gothic France is a set of 33 sheets of parchment covered with about 250 drawings in leadpoint and ink, signed by a man named Villard from the Picardy town of Honnecourt, and now bound into a book housed in the French National Library. Villard seems to have made these drawings in the 1220s and 1230s judging from the identifiable buildings that he recorded, during what seem to have been extensive travels, made for unknown reasons, mainly in France—where he recorded plans or individual details of the cathedrals of Cambrai, Chartres, Laon, and especially Reims—but also in Switzerland and Poland.

Villard seems simply to have drawn those things that interested him—animals, insects, human beings, church furnishings, buildings, and construction devices (**FIGS. 17–16, 17–17**). Although the majority of his drawings have nothing to do with architecture, his renderings of aspects of Gothic buildings have received the most attention since the book was rediscovered in the mid nineteenth century, and led to a widespread belief that he was an architect or master mason. There is no evidence for this. In fact, the evidence we have argues against it, since the architectural drawings actually suggest the work of someone passionately interested in, but without a great deal of knowledge of, the structural systems and design priorities of Gothic builders. This in no way diminishes the value of this amazing document, which allows us rare access into the mind of a curious, well-traveled thirteenth-century amateur, who drew the things that caught his fancy in the extraordinary world around him.

17–16 • Villard de Honnecourt SHEET OF DRAWINGS WITH GEOMETRIC FIGURES
c. 1230. Ink on vellum, 9¼″ × 6″ (23.5 × 15.2 cm). Bibliothèque Nationale, Paris. MS. fr. 19093

This page, labeled "help in drawing figures according to the lessons taught by the art of geometry," demonstrates how geometric configurations underlie the shapes of natural forms and the designs of architectural features. They seem to give insight into the design process of Gothic artists, but could they also represent the fertile doodlings of a passionate amateur?

17–17 • Villard de Honnecourt DRAWINGS OF THE INTERIOR AND EXTERIOR ELEVATION OF THE NAVE OF REIMS CATHEDRAL
c. 1230. Ink on vellum, 9¼″ × 6″ (23.5 × 15.2 cm). Bibliothèque Nationale, Paris. MS. fr. 19093

Scholars still debate whether Villard's drawings of Reims Cathedral—the church he documented most extensively, with five leaves showing views and two containing details —were made from observing the building itself, during construction, or copied from construction drawings that had been prepared to guide the work of the masons. But in either case, what Villard documents here are those aspects of Reims that distinguish it from other works of Gothic architecture, such as the use of bar tracery, the enlarged central colonnettes of the triforium, the broad bands of foliate carving on the pier capitals, or the statues of angels that perch on exterior buttresses. He seems to have grasped what it was that separated this building from the other cathedrals rising across France at this time.

📖 **Read** the document related to Villard de Honnecourt on myartslab.com

In 1237, Baldwin II, Latin ruler of Constantinople—descendant of the crusaders who had snatched the Byzantine capital from Emperor Alexius III Angelus in 1204—was in Paris, offering to sell the relic of Christ's Crown of Thorns to his cousin, King Louis IX of France. The relic was at that time hocked in Venice, securing a loan to the cash-poor Baldwin, who had decided, rather than redeeming it, to sell it to the highest bidder. Louis purchased the relic in 1239, and on August 18, when the newly acquired treasure arrived at the edge of Paris, the humble king, barefoot, carried it through the streets of his capital to the royal palace. Soon after its arrival, plans were under way to construct a glorious new palace building to house it—the Sainte-Chapelle, completed for its ceremonial consecration on April 26, 1248. In the 1244 charter establishing services in the Sainte-Chapelle, Pope Innocent IV claimed that Christ had crowned Louis with his own crown, strong confirmation for Louis's own sense of the sacred underpinnings of his kingship.

The Sainte-Chapelle is an extraordinary manifestation of the Gothic style. The two-story building (**FIG. 17-18**)—there is both a lower and an upper liturgical space—is large for a chapel, and though it is now swallowed up into modern Paris, when it was built it was one of the tallest and most elaborately decorated buildings in the capital. The upper chapel is a completely open interior space surrounded by walls composed almost entirely of stained glass (**FIG. 17-19**), presenting viewers with a glittering, multicolored expanse. Not only the king and his court experienced this chapel; members of the public came to venerate and celebrate the relic, as well as to receive the indulgences offered to pious visitors. The Sainte-Chapelle resembles a reliquary made of painted stone and glass instead of gold and gems, turned inside out so that we experience it from within.

But this arresting visual impression is only part of the story.

The stained-glass windows present extensive narrative cycles related to the special function of this chapel. Since they are painted in a bold, energetic style, the stories are easily legible, in spite of their breadth and complexity. Around the sanctuary's **hemicycle** (apse or semicircular interior space) are standard themes relating to the celebration of the Mass. But along the straight side walls are broader, four-lancet windows whose narrative expanse is dominated by the exploits of the sacred kings and queens of the Hebrew Bible, heroes Louis claimed as his own royal ancestors. Above the recessed niche where Louis himself sat at Mass was a window filled with biblical kings, whereas in the corresponding

niche on the other side of the chapel, his mother, Queen Blanche of Castile, and his wife, Queen Marguerite of Provence, sat under windows devoted to the lives of Judith and Esther, alternatively appropriate role models for medieval queens. Everywhere we look we see kings being crowned, leading soldiers into holy warfare, or performing royal duties, all framed with heraldic references to Louis and the French royal house. There is even a window that includes scenes from the life of Louis IX himself.

After the French Revolution, the Sainte-Chapelle was transformed into an archive, and some stained glass was removed to allow more light into the building. Deleted panels made their way onto the art market, and, in 1803, wealthy Philadelphia

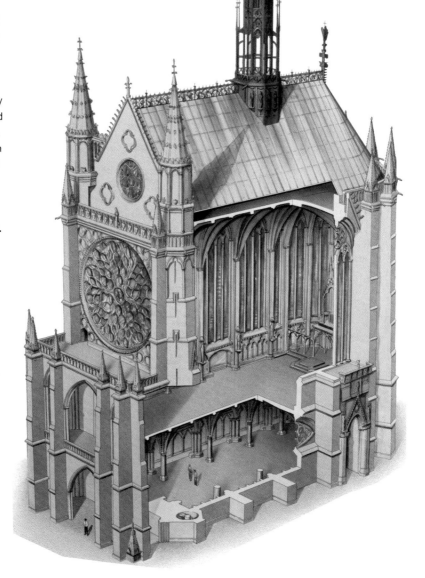

17–18 • SCHEMATIC DRAWING OF THE SAINTE-CHAPELLE
Paris. 1239–1248.

merchant William Powell bought three medallions from the Judith Window during a European tour, returning home to add them to his collection, the first in America to concentrate on medieval art. One portrays the armies of Holofernes crossing the Euphrates River (FIG. 17–20). A compact crowd of equestrian warriors to the right conforms to a traditional system of representing crowds as a measured, overlapping mass of essentially identical figures, but the warrior at the rear of the battalion breaks the pattern, turning to acknowledge a knight behind him. The foreshortened rump of this soldier's horse projects out into our space, as if he were marching from our real world into the fictive world of the window—an avant-garde touch from a major artist working in the progressive climate of the mid-thirteenth-century Parisian art world.

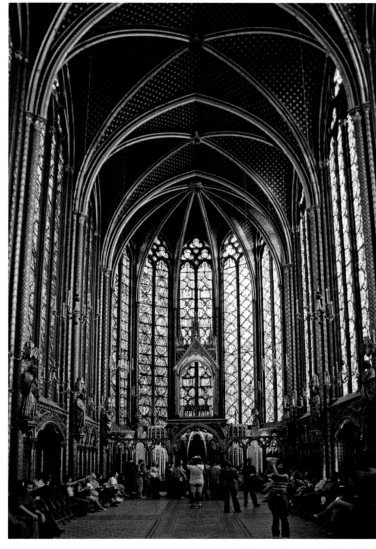

17-19 • UPPER CHAPEL INTERIOR,
THE SAINTE-CHAPELLE
Paris. 1239–1248.

17-20 • HOLOFERNES' ARMY CROSSING THE
EUPHRATES RIVER
Detail of the Judith Window, the Sainte-Chapelle, Paris. c. 1245.
Stained, painted, and leaded glass, diameter 23⁵⁄₁₆″ (59.2 cm).
Philadelphia Museum of Art.

Explore the architectural panoramas of Sainte-Chapelle on myartslab.com

ART IN THE AGE OF ST. LOUIS

During the time of Louis IX (r. 1226–1270; canonized as St. Louis in 1297), Paris became the artistic center of Europe. Artists from all over France were lured to the capital, responding to the growing local demand for new and remodeled buildings, as well as to the international demand for the extraordinary works of art that were the specialty of Parisian commercial workshops. Especially valued were small-scale objects in precious materials and richly illuminated manuscripts. The Parisian style of this period is often called the "Court Style," since its association with the court of St. Louis was one reason it spread beyond the capital to the courts of other European rulers. Parisian works became trans-European benchmarks of artistic quality and sophistication.

THE SAINTE-CHAPELLE IN PARIS The masterpiece of mid-thirteenth-century Parisian style is the Sainte-Chapelle (Holy Chapel) of the royal palace, commissioned by Louis IX to house his collection of relics of Christ's Passion, especially the Crown of Thorns (see "The Sainte-Chapelle in Paris," page 512). In many ways this huge chapel can be seen as the culmination of the Gothic style that emerged from Suger's pioneering choir at Saint-Denis. The interior walls have been reduced to a series of slender piers and mullions that act as skeletal support for a vast skin of stained glass. The structure itself is stabilized by external buttressing that projects from the piers around the exterior of the building. Interlocking iron bars between the piers and concealed within the windows themselves run around the entire building, adding further stabilization. The viewer inside is unaware of these systems of support, being focused instead on the kaleidoscopic nature of this jewelbox reliquary and the themes of sacred kingship that dominate the program of stained-glass windows.

ILLUMINATED MANUSCRIPTS Paris gained renown in the thirteenth century not only for its new architecture and sculpture but also for the production of books. Manuscript painters flocked to Paris from other regions to join workshops supervised by university officials who controlled the production and distribution of books. These works ranged from small Bibles used as textbooks by university students to extravagant devotional and theological works filled with exquisite miniatures for wealthy patrons.

17–21 • QUEEN BLANCHE OF CASTILE AND KING LOUIS IX
From a Moralized Bible made in Paris. 1226–1234. Ink, tempera, and gold leaf on vellum, each page 15″ × 10½″ (38 × 26.6 cm). The Morgan Library and Museum, New York. MS. M. 240, fol. 8r

A particularly sumptuous Parisian book from the time of St. Louis is a three-volume Moralized Bible from c. 1230, in which selected scriptural passages are paired with allegorical or moralized interpretations, using pictures as well as words to convey the message. The dedication page (**FIG. 17–21**) shows the teenage King Louis IX and his mother, Queen Blanche of Castile, who served as regent of France (1226–1234) until he came of age. The royal pair—emphasized by their elaborate thrones and slightly oversized heads—appear against a solid gold background under a multicolored architectural framework. Below them, a clerical scholar (left) dictates to a scribe, who seems to be working on a page from this very manuscript, with a column of roundels already outlined for paintings.

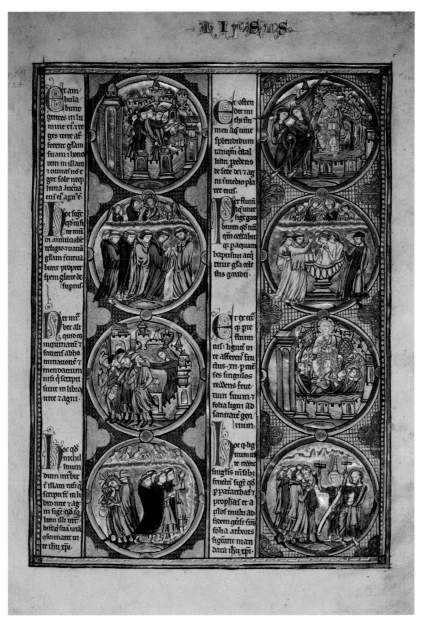

17-22 • MORALIZATIONS FROM THE APOCALYPSE
From a Moralized Bible made in Paris. 1226–1234. Ink, tempera, and gold leaf on vellum, each page 15″ × 10½″ (38 × 26.6 cm). The Morgan Library and Museum, New York. MS. M. 240, fol. 6r

clerical scholars at the University of Paris, but certainly painted by some of the most important professional artists in the cosmopolitan French capital.

GOTHIC ART IN ENGLAND

Plantagenet kings ruled England from the time of Henry II and Eleanor of Aquitaine until 1485. Many were great patrons of the arts. During this period, London grew into a large city, but most people continued to live in rural villages and bustling market towns. Textile production dominated manufacture and trade, and fine embroidery continued to be an English specialty. The French Gothic style influenced English architecture and manuscript illumination, but these influences were tempered by local materials and methods, traditions and tastes.

MANUSCRIPT ILLUMINATION

The universities of Oxford and Cambridge dominated intellectual life, but monasteries continued to house active scriptoria, in contrast to France, where book production became centralized in the professional workshops of Paris. By the end of the thirteenth century, secular workshops became increasingly active in England, meeting demands for books from students as well as from royal and noble patrons.

MATTHEW PARIS The monastic tradition of history writing that we saw in the Romanesque Worcester Chronicle (see FIG. 16–32) flourished into the Gothic period at the Benedictine monastery of St. Albans, where monk Matthew Paris (d. 1259) compiled a series of historical works. Paris wrote the texts of his chronicles, and he also added hundreds of marginal pictures that were integral to his history writing. The tinted drawings have a freshness that reveals the artist as someone working outside the rigid strictures of compositional conventions—or at least pushing against them. In one of his books, Paris included an almost full-page, framed image of the Virgin and Child in a tender embrace (FIG. 17–23). Under this picture, outside the sacred space of Mary and Jesus, Paris drew a picture of himself—identified not by likeness but by a label with his name, strung out in alternating red and blue capital letters behind him. He looks not at the holy couple, but at the words in front of him. These offer his commentary on the image, pointing to the affection shown in the playful Christ Child's movement toward his earthly mother, but emphasizing the authority he has as the divine incarnation of his father. Matthew Paris seems almost to hold his words in his hands, pushing them upward toward the object of his devotion.

This design of stacked medallions—forming the layout for most of this monumental manuscript (**FIG. 17–22**)—clearly derives from stained-glass lancets with their columns of superimposed images (see FIG. 17–10). In the book, however, the schema combines pictures with words. Each page has two vertical strips of painted scenes set against a mosaiclike field and filled out by half-quatrefoils in the interstices—the standard format of mid-thirteenth-century windows. Adjacent to each medallion is an excerpt of text, either a summary of a scriptural passage or a terse contemporary interpretation or allegory. Both painted miniatures and texts alternate between scriptural summaries and their moralizing explications, outlined in words and visualized with pictures. This adds up to a very learned and complicated compilation, perhaps devised by

The opening of the Windmill Psalter.
Made in England, probably London. Late 13th century. Ink, pigments, and gold on vellum, each page
12¾″ × 8¾″ (32.3 × 22.2 cm). The Morgan Library and Museum, New York. MS. 102, fols. lv–2r

Although this page initially seems to have been trimmed at left, the flattened outside edge of the roundels marks the original end of the page. What might have started as an independent Jesse Tree may later have been expanded into the initial B, widening the pictorial composition farther than originally planned.

The four evangelists appear in the corner roundels as personified symbols writing at desks.

The windmill that has given this psalter its name seems to be a religious symbol based on the fourth verse of this Psalm: "Not so the wicked, not so: but like the dust, which the wind driveth from the face of the earth."

Tucked within the surrounds of the letter B are scenes from God's creation of the world, culminating in the forming of Adam and Eve. Medieval viewers would meditate on how the new Adam (Christ) and Eve (Mary)—featured in the Jesse Tree—had redeemed humankind from the sin of the first man and woman. Similarly, Solomon's choice of the true mother would recall Christ's choice of the true Church. Medieval manuscripts are full of cross-references and multiple meanings, intended to stimulate extended reflection and meditation, not embody a single truth or tell a single story.

Participants in this scene of the Judgment of Solomon have been creatively distributed within the unusual narrative setting of the letter *E*. Solomon sits on the crossbar; the two mothers are stacked one above the other; and the knight balancing the baby has to hook his toe under the curling extension of the crossbar to maintain his balance.

 View the Closer Look for Psalm 1 in the Windmill Psalter on myartslab.com

17–23 • Matthew Paris SELF-PORTRAIT KNEELING BEFORE THE VIRGIN AND CHILD
From the *Historia Anglorum*, made in St. Albans, England. 1250–1259. Ink and color on parchment, 14″ × 9¾″ (35.8 × 25 cm). The British Library, London. Royal MS. 14.c.vii, fol. 6r

THE WINDMILL PSALTER The dazzling artistry and delight in ambiguity and contradiction that had marked early medieval manuscripts in the British Isles (see FIG. 15–1) also survived into the Gothic period in the Windmill Psalter of c. 1270–1280 (see "A Closer Look," opposite). The letter *B*—the first letter of Psalm 1, which begins with the words *Beatus vir qui non abit in consilio impiorum* ("Happy are those who do not follow the advice of the wicked")—fills an entire left-hand page and outlines a densely interlaced thicket of tendrils and figures. This is a Tree of Jesse, a genealogical diagram of Jesus' royal and spiritual ancestors in the Hebrew Bible based on a prophesy in Isaiah 11:1–3. An over-sized, semi-reclining figure of Jesse, father of King David, appears sheathed in a red mantle, with the blue trunk of a vinelike tree

emerging from his side. Above him is his majestically enthroned royal son, who, as an ancestor of Mary (shown just above him), is also an ancestor of Jesus, who appears at the top of the sequence. In the circling foliage flanking this sacred royal family tree are a series of prophets, representing Jesus' spiritual heritage.

E, the second letter of the psalm's first word, appears at the top of the right-hand page and is formed from large tendrils emerging from delicate background vegetation to support characters in the story of the Judgment of Solomon portrayed within it (I Kings 3:16–27). Two women (one above the other at the right) claiming the same baby appear before King Solomon (enthroned on the crossbar) to settle their dispute. The king orders a guard to slice the baby in half with his sword and give each woman her share.

This trick exposed the real mother, who hastened to give up her claim in order to save the baby's life. It has been suggested that the positioning of this story within the letter *E* may have made a subtle association between Solomon and the reigning King Edward I. The rest of the psalm's five opening words appear on a banner carried by an angel who swoops down at the bottom of the *E*.

ARCHITECTURE

The Gothic style in architecture appeared early in England, introduced by Cistercian and Norman builders and by traveling master masons. But in England there was less emphasis on height than in France. English churches have long, broad naves and screen-like façades.

SALISBURY CATHEDRAL The thirteenth-century cathedral in Salisbury is an excellent example of English Gothic. It has unusual origins. The first cathedral in this diocese had been built within the castle complex of the local lord. In 1217, Bishop Richard Poore petitioned the pope to relocate the church, claiming the wind on the hilltop howled so loudly that the clergy could not hear themselves sing the Mass. A more pressing concern was probably his desire to escape the lord's control. As soon as he moved, the bishop established a new town, called Salisbury. Material from the old church was carted down the hill and used in the new cathedral, along with dark, fossil-filled Purbeck stone from quarries in southern England and limestone imported from Caen. Building began in 1220, and most of the cathedral was finished by 1258,

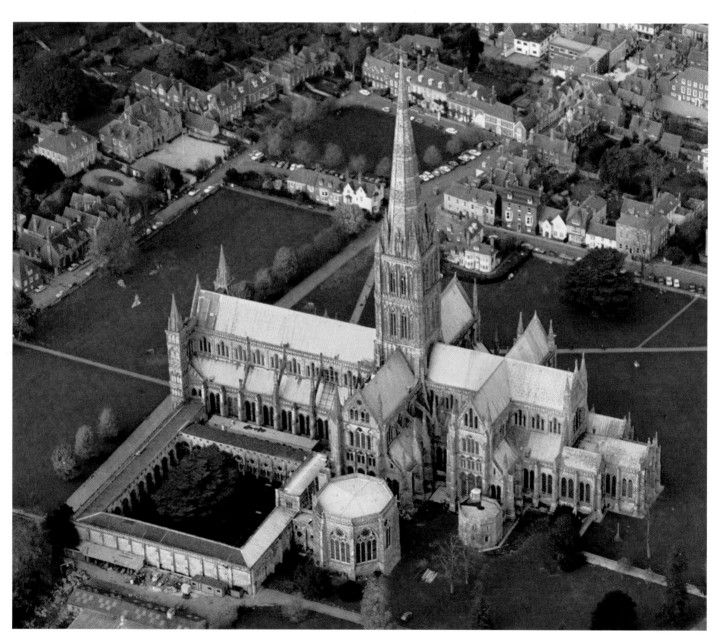

17-24 • SALISBURY CATHEDRAL
England. Church building 1220–1258; west façade finished 1265; spire c. 1320–1330; cloister and chapter house 1263–1284.

✳ Explore the architectural panoramas of Salisbury Cathedral on myartslab.com

Trinity
chapter

chapter house

entrance
porch

cloister

17-25 • PLAN OF SALISBURY CATHEDRAL

17-26 • INTERIOR LOOKING EAST, SALISBURY CATHEDRAL

In the eighteenth century, the English architect James Wyatt subjected the building to radical renovations, during which the remaining stained glass and figure sculpture were removed or rearranged. Similar campaigns to refurbish medieval churches were common at the time. The motives of the restorers were complex and their results far from our own notions of historical authenticity.

an unusually short period for such an undertaking (**FIG. 17-24**).

The west façade, however, was not completed until 1265. The small flanking towers project beyond the side walls and buttresses, giving the façade an increased width. A mighty crossing tower (the French preferred a slender spire) became the focal point of the building. (The huge crossing tower and its 400-foot spire are a fourteenth-century addition at Salisbury, as are the flying buttresses, which were added to stabilize the tower.) The slightly later cloister and chapter house provided for the cathedral's clergy.

Salisbury has a distinctive plan (**FIG. 17-25**), with wide projecting double transepts, a square east end with a single chapel, and a spacious sanctuary—more like a monastic church. The nave interior reflects the Norman building tradition of heavy walls and a tall nave arcade surmounted by a gallery and a clerestory with simple lancet windows (**FIG. 17-26**). The walls alone are substantial enough to buttress the four-part ribbed vault. The emphasis on the

horizontal movement of the arcades, unbroken by continuous vertical colonnettes extending from the compound piers, directs worshipers' attention forward toward the altar behind the choir screen. The use of color in the stonework is reminiscent of the decorative effects in Romanesque interiors. The shafts supporting the four-part rib vaults are made of dark Purbeck stone that contrasts with the lighter limestone of the rest of the interior. The original painting and gilding of the stonework would have enhanced the effect.

MILITARY AND DOMESTIC ARCHITECTURE Cathedrals were not the only Gothic buildings. Western European knights who traveled east during the crusades were impressed by the architectural forms they saw in Muslim castles and Byzantine fortifications. When they returned home, they had their own versions of these fortifications built. Castle gateways became more complex, nearly independent fortifications, often guarded by twin towers

rather than just one. New rounded towers eliminated the corners that had made earlier square towers vulnerable to battering rams, and crenellations (notches) were added to tower tops to provide stone shields for more effective defense. The outer, enclosing walls were likewise strengthened. The open, interior space was enlarged and filled with more comfortable living quarters for the lord and wooden buildings to house the garrison and the support staff. Barns and stables for animals, including the extremely valuable war horses, were also erected within the enclosure.

STOKESAY CASTLE Military structures were not the only secular buildings outfitted for defense. In uncertain times, the manor (a landed estate), which continued to be an important economic unit in the thirteenth century, also had to fortify its buildings. And country houses equipped with a tower and crenellated rooflines became a status symbol as well as a necessity. **STOKESAY CASTLE**, a remarkable fortified manor house, survives in England near the Welsh border. In 1291, a wool merchant, Lawrence of Ludlow, acquired the property of Stokesay and secured permission from King Edward I to fortify his dwelling—officially known as a "license to crenellate" (**FIG. 17-27**). Two towers—including a massive crenellated south tower—and a great hall still survive.

Life in the Middle Ages revolved around the hall. Windows on each side of Stokesay's hall open both toward the courtyard and out across a moat toward the countryside. By the thirteenth century, people began to expect some privacy as well as security;

therefore at both ends of the hall are two-story additions that provided retiring rooms for the family and workrooms where women could spin and weave. Rooms on the north end could be reached from the hall, but the upper chamber at the south was accessible only by means of an exterior stairway. A tiny window—a peephole—let women and members of the household observe the often rowdy activities in the hall below. In layout, there was essentially no difference between this manor far from the London court and the mansions built by the nobility in the city. Palaces followed the same pattern of hall and retiring rooms; they were simply larger.

GOTHIC ART IN GERMANY AND THE HOLY ROMAN EMPIRE

The Holy Roman Empire, weakened by internal strife and a prolonged struggle with the papacy, ceased to be a significant power in the thirteenth century. England and France were becoming strong nation-states, and the empire's hold on southern Italy and Sicily ended at mid century with the death of Emperor Frederick II. Subsequent emperors—who were elected—had only nominal authority over a loose conglomeration of independent principalities, bishoprics, and free cities. As in England, the French Gothic style, avidly embraced in the western Germanic territories, shows regional adaptations and innovations.

and she was canonized in 1235. Between 1235 and 1283, the knights of the Teutonic Order (who had moved to Germany from Jerusalem) built a church to serve as her mausoleum and pilgrimage center.

The plan of the church is an early German form, with choir and transepts of equal size, each ending in apses. The elevation of the building, however, is new, with nave and aisles of equal height. On the exterior wall, tall buttresses emphasize its verticality, and the two rows of windows suggest a two-story building, which is not the case. Inside, the closely spaced piers of the nave support the ribbed vault and, as with the buttresses, give the building a vertical, linear quality (**FIG. 17–29**). Light from the two stories of windows fills the interior, unimpeded by walls or galleries. The hall-church design was adopted widely for civic and residential buildings in Germanic lands and also for Jewish architecture.

ARCHITECTURE

In the thirteenth century, the increasing importance of the sermon in church services led architects in Germany to develop the **hall church**, a type of open, light-filled interior space that appeared in Europe in the early Middle Ages, characterized by a nave and side aisles of equal height. The spacious and well-lit design of the hall church provided accommodation for the large crowds drawn by charismatic preachers.

CHURCH OF ST. ELIZABETH OF HUNGARY IN MARBURG Perhaps the first true Gothic hall church, and one of the earliest Gothic buildings in Germany, was the **CHURCH OF ST. ELIZABETH OF HUNGARY** in Marburg (**FIG. 17–28**). The Hungarian princess Elizabeth (1207–1231) had been sent to Germany at age 4 to marry the ruler of Thuringia. He soon died of the plague, and she devoted herself to caring for people with incurable diseases. It was said that she died at age 24 from exhaustion,

17-29 • INTERIOR, CHURCH OF ST. ELIZABETH
OF HUNGARY
Marburg, Germany. 1235–1283.

17–30 • INTERIOR, OLD-NEW SYNAGOGUE (ALTNEUSCHUL)

Prague, Bohemia (Czech Republic). c. late 13th century; *bimah* after 1483.

THE OLD-NEW SYNAGOGUE Built in the third quarter of the thirteenth century using the hall-church design, Prague's **OLD-NEW SYNAGOGUE** (Altneuschul) is the oldest functioning synagogue in Europe and one of two principal synagogues serving the Jews of Prague (**FIG. 17-30**). Like a hall church, the vaults of the synagogue are all the same height. Unlike a basilican church, however, with its division into nave and side aisles, the Old-New Synagogue has only two aisles, each with three bays supported by the walls and two octagonal piers. Each bay has Gothic four-part ribbed vaulting to which a nonfunctional fifth rib has been added. Some say that this fifth rib was added to undermine the cross form made by the intersecting diagonal ribs.

Medieval synagogues were both places of prayer and communal centers of learning and inspiration where men gathered to read and discuss the Torah. The synagogue had two focal points, a shrine for the Torah scrolls (the *aron*), and a raised platform for reading from them (the *bimah*). The congregation faced the Torah shrine, which was located on the east wall, in the direction of Jerusalem, while the reading platform stood in the center of the hall, straddling the two center bays. In Prague it was surrounded by an ironwork open screen. The single entrance was placed off-center in a corner bay at the west end. Men worshiped and studied in the main space; women had to worship in annexes on the north and west sides.

SCULPTURE

Since the eleventh century, among the most creative centers of European sculpture were the Rhine River Valley and the region known as the Mosan (from the Meuse River, in present-day Belgium), with centers in Liège and Verdun. Ancient Romans had built camps and cities in this area, and Classical influence lingered through the Middle Ages, when Nicholas of Verdun and his fellow goldsmiths initiated a new classicizing style in the arts.

SHRINE OF THE THREE KINGS For the archbishop of Cologne, Nicholas created the magnificent **SHRINE OF THE THREE KINGS** (c. 1190–c. 1205/10), a reliquary for what were believed to be relics of the three Magi. Shaped in the form of a basilican church (**FIG. 17-31**), it is made of gilded bronze and silver, set with gemstones and dark blue enamel plaques that accentuate its architectural details. Like his fellow Mosan artists, Nicholas was inspired by ancient Roman art still found in the region, as well as by classicizing Byzantine works. The figures are lifelike, fully modeled, and swathed in voluminous but revealing drapery. The three Magi and the Virgin fill the front gable end, and prophets and apostles sit in the niches in the two levels of arcading on the sides. The work combines robust, expressively mobile sculptural forms with a jeweler's exquisitely ornamental detailing to create an opulent, monumental setting for its precious contents.

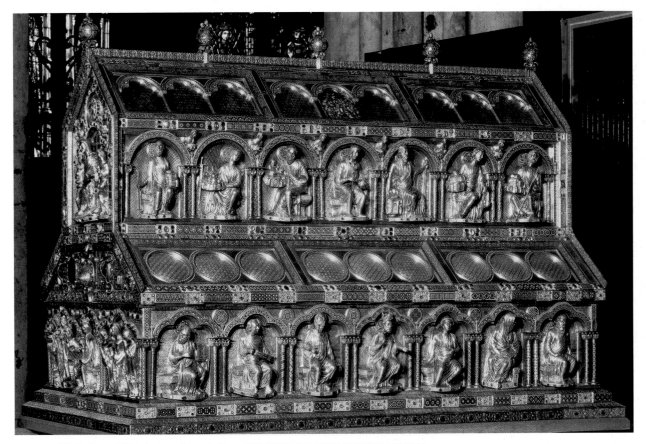

17–31 • Nicholas of Verdun and workshop SHRINE OF THE THREE KINGS
Cologne (Köln) Cathedral, Germany. c. 1190–c. 1205/10. Silver and gilded bronze with enamel and gemstones, 5′8″ × 6′ × 3′8″ (1.73 × 1.83 × 1.12 m).

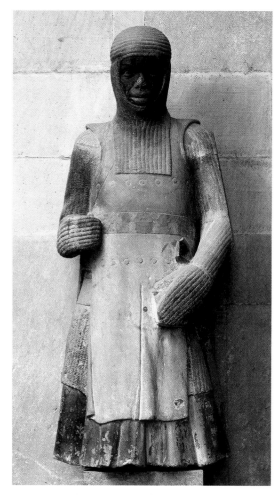

17-32 • ST. MAURICE
Magdeburg Cathedral, Magdeburg, Germany. c. 1240–1250. Dark sandstone with traces of polychromy.

17-33 • EKKEHARD AND UTA
West chapel, Naumburg Cathedral, Germany. c. 1245–1260. Stone with polychromy, height approx. 6′2″ (1.88 m).

ST. MAURICE A powerful current of realism runs through German Gothic sculpture. Some works seem to be carved after a living model. Among them is an arresting mid-thirteenth-century statue of **ST. MAURICE** in Magdeburg Cathedral (**FIG. 17-32**), the location of his relics since 968. The Egyptian Maurice, a commander in the Roman army, was martyred in 286 together with his Christian battalion while they were stationed in Germany. As patron saint of Magdeburg, he was revered by Ottonian emperors, who were anointed in St. Peter's in Rome at the altar of St. Maurice. He remained a favorite saint of military aristocrats. This is the first surviving representation of Maurice as a black African, an acknowledgment of his Egyptian origins and an aspect of the growing German interest in realism, which extends here to the detailed rendering of his costume of chain mail and riveted leather.

EKKEHARD AND UTA Equally portraitlike is the depiction of this couple, commissioned about 1245 by Dietrich II, bishop of Wettin, for the family funeral chapel, built at the west end of Naumburg Cathedral. Bishop Dietrich ordered life-size statues of

12 of his ancestors, who had been patrons of the church, to be placed on pedestals mounted at window level around the chapel.

In the representations of Margrave Ekkehard of Meissen (a margrave—count of the march or border—was a territorial governor who defended the frontier) and his Polish-born wife, Uta (**FIG. 17-33**), the sculptor created highly individualized figures and faces. Since these are eleventh-century people, sculpted in the thirteenth century, we are not looking at their portrait likenesses, but it is still possible that live models were used to heighten the sense of a living presence in their portraits. But more than their faces contribute to this liveliness. The margrave nervously fingers the strap of the shield that is looped over his arm, and the coolly elegant Uta pulls her cloak around her neck as if to protect herself from the cold, while the extraordinary spread of her left hand is necessary to control the cloak's voluminous, thick cloth. The survival of original **polychromy** (multicolored painting on the surface of sculpture or architecture) indicates that color added to the impact of the figures. The impetus toward descriptive realism and psychological presence, initiated in the thirteenth century, will expand in the art of northern Europe into the fifteenth century and beyond.

GOTHIC ART IN ITALY

The thirteenth century was a period of political division and economic expansion for the Italian peninsula. Part of southern Italy and Sicily was controlled by Frederick II von Hohenstaufen (1194–1250), Holy Roman emperor from 1220. Frederick was a politically unsettling force. He fought with a league of north Italian cities and briefly controlled the Papal States. On his death, however, Germany and the Holy Roman Empire ceased to be an important factor in Italian politics and culture.

In northern Italy, in particular, organizations of successful merchants created communal governments in their prosperous and independent city-states and struggled against powerful families for political control. Artists began to emerge as independent agents, working directly with wealthy clients and with civic and religious institutions.

It was during this time that new religious orders known as the mendicants (begging monks) arose to meet the needs of the growing urban population. They espoused an ideal of poverty, charity, and love, and they dedicated themselves to teaching and preaching, while living among the urban poor. Most notable in the beginning were the Franciscans, founded by St. Francis of Assisi (1182–1226; canonized in 1228). This son of a wealthy merchant gave away his possessions and devoted his life to God and the poor. As others began to join him, he wrote a simple rule for his followers, who were called brothers, or friars (from the Latin *frater*, meaning "brother"), and the pope approved the new order in 1209–1210.

SCULPTURE: THE PISANO FAMILY

During the first half of the thirteenth century, the culturally enlightened Frederick II fostered a Classical revival at his southern Italian court. In the Romanesque period, artists in southern Italy had already turned to ancient sculpture for inspiration, but Frederick, mindful of his imperial status as Holy Roman emperor, encouraged this tendency to help communicate a message of power. He also encouraged artists to emulate the natural world around them. Nicola Pisano (active in Tuscany c. 1258–1278), who moved from the southern region of Apulia to Tuscany at mid century, became the leading exponent of this classicizing and naturalistic style.

NICOLA PISANO'S PULPIT AT PISA In an inscription on a free-standing marble pulpit in the Pisa Baptistery (**FIG. 17-34**), Nicola identifies himself as a supremely self-confident sculptor: "In the year 1260 Nicola Pisano carved this noble work. May so gifted a hand be praised as it deserves." Columns topped with leafy Corinthian capitals support standing figures and Gothic trefoil arches, which in turn provide a platform for the six-sided pulpit. The columns rest on high bases carved with crouching figures, domestic animals, and shaggy-maned lions. Panels forming the

17-34 • Nicola Pisano **PULPIT**
Baptistery, Pisa, Italy. 1260. Marble, height approx. 15′ (4.6 m).

pulpit enclosure illustrate New Testament subjects, each framed as an independent composition.

Each panel illustrates several scenes in a continuous narrative; **FIGURE 17-35** depicts the **ANNUNCIATION, NATIVITY, AND ADORATION OF THE SHEPHERDS**. The Virgin reclines in the middle of the composition after having given birth to Jesus, who below receives his first bath from midwives. The upper left corner holds the Annunciation—the moment of Christ's conception, as announced by the archangel Gabriel. The scene in the upper right combines the Annunciation to the Shepherds with their Adoration

of the Child. The viewer's attention moves from group to group within the shallow space, always returning to the regally detached Mother of God. The format, style, and technique of Roman sarcophagus reliefs—readily accessible in the burial ground near the baptistery—may have provided Nicola's models for this carving. The sculptural treatment of the deeply cut, full-bodied forms is certainly Classical in inspiration, as are the heavy, placid faces.

GIOVANNI PISANO'S PULPIT AT PISTOIA Nicola's son Giovanni (active c. 1265–1314) assisted his father while learning

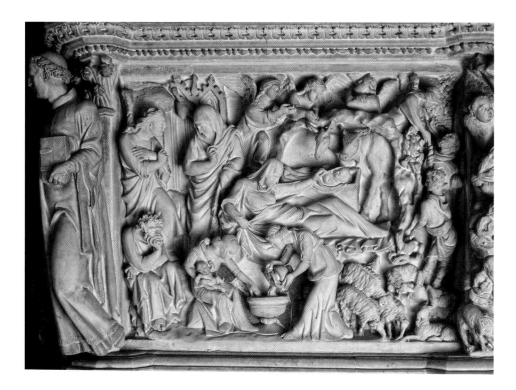

17-36 • Giovanni Pisano
ANNUNCIATION, NATIVITY, AND ADORATION OF THE SHEPHERDS
Detail of pulpit, Sant'Andrea, Pistoia, Italy. 1298–1301. Marble, 33″ × 40⅛″ (83 × 102 cm).

17-37 • Coppo di Marcovaldo CRUCIFIX
From the Franciscan convent of Santa Chiara, San Gimignano, Italy. c. 1250–1270. Tempera and gold on wood panel, 9′7⅜″ × 8′1¼″ (2.93 × 2.47 m). Pinacoteca, San Gimignano, Italy.

from him, and he may also have worked or studied in France. By the end of the thirteenth century, he had emerged as a versatile artist in his own right. Between 1298 and 1301, he and his workshop carved a pulpit for Sant'Andrea in Pistoia that is similar to his father's in conception but significantly different in style and execution. In his more dramatic rendering of the **ANNUNCIATION, NATIVITY, AND ADORATION OF THE SHEPHERDS**, Giovanni places graceful but energetic figures in an uptilted, deeply carved setting (**FIG. 17-36**). He replaces Nicola's imperious, stately Roman matron with a lithe, younger Mary, who recoils from Gabriel's advance at left, and at center, exhausted from giving birth, pulls at her bed-sheets for support while reaching toward her newborn baby. Sheep, shepherds, and angels spiral up through the trees at the right. Giovanni's sculpture is as dynamic as Nicola's is static.

PAINTING

The capture of Constantinople by crusaders in 1204 brought an influx of Byzantine art and artists to Italy. The imported style of painting, the *maniera greca* ("the Greek manner"), influenced thirteenth- and fourteenth-century Italian painting in style and technique and introduced a new emphasis on pathos and emotion.

PAINTED CRUCIFIXES One example, a large wooden crucifix attributed to the thirteenth-century Florentine painter Coppo di Marcovaldo (**FIG. 17-37**), represents an image of a suffering Christ on the cross, a Byzantine type with closed eyes and bleeding, sagging body that encourages viewers to respond emotionally and empathetically to the image (as in FIGS. 8-22, 15-24). This is a "historiated crucifix," meaning that narrative scenes flank Christ's body, in this case episodes from the story of his Passion.

17-38 • SCHEMATIC DRAWING OF THE CHURCH OF ST. FRANCIS, ASSISI
Umbria, Italy. 1228–1253.

✴ Explore the architectural panoramas of the church of St. Francis on myartslab.com

Such monumental crosses—this one is almost 10 feet high—were mounted on the choir screens that separated the clergy in the sanctuary from the lay people in the nave, especially in the churches of the Italian mendicants. One such cross can be seen from behind with its wooden bracing in FIGURE 17-39, tilted out to lean toward the worshiper's line of vision and increase the emotional impact.

THE CHURCH OF ST. FRANCIS AT ASSISI Two years after St. Francis's death in 1226, the church in his birthplace, Assisi, was begun. It was nearly finished in 1239 but was not dedicated until 1253. This building was unusually elaborate in its design, with upper and lower churches on two stories and a crypt at the choir end underneath both (**FIG. 17-38**). Both upper and lower churches have a single nave of four square vaulted bays, and both end in a transept and a single apse. The lower church has massive walls and a narrow nave flanked by side chapels. The upper church is a spacious, well-lit hall with excellent visibility and acoustics, designed to accommodate the crowds of pilgrims who came to see and hear the friars preach as well as to participate in church rituals and venerate the tomb of the saint. The church walls presented expanses of uninterrupted wall surface where sacred stories could unfold in murals. In the wall paintings of the upper

church, the focus was on the story of Francis himself, presented as a model Christian life to which pilgrims, as well as resident friars, might aspire.

Scholars differ over whether the murals of the upper church were painted as early as 1290, but they agree on their striking narrative effectiveness. Like most Franciscan paintings, these scenes were designed to engage with viewers by appealing to their memories of their own life experiences, evoked by the inclusion of recognizable anecdotal details and emotionally expressive figures. A good example is **THE MIRACLE OF THE CRIB AT GRECCIO (FIG. 17-39)**, portraying St. Francis making the first Christmas manger scene in the church at Greccio.

The scene—like all Gothic visual narratives, set in the present, even though the event portrayed took place in the past—unfolds within a Gothic church that would have looked very familiar to late thirteenth-century viewers. A large wooden crucifix, similar to the one by Coppo di Marcovaldo (see FIG. 17-37), has been suspended from a stand on top of a screen separating the sanctuary from the nave. The cross has been reinforced on the back and tilted forward to hover over people in the nave, whom we see crowding behind an open door in the choir screen. A pulpit, with stairs leading up to its entrance and candlesticks at its corners, rises above the screen

17-39 • THE MIRACLE OF THE CRIB AT GRECCIO
From a cycle of the Life of St. Francis, church of St. Francis, Assisi. Late 13th or early 14th century. Fresco.

at the left. An elaborate carved baldacchino (canopy) surmounts the altar at the right, and an adjustable wooden lectern stands in front of the altar. Other small but telling touches include a seasonal liturgical calendar posted on the lectern, foliage swags decorating the baldacchino, and an embroidered altar cloth. And sound as well as sight is referenced here in the figures of the friars who throw their heads back, mouths wide open, to provide the liturgical soundtrack to this cinematic tableau.

The focus on the sacred narrative is confined to a small area at lower right, where St. Francis reverently holds the Holy Infant above a plain, boxlike crib next to miniature representations of various animals that might have been present at the Nativity, capturing the miraculous moment when, it was said, the Christ Child himself appeared in the manger. But even if the story is about a miracle, it takes place in a setting rich in worldly references that allowed contemporary viewers to imagine themselves as part of the scene, either as worshipers kneeling in front of the altar or as spectators pushing toward the doorway to get a better view. This narrative aspiration to engage directly with viewers through references to their own lives and their own time, initiated during the Middle Ages, will continue into the Renaissance.

THINK ABOUT IT

17.1 Characterize the most important technological innovations and sociocultural formations that made the "Age of the Cathedrals" possible?

17.2 Explain how manuscript illumination was used to convey complex theological ideas during the Gothic period. Analyze the iconography of one manuscript discussed in this chapter.

17.3 How was St. Francis's message of empathy conveyed in the frescos of the church of St. Francis in Assisi?

17.4 Analyze Salisbury Cathedral in England and the German church of St. Elizabeth of Hungary in Marburg. How does each reflect characteristics of French Gothic style, and how does each depart from that style and express architectural features characteristic of its own region?

CROSSCURRENTS

FIG. 16–20

FIG. 17–1

These two works of art, one Romanesque and one Gothic, portray events from the same Bible story in a public context where they would have been seen by a diverse cross section of viewers. Compare the style of presentation. What features do these visual narratives have in common? How are they different? Is there a relationship between style, meaning, and medium?

✓—[**Study** and review on myartslab.com

18–1 • Ambrogio Lorenzetti **FRESCOS OF THE SALA DEI NOVE (OR SALA DELLA PACE)**
Palazzo Pubblico, Siena, Italy. 1338–1339. Length of long wall about 46′ (14 m).

Read the document related to the frescos in the Palazzo Pubblico on myartslab.com

Fourteenth-Century Art in Europe

In 1338, the Nine—a council of merchants and bankers that governed Siena as an oligarchy—commissioned frescos from renowned Sienese painter Ambrogio Lorenzetti (c. 1295–c. 1348) for three walls in the chamber within the Palazzo Pubblico where they met to conduct city business. This commission came at the moment of greatest prosperity and security since the establishment of their government in 1287.

Lorenzetti's frescos combine allegory with panoramic landscapes and cityscapes to visualize and justify the beneficial effects of the Sienese form of government. The moral foundation of the rule of the Nine is outlined in a complicated allegory in which seated personifications (far left in **FIG. 18–1**) of Concord, Justice, Peace, Strength, Prudence, Temperance, and Magnanimity, not only diagram good governance but actually reference the Last Judgment in a bold assertion of the relationship between secular rule and divine authority. This tableau contrasts with a similar presentation of bad government, where Tyranny is flanked by the personified forces that keep tyrants in power—Cruelty, Treason, Fraud, Fury, Division, and War. A group of scholars would have devised this complex program of symbols and meanings; it is unlikely that Lorenzetti would have known the philosophical works that underlie them. Lorenzetti's fame, however, and the wall paintings' secure position among the most remarkable

surviving mural programs of the period, rests on the other part of this ensemble—the effects of good and bad government in city and country life (see **FIG. 18–15**).

Unlike the tableau showing the perils of life under tyrannical rule, the panoramic view of life under good government—which in this work of propaganda means life under the rule of the Nine—is well preserved. A vista of fourteenth-century Siena—identifiable by the cathedral dome and tower peeking over the rooftops in the background—showcases carefree life within shops, schools, taverns, and worksites, as the city streets bustle with human activity. Outside, an expansive landscape highlights agricultural productivity.

Unfortunately, within a decade of the frescos' completion, life in Siena was no longer as stable and carefree. The devastating bubonic plague visited in 1348—Ambrogio Lorenzetti himself was probably one of the victims—and the rule of the Nine collapsed in 1355. But this glorious vision of joyful prosperity preserves the dreams and aspirations of a stable government, using some of the most progressive and creative ideas in fourteenth-century Italian art, ideas we will see developed at the very beginning of the century, and whose history we will trace over the next two centuries through the Renaissance.

LEARN ABOUT IT

18.1 Compare and contrast the Florentine and Sienese styles of narrative painting as exemplified by Giotto and Duccio.

18.2 Investigate the Bible stories that were the subject of fourteenth-century sacred art, as well as the personal and political themes highlighted in secular art.

18.3 Assess the close connections between works of art and their patrons in fourteenth-century Europe.

18.4 Explore the production of small-scale works, often made of precious materials and highlighting extraordinary technical virtuosity, that continues from the earlier Gothic period.

((•—[**Listen** to the chapter audio on myartslab.com

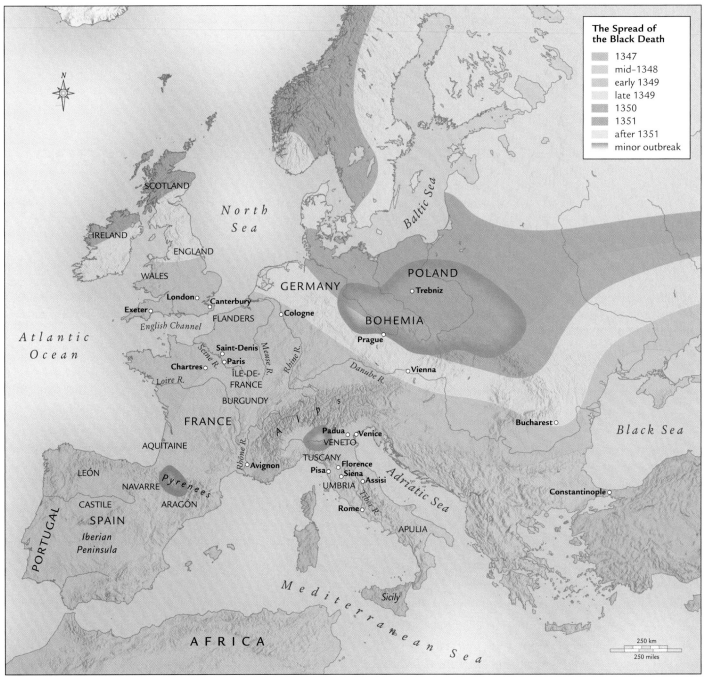

The Spread of the Black Death

- 1347
- mid-1348
- early 1349
- late 1349
- 1350
- 1351
- after 1351
- minor outbreak

MAP 18-1 • EUROPE IN THE FOURTEENTH CENTURY

Following its outbreak in the Mediterranean in 1347, the Black Death swept across the European mainland over the next four years.

FOURTEENTH-CENTURY EUROPE

Literary luminaries Dante, Petrarch, Boccaccio, Chaucer, and Christine de Pizan (see "A New Spirit in Fourteenth-Century Literature," opposite) and the visionary painters Giotto, Duccio, Jean Pucelle, and Master Theodoric participated in a cultural explosion that swept through fourteenth-century Europe, and especially Italy. The poet Petrarch (1304–1374) was a towering figure in this change, writing his love lyrics in Italian, the language of everyday life, rather than Latin, the language of ceremony and high art. Similarly, the deeply moving murals of Florentine painter Giotto di Bondone (c. 1277–1337) were rooted in his observation of the people around him, giving the participants in sacred narratives both great dignity and striking humanity, thus making them familiar, yet new, to the audiences that originally experienced them. Even in Paris—still the artistic center of Europe as far as refined taste and technical sophistication were concerned—the painter Jean Pucelle began to show an interest in experimenting with established conventions.

For Petrarch and his contemporaries, the essential qualifications for a writer were an appreciation of Greek and Roman authors and an ability to observe the people living around them. Although fluent in Latin, they chose to write in the language of their own time and place—Italian, English, French. Leading the way was Dante Alighieri (1265–1321), who wrote *The Divine Comedy*, his great summation of human virtue and vice, and ultimately human destiny, in Italian, establishing his daily vernacular as worthy to express great literary themes.

Francesco Petrarca, called simply Petrarch (1304–1374), raised the status of secular literature with his sonnets to his unattainable beloved, Laura, his histories and biographies, and his writings on the joys of country life in the Roman manner. Petrarch's imaginative updating of Classical themes in a work called *The Triumphs*—which examines the themes of Chastity triumphant over Love, Death over Chastity, Fame over Death, Time over Fame, and Eternity over Time—provided later Renaissance poets and painters with a wealth of allegorical subject matter.

More earthy, Giovanni Boccaccio (1313–1375) perfected the art of the short story in *The Decameron*, a collection of amusing and moralizing tales told by a group of young Florentines who moved to the countryside to escape the Black Death. With wit and sympathy, Boccaccio presents the full spectrum of daily life in Italy. Such secular literature, written in Italian as it was then spoken in Tuscany, provided a foundation for fifteenth-century Renaissance writers.

In England, Geoffrey Chaucer (c. 1342–1400) was inspired by Boccaccio to write his own series of stories, *The Canterbury Tales*, told by pilgrims traveling to the shrine of St. Thomas à Becket (1118?–1170) in Canterbury. Observant and witty, Chaucer depicted the pretensions and foibles, as well as the virtues, of humanity.

Christine de Pizan (1364–c. 1431), born in Venice but living and writing at the French court, became an author out of necessity when she was left a widow with three young children and an aged mother to support. Among her many works are a poem in praise of Joan of Arc and a history of famous women—including artists—from antiquity to her own time. In *The Book of the City of Ladies*, she defended women's abilities and argued for women's rights and status.

These writers, as surely as Giotto, Duccio, Peter Parler, and Master Theodoric, led the way into a new era.

Changes in the way that society was organized were also under way, and an expanding class of wealthy merchants supported the arts as patrons. Artisan guilds—organized by occupation—exerted quality control among members and supervised education through an apprenticeship system. Admission to the guild came after examination and the creation of a "masterpiece"—literally, a piece fine enough to achieve master status. The major guilds included cloth finishers, wool merchants, and silk manufacturers, as well as pharmacists and doctors. Painters belonged to the pharmacy guild, perhaps because they used mortars and pestles to grind their colors. Their patron saint, Luke, who was believed to have painted the first image of the Virgin Mary, was also a physician—or so they thought. Sculptors who worked in wood and stone had their own guild, while those who worked in metals belonged to another. Guilds provided social services for their members, including care of the sick and funerals for the deceased. Each guild had its patron saint, maintained a chapel, and participated in religious and civic festivals.

Despite the cultural flourishing and economic growth of the early decades, by the middle of the fourteenth century much of Europe was in crisis. Prosperity had fostered population growth, which began to exceed food production. A series of bad harvests compounded this problem with famine. To make matters worse, a prolonged conflict known as the Hundred Years' War (1337–1453) erupted between France and England. Then, in mid century, a lethal plague known as the Black Death swept across Europe (MAP 18–1), wiping out as much as 40 percent of the population. In spite of these catastrophic events, however, the strong current of cultural change still managed to persist through to the end of the century and beyond.

ITALY

As great wealth promoted patronage of art in fourteenth-century Italy, artists began to emerge as individuals, in the modern sense, both in their own eyes and in the eyes of patrons. Although their methods and working conditions remained largely unchanged from the Middle Ages, artists in Italy contracted freely with wealthy townspeople and nobles as well as with civic and religious bodies. Perhaps it was their economic and social freedom that encouraged ambition and self-confidence, individuality and innovation.

FLORENTINE ARCHITECTURE AND METALWORK

The typical medieval Italian city was a walled citadel on a hilltop. Houses clustered around the church and an open city square. Powerful families added towers to their houses, both for defense and as expressions of family pride. In Florence, by contrast, the ancient Roman city—with its axial rectangular plan and open city squares—formed the basis for civic layout. The cathedral stood northeast of the ancient forum and a street following the Roman plan connected it with the Piazza della Signoria, the seat of the government.

THE PALAZZO DELLA SIGNORIA The Signoria (ruling body, from *signore*, meaning "Lord") that governed Florence met

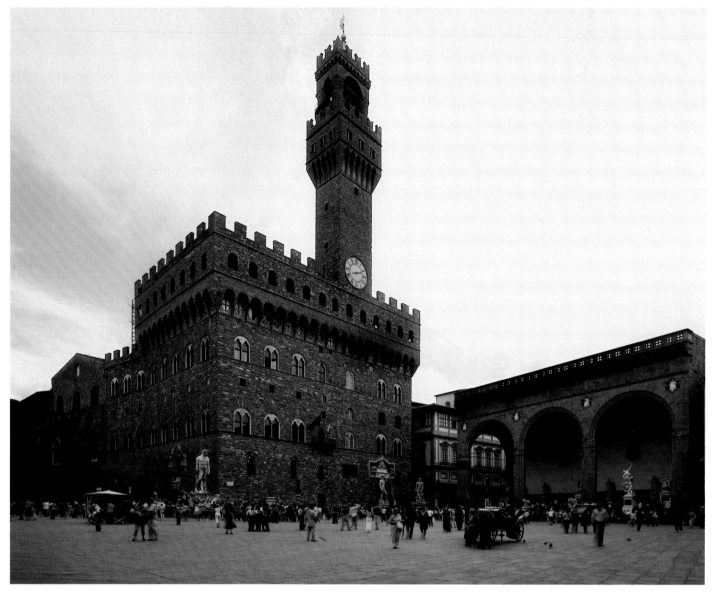

18-2 • PIAZZA DELLA SIGNORIA WITH PALAZZO DELLA SIGNORIA (TOWN HALL) 1299–1310, AND LOGGIA DEI LANZI (LOGGIA OF THE LANCERS), 1376–1382
Florence.

in the **PALAZZO DELLA SIGNORIA**, a massive fortified building with a bell tower 300 feet tall (**FIG. 18-2**). The building faces a large square, or piazza, which became the true center of Florence. The town houses around the piazza often had benches along their walls to provide convenient public seating. Between 1376 and 1382, master builders Benci di Cione and Simone Talenti constructed a huge **loggia** or covered open-air corridor at one side—now known as the Loggia dei Lanzi (Loggia of the Lancers)—to provide a sheltered locale for ceremonies and speeches.

THE BAPTISTERY DOORS In 1330, Andrea Pisano (c. 1290–1348) was awarded the prestigious commission for a pair of gilded bronze doors for Florence's Baptistery of San Giovanni, situated directly in front of the cathedral. (Andrea's "last" name means "from Pisa," and he was not related to Nicola and Giovanni

Pisano.) The doors were completed within six years and display 20 scenes from the **LIFE OF ST. JOHN THE BAPTIST** (the San Giovanni to whom the baptistery is dedicated) set above eight personifications of the Virtues (**FIG. 18-3**). The overall effect is two-dimensional and decorative: a grid of 28 rectangles with repeated quatrefoils filled by the graceful, patterned poses of delicate human figures. Within the quatrefoil frames, however, the figural compositions create the illusion of three-dimensional forms moving within the described spaces of natural and architectural worlds.

The scene of John baptizing a multitude (**FIG. 18-4**) takes place on a shelflike stage created by a forward extension of the rocky natural setting, which also expands back behind the figures into a corner of the quatrefoil frame. Composed as a rectangular group, the gilded figures present an independent mass of modeled forms. The illusion of three-dimensionality is enhanced by the

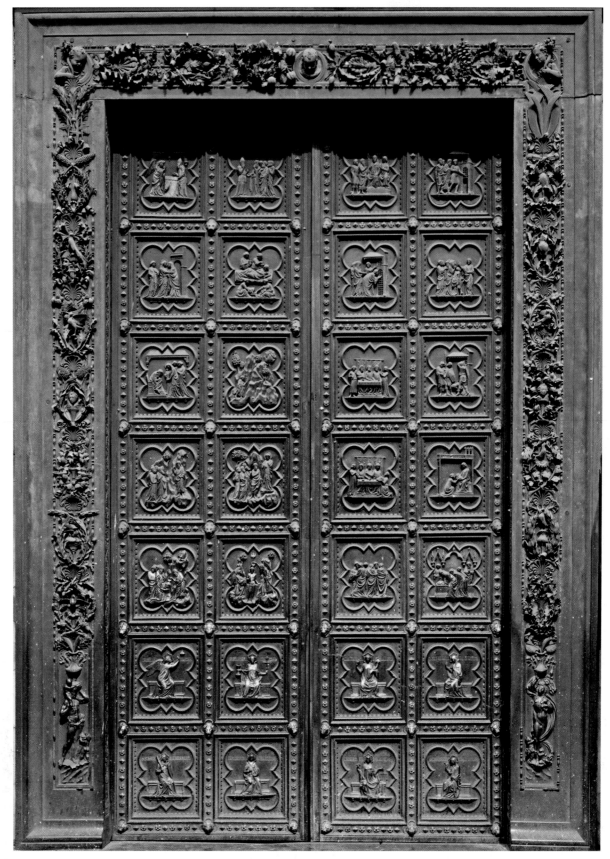

18-3 • Andrea Pisano LIFE OF ST. JOHN THE BAPTIST
South doors, baptistery of San Giovanni, Florence. 1330–1336. Gilded bronze, each panel 19¼″ × 17″ (48 × 43 cm). Frame, Ghiberti workshop, mid 15th century.

The bronze vine scrolls filled with flowers, fruits, and birds on the lintel and jambs framing the door were added in the mid fifteenth century.

way the curving folds of their clothing wrap around their bodies. At the same time, their graceful gestures and the elegant fall of their drapery reflect the soft curves and courtly postures of French Gothic art.

FLORENTINE PAINTING

Florence and Siena, rivals in so many ways, each supported a flourishing school of painting in the fourteenth century. Both grew out of local thirteenth-century painting traditions and engendered individual artists who became famous in their own time. The Byzantine influence—the *maniera greca* ("Greek style")—continued to provide models of dramatic pathos and narrative iconography, as well as stylized features including the use of gold for drapery folds and striking contrasts of highlights and shadows in the modeling of individual forms. By the end of the fourteenth century, the painter and commentator Cennino Cennini (see "Cennino

Cennini on Panel Painting," page 546) would be struck by the accessibility and modernity of Giotto's art, which, though it retained traces of the *maniera greca*, was moving toward the depiction of a lifelike, contemporary world anchored in solid, three-dimensional forms.

CIMABUE In Florence, this stylistic transformation began a little earlier than in Siena. About 1280, a painter named Cenni di Pepi (active c. 1272–1302), better known by his nickname "Cimabue," painted a panel portraying the **VIRGIN AND CHILD ENTHRONED** (**FIG. 18-5**), perhaps for the main altar of the church of Santa Trinità in Florence. At over 12 feet tall, this enormous painting set a new precedent for monumental altarpieces. Cimabue surrounds the Virgin and Child with angels and places a row of Hebrew Bible prophets beneath them. The hierarchically scaled figure of Mary holds the infant Jesus in her lap. Looking

out at the viewer while gesturing toward her son as the path to salvation, she adopts a formula popular in Byzantine iconography since at least the sixth century (see FIG. 8–14).

Mary's huge throne, painted to resemble gilded bronze with inset enamels and gems, provides an architectural framework for the figures. Cimabue creates highlights on the drapery of Mary, Jesus, and the angels with thin lines of gold, as if to capture their divine radiance. The viewer seems suspended in space in front of the image, simultaneously looking down on the projecting elements of the throne and Mary's lap, while looking straight ahead at the prophets at the base of the throne and the angels at each side. These spatial ambiguities, the subtle asymmetries within the centralized composition, the Virgin's engaging gaze, and the individually conceived faces of the old men give the picture a sense of life and the figures a sense of presence. Cimabue's ambitious attention to spatial volumes, his use of delicate modeling in light and shade to simulate three-dimensional form, and his efforts to give naturalistic warmth to human figures had an impact on the future development of Florentine painting.

18-5 • Cimabue VIRGIN AND CHILD ENTHRONED
Most likely painted for the high altar of the church of Santa Trinità, Florence. c. 1280. Tempera and gold on wood panel, 12′7″ × 7′4″ (3.53 × 2.2 m). Galleria degli Uffizi, Florence.

 Watch a video about the egg tempera process on myartslab.com

GIOTTO DI BONDONE According to the sixteenth-century chronicler Giorgio Vasari, Cimabue discovered a talented shepherd boy, Giotto di Bondone (active c. 1300–1337), and taught him to paint; "not only did the young boy equal the style of his master, but he became such an excellent imitator of nature that he completely banished that crude Greek [i.e., Byzantine] style and revived the modern and excellent art of painting, introducing good drawing from live natural models, something which had not been done for more than two hundred years" (Vasari, translated by Bondanella and Bondanella, p. 16). After his training, Giotto

may have collaborated on murals at the prestigious church of St. Francis in Assisi. We know he worked for the Franciscans in Florence and absorbed facets of their teaching. St. Francis's message of simple, humble devotion, direct experience of God, and love for all creatures was gaining followers throughout western Europe, and it had a powerful impact on thirteenth- and fourteenth-century Italian literature and art.

Compared to Cimabue's *Virgin and Child Enthroned*, Giotto's altarpiece of the same subject (**FIG. 18-6**), painted about 30 years later for the church of the Ognissanti (All Saints) in Florence,

18-6 • Giotto di Bondone VIRGIN AND CHILD ENTHRONED
Most likely painted for the high altar of the church of the Ognissanti (All Saints), Florence. 1305–1310. Tempera and gold on wood panel, 10′8″ × 6′8¼″ (3.53 × 2.05 m). Galleria degli Uffizi, Florence.

The two techniques used in mural painting are *buon* ("true") *fresco* ("fresh"), in which water-based paint is applied on wet plaster, and *fresco secco* ("dry"), in which paint is applied to a dry plastered wall. The two methods can be used on the same wall painting.

The advantage of *buon fresco* is its durability. A chemical reaction occurs as the painted plaster dries, which bonds the pigments into the wall surface. In *fresco secco*, by contrast, the color does not become part of the wall and tends to flake off over time. The chief disadvantage of *buon fresco* is that it must be done quickly without mistakes. The painter plasters and paints only as much as can be completed in a day, which explains the Italian term for each of these sections: **giornata**, or a day's work. The size of a *giornata* varies according to the complexity of the painting within it. A face, for instance, might take an entire day, whereas large areas of sky can be painted quite rapidly. In Giotto's Scrovegni Chapel, scholars have identified 852 separate *giornate*, some worked on concurrently within a single day by assistants in Giotto's workshop.

In medieval and Renaissance Italy, a wall to be frescoed was first prepared with a rough, thick undercoat of plaster known as the *arriccio*. When this was dry, assistants copied the master painter's composition onto it with reddish-brown pigment or charcoal. The artist made any necessary adjustments. These underdrawings, known as **sinopia**, have an immediacy and freshness that are lost in the finished painting. Work proceeded in irregularly shaped *giornate* conforming to the contours of major figures and objects. Assistants covered one section at a time with a fresh, thin coat of very fine plaster—the *intonaco*—over

the *sinopia*, and when this was "set" but not dry, the artist worked with pigments mixed with water, painting from the top down so that drips fell on unfinished portions. Some areas requiring pigments such as ultramarine blue (which was unstable in *buon fresco*), as well as areas requiring gilding, would be added after the wall was dry using the *fresco secco* technique.

arriccio

sinopia drawing

water-based paint on damp *intonaco*

wall

intonaco layer

buon fresco

exhibits greater spatial consistency and sculptural solidity while retaining some of Cimabue's conventions. The position of the figures within a symmetrical composition reflects Cimabue's influence. Gone, however, are Mary's modestly inclined head and the delicate gold folds in her drapery. Instead, light and shadow play gently across her stocky form, and her action—holding her child's leg instead of pointing him out to us—seems less contrived. This colossal Mary overwhelms her slender Gothic tabernacle of a throne, where figures peer through openings and haloes overlap faces. In spite of the hierarchic scale and the formal, enthroned image and flat, gold background, Giotto has created the sense that these are fully three-dimensional beings, whose plainly draped, bulky bodies inhabit real space. The Virgin's solid torso is revealed by her thin tunic, and Giotto's angels are substantial solids whose foreshortened postures project from the foreground toward us, unlike those of Cimabue, which stay on the surface along lateral strips composed of overlapping screens of color.

Although he was trained in the Florentine tradition, many of Giotto's principal works were produced elsewhere. After a sojourn in Rome during the last years of the thirteenth century, he was called to Padua in northern Italy soon after 1300 to paint frescos (see "*Buon Fresco*," above) for a new chapel being constructed at the site of an ancient Roman arena—explaining why it is usually

referred to as the Arena Chapel. The chapel was commissioned by Enrico Scrovegni, whose family fortune was made through the practice of usury—which at this time meant charging interest when loaning money, a sin so grave that it resulted in exclusion from the Christian sacraments. Enrico's father, Regibaldo, was a particularly egregious case (he appears in Dante's *Inferno* as the prototypical usurer), but evidence suggests that Enrico followed in his father's footsteps, and the building of the Arena Chapel next to his new palatial residence seems to have been conceived at least in part as a penitential act, part of Enrico's campaign not only to atone for his father's sins, but also to seek absolution for his own. He was pardoned by Pope Benedict XI (pontificate 1303–1304).

That Scrovegni called two of the most famous artists of the time—Giotto and Giovanni Pisano (see FIG. 17-36)—to decorate his chapel indicates that his goals were to express his power, sophistication, and prestige, as well as to atone for his sins. The building itself has little architectural distinction. It is a simple, barrel-vaulted room that provides broad walls, a boxlike space to showcase Giotto's paintings (FIG. 18-7). Giotto covered the entrance wall with the *Last Judgment* (not visible here), and the sanctuary wall with three highlighted scenes from the life of Christ. The Annunciation spreads over the two painted architectural frameworks on either side of the high arched opening into the sanctuary itself.

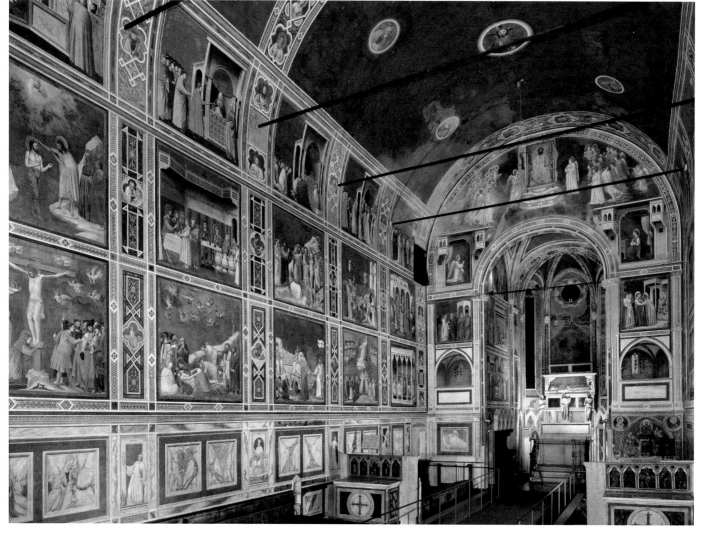

18-7 • Giotto di Bondone **SCROVEGNI (ARENA) CHAPEL, VIEW TOWARD EAST WALL**
Padua. 1305–1306. Frescos.

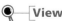 **View** the Closer Look for the Scrovegni Chapel on myartslab.com

Below this are, to the left, the scene of Judas receiving payment for betraying Jesus, and, to the right, the scene of the Visitation, where the Virgin, pregnant with God incarnate, embraces her cousin Elizabeth, pregnant with John the Baptist. The compositions and color arrangement of these two scenes create a symmetrical pairing that encourages viewers to relate them, comparing the ill-gotten financial gains of Judas (a rather clear reference to Scrovegni usury) to the miraculous pregnancy that brought the promise of salvation.

Giotto subdivided the side walls of the chapel into framed pictures. A dado of faux-marble and allegorical **grisaille** (monochrome paintings in shades of gray) paintings of the Virtues and Vices support vertical bands painted to resemble marble inlay into which are inserted painted imitations of carved medallions. The central band of medallions spans the vault, crossing a brilliant, lapis-blue, star-spangled sky in which large portrait disks float like glowing moons. Set into this framework are three horizontal bands of rectangular narrative scenes from the life of the Virgin and her parents at the top, and Jesus along the middle and lower registers,

constituting together the primary religious program of the chapel.

Both the individual scenes and the overall program display Giotto's genius for distilling complex stories into a series of compelling moments. He concentrates on the human dimensions of the unfolding drama—from touches of anecdotal humor to expressions of profound anguish—rather than on its symbolic or theological weight. His prodigious narrative skills are apparent in a set of scenes from Christ's life on the north wall (**FIG. 18-8**). At top left Jesus performs his first miracle, changing water into wine at the wedding feast at Cana. The wine steward—looking very much like the jars of new wine himself—sips the results. To the right is the Raising of Lazarus, where boldly modeled and individualized figures twist in space. Through their postures and gestures they react to the human drama by pleading for Jesus' help, or by expressing either astonishment at the miracle or revulsion at the smell of death. Jesus is separated from the crowd. His transforming gesture is highlighted against the dark blue of the background, his profile face locked in communication with the similarly isolated

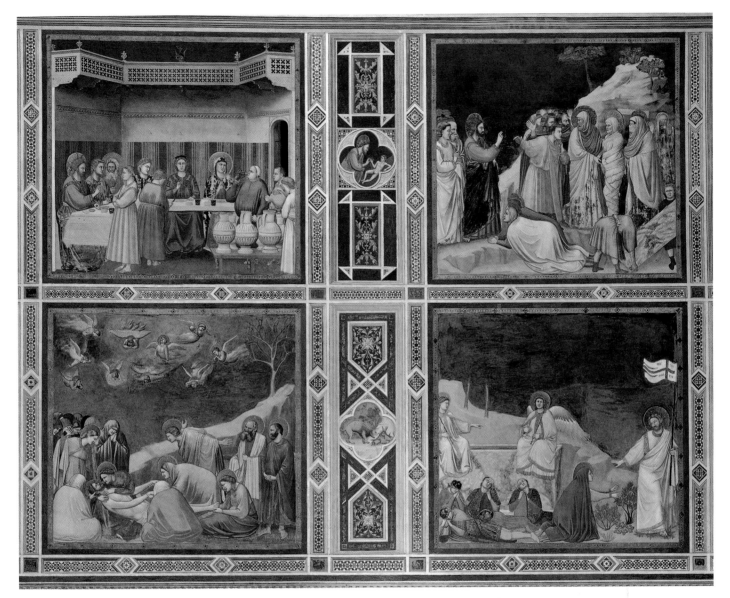

18-8 • Giotto di Bondone **MARRIAGE AT CANA, RAISING OF LAZARUS, LAMENTATION, AND RESURRECTION/NOLI ME TANGERE**
North wall of Scrovegni (Arena) Chapel, Padua. 1305–1306. Fresco, each scene approx. 6′5″ × 6′ (2 × 1.85 m).

Lazarus, whose eyes—still fixed in death—let us know that the miracle is just about to happen.

On the lower register, where Jesus' grief-stricken followers lament over his dead body, Giotto conveys palpable human suffering, drawing viewers into a circle of personal grief. The stricken Virgin pulls close to her dead son, communing with mute intensity, while John the Evangelist flings his arms back in convulsive despair and others hunch over the corpse. Giotto has linked this somber scene—much as he linked the scene of Judas' pact and the Visitation across the sanctuary arch—to the mourning of Lazarus on the register above through the seemingly continuous diagonal implied by the sharply angled hillside behind both scenes and by the rhyming repetition of mourners in each scene—facing in opposite directions—who throw back their arms to express their emotional state. Viewers would know that the mourning in both

scenes is resolved by resurrection, portrayed in the last picture in this set.

Following traditional medieval practice, the fresco program is full of scenes and symbols like these that are intended to be contemplated as coordinated or contrasting juxtapositions. What is new here is the way Giotto draws us into the experience of these events. This direct emotional appeal not only allows viewers to imagine these scenes in relation to their own life experiences; it also embodies the new Franciscan emphasis on personal devotion rooted in empathetic responses to sacred stories.

One of the most gripping paintings in the chapel is Giotto's portrayal of the **KISS OF JUDAS**, the moment of betrayal that represents the first step on Jesus' road to the Crucifixion (**FIG. 18-9**). Savior and traitor are slightly off-center in the near foreground. The expansive sweep of Judas' strident yellow cloak—the same outfit he

18-9 • Giotto di Bondone **KISS OF JUDAS**
South wall of Scrovegni (Arena) Chapel, Padua. 1305–1306. Fresco, 6'6¾" × 6'7⅞" (2 × 1.85 m).

wore at the scene of his payment for the betrayal on the strip of wall to the left of the sanctuary arch—almost completely swallows Christ's body. Surrounding them, faces glare from all directions. A bristling array of weapons radiating from the confrontation draws attention to the encounter between Christ and Judas and documents the militarism of the arresting battalion. Jesus stands solid, a model of calm resolve that recalls his visual characterization in the Resurrection of Lazarus, and forms a striking foil to the noisy and chaotic aggression that engulfs him. Judas, in simian profile, purses his lips for the treacherous kiss that will betray Jesus to his captors, setting up a mythic confrontation of good and evil. In a subplot to the left, Peter lunges forward to sever the ear of a member of the arresting retinue. They are behind another broad sweep of fabric, this one extended by an ominous figure seen from behind and completely concealed except for the clenched hand that pulls at Peter's mantle. Indeed, a broad expanse of cloth and lateral gestures creates a barrier along the picture plane—as if to protect viewers from the compressed chaos of the scene itself. Rarely has this poignant event been visualized with such riveting power.

SIENESE PAINTING

Like their Florentine rivals, Sienese painters were rooted in thirteenth-century pictorial traditions, especially those of Byzantine art. Sienese painting emphasized the decorative potential of narrative painting, with brilliant, jewel-like colors and elegantly posed figures. For this reason, some art historians consider Sienese art more conservative than Florentine art, but we will see that it has its own charm, and its own narrative strategies.

DUCCIO DI BUONINSEGNA Siena's foremost painter was Duccio di Buoninsegna (active 1278–1318), whose creative synthesis of Byzantine and French Gothic sources transformed the tradition in which he worked. Between 1308 and 1311, Duccio and his workshop painted a huge altarpiece commissioned for Siena Cathedral and known as the **MAESTÀ** ("Majesty") (**FIG. 18-10**). Creating this altarpiece—assembled from many wood panels bonded together before painting—was an arduous undertaking. The work was not only large—the central panel alone was 7 by 13 feet—but it had to be painted on both sides since it could

18-10 • Duccio di Buoninsegna
CONJECTURAL RECONSTRUCTION OF THE FRONT (A) AND BACK (B) OF THE MAESTÀ ALTARPIECE
Made for Siena Cathedral. 1308–1311. Tempera and gold on wood, main front panel 7′ × 13′ (2.13 × 4.12 m).

Read the document related to Duccio's *Maestà* on myartslab.com

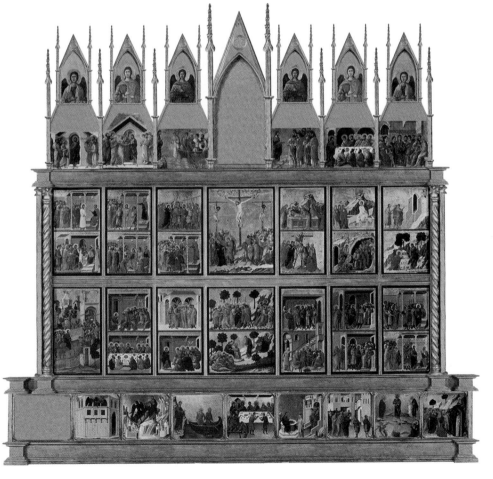

18-11 • Duccio di Buoninsegna
RAISING OF LAZARUS
From the predella of the back of the
Maestà altarpiece (lower right corner of
FIG. 18–10B), made for Siena Cathedral.
1308–1311. Tempera and gold on
wood, 17⅛″ × 18¼″ (43.5 × 46.4 cm).
Kimbell Art Museum, Fort Worth, Texas.

be seen from all directions when installed on the main altar at the center of the sanctuary.

Because the *Maestà* was dismantled in 1771, its power and beauty can only be imagined from scattered parts, some still in Siena but others elsewhere. FIGURE 18–10A is a reconstruction of how the front of the original altarpiece might have looked. It is dominated by a large representation of the Virgin and Child in Majesty (thus its title of *Maestà*), flanked by 20 angels and ten saints, including the four patron saints of Siena kneeling in the foreground. Above and below this lateral tableau were small narrative scenes from the last days of the life of the Virgin (above) and the infancy of Christ (spread across the predella). An inscription running around the base of Mary's majestic throne places the artist's signature within an optimistic framework: "Holy Mother of God, be thou the cause of peace for Siena and life to Duccio because he painted thee thus." This was not Duccio's first work for the cathedral. In 1288, he had designed a stunning stained-glass window portraying the Death, Assumption, and Coronation of the Virgin for the huge circular opening in the east wall of the sanctuary. It would have hovered over the installed *Maestà* when it was placed on the altar in 1311.

On the back of the *Maestà* (FIG. 18–10B) were episodes from the life of Christ, focusing on his Passion. Sacred narrative unfolds in elegant episodes enacted by graceful figures who seem to dance their way through these stories while still conveying emotional content. Characteristic of Duccio's narrative style is the scene of the **RAISING OF LAZARUS** (FIG. 18–11). Lyrical figures enact the event with graceful decorum, but their highly charged glances and expressive gestures—especially the bold reach of Christ—convey a strong sense of dramatic urgency that contrasts with the tense stillness that we saw in Giotto's rendering of this same moment of confrontation (see FIG. 18–8). Duccio's shading of drapery, like his modeling of faces, faithfully describes the figures' three-dimensionality, but the crisp outlines of the jewel-colored shapes created by their clothing, as well as the sinuous continuity of folds and gestures, generate rhythmic patterns crisscrossing the surface. Experimentation with the portrayal of space extends from the receding rocks of the mountainous landscape to carefully studied interiors, here the tomb of Lazarus whose heavy door was removed by the straining hug of a bystander to reveal the shrouded figure of Jesus' resurrected friend, propped up against the door jamb.

Duccio's rendering of the **BETRAYAL OF JESUS** (FIG. 18–12) is more expansive, both pictorially and temporally, occupying one of the broadest panels in the altarpiece (see FIG. 18–10B, lower center) and encompassing within this one composition several moments in the sequential narrative of its subject matter. The tableau is centered and stabilized by the frontal figure of Jesus, whose dark mantle with its sinuous gold trim stands out from the densely packed, colorful crowd of figures surrounding him. Judas

approaches from the left to identify Jesus; although the heads of betrayer and betrayed touch in this moment, Duccio avoids the psychological power of Giotto's face-to-face confrontation in the Scrovegni chapel (see FIG. 18-9). Flanking Duccio's stable, packed central scene of betrayal, are two subsequent moments in the story, each pulling our attention away from the center and toward the sides. To the left, with a forceful stride and dynamic gesture, the apostle Peter lunges to sever the ear of a member of the arresting party, while on the other side of the composition a group of fearful apostles rushes gracefully but with united resolve to escape the central scene, abandoning Jesus to his fate. Within the complexity of this broad, multi-figure, continuous narrative, Duccio manages to express—through the postures and facial expressions of his figures—the emotional charge of these pivotal moments in the narrative of Christ's Passion. At the same time, he creates a dazzling picture, as rich in color and linear elegance as it is faithful to the human dimensions of the situations it portrays.

The enthusiasm with which citizens greeted a great painting or altarpiece like the *Maestà* demonstrates the power of images as well as the association of such magnificent works with the glory of the city itself. According to a contemporary account, on December 20, 1311, the day that Duccio's altarpiece was carried from his workshop to the cathedral, all the shops were shut, and everyone in the city participated in the procession, with "bells ringing joyously, out of reverence for so noble a picture as is this" (Holt, p. 69).

SIMONE MARTINI The generation of painters who followed Duccio continued to paint in the elegant style he established, combining the evocation of three-dimensional form with a graceful continuity of linear pattern. One of Duccio's most successful and innovative followers was Simone Martini (c. 1284–1344), whose paintings were in high demand throughout Italy, including in Assisi where he covered the walls of the St. Martin Chapel with frescos between 1312 and 1319. His most famous work, however, was commissioned in 1333 for the cathedral of his native Siena, an altarpiece of the **ANNUNCIATION** flanked by two saints (**FIG. 18-13**) that he painted in collaboration with his brother-in-law, Lippo Memmi.

18-12 • Duccio di Buoninsegna BETRAYAL OF JESUS
From the back of the *Maestà* altarpiece (lower center of FIG. 18-10B), made for Siena Cathedral. 1308–1311.
Tempera and gold on wood, 22½″ × 40″ (57.2 × 101.6 cm). Museo dell'Opera del Duomo, Siena.

Il Libro dell' Arte (*The Book of Art*) of Cennino Cennini (c. 1370–1440) is a compendium of Florentine painting techniques from about 1400 that includes step-by-step instructions for making panel paintings, a process also used in Sienese paintings of the same period.

The wood for the panels, he explains, should be fine-grained, free of blemishes, and thoroughly seasoned by slow drying. The first step in preparing such a panel for painting was to cover its surface with clean white linen strips soaked in a **gesso** made from gypsum, a task, he tells us, best done on a dry, windy day. Gesso provided a ground, or surface, on which to paint, and Cennini specified that at least nine layers should be applied. The gessoed surface should then be burnished until it resembles ivory. Only then could the artist sketch the composition of the work with charcoal made from burned willow twigs. At this point, advised Cennini, "When you have finished drawing your figure, especially if it is in a very valuable [altarpiece], so that you are counting on profit and reputation from it, leave it alone for a few days, going back to it now and then to look it over and improve it wherever it still needs something. When it seems to you about right (and bear in mind that you may copy and examine things done by other good masters; that it is no shame to

you) when the figure is satisfactory, take the feather and rub it over the drawing very lightly, until the drawing is practically effaced" (Cennini, trans. Thompson, p. 75). At this point, the final design would be inked in with a fine squirrel-hair brush. Gold leaf, he advises, should be affixed on a humid day, the tissue-thin sheets carefully glued down with a mixture of fine powdered clay and egg white on the reddish clay ground called bole. Then the gold is burnished with a gemstone or the tooth of a carnivorous animal. Punched and incised patterning should be added to the gold leaf later.

Fourteenth- and fifteenth-century Italian painters worked principally in tempera paint, powdered pigments mixed with egg yolk, a little water, and an occasional touch of glue. Apprentices were kept busy grinding pigments and mixing paints, setting them out for more senior painters in wooden bowls or shell dishes.

Cennini outlined a detailed and highly formulaic painting process. Faces, for example, were always to be done last, with flesh tones applied over two coats of a light greenish pigment and highlighted with touches of red and white. The finished painting was to be given a layer of varnish to protect it and intensify its colors.

Read the document related to Cennino Cennini on myartslab.com

18–13 • Simone Martini and Lippo Memmi ANNUNCIATION
Made for Siena Cathedral. 1333. Tempera and gold on wood, 10′ × 8′9″ (3 × 2.67 m). Galleria degli Uffizi, Florence.

18-14 • AERIAL VIEW OF THE CAMPO IN SIENA WITH THE PALAZZO PUBBLICO (CITY HALL INCLUDING ITS TOWER) FACING ITS STRAIGHT SIDE
Siena. Palazzo Pubblico 1297–c. 1315; tower 1320s–1340s.

The smartly dressed figure of Gabriel—the extended flourish of his drapery behind him suggesting he has just arrived, and with some speed—raises his hand to address the Virgin. The words of his message are actually incised into the gold-leafed gesso of the background, running from his opened mouth toward the Virgin's ear: *Ave gratia plena dominus tecum* (Luke 1:28: "Hail, full of grace, the Lord is with thee"). Seemingly frightened—at the very least startled—by this forceful and unexpected celestial messenger, Mary recoils into her lavish throne, her thumb inserted into the book she had been reading to safeguard her place, while her other hand pulls at her clothing in an elegant gesture of nobility ultimately deriving from the courtly art of thirteenth-century Paris (see Solomon, second lancet from the right in FIGURE 17–11).

AMBROGIO LORENZETTI The most important civic structure in Siena was the **PALAZZO PUBBLICO** (FIG. **18-14**), the town hall which served as the seat of government, just as the Palazzo della Signoria did in rival Florence (see FIG. **18-2**). There are similarities between these two buildings. Both are designed as strong, fortified structures sitting on the edge of a public piazza; both have a tall tower, making them visible signs of the city from a considerable distance. The Palazzo Pubblico was constructed from 1297 to c. 1315, but the tower was not completed until 1348, when the bronze bell, which rang to signal meetings of the ruling council, was installed.

The interior of the Palazzo Pubblico was the site of important commissions by some of Siena's most famous artists. In c. 1315, Simone Martini painted a large mural of the Virgin in Majesty surrounded by saints—clearly based on Duccio's recently installed *Maestà*. Then, in 1338, the Siena city council commissioned Ambrogio Lorenzetti to paint frescos for the council room of the Palazzo known as the Sala dei Nove (Chamber of the Nine) or Sala della Pace (Chamber of Peace) on the theme of the contrast between good and bad government (see FIG. 18-1).

Ambrogio painted the results of both good and bad government on the two long walls. For the expansive scene of **THE EFFECTS OF GOOD GOVERNMENT IN THE CITY AND IN THE COUNTRY**, and in tribute to his patrons, Ambrogio created

an idealized but recognizable portrait of the city of Siena and its immediate environs (**FIG. 18-15**). The cathedral dome and the distinctive striped campanile are visible in the upper left-hand corner; the streets are filled with the bustling activity of productive citizens who also have time for leisurely diversions. Ambrogio shows the city from shifting viewpoints so we can see as much as possible, and renders its inhabitants larger in scale than the buildings around them so as to highlight their activity. Featured in the foreground is a circle of dancers—probably a professional troupe of male entertainers masquerading as women as part of a spring festival—and above them, at the top of the painting, a band of masons stand on exterior scaffolding constructing the wall of a new building.

The Porta Romana, Siena's gateway leading to Rome, divides the thriving city from its surrounding countryside. In this panoramic landscape painting, Ambrogio describes a natural world marked by agricultural productivity, showing activities of all seasons simultaneously—sowing, hoeing, and harvesting. Hovering above the gate that separates city life and country life is a woman clad in a wisp of transparent drapery, a scroll in one hand and a miniature gallows complete with a hanged man in the other. She represents Security, and her scroll bids those coming to the city to enter without fear because she has taken away the power of the guilty who would harm them.

The world of the Italian city-states—which had seemed so full of promise in Ambrogio Lorenzetti's *Good Government* fresco—was transformed as the middle of the century approached into uncertainty and desolation by a series of natural and societal disasters. In 1333, a flood devastated Florence, followed by banking failures in the 1340s, famine in 1346–1347, and epidemics of the bubonic plague, especially virulent in the summer of 1348, just a few years after Ambrogio's frescos were completed. Some art historians have traced the influence of these calamities on the visual arts at the middle of the fourteenth century (see "The Black Death," page 550). Yet as dark as those days must have seemed to the men and women living through them, the strong currents of cultural and artistic change initiated earlier in the century would persist. In a relatively short span of time, the European Middle Ages gave way in Florence to a new movement that would blossom in the Italian Renaissance.

FRANCE

At the beginning of the fourteenth century, the royal court in Paris was still the arbiter of taste in western Europe, as it had been in the days of King Louis IX (St. Louis). During the Hundred Years' War, however, the French countryside was ravaged by armed struggles and civil strife. The power of the nobility, weakened significantly by warfare, was challenged by townsmen, who took advantage of new economic opportunities that opened up in the wake of the conflict. As centers of art and architecture, the duchy of Burgundy, England, and, for a brief golden moment, the court of Prague began to rival Paris.

French sculptors found lucrative new outlets for their work—not only in stone, but in wood, ivory, and precious metals, often decorated with enamel and gemstones—in the growing demand among wealthy patrons for religious art intended for homes as well as churches. Manuscript painters likewise created lavishly illustrated books for the personal devotions of the wealthy and powerful. And

18-15 • Ambrogio Lorenzetti THE EFFECTS OF GOOD GOVERNMENT IN THE CITY AND IN THE COUNTRY
Sala dei Nove (also known as Sala della Pace), Palazzo Pubblico, Siena, Italy. 1338–1339. Fresco, total length about 46′ (14 m).

architectural commissions focused on exquisitely detailed chapels or small churches, often under private patronage, rather than on the building of grand cathedrals funded by Church institutions.

MANUSCRIPT ILLUMINATION

By the late thirteenth century, private prayer books became popular among wealthy patrons. Because they contained special prayers to be recited at the eight canonical devotional "hours" between morning and night, an individual copy of one of these books came to be called a **Book of Hours**. Such a book included everything the lay person needed for pious practice—psalms, prayers and offices of the Virgin and other saints (such as the owners' patron or the patron of their home church), a calendar of feast days, and sometimes prayers for the dead. During the fourteenth century, a richly decorated Book of Hours was worn or carried like jewelry, counting among a noble person's most important portable possessions.

THE BOOK OF HOURS OF JEANNE D'ÉVREUX Perhaps at their marriage in 1324, King Charles IV gave his 14-year-old queen, Jeanne d'Évreux, a tiny Book of Hours—it fits easily when open within one hand—illuminated by Parisian painter Jean Pucelle (see "A Closer Look," page 551). This book was so precious to the queen that she mentioned it and its illuminator specifically in her will, leaving this royal treasure to King Charles V. Pucelle painted the book's pictures in *grisaille*—monochromatic painting in shades of gray with only delicate touches of color. His style clearly derives from the courtly mode established in Paris at the time of St. Louis, with its softly modeled, voluminous draper-ies gathered loosely and falling in projecting diagonal folds around tall, elegantly posed figures with carefully coiffed curly hair, broad foreheads, and delicate features. But his conception of space, with figures placed within coherent, discrete architectural settings, suggests a firsthand knowledge of contemporary Sienese art.

Jeanne appears in the initial *D* below the Annunciation, kneeling in prayer before a lectern, perhaps using this Book of Hours to guide her meditations, beginning with the words written on this page: *Domine labia mea aperies* (Psalm 51:15: "O Lord, open thou my lips"). The juxtaposition of the praying Jeanne's portrait with a scene from the life of the Virgin Mary suggests that the sacred scene is actually a vision inspired by Jeanne's meditations. The young queen might have identified with and sought to feel within herself Mary's joy at Gabriel's message. Given what we know of Jeanne's own life story and her royal husband's predicament, it might also have directed the queen's prayers toward the fulfillment of his wish for a male heir.

In the Annunciation, Mary is shown receiving the archangel Gabriel in a Gothic building that seems to project outward from the page toward the viewer, while rejoicing angels look on from windows under the eaves. The group of romping youths at the bottom of the page at first glance seems to echo the angelic jubilation. Folklorists have suggested, however, that the children are playing "froggy in the middle" or "hot cockles," games in which one child was tagged by the others. To the medieval viewer, if the game symbolized the mocking of Christ or the betrayal of Judas, who "tags" his friend, it would have evoked a darker mood by referring to the picture on the other page of this opening, fore-shadowing Jesus' imminent death even as his life is beginning.

Read the document related to *The Effects of Good Government in the City and in the Country* on myartslab.com

A deadly outbreak of the bubonic plague, known as the Black Death after the dark sores that developed on the bodies of its victims, spread to Europe from Asia, both by land and by sea, in the middle of the fourteenth century. At least half the urban population of Florence and Siena—some estimate 80 percent—died during the summer of 1348, probably including the artists Andrea Pisano and Ambrogio Lorenzetti. Death was so quick and widespread that basic social structures crumbled in the resulting chaos; people did not know where the disease came from, what caused it, or how long the pandemic would last.

Mid-twentieth-century art historian Millard Meiss proposed that the Black Death had a significant impact on the development of Italian art in the middle of the fourteenth century. Pointing to what he saw as a reactionary return to hieratic linearity in religious art, Meiss theorized that artists had retreated from the rounded forms that had characterized the work of Giotto to old-fashioned styles, and that this artistic change reflected a growing reliance on traditional religious values in the wake of a disaster that some interpreted as God's punishment of a world in moral decline.

An altarpiece painted in 1354–1357 by Andrea di Cione, nicknamed Orcagna ("Archangel"), under the patronage of Tommaso Strozzi—the so-called Strozzi Altarpiece (**FIG. 18–16**)—is an example of the sort of paintings that led Meiss to his interpretation. This painting's otherworldly vision is dominated by a central figure of Christ, presumably enthroned, but without any hint of an actual seat, evoking the image of the judge at the Last Judgment, outside time and space. The silhouetted outlines of the standing and kneeling saints emphasize surface over depth; the gold expanse of floor beneath them does not offer any reassuring sense of spatial recession to contain them and their activity. Throughout, line and color are more prominent than form.

Recent art historians have stepped back from Meiss's contextual explanation of stylistic change. Some have pointed out logical relationships between style and subject in the works Meiss cites; others have seen in them a mannered outgrowth of current style rather than a reversion to an earlier style; still others have discounted the underlying notion that stylistic change is connected with social situations. But there is a clear relationship of works such as the Strozzi Altarpiece with death and judgment, sanctity and the promise of salvation—themes also suggested in the narrative scenes on the **predella** (the lower zone of the altarpiece): Thomas Aquinas's ecstasy during Mass, Christ's miraculous walk on water to rescue Peter, and the salvation of Emperor Henry II because of a pious donation. While these are not uncommon scenes in sacred art, it is easy to see a relationship between their choice as subject matter here and the specter cast by the Black Death over a world that had just imagined its prosperity in pathbreaking works of visual art firmly rooted in references to everyday life (see FIG. 18–15).

18–16 • Andrea di Cione (nicknamed Orcagna) **ENTHRONED CHRIST WITH SAINTS, FROM THE STROZZI ALTARPIECE**
Strozzi Chapel, Santa Maria Novella, Florence. 1354–1357. Tempera and gold on wood, 9′ × 9′8″ (2.74 × 2.95 m).

📖—**Read** the document related to the Black Death on myartslab.com

A CLOSER LOOK | The Hours of Jeanne d'Évreux

by Jean Pucelle, Two-Page Opening with the Kiss of Judas and the Annunciation.
Paris. c. 1324–1328. *Grisaille* and color on vellum, each page 3⅝" × 2⁷⁄₁₆" (9.2 × 6.2 cm).
Metropolitan Museum of Art, New York. The Cloisters Collection (54.1.2), fols. 15v–16r

In this opening Pucelle juxtaposes complementary scenes drawn from the Infancy and Passion of Christ, placed on opposing pages, in a scheme known as the Joys and Sorrows of the Virgin. The "joy" of the Annunciation on the right is paired with the "sorrow" of the betrayal and arrest of Christ on the left.

Christ sways back gracefully as Judas betrays him with a kiss. The S-curve of his body mirrors the Virgin's pose on the opposite page, as both accept their fate with courtly decorum.

The prominent lamp held aloft by a member of the arresting battalion informs the viewer that this scene takes place at night, in the dark.

The angel who holds up the boxlike enclosure where the Annunciation takes place is an allusion to the legend of the miraculous transportation of this building from Nazareth to Loreto in 1294.

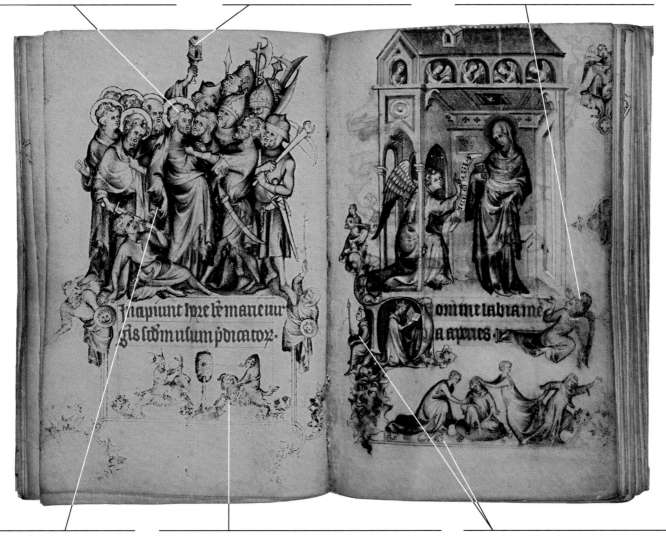

Christ reaches casually down to heal Malchus, the assistant of the high priest whose ear Peter had just cut off in angry retaliation for his participation in the arrest of Jesus.

Scenes of secular amusements from everyday life, visual puns, and off-color jokes appear at the bottom of many pages of this book. Sometimes they relate to the themes of the sacred scenes above them. These comic knights riding goats may be a commentary on the lack of valor shown by the soldiers assaulting Jesus, especially if this wine barrel conjured up for Jeanne an association with the Eucharist.

The candle held by the cleric who guards the "door" to Jeanne's devotional retreat, as well as the rabbit emerging from its burrow in the marginal scene, are sexually charged symbols of fertility that seem directly related to the focused prayers of a child bride required to produce a male heir.

 View the Closer Look for the Hours of Jeanne d'Évreux on myartslab.com

Fourteenth-century Paris was renowned for more than its goldsmiths (see FIG. 18–20). Among the most sumptuous and sought-after Parisian luxury products were small chests assembled from carved ivory plaques that were used by wealthy women to store jewelry or other personal treasures. The entirely secular subject matter of these chests explored romantic love. Indeed, they seem to have been courtship gifts from smitten men to desired women, or wedding presents offered by grooms to their brides.

A chest from around 1330–1350, now in the Walters Museum (**FIGS. 18–17, 18–18, 18–19**), is one of seven that have survived intact; there are fragments of a dozen more. It is a delightful and typical example. Figural relief covers five exterior sides of the box: around the perimeter and on the hinged top. The assembled panels were joined by metal hardware—strips, brackets, hinges, handles, and locks—originally wrought in silver. Although some chests tell a single romantic story in sequential episodes, most, like this one, anthologize scenes drawn from a group of stories, combining courtly romance, secular allegory, and ancient fables.

On the lid of the Walters casket (see FIG. 18–18), jousting is the theme. Spread over the central two panels, a single scene catches two charging knights in the heat of a tournament, while trumpeting heralds call the attention of spectators, lined up above in a gallery to observe this public display of virility. The panel at right mocks the very ritual showcased in the middle panels by pitting a woman against a knight, battling not with lances but with a long-stemmed rose (symbolizing sexual surrender) and an oak bough (symbolizing fertility). Instead of observing these silly goings-on, however, the spectators tucked into the upper architecture pursue their own amorous flirtations. Finally, in the scene on the left, knights use crossbows and a catapult to hurl roses at the Castle of Love, while Cupid returns fire with his seductive arrows.

On the front of the chest (see FIG. 18–17), generalized romantic allegory gives way to vignettes from a specific story. At left, the long-bearded Aristotle teaches the young Alexander the Great, using exaggerated gestures and an authoritative text to emphasize his point. Today's lesson is a stern warning not to allow the seductive power of women to distract the young prince from his studies. The subsequent scene, however, pokes fun at his eminent teacher, who has become so smitten by the wiles of a young beauty named Phyllis that he lets her ride him around like a horse, while his student observes this farce, peering out of the castle in the background. The two scenes at right relate to an eastern legend of the fountain of youth, popular in medieval Europe. A line of bearded elders approaches the fountain

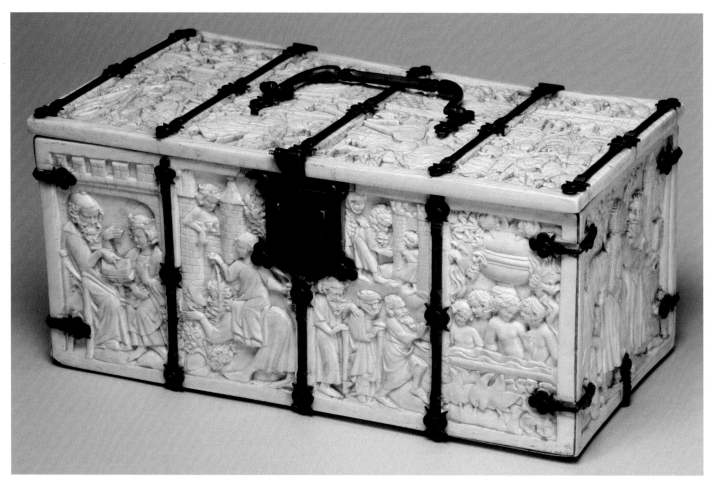

18–17 • SMALL IVORY CHEST WITH SCENES FROM COURTLY ROMANCES
Made in Paris. c. 1330–1350. Elephant ivory with modern iron mounts, height 4½″ (11.5 cm), width 9¹¹⁄₁₆″ (24.6 cm), depth 4⅞″ (12.4 cm). The Walters Art Museum, Baltimore.

from the left, steadied by their canes. But after having partaken of its transforming effects, two newly rejuvenated couples, now nude, bathe and flirt within the fountain's basin. The man first in line for treatment, stepping up to climb into the fountain, looks suspiciously like the figure of the aging Aristotle, forming a link between the two stories on the casket front.

Unlike royal marriages of the time, which were essentially business contracts based on political or financial exigencies, the romantic love of the aristocratic wealthy involved passionate devotion. Images of gallant knights and their coy paramours, who could bring intoxicating bliss or cruelly withhold their love on a whim, captured the popular Gothic imagination. They formed the principal subject matter on personal luxury objects, not only chests like this, but mirror backs, combs, writing tablets, even ceremonial saddles. And these stories evoke themes that still captivate us since they reflect notions of desire and betrayal, cruel rejection and blissful folly, at play in our own romantic conquests and relationships to this day. In this way they allow us some access to the lives of the people who commissioned and owned these precious objects, even if we ourselves are unable to afford them.

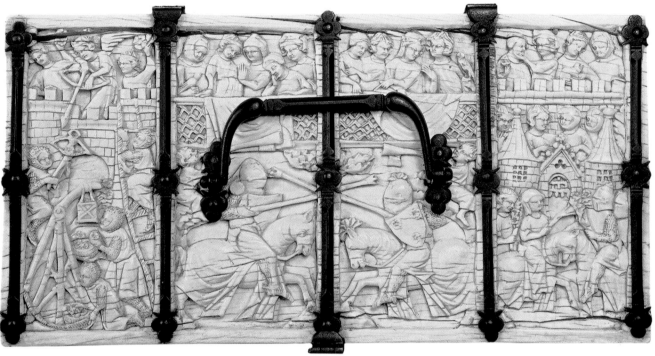

18-18 • ATTACK ON THE CASTLE OF LOVE
Top of the chest in FIG. 18–17.

18-19 • TRISTAN AND ISEULT AT THE FOUNTAIN; CAPTURE OF THE UNICORN
Left short side of the chest in FIG. 18–17.

Two other well-known medieval themes are juxtaposed on this plaque from the short side of the ivory chest. At left, Tristan and Iseult have met secretly for an illicit romantic tryst, while Iseult's husband, King Mark, tipped off by an informant, observes them from a tree. But when they see his reflection in a fountain between them, they alter their behavior accordingly, and the king believes them innocent of the adultery he had (rightly) suspected. The medieval bestiary ("book of beasts") claimed that only a virgin could capture the mythical unicorn, which at right lays his head, with its aggressively phallic horn, into the lap of just such a pure maiden so that the hunter can take advantage of her alluring powers over the animal to kill it with his phallic counterpart of its horn, a large spear.

METALWORK AND IVORY

Fourteenth-century French sculpture is intimate in character. Religious subjects became more emotionally expressive; objects became smaller and demanded closer scrutiny from the viewer. In the secular realm, tales of love and valor were carved on luxury items to delight the rich (see "An Ivory Chest with Scenes of Romance," page 552). Precious materials—gold, silver, and ivory—were preferred.

THE VIRGIN AND CHILD FROM SAINT-DENIS

A silver-gilt image of a standing **VIRGIN AND CHILD** (**FIG. 18-20**) is a rare survivor that verifies the acclaim that was accorded fourteenth-century Parisian goldsmiths. An inscription on the base documents the statue's donation to the abbey church of Saint-Denis in 1339 and the donor's name, the same Queen Jeanne d'Évreux whose Book of Hours we have just examined. In a style that recalls the work of artist Jean Pucelle in that Book of Hours, the Virgin holds Jesus in her left arm with her weight on her left leg, standing in a graceful, characteristically Gothic S-curve pose. Mary originally wore a crown, and she still holds a large enameled and jeweled *fleur-de-lis*—the heraldic symbol of royal France—which served as a reliquary container for strands of Mary's hair. The Christ Child, reaching out tenderly to caress his mother's face, is babylike in both form and posture. On the base, minuscule statues of prophets stand on projecting piers to separate 14 enameled scenes from Christ's Infancy and Passion, reminding us of the suffering to come. The apple in the baby's hand carries the theme further with its reference to Christ's role as the new Adam, whose sacrifice on the cross—medieval Christians believed—redeemed humanity from the first couple's fall into sin when Eve bit into the forbidden fruit.

ENGLAND

Fourteenth-century England prospered in spite of the ravages of the Black Death and the Hundred Years' War with France. English life at this time is described in the brilliant social commentary of Geoffrey Chaucer in the *Canterbury Tales* (see "A New Spirit in Fourteenth-Century Literature," page 533). The royal family, especially Edward I (r. 1272–1307)—the castle builder—and many of the nobles and bishops were generous patrons of the arts.

EMBROIDERY: OPUS ANGLICANUM

Since the thirteenth century, the English had been renowned for pictorial needlework, using colored silk and gold threads to create images as detailed as contemporary painters produced in manuscripts. Popular throughout

18–20 • VIRGIN AND CHILD
c. 1324–1339. Silver gilt and enamel, height 27⅛″ (69 cm).
Musée du Louvre, Paris.

Europe, the art came to be called *opus anglicanum* ("English work"). The popes had more than 100 pieces in the Vatican treasury. The names of several prominent embroiderers are known, but in the thirteenth century no one surpassed Mabel of Bury St. Edmunds, who created both religious and secular articles for King Henry III (r. 1216–1272).

THE CHICHESTER-CONSTABLE CHASUBLE This *opus anglicanum* liturgical vestment worn by a priest during Mass (**FIG. 18-21**) was embroidered c. 1330–1350 with images formed by subtle gradations of colored silk. Where gold threads were laid and couched (tacked down with colored silk), the effect resembles the burnished gold-leaf backgrounds of manuscript illuminations.

The Annunciation, the Adoration of the Magi, and the Coronation of the Virgin are set in cusped, crocketed ogee (S-shape) arches, supported on animal-head corbels and twisting branches sprouting oak leaves with seed-pearl acorns. Because the star and crescent moon in the Coronation of the Virgin scene are heraldic emblems of Edward III (r. 1327–1377), perhaps he or a family member commissioned this luxurious vestment.

During the celebration of the Mass, especially as the priest moved, *opus anglicanum* would have glinted in the candlelight amid treasures on the altar. Court dress was just as rich and colorful, and at court such embroidered garments proclaimed the rank and status of the wearer. So heavy did such gold and bejeweled garments become that their wearers often needed help to move.

18-21 • LIFE OF THE VIRGIN, BACK OF THE CHICHESTER-CONSTABLE CHASUBLE
From a set of vestments embroidered in *opus anglicanum* from southern England. c. 1330–1350. Red velvet with silk and metallic thread and seed pearls, length 4′3″ (129.5 cm), width 30″ (76 cm). Metropolitan Museum of Art, New York. Fletcher Fund, 1927 (27 162.1)

ARCHITECTURE

In the later years of the thirteenth century and early years of the fourteenth, a distinctive and influential Gothic architectural style, popularly known as the "Decorated style," developed in England. This change in taste has been credited to Henry III's ambition to surpass St. Louis, who was his brother-in-law, as a royal patron of the arts.

THE DECORATED STYLE AT EXETER One of the most complete Decorated-style buildings is **EXETER CATHEDRAL**. Thomas of Witney began construction in 1313 and remained master mason from 1316 to 1342. He supervised construction of the nave and redesigned upper parts of the choir. He left the towers of the original Norman cathedral but turned the interior into a dazzling stone forest of colonnettes, moldings, and vault ribs (**FIG. 18–22**). From piers formed by a cluster of colonnettes rise multiple moldings that make the arcade seem to ripple. Bundled colonnettes spring from sculptured foliate corbels (brackets that project from a wall) between the arches and rise up the wall to support conical clusters of 13 ribs that meet at the summit of the vault, a modest 69 feet above the floor. The basic structure here is the four-part vault with intersecting cross-ribs, but the designer added additional ribs, called tiercerons, to create a richer linear pattern. Elaborately carved **bosses** (decorative knoblike elements) signal the point where ribs meet along the ridge of the vault. Large bar-tracery clerestory windows illuminate the 300-foot-long nave. Unpolished gray marble shafts, yellow sandstone arches, and a white French stone, shipped from Caen, add subtle gradations of color to the upper wall.

Detailed records survive for the building of Exeter Cathedral, documenting work over the period from 1279 to 1514, with only two short breaks. They record where masons and carpenters were housed (in a hostel near the cathedral) and how they were paid (some by the day with extra for drinks, some by the week, some for each finished piece); how materials were acquired and transported (payments for horseshoes and fodder for the horses); and, of course, payments for the building materials (not only stone and wood but rope for measuring and parchment on which to draw forms for the masons). The bishops contributed generously to the building funds. This was not a labor only of love.

Thomas of Witney also designed the intricate, 57-foot-high bishop's throne (at right in FIGURE 18–22), constructed by Richard de Galmeton and Walter of Memburg, who led a team of a dozen carpenters. The

18-22 • INTERIOR, EXETER CATHEDRAL

Devon, England. Thomas of Witney, choir, 14th century and bishop's throne, 1313–1317; Robert Lesyngham, east window, 1389–1390.

canopy resembles embroidery translated into wood, with its maze of pinnacles, bursting with leafy crockets and tiny carved animals and heads. To finish the throne in splendor, Master Nicolas painted and gilded the wood. When the bishop was seated on his throne wearing embroidered vestments like the Chichester-Constable Chasuble (see FIG. 18-21), he must have resembled a golden image in a shrine—more a symbol of the power and authority of the Church than a specific human being.

THE PERPENDICULAR STYLE AT EXETER During years following the Black Death, work at Exeter Cathedral came to a standstill. The nave had been roofed but not vaulted, and the windows had no glass. When work could be resumed, tastes had changed. The exuberance of the Decorated style gave way to an austere style in which rectilinear patterns and sharp angular shapes replaced intricate curves, and luxuriant foliage gave way to simple stripped-down patterns. This phase is known as the Perpendicular style.

In 1389–1390, well-paid master mason Robert Lesyngham rebuilt the great east window (see FIG. 18-22, far wall), designing its tracery in the new Perpendicular style. The window fills the east wall of the choir like a glowing altarpiece. A single figure in each light stands under a tall painted canopy that flows into and blends with the stone tracery. The Virgin with the Christ Child stands in the center over the high altar, with four female saints at the left and four male saints on the right, including St. Peter, to whom the church is dedicated. At a distance, the colorful figures silhouetted against the silver *grisaille* glass become a band of color, conforming to and thus reinforcing the rectangular pattern of the mullions and transoms. The combination of *grisaille*, silver-oxide stain (staining clear glass with shades of yellow or gold), and colored glass produces a glowing wall and casts a cool, silvery light over the nearby stonework.

Perpendicular architecture heralds the Renaissance style in its regularity, its balanced horizontal and vertical lines, and its plain wall or window surfaces. When Tudor monarchs introduced Renaissance art into the British Isles, builders were not forced to rethink the form and structure of their buildings; they simply changed the ornament from the pointed cusps and crocketed arches of the Gothic style to the round arches and columns and capitals of Roman Classicism. The Perpendicular style itself became an English architectural vernacular. It has even been popular in the United States, especially for churches and college buildings.

THE HOLY ROMAN EMPIRE

By the fourteenth century, the Holy Roman Empire existed more as an ideal fiction than a fact. The Italian territories had established their independence, and in contrast to England and France, Germany had become further divided into multiple states with powerful regional associations and princes. The Holy Roman emperors, now elected by Germans, concentrated on securing the fortunes of their families. They continued to be patrons of the arts, promoting local styles.

MYSTICISM AND SUFFERING

The by-now-familiar ordeals of the fourteenth century—famines, wars, and plagues—helped inspire a mystical religiosity in Germany that emphasized both ecstatic joy and extreme suffering. Devotional images, known as *Andachtsbilder* in German, inspired worshipers to contemplate Jesus' first and last hours, especially during evening prayers, or vespers, giving rise to the term *Vesperbild* for the image of Mary mourning her son. Through such religious exercises, worshipers hoped to achieve understanding of the divine and union with God.

VESPERBILD In this well-known example (**FIG. 18-23**), blood gushes from the hideous rosettes that form the wounds of an emaciated and lifeless Jesus who teeters improbably on the lap of his

18-23 • VESPERBILD (PIETÀ)
From the Middle Rhine region, Germany. c. 1330. Wood and polychromy, height 34½″ (88.4 cm). Landesmuseum, Bonn.

hunched-over mother. The Virgin's face conveys the intensity of her ordeal, mingling horror, shock, pity, and grief. Such images took on greater poignancy since they would have been compared, in the worshiper's mind, to the familiar, almost ubiquitous images of the young Virgin mother holding her innocent and loving baby Jesus.

THE HEDWIG CODEX The extreme physicality and emotionalism of the *Vesperbild* finds parallels in the actual lives of some medieval saints in northern Europe. St. Hedwig (1174–1243), married at age 12 to Duke Henry I of Silesia and mother of his seven children, entered the Cistercian convent of Trebniz (in modern Poland) on her husband's death in 1238. She devoted the rest of her life to caring for the poor and seeking to emulate the suffering

of Christ by walking barefoot in the snow. As described in her *vita* (biography), she had a particular affection for a small ivory statue of the Virgin and Child, which she carried with her at all times, and which "she often took up in her hands to envelop it in love, so that out of passion she could see it more often and through the seeing could prove herself more devout, inciting her to even greater love of the glorious Virgin. When she once blessed the sick with this image they were cured immediately" (translation from Schleif, p. 22). Hedwig was buried clutching the statue, and when her tomb was opened after her canonization in 1267, it was said that although most of her body had deteriorated, the fingers that still gripped the beloved object had miraculously not decayed.

A picture of Hedwig serves as the frontispiece (**FIG. 18-24**) of a manuscript of her *vita* known as the Hedwig Codex, commissioned

18-24 • ST. HEDWIG OF SILESIA WITH DUKE LUDWIG I OF LIEGNITZ-BRIEG AND DUCHESS AGNES
Dedication page of the Hedwig Codex. 1353. Ink and paint on parchment, 13⁷⁄₁₆″ × 9¾″ (34 × 25 cm). The J. Paul Getty Museum, Los Angeles. MS. Ludwig XI 7, fol. 12v

in 1353 by one her descendants, Ludwig I of Liegnitz-Brieg. Duke Ludwig and his wife, Agnes, are shown here kneeling on either side of St. Hedwig, dwarfed by the saint's architectural throne and her own imposing scale. With her prominent, spidery hands, she clutches the famous ivory statue, as well as a rosary and a prayer book, inserting her fingers within it to maintain her place as if our arrival had interrupted her devotions. She has draped her leather boots over her right wrist in a reference to her practice of removing them to walk in the snow. Hedwig's highly volumetric figure stands in a swaying pose of courtly elegance derived from French Gothic, but the fierce intensity of her gaze and posture are far removed from the mannered graciousness of the smiling angel of Reims (see statue at far left in FIG. 17-14), whose similar gesture

and extended finger are employed simply to grasp his drapery and assure its elegant display.

THE SUPREMACY OF PRAGUE

Charles IV of Bohemia (r. 1346–1378) was raised in France, and his admiration for the French king Charles IV was such that he changed his own name from Wenceslas to Charles. He was officially crowned king of Bohemia in 1347 and Holy Roman Emperor in 1355. He established his capital in Prague, which, in the view of his contemporaries, replaced Constantinople as the "New Rome." Prague had a great university, a castle, and a cathedral overlooking a town that spread on both sides of a river joined by a stone bridge, a remarkable structure itself.

18-25 • Heinrich and Peter Parler PLAN AND INTERIOR OF THE CHURCH OF THE HOLY CROSS, SCHWÄBISCH GMÜND
Germany. Begun in 1317 by Heinrich Parler; choir by Peter Parler begun in 1351; vaulting completed 16th century.

18–26 • Master Theodoric ST. LUKE
Holy Cross Chapel, Karlstejn Castle, near Prague. 1360–1364. Paint and gold on panel, 45¼″ × 37″ (115 × 94 cm).

When Pope Clement VI made Prague an archbishopric in 1344, construction began on a new cathedral in the Gothic style—to be named for St. Vitus. It would also serve as the coronation church and royal pantheon. But the choir was not finished for Charles's first coronation, so he brought Peter Parler from Swabia to complete it.

THE PARLER FAMILY In 1317, Heinrich Parler, a former master of works on Cologne Cathedral, designed and began building the church of the Holy Cross in Schwäbisch Gmünd, in southwest Germany. In 1351, his son Peter (c. 1330–1399), the most brilliant architect of this talented family, joined the workshop. Peter designed the choir (**FIG. 18-25**) in the manner of a hall church whose triple-aisled form was enlarged by a ring of deep chapels between the buttresses. The contrast between Heinrich's nave and Peter's choir (seen clearly in the plan of FIGURE 18-25) illustrates the increasing complexity of rib patterns covering the vaults, which emphasizes the unity of interior space rather than its division into bays.

Called by Charles IV to Prague in 1353, Peter turned the unfinished St. Vitus Cathedral into a "glass house," adding a vast clerestory and glazed triforium supported by double flying buttresses, all covered by net vaults that created a continuous canopy over the space. Because of the success of projects such as this, Peter and his family became the most successful architects in the Holy Roman Empire. Their concept of space, luxurious decoration, and intricate vaulting dominated central European architecture for three generations.

MASTER THEODORIC At Karlstejn Castle, a day's ride from Prague, Charles IV built another chapel, covering the walls with gold and precious stones as well as with paintings. There were 130 paintings of the saints serving as reliquaries, with relics inserted into their frames. Master Theodoric, the court painter, provided drawings on the wood panels, and he painted about 30 images himself. Figures are crowded into—even extend over—their frames, emphasizing their size and power. Master Theodoric was head of the Brotherhood of St. Luke, and the way that his painting of **ST. LUKE** (**FIG. 18-26**), patron saint of painters, looks out at the viewer has suggested to scholars that this may be a self-portrait. His personal style combined a preference for substantial bodies, oversized heads and hands, dour and haunted faces, and soft, deeply modeled drapery, with a touch of grace derived from the French Gothic style. The chapel, consecrated in 1365, so pleased the emperor that in 1367 he gave the artist a farm in appreciation of his work.

Prague and the Holy Roman Empire under Charles IV had become a multicultural empire where people of different religions (Christians and Jews) and ethnic heritages (German and Slav) lived side by side. Charles died in 1378, and without his strong central government, political and religious dissent overtook the empire. Jan Hus, dean of the philosophy faculty at Prague University and a powerful reforming preacher, denounced the immorality he saw in the Church. He was burned at the stake, becoming a martyr and Czech national hero. The Hussite Revolution in the fifteenth century ended Prague's—and Bohemia's—leadership in the arts.

THINK ABOUT IT

18.1 Compare and contrast Giotto's and Duccio's renderings of the biblical story of Christ's Raising of Lazarus (FIGS. 18–8, 18–11).

18.2 Discuss Ambrogio Lorenzetti's engagement with secular subject matter in his frescos for Siena's Palazzo Pubblico (FIG. 18–15). How did these paintings relate to their sociopolitical context?

18.3 Discuss the circumstances surrounding the construction and decoration of the Scrovegni (Arena) Chapel, with special attention to its relationship to the life and aspirations of its patron.

18.4 Choose one small work of art in this chapter that is crafted from precious materials with exceptional technical skill. Explain how it was made and how it was used. How does the work of art relate to its cultural and social context?

CROSSCURRENTS

FIG. 16–26

FIG. 18–20

Depictions of the Virgin Mary holding the infant Jesus represent a continuing theme in the history of European Christian art, developed early on, and continuing to this day. Describe the relationship between the mother and child in these two examples. Characterize the difference in artistic style. How does the choice of medium contribute to the distinction between them? How were they used?

Study and review on myartslab.com

Glossary

abacus (p. 108) The flat slab at the top of a **capital**, directly under the **entablature**.

abbey church (p. 239) An abbey is a monastic religious community headed by an abbot or abbess. An abbey church often has an especially large **choir** to provide space for the monks or nuns.

absolute dating (p. 12) A method, especially in archaeology, of assigning a precise historical date at which, or span of years during which, an object was made. Based on known and recorded events in the region, as well as technically extracted physical evidence (such as carbon-14 disintegration). See also **radiometric dating**, **relative dating**.

abstract (p. 7) Of art that does not attempt to describe the appearance of visible forms but rather to transform them into stylized patterns or to alter them in conformity to ideals.

academy (p. 926) An institution established for the training of artists. Academies date from the Renaissance and after; they were particularly powerful, state-run institutions in the seventeenth and eighteenth centuries. In general, academies replaced **guilds** as the venues where students learned the craft of art and were educated in art theory. Academies helped the recognition of artists as trained specialists, rather than craftsmakers, and promoted their social status. An academician is an academy-trained artist.

acanthus (p. 110) A Mediterranean plant whose leaves are reproduced in Classical architectural ornament used on **moldings**, **friezes**, and **capitals**.

acroterion (*pl.* acroteria) (p. 110) An ornament at the corner or peak of a roof.

Action painting (p. 1074) Using broad gestures to drip or pour paint onto a pictorial surface. Associated with mid-twentieth-century American Abstract Expressionists, such as Jackson Pollock.

adobe (p. 399) Sun-baked blocks made of clay mixed with straw. Also: buildings made with this material.

aedicula (p. 609) A decorative architectural frame, usually found around a niche, door, or window. An aedicula is made up of a **pediment** and **entablature** supported by **columns** or **pilasters**.

aerial perspective (p. 626) See under **perspective**.

agora (p. 137) An open space in a Greek town used as a central gathering place or market. Compare **forum**.

aisle (p. 225) Passage or open corridor of a church, hall, or other building that parallels the main space, usually on both sides, and is delineated by a row, or **arcade**, of **columns** or **piers**. Called side aisles when they flank the **nave** of a church.

akropolis (p. 128) The citadel of an ancient Greek city, located at its highest point and housing temples, a treasury, and sometimes a royal palace. The most famous is the Akropolis in Athens.

album (p. 796) A book consisting of a series of paint-ings or prints (album leaves) mounted into book form.

allegory (p. 627) In a work of art, an image (or images) that symbolizes an idea, concept, or principle, often moral or religious.

alloy (p. 23) A mixture of metals; different metals melted together.

altarpiece (p. xl) A painted or carved panel or ensemble of panels placed at the back of or behind and above an altar. Contains religious imagery (often specific to the place of worship for which it was made) that viewers can look at during liturgical ceremonies (especially the **Eucharist**) or personal devotions.

amalaka (p. 302) In Hindu architecture, the circular or square-shaped element on top of a spire (**shikhara**), often crowned with a **finial**, symbolizing the cosmos.

ambulatory (p. 224) The passage (walkway) around the **apse** in a church, especially a **basilica**, or around the central space in a **central-plan building**.

amphora (*pl.* amphorae) (p. 101) An ancient Greek or Roman jar for storing oil or wine, with an egg-shaped body and two curved handles.

animal style or **interlace** (p. 433) Decoration made of interwoven animals or serpents, often found in early medieval Northern European art.

ankh (p. 51) A looped cross signifying life, used by ancient Egyptians.

appropriation (p. xxviii) The practice of some Postmodern artists of adopting images in their entirety from other works of art or from visual culture for use in their own art. The act of recontextualizing the appropriated image allows the artist to critique both it and the time and place in which it was created.

apse (p. 192) A large semicircular or polygonal (and usually **vaulted**) recess on an end wall of a building. In a Christian church, it often contains the altar. "Apsidal" is the adjective describing the condition of having such a space.

arabesque (p. 267) European term for a type of linear surface decoration based on foliage and calligraphic forms, thought by Europeans to be typical of Islamic art and usually characterized by flowing lines and swirling shapes.

arcade (p. 170) A series of **arch**es, carried by **column**s or **pier**s and supporting a common wall or **lintel**. In a **blind arcade**, the arches and supports are **engaged** and have a purely decorative function.

arch (p. 95) In architecture, a curved structural element that spans an open space. Built from wedge-shaped stone blocks called **voussoir**s placed together and held at the top by a trapezoidal **keystone**. It forms an effective space-spanning and weight-bearing unit, but requires **buttress**es at each side to contain the outward **thrust** caused by the weight of the structure. *Corbeled arch*: an arch or **vault** formed by **courses** of stones, each of which projects beyond the lower course until the space is enclosed; usually finished with a **capstone**. *Horseshoe arch*: an arch of more than a half-circle; typical of western Islamic architecture. *Round arch*: an arch that displaces most of its weight, or downward thrust along its curving sides, transmitting that weight to adjacent supporting uprights (door or window **jamb**s, **column**s, or **pier**s). *Ogival arch*: a sharply pointed arch created by S-curves. *Relieving arch*: an arch built into a heavy wall just above a **post-and-lintel** structure (such as a gate, door, or window) to help support the wall above by transferring the load to the side walls. *Transverse arch*: an arch that connects the wall **pier**s on both sides of an interior space, up and over a stone **vault**.

Archaic smile (p. 114) The curved lips of an ancient Greek statues in the period c. 600–480 BCE, usually interpreted as a way of animating facial features.

architrave (p. 107) The bottom element in an **entablature**, beneath the **frieze** and the **cornice**.

archivolt (p. 478) A band of **molding** framing an **arch**, or a series of stone blocks that form an arch resting directly on flanking **columns** or **piers**.

ashlar (p. 99) A highly finished, precisely cut block of stone. When laid in even **courses**, ashlar masonry creates a uniform face with fine joints. Often used as a facing on the visible exterior of a building, especially as a veneer for the **façade**. Also called **dressed stone**.

assemblage (p. 1026) Artwork created by gathering and manipulating two- and/or three-dimensional found objects.

astragal (p. 110) A thin convex decorative **molding**, often found on a Classical **entablature**, and usually decorated with a continuous row of beadlike circles.

atelier (p. 946) The studio or workshop of a master artist or craftsmaker, often including junior associates and apprentices.

atmospheric perspective (p. 183) See under **perspective**.

atrial cross (p. 943) A cross placed in the **atrium** of a church. In Colonial America, used to mark a gathering and teaching place.

atrium (p. 158) An unroofed interior courtyard or room in a Roman house, sometimes having a pool or garden, sometimes surrounded by **columns**. Also: the open courtyard in front of a Christian church; or an entrance area in modern architecture.

automatism (p. 1057) A technique in which artists abandon the usual intellectual control over their brushes or pencils to allow the subconscious to create the artwork without rational interference.

avant-garde (p. 972) Term derived from the French military word meaning "before the group," or "vanguard." Avant-garde denotes those artists or concepts of a strikingly new, experimental, or radical nature for their time.

axis (p. xxxii) In pictures, an implied line around which elements are composed or arranged. In buildings, a dominant line around which parts of the structure are organized and along which human movement or attention is concentrated.

axis mundi (p. 300) A concept of an "axis of the world," which marks sacred sites and denotes a link between the human and celestial realms. For example, in Buddhist art, the axis mundi can be marked by monumental free-standing decorative pillars.

baldachin (p. 472) A canopy (whether suspended from the ceiling, projecting from a wall, or supported by columns) placed over an honorific or sacred space such as a throne or church altar.

bar tracery (p. 510) See under **tracery**.

barbarian (p. 149) A term used by the ancient Greeks and Romans to label all foreigners outside their cultural orbit (e.g., Celts, Goths, Vikings). The word derives from an imitation of what the "barblings" of their language sounded like to those who could not understand it.

barrel vault (p. 187) See under **vault**.

bas-relief (p. 325) Another term for low relief ("bas" is the French word for "low"). See under **relief sculpture**.

basilica (p. 191) A large rectangular building. Often built with a **clerestory**, side **aisles** separated from the center **nave** by **colonnades**, and an **apse** at one or both ends. Originally Roman centers for administration, later adapted to Christian church use.

bay (p. 170) A unit of space defined by architectural elements such as **columns**, **piers**, and walls.

beehive tomb (p. 98) A **corbel**-**vaulted** tomb, conical in shape like a beehive, and covered by an earthen mound.

Benday dots (p. 1095) In modern printing and typesetting, the individual dots that, together with many others, make up lettering and images. Often machine- or computer-generated, the dots are very small and closely spaced to give the effect of density and richness of tone.

bilum (p. 865) Netted bags made mainly by women throughout the central highlands of New Guinea. The bags can be used for everyday purposes or even to carry the bones of the recently deceased as a sign of mourning.

biomorphic (p. 1058) Denoting the biologically or organically inspired shapes and forms that were routinely included in abstracted Modern art in the early twentieth century.

black-figure (p. 105) A technique of ancient Greek **ceramic** decoration in which black figures are painted on a red clay ground. Compare **red-figure**.

blackware (p. 855) A **ceramic** technique that produces pottery with a primarily black surface with **matte** and glossy patterns on the surface.

blind arcade (p. 780) See under **arcade**.

bodhisattva (p. 311) In Buddhism, a being who has attained enlightenment but chooses to remain in this world in order to help others advance spiritually. Also defined as a potential Buddha.

Book of Hours (p. 549) A prayer book for private use, containing a calendar, services for the canonical hours, and sometimes special prayers.

boss (p. 556) A decorative knoblike element that can be found in many places, e.g. at the intersection of a Gothic **rib vault** or as a buttonlike projection on metalwork.

bracket, bracketing (p. 341) An architectural element that projects from a wall to support a horizontal part of a building, such as beams or the eaves of a roof.

buon fresco (p. 87) See under **fresco**.

burin (p. 592) A metal instrument used in **engraving** to cut lines into the metal plate. The sharp end of the burin is trimmed to give a diamond-shaped cutting point, while the other end is finished with a wooden handle that fits into the engraver's palm.

buttress, buttressing (p. 170) A projecting support built against an external wall, usually to counteract the lateral **thrust** of a **vault** or **arch**. In Gothic church architecture, a **flying buttress** is an arched bridge above the **aisle** roof that extends from the upper **nave** wall, where the lateral thrust of the main vault is greatest, down to a solid **pier**.

cairn (p. 17) A pile of stones or earth and stones that served both as a prehistoric burial site and as a marker for underground tombs.

calligraphy (p. 275) Handwriting as an art form.

calyx krater (p. 119) See under **krater**.

calotype (p. 969) The first photographic process utilizing negatives and paper positives; invented by William Henry Fox Talbot in the late 1830s.

came (*pl.* **cames**) (p. 501) A lead strip used in the making of leaded or **stained-glass** windows. Cames have an indented groove on the sides into which individual pieces of glass are fitted to make the overall design.

cameo (p. 172) Gemstone, clay, glass, or shell having layers of color, carved in low relief (see under **relief sculpture**) to create an image and ground of different colors.

camera obscura (p. 750) An early cameralike device used in the Renaissance and later for recording images from the real world. It consists of a dark box (or room) with a hole in one side (sometimes fitted with a lens). The camera obscura operates when bright light shines through the hole, casting an upside-down image of an object outside onto the inside wall of the box.

canon of proportions (p. 64) A set of ideal mathematical ratios in art based on measurements, as in the proportional relationships between the basic elements of the human body.

canopic jar (p. 53) In ancient Egyptian culture, a special jar used to store the major organs of a body before embalming.

capital (p. 110) The sculpted block that tops a **column**. According to the **convention**s of the orders, capitals include different decorative elements (see **order**). A *historiated capital* is one displaying a figural composition and/or narrative scenes.

capriccio (*pl.* *capricci*) (p. 915) A painting or print of a fantastic, imaginary landscape, usually with architecture.

capstone (p. 17) The final, topmost stone in a **corbeled arch** or **vault**, which joins the sides and completes the structure.

cartoon (p. 501) A full-scale drawing of a design that will be executed in another **medium**, such as wall painting, **tapestry**, or **stained glass**.

cartouche (p. 187) A frame for a **hieroglyphic** inscription formed by a rope design surrounding an oval space. Used to signify a sacred or honored name. Also: in architecture, a decorative device or plaque, usually with a plain center used for inscriptions or epitaphs.

caryatid (p. 107) A sculpture of a draped female figure acting as a **column** supporting an **entablature**.

cassone (*pl.* *cassoni*) (p. 616) An Italian dowry chest often highly decorated with carvings, paintings, inlaid designs, and gilt embellishments.

catacomb (p. 215) An underground cemetery consisting of tunnels on different levels, having niches for urns and **sarcophagi** and often incorporating rooms (**cubicula**).

cathedral (p. 220) The principal Christian church in a diocese, the bishop's administrative center and housing his throne (*cathedra*).

celadon (p. 358) A high-fired, transparent **glaze** of pale bluish-green hue whose principal coloring agent is an oxide of iron. In China and Korea, such glazes were typically applied over a pale gray **stoneware** body, though Chinese potters sometimes applied them over **porcelain** bodies during the Ming (1368–1644) and Qing (1644–1911) dynasties. Chinese potters invented celadon glazes and initiated the continuous production of celadon-glazed wares as early as the third century CE.

cella (p. 108) The principal interior room at the center of a Greek or Roman temple within which the cult statue was usually housed. Also called the **naos**.

celt (p. 383) A smooth, oblong stone or metal object, shaped like an axe-head.

cenotaph (p. 771) A funerary monument commemorating an individual or group buried elsewhere.

centering (p. 170) A temporary structure that supports a masonry **arch**, **vault**, or **dome** during construction until the mortar is fully dried and the masonry is self-sustaining.

central-plan building (p. 225) Any structure designed with a primary central space surrounded by symmetrical areas on each side, e.g., a **rotunda**.

ceramics (p. 20) A general term covering all types of wares made from fired clay.

chacmool (p. 396) In Maya sculpture, a half-reclining figure probably representing an offering bearer.

chaitya (p. 305) A type of Buddhist temple found in India. Built in the form of a hall or **basilica**, a *chaitya* hall is highly decorated with sculpture and usually is carved from a cave or natural rock location. It houses a sacred shrine or **stupa** for worship.

chamfer (p. 780) The slanted surface produced when an angle is trimmed or beveled, common in building and metalwork.

chasing (p. 432) Ornamentation made on metal by incising or hammering the surface.

château (*pl.* *châteaux*) (p. 693) A French country house or residential castle. A *château fort* is a military castle incorporating defensive works such as towers and battlements.

chattri (p. 780) In Indian architecture, a decorative pavilion with an umbrella-shaped **dome**.

chevron (p. 357) A decorative or heraldic motif of repeated Vs; a zigzag pattern.

chiaroscuro (p. 636) An Italian word designating the contrast of dark and light in a painting, drawing, or print. *Chiaroscuro* creates spatial depth and volumetric forms through gradations in the intensity of light and shadow.

choir (p. 225) The part of a church reserved for the clergy, monks, or nuns, either between the **transept** crossing and the **apse** or extending farther into the **nave**; separated from the rest of the church by screens or walls and fitted with stalls (seats).

cista (*pl.* *cistae*) (p. 157) Cylindrical containers used in antiquity by wealthy women as a case for toiletry articles such as a mirror.

clerestory (p. 57) In a **basilica**, the topmost zone of a wall with windows, extending above the **aisle** roofs. Provides direct light into the **nave**.

cloisonné (p. 257) An **enameling** technique in which artists affix wires or strips to a metal surface to delineate designs and create compartments (*cloisons*) that they subsequently fill with enamel.

cloister (p. 448) An enclosed space, open to the sky, especially within a monastery, surrounded by an **arcade**d walkway, often having a fountain and garden. Since the most important monastic buildings (e.g., dormitory, refectory, church) open off the cloister, it represents the center of the monastic world.

codex (*pl.* **codices**) (p. 245) A book, or a group of **manuscript** pages (folios), held together by stitching or other binding along one edge.

coffer (p. 197) A recessed decorative panel used to decorate ceilings or **vault**s. The use of coffers is called coffering.

coiling (p. 848) A technique in basketry. In coiled baskets a spiraling coil, braid, or rope of material is held in place by stitching or interweaving to create a permanent shape.

collage (p. 1025) A composition made of cut and pasted scraps of materials, sometimes with lines or forms added by the artist.

colonnade (p. 69) A row of **columns**, supporting a straight **lintel** (as in a **porch** or **portico**) or a series of **arch**es (as in an **arcade**).

colophon (p. 438) The data placed at the end of a book listing the book's author, publisher, illuminator, and other information related to its production. In East Asian **handscroll**s, the inscriptions which follow the painting are also called colophons.

column (p. 110) An architectural element used for support and/or decoration. Consists of a rounded or polygonal vertical **shaft** placed on a **base** and topped by a decorative **capital**. In Classical architecture, columns are built in accordance with the rules of one of the architectural **order**s. They can be free-standing or attached to a background wall (**engaged**).

combine (p. 1087) Combination of painting and sculpture using nontraditional art materials.

complementary color (p. 995) The primary and secondary colors across from each other on the color wheel (red and green, blue and orange, yellow and purple). When juxtaposed, the intensity of both colors increases. When mixed together, they negate each other to make a neutral gray-brown.

Composite order (p. 161) See under **order**.

composite pose or **image** (p. 10) Combining different viewpoints within a single representation.

composition (p. xxix) The overall arrangement, organizing design, or structure of a work of art.

conch (p. 236) A halfdome.

connoisseur (p. 289) A French word meaning "an expert," and signifying the study and evaluation of art based primarily on formal, visual, and stylistic analysis. A connoisseur studies the style and technique of an object to assess its relative quality and identify its maker through visual comparison with other works of secure authorship. See also **Formalism**.

continuous narrative (p. 245) See under **narrative image**.

contrapposto (p. 120) Italian term meaning "set against," used to describe the Classical convention of representing human figures with opposing alternations of tension and relaxation on either side of a central **axis** to imbue figures with a sense of the potential for movement.

convention (p. 31) A traditional way of representing forms.

corbel, corbeling (p. 19) An early roofing and arching technique in which each **course** of stone projects slightly beyond the previous layer (a corbel) until the uppermost corbels meet; see also under **arch**. Also: **bracket**s that project from a wall.

corbeled vault (p. 99) See under **vault**.

Corinthian order (p. 108) See under **order**.

cornice (p. 110) The uppermost section of a Classical **entablature**. More generally, a horizontally projecting element found at the top of a building wall or **pedestal**. A *raking cornice* is formed by the junction of two slanted cornices, most often found in **pediment**s.

course (p. 99) A horizontal layer of stone used in building.

crenellation, crenellated (p. 44) Alternating high and low sections of a wall, giving a notched appearance and creating permanent defensive shields on top of fortified buildings.

crocket (p. 587) A stylized leaf used as decoration along the outer angle of spires, pinnacles, gables, and around **capital**s in Gothic architecture.

cruciform (p. 228) Of anything that is cross-shaped, as in the cruciform plan of a church.

cubiculum (*pl.* **cubicula**) (p. 220) A small private room for burials in a **catacomb**.

cuneiform (p. 28) An early form of writing with wedge-shaped marks impressed into wet clay with a **stylus**, primarily used by ancient Mesopotamians.

curtain wall (p. 1045) A wall in a building that does not support any of the weight of the structure.

cyclopean (p. 93) A method of construction using huge blocks of rough-hewn stone. Any large-scale, monumental building project that impresses by sheer size. Named after the Cyclopes (sing. Cyclops), one-eyed giants of legendary strength in Greek myths.

cylinder seal (p. 35) A small cylindrical stone decorated with **incised** patterns. When rolled across soft clay or wax, the resulting raised pattern or design served in Mesopotamian and Indus Valley cultures as an identifying signature.

dado (*pl.* **dadoes**) (p. 161) The lower part of a wall, differentiated in some way (by a **molding** or different coloring or paneling) from the upper section.

daguerreotype (p. 969) An early photographic process that makes a positive print on a light-sensitized copperplate; invented and marketed in 1839 by Louis-Jacques-Mandé Daguerre.

dendrochronology (p. xxxvi) The dating of wood based on the patterns of the tree's growth rings.

dentils (p. 110) A row of projecting rectangular blocks forming a **molding** or running beneath a **cornice** in Classical architecture.

desert varnish (p. 406) A naturally occurring coating that turns rock faces into dark surfaces. Artists would draw images by scraping through the dark surface and revealing the color of the underlying rock. Extensively used in southwest North America.

diptych (p. 212) Two panels of equal size (usually decorated with paintings or reliefs) hinged together.

dogu (p. 362) Small human figurines made in Japan during the Jomon period. Shaped from clay, the figures have exaggerated expressions and are in contorted poses. They were probably used in religious rituals.

dolmen (p. 17) A prehistoric structure made up of two or more large upright stones supporting a large, flat, horizontal slab or slabs.

dome (p. 187) A rounded **vault**, usually over a circular space. Consists of curved masonry and can vary in shape from hemispherical to bulbous to ovoidal. May use a supporting vertical wall (**drum**), from which the vault springs, and may be crowned by an open space (**oculus**) and/or an exterior **lantern**. When a dome is built over a square space, an intermediate element is required to make the transition to a circular drum. There are two systems. A dome on **pendentives** incorporates arched, sloping intermediate sections of wall that carry the weight and **thrust** of the dome to heavily **buttress**ed supporting **pier**s. A dome on **squinch**es uses an arch built into the wall (squinch) in the upper corners of the space to carry the weight of the dome across the corners of the square space below. A halfdome or **conch** may cover a semicircular space.

domino construction (p. 1045) System of building construction introduced by the architect Le Corbusier in which reinforced concrete floor slabs are floated on six free-standing posts placed as if at the positions of the six dots on a domino playing piece.

Doric order (p. 108) See **order**.

dressed stone (p. 84) Another term for **ashlar**.

drillwork (p. 188) The technique of using a drill for the creation of certain effects in sculpture.

drum (p. 110) The circular wall that supports a **dome**. Also: a segment of the circular **shaft** of a **column**.

drypoint (p. 748) An **intaglio** printmaking process by which a metal (usually copper) plate is directly inscribed with a pointed instrument (**stylus**). The resulting design of scratched lines is inked, wiped, and printed. Also: the print made by this process.

earthenware (p. 20) A low-fired, opaque **ceramic** ware, employing humble clays that are naturally heat-resistant and remain porous after firing unless **glaze**d. Earthenware occurs in a range of earth-toned colors, from white and tan to gray and black, with tan predominating.

earthwork (p. 1102) Usually very large-scale, outdoor artwork that is produced by altering the natural environment.

echinus (p. 110) A cushionlike circular element found below the **abacus** of a Doric **capital**. Also: a similarly shaped **molding** (usually with egg-and-dart motifs) underneath the **volute**s of an Ionic capital.

electronic spin resonance (p. 12) Method that uses magnetic field and microwave irradiation to date material such as tooth enamel and its surrounding soil.

elevation (p. 108) The arrangement, proportions, and details of any vertical side or face of a building. Also: an architectural drawing showing an exterior or interior wall of a building.

embroidery (p. 397) Stitches applied in a decorative pattern on top of an already-woven fabric ground.

en plein air (p. 987) French term (meaning "in the open air") describing the Impressionist practice of painting outdoors so artists could have direct access to the fleeting effects of light and atmosphere while working.

enamel (p. 255) Powdered, then molten, glass applied to a metal surface, and used by artists to create designs. After firing, the glass forms an opaque or transparent substance that fuses to the metal background. Also: an object created by the enameling technique. See also *cloisonné*.

encaustic (p. 246) A painting **medium** using pigments mixed with hot wax.

engaged (p. 171) Of an architectural feature, usually a **column**, attached to a wall.

engraving (p. 592) An **intaglio** printmaking process of inscribing an image, design, or letters onto a metal or wood surface from which a print is made. An engraving is usually drawn with a sharp implement (**burin**) directly onto the surface of the plate. Also: the print made from this process.

entablature (p. 107) In the Classical **order**s, the horizontal elements above the **column**s and **capital**s. The entablature consists of, from bottom to top, an **architrave**, a **frieze**, and a **cornice**.

entasis (p. 108) A slight swelling of the **shaft** of a Greek **column**. The optical illusion of entasis makes the column appear from afar to be straight.

esquisse (p. 946) French for "sketch." A quickly executed drawing or painting conveying the overall idea for a finished painting.

etching (p. 748) An **intaglio** printmaking process in which a metal plate is coated with acid-resistant resin and then inscribed with a **stylus** in a design, revealing the plate below. The plate is then immersed in acid, and the exposed metal of the design is eaten away by the acid. The resin is removed, leaving the design etched permanently into the metal and the plate ready to be inked, wiped, and printed.

Eucharist (p. 220) The central rite of the Christian Church, from the Greek word for "thanksgiving." Also known as the Mass or Holy Communion, it reenacts Christ's sacrifice on the cross and commemorates the Last Supper. According to traditional Catholic Christian belief, consecrated bread and wine become the body and blood of Christ; in Protestant belief, bread and wine symbolize the body and blood.

exedra (*pl.* **exedrae**) (p. 197) In architecture, a semicircular niche. On a small scale, often used as decoration, whereas larger exedrae can form interior spaces (such as an **apse**).

expressionism (p. 149) Artistic styles in which aspects of works of art are exaggerated to evoke subjective emotions rather than to portray objective reality or elicit a rational response.

façade (p. 52) The face or front wall of a building.

faience (p. 88) Type of **ceramic** covered with colorful, opaque glazes that form a smooth, impermeable surface. First developed in ancient Egypt.

fang ding (p. 334) A square or rectangular bronze vessel with four legs. The *fang ding* was used for ritual offerings in ancient China during the Shang dynasty.

fête galante (p. 910) A subject in painting depicting well-dressed people at leisure in a park or country setting. It is most often associated with eighteenth-century French Rococo painting.

filigree (p. 90) Delicate, lacelike ornamental work.

fillet (p. 110) The flat ridge between the carved-out **flutes** of a **column shaft**.

finial (p. 780) A knoblike architectural decoration usually found at the top end of a spire, pinnacle, canopy, or gable. Also found on furniture. Also the ornamental top of a staff.

flutes (p. 110) In architecture, evenly spaced, rounded parallel vertical grooves incised on **shafts** of **columns** or on columnar elements such as **pilasters**.

flying buttress (p. 503) See under **buttress**.

flying gallop (p. 88) A non-naturalistic pose in which animals are depicted hovering above the ground with legs fully extended backwards and forwards to signify that they are running.

foreshortening (p. xxxi) The illusion created on a flat surface by which figures and objects appear to recede or project sharply into space. Accomplished according to the rules of **perspective**.

formal analysis (p. xxix) An exploration of the visual character that artists bring to their works through the expressive use of elements such as line, form, color, and light, and through its overall structure or composition.

Formalism (p. 1073) An approach to the understanding, appreciation, and valuation of art based almost solely on considerations of form. The Formalist's approach tends to regard an artwork as independent of its time and place of making.

forum (p. 176) A Roman town center; site of temples and administrative buildings and used as a market or gathering area for the citizens.

fresco (p. 81) A painting technique in which water-based pigments are applied to a plaster surface. If the plaster is painted when wet, the color is absorbed by the plaster, becoming a permanent part of the wall (*buon fresco*). *Fresco secco* is created by painting on dried plaster, and the color may eventually flake off. Murals made by both these techniques are called frescos.

frieze (p. 107) The middle element of an **entablature**, between the **architrave** and the **cornice**. Usually decorated with sculpture, painting, or **moldings**. Also: any continuous flat band with **relief sculpture** or painted decoration.

frottage (p. 1057) A design produced by laying a piece of paper over a textured surface and rubbing with charcoal or other soft **medium**.

fusuma (p. 820) Sliding doors covered with paper, used in traditional Japanese construction. *Fusuma* are often highly decorated with paintings and colored backgrounds.

gallery (p. 236) A roofed passageway with one or both of its long sides open to the air. In church architecture, the story found above the side **aisles** of a church or across the width at the end of the **nave** or **transepts**, usually open to and overlooking the area below. Also: a building or hall in which art is displayed or sold.

garbhagriha (p. 302) From the Sanskrit word meaning "womb chamber," a small room or shrine in a Hindu temple containing a holy image.

genre painting (p. 714) A term used to loosely categorize paintings depicting scenes of everyday life, including (among others) domestic interiors, parties, inn scenes, and street scenes.

geoglyph (p. 399) Earthen design on a colossal scale, often created in a landscape as if to be seen from an aerial viewpoint.

gesso (p. 546) A ground made from glue, gypsum, and/or chalk, used as the ground of a wood panel or the priming layer of a canvas. Provides a smooth surface for painting.

gilding (p. 90) The application of paper-thin gold leaf or gold pigment to an object made from another **medium** (for example, a sculpture or painting). Usually used as a decorative finishing detail.

giornata (*pl. giornate*) (p. 539) Adopted from the Italian term meaning "a day's work," a *giornata* is the section of a **fresco** plastered and painted in a single day.

glazing (p. 600) In **ceramics**, an outermost layer of vitreous liquid (**glaze**) that, upon firing, renders the ware waterproof and forms a decorative surface. In painting, a technique used with oil **media** in which a transparent layer of paint (glaze) is laid over another, usually lighter, painted or glazed area. In architecture, the process of filling openings in a building with windows of clear or **stained glass**.

gold leaf (p. 47) Paper-thin sheets of hammered gold that are used in **gilding**. In some cases (such as Byzantine **icons**), also used as a ground for paintings.

gopura (p. 775) The towering gateway to an Indian Hindu temple complex.

Grand Manner (p. 923) An elevated style of painting popular in the eighteenth century in which the artist looked to the ancients and to the Renaissance for inspiration; for portraits as well as history painting, the artist would adopt the poses, compositions, and attitudes of Renaissance and antique models.

Grand Tour (p. 913) Popular during the eighteenth and nineteenth centuries, an extended tour of cultural sites in France and Italy intended to finish the education of a young upper-class person primarily from Britain or North America.

granulation (p. 90) A technique of decoration in which metal granules, or tiny metal balls, are fused onto a metal surface.

graphic arts (p. 698) A term referring to those arts that are drawn or printed and that utilize paper as the primary support.

grattage (p. 1057) A pattern created by scraping off layers of paint from a canvas laid over a textured surface. Compare **frottage**.

grid (p. 65) A system of regularly spaced horizontally and vertically crossed lines that gives regularity to an architectural plan or in the composition of a work of art. Also: in painting, a grid is used to allow designs to be enlarged or transferred easily.

grisaille (p. 540) A style of monochromatic painting in shades of gray. Also: a painting made in this style.

groin vault (p. 187) See under **vault**.

grozing (p. 501) Chipping away at the edges of a piece of glass to achieve the precise shape needed for inclusion in the composition of a **stained-glass** window.

guild (p. 419) An association of artists or craftsmakers. Medieval and Renaissance guilds had great economic power, as they controlled the marketing of their members' products and provided economic protection, political solidarity, and training in the craft to its members. The painters' guild was usually dedicated to St. Luke, their patron saint.

hall church (p. 521) A church with **nave** and **aisles** of the same height, giving the impression of a large, open hall.

halo (p. 215) A circle of light that surrounds and frames the heads of emperors and holy figures to signify their power and/or sanctity. Also known as a nimbus.

handscroll (p. 343) A long, narrow, horizontal painting or text (or combination thereof) common in Chinese and Japanese art and of a size intended for individual use. A handscroll is stored wrapped tightly around a wooden pin and is unrolled for viewing or reading.

hanging scroll (p. 796) In Chinese and Japanese art, a vertical painting or text mounted within sections of silk. At the top is a semicircular rod; at the bottom is a round dowel. Hanging scrolls are kept rolled and tied except for special occasions, when they are hung for display, contemplation, or commemoration.

haniwa (p. 362) Pottery forms, including cylinders, buildings, and human figures, that were placed on top of Japanese tombs or burial mounds during the Kofun period (300–552 ce).

Happening (p. 1087) An art form developed by Allan Kaprow in the 1960s, incorporating performance, theater, and visual images. A Happening was organized without a specific narrative or intent; with audience participation, the event proceeded according to chance and individual improvisation.

hemicycle (p. 512) A semicircular interior space or structure.

henge (p. 17) A circular area enclosed by stones or wood posts set up by Neolithic peoples. It is usually bounded by a ditch and raised embankment.

hierarchic scale (p. 27) The use of differences in size to indicate relative importance. For example, with human figures, the larger the figure, the greater her or his importance.

hieratic (p. 484) Highly stylized, severe, and detached, often in relation to a strict religious tradition.

hieroglyph (p. 52) Picture writing; words and ideas rendered in the form of pictorial symbols.

high relief (p. 307) See under **relief sculpture**.

historiated capital (p. 484) See under **capital**.

historicism (p. 965) The strong consciousness of and attention to the institutions, themes, styles, and forms of the past, made accessible by historical research, textual study, and archaeology.

history paintings (p. 926) Paintings based on historical, mythological, or biblical narratives. Once considered the noblest form of art, history paintings generally convey a high moral or intellectual idea and are often painted in a grand pictorial style.

horizon line (p. 569) A horizontal "line" formed by the implied meeting point of earth and sky. In **linear perspective**, the **vanishing point** or points are located on this "line."

horseshoe arch (p. 272) See under **arch**.

hue (p. 77) Pure color. The saturation or intensity of the hue depends on the purity of the color. Its value depends on its lightness or darkness.

hydria (p. 139) A large ancient Greek or Roman jar with three handles (horizontal ones at both sides and one vertical at the back), used for storing water.

hypostyle hall (p. 66) A large interior room characterized by many closely spaced **columns** that support its roof.

icon (p. 246) An image representing a sacred figure or event in the Byzantine (later the Orthodox) Church. Icons are venerated by the faithful, who believe their prayers are transmitted through them to God.

iconic image (p. 215) A picture that expresses or embodies an intangible concept or idea.

iconoclasm (p. 248) The banning and/or destruction of images, especially **icons** and religious art. Iconoclasm in eighth- and ninth-century Byzantium and sixteenth- and seventeenth-century Protestant territories arose from differing beliefs about the power, meaning, function, and purpose of imagery in religion.

iconography (p. xxxiii) Identifying and studying the subject matter and **conventional** symbols in works of art.

iconology (p. xxxv) Interpreting works of art as embodiments of cultural situation by placing them within broad social, political, religious, and intellectual contexts.

iconophile (p. 247) From the Greek for "lover of images." In periods of **iconoclasm**, iconophiles advocate the continued use of sacred images.

idealization (p. 134) A process in art through which artists strive to make their forms and figures attain perfection, based on pervading cultural values and/or their own personal ideals.

illumination (p. 431) A painting on paper or parchment used as an illustration and/or decoration in a **manuscript** or **album**. Usually richly colored, often supplemented by gold and other precious materials. The artists are referred to as illuminators. Also: the technique of decorating manuscripts with such paintings.

impasto (p. 749) Thick applications of pigment that give a painting a palpable surface texture.

impluvium (p. 178) A pool under a roof opening that collected rainwater in the **atrium** of a Roman house.

impost block (p. 170) A block of masonry imposed between the top of a **pier** or above the **capital** of a **column** in order to provide extra support at the springing of an **arch**.

incising (p. 118) A technique in which a design or inscription is cut into a hard surface with a sharp instrument. Such a surface is said to be incised.

ink painting (p. 812) A monochromatic style of painting developed in China, using black ink with gray washes.

inlay (p. 30) To set pieces of a material or materials into a surface to form a design. Also: material used in or decoration formed by this technique.

installation, installation art (p. 1051) Contemporary art created for a specific site, especially a gallery or outdoor area, that creates a complete and controlled environment.

intaglio (p. 592) A technique in which the design is carved out of the surface of an object, such as an engraved seal stone. In the **graphic arts**, intaglio includes **engraving**, **etching**, and **drypoint**—all processes in which ink transfers to paper from incised, ink-filled lines cut into a metal plate.

intarsia (p. 618) Technique of **inlay** decoration using variously colored woods.

intuitive perspective (p. 182) See under **perspective**.

Ionic order (p. 107) See under **order**.

iwan (p. 277) In Islamic architecture, a large, vaulted chamber with a monumental arched opening on one side.

jamb (p. 478) In architecture, the vertical element found on both sides of an opening in a wall, and supporting an **arch** or **lintel**.

Japonisme (p. 996) A style in French and American nineteenth-century art that was highly influenced by Japanese art, especially prints.

jasperware (p. 919) A fine-grained, unglazed, white **ceramic** developed in the eighteenth century by Josiah Wedgwood, often with raised designs remaining white above a background surface colored by metallic oxides.

Jataka tales (p. 303) In Buddhism, stories associated with the previous lives of Shakyamuni, the historical Buddha.

joggled voussoirs (p. 268) Interlocking **voussoirs** in an **arch** or **lintel**, often of contrasting materials for colorful effect.

joined-block sculpture (p. 373) Large-scale wooden sculpture constructed by a method developed in Japan. The entire work is made from smaller hollow blocks, each individually carved, and assembled when complete. The joined-block technique allowed production of larger sculpture, as the multiple joints alleviate the problems of drying and cracking found with sculpture carved from a single block.

kantharos (p. 117) A type of ancient Greek goblet with two large handles and a wide mouth.

keep (p. 477) The innermost and strongest structure or central tower of a medieval castle, sometimes used as living quarters, as well as for defense. Also called a donjon.

kente (p. 892) A woven cloth made by the Ashanti peoples of West Africa. *Kente* cloth is woven in long, narrow pieces featuring complex and colorful patterns, which are then sewn together.

key block (p. 828) The master block in the production of a colored **woodblock print**, which requires different blocks for each color. The key block is a flat piece of wood upon which the outlines for the entire design of the print were first drawn on its surface and then all but these outlines were carved away with a knife. These outlines serve as a guide for the accurate **registration** or alignment of the other blocks needed to add colors to specific parts of a print.

keystone (p. 170) The topmost **voussoir** at the center of an **arch**, and the last block to be placed. The pressure of this block holds the arch together. Often of a larger size and/or decorated.

kiln (p. 20) An oven designed to produce enough heat for the baking, or firing, of clay, for the melting of the glass used in **enamel** work, and for the fixing of vitreous paint on **stained glass**.

kiva (p. 405) A subterranean, circular room used as a ceremonial center in some Native American cultures.

kondo (p. 366) The main hall inside a Japanese Buddhist temple where the images of Buddha are housed.

korambo (p. 865) A ceremonial or spirit house in Pacific cultures, reserved for the men of a village and used as a meeting place as well as to hide religious artifacts from the uninitiated.

kore (*pl.* **kourai**) (p. 114) An Archaic Greek statue of a young woman.

koru (p. 872) A design depicting a curling stalk with a bulb at the end that resembles a young tree fern; often found in Maori art.

kouros (*pl.* **kouroi**) (p. 114) An Archaic Greek statue of a young man or boy.

kowhaiwhai (p. 872) Painted curvilinear patterns often found in Maori art.

krater (p. 99) An ancient Greek vessel for mixing wine and water, with many subtypes that each have a distinctive shape. *Calyx krater*: a bell-shaped vessel with handles near the base that resembles a flower calyx. *Volute krater*: a krater with handles shaped like scrolls.

Kufic (p. 275) An ornamental, angular Arabic script.

kylix (p. 120) A shallow ancient Greek cup, used for drinking, with a wide mouth and small handles near the rim.

lacquer (p. 824) A type of hard, glossy surface varnish, originally developed for use on objects in East Asian cultures, made from the sap of the Asian sumac or from shellac, a resinous secretion from the lac insect. Lacquer can be layered and manipulated or combined with pigments and other materials for various decorative effects.

lakshana (p. 306) The 32 marks of the historical Buddha. The *lakshana* include, among others, the Buddha's golden body, his long arms, the wheel impressed on his palms and the soles of his feet, and his elongated earlobes.

lamassu (p. 42) Supernatural guardian-protector of ancient Near Eastern palaces and throne rooms, often represented sculpturally as a combination of the bearded head of a man, powerful body of a lion or bull, wings of an eagle, and the horned headdress of a god, usually possessing five legs.

lancet (p. 505) A tall, narrow window crowned by a sharply pointed arch, typically found in Gothic architecture.

lantern (p. 464) A turretlike structure situated on a roof, vault, or dome, with windows that allow light into the space below.

lekythos (*pl.* **lekythoi**) (p. 141) A slim ancient Greek oil vase with one handle and a narrow mouth.

linear perspective (p. 595) See under **perspective**.

linga shrine (p. 315) A place of worship centered on an object or representation in the form of a phallus (the lingam), which symbolizes the power of the Hindu god Shiva.

lintel (p. 18) A horizontal element of any material carried by two or more vertical supports to form an opening.

literati painting (p. 793) A style of painting that reflects the taste of the educated class of East Asian intellectuals and scholars. Characteristics include an appreciation for the antique, small scale, and an intimate connection between maker and audience.

lithography (p. 953) Process of making a print (lithograph) from a design drawn on a flat stone block with greasy crayon. Ink is applied to the wet stone and adheres only to the greasy areas of the design.

loggia (p. 534) Italian term for a **gallery**. Often used as a corridor between buildings or around a courtyard, a loggia usually features an **arcade** or **colonnade**.

longitudinal-plan building (p. 225) Any structure designed with a rectangular shape and a longitudinal axis. In a cross-shaped building, the main arm of the building would be longer than any arms that cross it. For example, a **basilica**.

lost-wax casting (p. 36) A method of casting metal, such as bronze. A wax mold is covered with clay and plaster, then fired, thus melting the wax and leaving a hollow form. Molten metal is then poured into the hollow space and slowly cooled. When the hardened clay and plaster exterior shell is removed, a solid metal form remains to be smoothed and polished.

low relief (p. 40) See under **relief sculpture**.

lunette (p. 221) A semicircular wall area, framed by an **arch** over a door or window. Can be either plain or decorated.

lusterware (p. 277) Pottery decorated with metallic **glaze**s.

madrasa (p. 277) An Islamic institution of higher learning, where teaching is focused on theology and law.

maenad (p. 104) In ancient Greece, a female devotee of the wine god Dionysos who participated in orgiastic rituals. Often depicted with swirling drapery to indicate wild movement or dance. Also called a Bacchante, after Bacchus, the Roman equivalent of Dionysos.

majolica (p. 573) Pottery painted with a tin **glaze** that, when fired, gives a lustrous and colorful surface.

mandala (p. 302) An image of the cosmos represented by an arrangement of circles or concentric geometric shapes containing diagrams or images. Used for meditation and contemplation by Buddhists.

mandapa (p. 302) In a Hindu temple, an open hall dedicated to ritual worship.

mandorla (p. 479) Light encircling, or emanating from, the entire figure of a sacred person.

manuscript (p. 244) A hand-written book or document.

maqsura (p. 272) An enclosure in a Muslim **mosque**, near the **mihrab**, designated for dignitaries.

martyrium (*pl.* **martyria**) (p. 238) A church, chapel, or shrine built over the grave of a Christian martyr.

mastaba (p. 53) A flat-topped, one-story structure with slanted walls built over an ancient Egyptian underground tomb.

matte (p. 573) Of a smooth surface that is without shine or luster.

mausoleum (p. 175) A monumental building used as a tomb. Named after the tomb of King Mausolos erected at Halikarnassos around 350 BCE.

medallion (p. 222) Any round ornament or decoration. Also: a large medal.

medium (*pl.* **media**) (p. xxix) The material from which a work of art is made.

megalith (*adj.* **megalithic**) (p. 16) A large stone used in some prehistoric architecture.

megaron (p. 93) The main hall of a Mycenaean palace or grand house.

memento mori (p. 909) From Latin for "remember that you must die." An object, such as a skull or extinguished candle, typically found in a *vanitas* image, symbolizing the transience of life.

menorah (p. 186) A Jewish lampstand with seven or nine branches; the nine-branched menorah is used during the celebration of Hanukkah. Representations of the seven-branched menorah, once used in the Temple of Jerusalem, became a symbol of Judaism.

metope (p. 110) The carved or painted rectangular panel between the **triglyph**s of a Doric **frieze**.

mihrab (p. 265) A recess or niche that distinguishes the wall oriented toward Mecca (*qibla*) in a **mosque**.

millefiori (p. 434) A glassmaking technique in which rods of differently colored glass are fused in a long bundle that is subsequently sliced to produce disks or beads with small-scale, multicolor patterns. The term derives from the Italian for "a thousand flowers."

minaret (p. 274) A tower on or near a **mosque** from which Muslims are called to prayer five times a day.

minbar (p. 265) A high platform or pulpit in a **mosque**.

miniature (p. 245) Anything small. In painting, miniatures may be illustrations within **album**s or **manuscript**s or intimate portraits.

mirador (p. 280) In Spanish and Islamic palace architecture, a very large window or room with windows, and sometimes balconies, providing views to interior courtyards or the exterior landscape.

mithuna (p. 305) The amorous male and female couples in Buddhist sculpture, usually found at the entrance to a sacred building. The *mithuna* symbolizes the harmony and fertility of life.

moai (p. 875) Statues found in Polynesia, carved from tufa, a yellowish brown volcanic stone, and depicting the human form. Nearly 1,000 of these statues have been found on the island of Rapa Nui but their significance has been a matter of speculation.

modeling (p. xxix) In painting, the process of creating the illusion of three-dimensionality on a two-dimensional surface by use of light and shade. In sculpture, the process of molding a three-dimensional form out of a malleable substance.

module (p. 346) A segment or portion of a repeated design. Also: a basic building block.

molding (p. 319) A shaped or sculpted strip with varying contours and patterns. Used as decoration on architecture, furniture, frames, and other objects.

mortise-and-tenon (p. 18) A method of joining two elements. A projecting pin (tenon) on one element fits snugly into a hole designed for it (mortise) on the other.

mosaic (p. 145) Image formed by arranging small colored stone or glass pieces (**tesserae**) and affixing them to a hard, stable surface.

mosque (p. 265) A building used for communal Islamic worship.

Mozarabic (p. 439) Of an eclectic style practiced in Christian medieval Spain when much of the Iberian peninsula was ruled by Islamic dynasties.

mudra (p. 307) A symbolic hand gesture in Buddhist art that denotes certain behaviors, actions, or feelings.

mullion (p. 510) A slender straight or curving bar that divides a window into subsidiary sections to create **tracery**.

muqarna (p. 280) In Islamic architecture, one of the nichelike components, often stacked in tiers to mark the transition between flat and rounded surfaces and often found on the **vault** of a **dome**.

naos (p. 236) The principal room in a temple or church. In ancient architecture, the **cella**. In a Byzantine church, the **nave** and **sanctuary**.

narrative image (p. 215) A picture that recounts an event drawn from a story, either factual (e.g. biographical) or fictional. In **continuous narrative**, multiple scenes from the same story appear within a single compositional frame.

narthex (p. 220) The vestibule or entrance porch of a church.

nave (p. 191) The central space of a church, two or three stories high and usually flanked by **aisle**s.

necropolis (p. 53) A large cemetery or burial area; literally a "city of the dead."

nemes headdress (p. 51) The royal headdress of ancient Egypt.

niello (p. 90) A metal technique in which a black sulfur **alloy** is rubbed into fine lines engraved into metal (usually gold or silver). When heated, the alloy becomes fused with the surrounding metal and provides contrasting detail.

oculus (*pl.* **oculi**) (p. 187) In architecture, a circular opening. Usually found either as windows or at the apex of a **dome**. When at the top of a dome, an oculus is either open to the sky or covered by a decorative exterior **lantern**.

odalisque (p. 952) Turkish word for "harem slave girl" or "concubine."

oil painting (p. 575) Any painting executed with pigments suspended in a **medium** of oil. Oil paint has particular properties that allow for greater ease of working: among others, a slow drying time (which allows for corrections), and a great range of relative opaqueness of paint layers (which permits a high degree of detail and luminescence).

oinochoe (p. 126) An ancient Greek jug used for wine.

olpe (p. 105) Any ancient Greek vessel without a spout.

one-point perspective (p. 259) See under **perspective**.

orant (p. 220) Of a standing figure represented praying with outstretched and upraised arms.

oratory (p. 228) A small chapel.

order (p. 110) A system of proportions in Classical architecture that includes every aspect of the building's plan, elevation, and decorative system. *Composite*: a combination of the Ionic and the Corinthian orders. The **capital** combines **acanthus** leaves with **volute** scrolls. *Corinthian*: the most ornate of the orders, the Corinthian includes a **base**, a **fluted column shaft** with a capital elaborately decorated with acanthus leaf carvings. Its **entablature** consists of an **architrave** decorated with **moldings**, a **frieze** often containing **relief sculpture**, and a **cornice** with **dentils**. *Doric*: the column shaft of the Doric order can be fluted or smooth-surfaced and has no base. The Doric capital consists of an undecorated **echinus** and **abacus**. The Doric entablature has a plain architrave, a frieze with **metope**s and **triglyph**s, and a simple cornice. *Ionic*: the column of the Ionic order has a base, a fluted shaft, and a capital decorated with volutes. The Ionic entablature consists of an architrave of three panels and moldings,

a frieze usually containing sculpted relief ornament, and a cornice with dentils. *Tuscan*: a variation of Doric characterized by a smooth-surfaced column shaft with a base, a plain architrave, and an undecorated frieze. *Colossal* or *giant*: any of the above built on a large scale, rising through two or more stories in height and often raised from the ground on a **pedestal**.

Orientalism (p. 968) A fascination with Middle Eastern cultures that inspired eclectic nineteenth-century European fantasies of exotic life that often formed the subject of paintings.

orthogonal (p. 138) Any line running back into the represented space of a picture perpendicular to the imagined **picture plane**. In **linear perspective**, all orthogonals converge at a single **vanishing point** in the picture and are the basis for a **grid** that maps out the internal space of the image. An orthogonal plan is any plan for a building or city that is based exclusively on right angles, such as the grid plan of many major cities.

pagoda (p. 347) An East Asian **reliquary** tower built with successively smaller, repeated stories. Each story is usually marked by an elaborate projecting roof.

painterly (p. 253) A style of painting which emphasizes the techniques and surface effects of brushwork (also color, light, and shade).

palace complex (p. 41) A group of buildings used for living and governing by a ruler and his or her supporters, usually fortified.

palazzo (p. 602) Italian term for palace, used for any large urban dwelling.

palette (p. 183) A hand-held support used by artists for arranging colors and mixing paint during the process of painting. Also: the choice of a range of colors used by an artist in a particular work, as typical of his or her style. In ancient Egypt, a flat stone used to grind and prepare makeup.

panel painting (p. xli) Any painting executed on a wood support, usually planed to provide a smooth surface. A panel can consist of several boards joined together.

parchment (p. 245) A writing surface made from treated skins of animals. Very fine parchment is known as **vellum**.

parterre (p. 761) An ornamental, highly regimented flowerbed; especially as an element of the ornate gardens of a seventeenth-century palace or **château**.

passage grave (p. 17) A prehistoric tomb under a **cairn**, reached by a long, narrow, slab-lined access passageway or passageways.

pastel (p. 914) Dry pigment, chalk, and gum in stick or crayon form. Also: a work of art made with pastels.

pedestal (p. 107) A platform or base supporting a sculpture or other monument. Also: the block found below the base of a Classical **column** (or **colonnade**), serving to raise the entire element off the ground.

pediment (p. 107) A triangular gable found over major architectural elements such as Classical Greek **portico**s, windows, or doors. Formed by an **entablature** and the ends of a sloping roof or a raking **cornice**. A similar architectural element is often used decoratively above a door or window, sometimes with a curved upper **molding**. A *broken pediment* is a variation on the traditional pediment, with an open space at the center of the topmost angle and/or the horizontal cornice.

pendant (also **pendent**) (p. 640) One of a pair of artworks meant to be seen in relation to each other as a set.

pendentive (p. 236) The concave triangular section of a **vault** that forms the transition between a square or polygonal space and the circular base of a **dome**.

Performance art (p. 1087) A contemporary artwork based on a live, sometimes theatrical performance by the artist.

peristyle (p. 66) In Greek architecture, a surrounding **colonnade**. A peristyle building is surrounded on the exterior by a colonnade. Also: a peristyle court is an open colonnaded courtyard, often having a pool and garden.

perspective (p. xxvii) A system for representing three-dimensional space on a two-dimensional surface. *Atmospheric* or *aerial perspective*: a method of rendering the effect of spatial distance by subtle variations in color and clarity of representation. *Intuitive perspective*: a method of giving the impression of recession by visual instinct, not by the use of an overall system or program. *Oblique perspective*: an intuitive spatial system in which a building or room is placed with one corner in the **picture plane**, and the other parts of the structure recede to an imaginary **vanishing point** on its other side. Oblique perspective is not a comprehensive, mathematical system. *One-point* and multiple-point perspective (also called linear, scientific, or mathematical perspective): a method of creating the illusion of three-dimensional space on a two-dimensional surface by delineating a **horizon line** and multiple **orthogonal** lines. These recede to meet at one or more points on the horizon (vanishing point), giving the appearance of spatial depth. Called scientific or mathematical because its use requires some knowledge of geometry and mathematics, as well as optics. *Reverse perspective*: a Byzantine perspective theory in which the orthogonals or rays of sight do not converge on a vanishing point in the picture, but are thought to originate in the viewer's eye in front of the picture. Thus, in reverse perspective the image is constructed with orthogonals that diverge, giving a slightly tipped aspect to objects.

photomontage (p. 1039) A photographic work created from many smaller photographs arranged (and often overlapping) in a composition, which is then rephotographed.

pictograph (p. 337) A highly stylized depiction serving as a symbol for a person or object. Also: a type of writing utilizing such symbols.

picture plane (p. 575) The theoretical plane corresponding with the actual surface of a painting, separating the spatial world evoked in the painting from the spatial world occupied by the viewer.

picturesque (p. 919) Of the taste for the familiar, the pleasant, and the agreeable, popular in the eighteenth and nineteenth centuries in Europe. Originally used to describe the "picturelike" qualities of some landscape scenes. When contrasted with the **sublime**, the picturesque stood for the interesting but ordinary domestic landscape.

piece-mold casting (p. 334) A casting technique in which the mold consists of several sections that are connected during the pouring of molten metal, usually bronze. After the cast form has hardened, the pieces of the mold are disassembled, leaving the completed object.

pier (p. 270) A masonry support made up of many stones, or rubble and concrete (in contrast to a column **shaft** which is formed from a single stone or a series of **drums**), often square or rectangular in plan, and capable of carrying very heavy architectural loads.

pietà (p. 230) A devotional subject in Christian religious art. After the Crucifixion the body of Jesus was laid across the lap of his grieving mother, Mary. When other mourners are present, the subject is called the Lamentation.

pietra serena (p. 602) A gray Tuscan sandstone used in Florentine architecture.

pilaster (p. 158) An **engaged** columnlike element that is rectangular in format and used for decoration in architecture.

pilgrimage church (p. 239) A church that attracts visitors wishing to venerate **relic**s as well as attend religious services.

pinnacle (p. 503) In Gothic architecture, a steep pyramid decorating the top of another element such as a **buttress**. Also: the highest point.

plate tracery (p. 505) See under **tracery**.

plein air (p. 989) See under *en plein air*.

plinth (p. 161) The slablike base or **pedestal** of a **column**, statue, wall, building, or piece of furniture.

pluralism (p. 1107) A social structure or goal that allows members of diverse ethnic, racial, or other groups to exist peacefully within the society while continuing to practice the customs of their own divergent cultures. Also: an adjective describing the state of having a variety of valid contemporary styles available at the same time to artists.

podium (p. 138) A raised platform that acts as the foundation for a building, or as a platform for a speaker.

poesia (*pl.* **poesie**) (p. 656) Italian Renaissance paintings based on Classical themes, often with erotic overtones, notably in the mid-sixteenth-century works of the Venetian painter Titian.

polychromy (p. 524) Multicolored decoration applied to any part of a building, sculpture, or piece of furniture. This can be accomplished with paint or by the use of multicolored materials.

polyptych (p. 566) An **altarpiece** constructed from multiple panels, sometimes with hinges to allow for movable wings.

porcelain (p. 20) A type of extremely hard and fine white **ceramic** first made by Chinese potters in the eighth century CE. Made from a mixture of kaolin and petuntse, porcelain is fired at a very high temperature, and the final product has a translucent surface.

porch (p. 108) The covered entrance on the exterior of a building. With a row of **column**s or **colonnade**, also called a **portico**.

portal (p. 40) A grand entrance, door, or gate, usually to an important public building, and often decorated with sculpture.

portico (p. 63) In architecture, a projecting roof or porch supported by **column**s, often marking an entrance. See also **porch**.

post-and-lintel (p. 19) An architectural system of construction with two or more vertical elements (posts) supporting a horizontal element (**lintel**).

potassium-argon dating (p. 12) Archaeological method of **radiometric dating** that measures the decay of a radioactive potassium isotope into a stable isotope of argon, and inert gas.

potsherd (p. 20) A broken piece of **ceramic** ware.

poupou (p. 873) In Pacific cultures, a house panel, often carved with designs.

Prairie Style (p. 1046) Style developed by a group of Midwestern architects who worked together using the aesthetic of the prairie and indigenous prairie plants for landscape design to create mostly domestic homes and small public buildings.

predella (p. 550) The base of an **altarpiece**, often decorated with small scenes that are related in subject to that of the main panel or panels.

primitivism (p. 1022) The borrowing of subjects or forms, usually from non-European or prehistoric sources by Western artists, in an attempt to infuse their work with the expressive qualities they attributed to other cultures, especially colonized cultures.

pronaos (p. 108) The enclosed vestibule of a Greek or Roman temple, found in front of the **cella** and marked by a row of **column**s at the entrance.

proscenium (p. 148) The stage of an ancient Greek or Roman theater. In a modern theater, the area of the stage in front of the curtain. Also: the framing **arch** that separates a stage from the audience.

psalter (p. 256) In Jewish and Christian scripture, a book of the Psalms (songs) attributed to King David.

psykter (p. 126) An ancient Greek vessel with an extended base to allow it to float in a larger **krater**; used to chill wine.

putto (*pl.* **putti**) (p. 224) A plump, naked little boy, often winged. In Classical art, called a cupid; in Christian art, a cherub.

pylon (p. 66) A massive gateway formed by a pair of tapering walls of oblong shape. Erected by ancient Egyptians to mark the entrance to a temple complex.

qibla (p. 274) The **mosque** wall oriented toward Mecca; indicated by the *mihrab*.

quatrefoil (p. 508) A four-lobed decorative pattern common in Gothic art and architecture.

quillwork (p. 847) A Native American technique in which the quills of porcupines and bird feathers are dyed and attached to materials in patterns.

radiometric dating (p. 12) Archaeological method of **absolute dating** by measuring the degree to which radioactive materials have degenerated over time. For dating organic (plant or animal) materials, one radiometric method measures a carbon isotope called radiocarbon, or carbon-14.

raigo (p. 378) A painted image that depicts the Amida Buddha and other Buddhist deities welcoming the soul of a dying believer to paradise.

raku (p. 823) A type of **ceramic** made by hand, coated with a thick, dark **glaze**, and fired at a low heat. The resulting vessels are irregularly shaped and glazed and are highly prized for use in the Japanese tea ceremony.

readymade (p. 1038) An object from popular or material culture presented without further manipulation as an artwork by the artist.

red-figure (p. 119) A technique of ancient Greek **ceramic** decoration characterized by red clay-colored figures on a black background. The figures are reserved against a painted ground and details are drawn, not engraved; compare **black-figure**.

register (p. 30) A device used in systems of spatial definition. In painting, a register indicates the use of differing groundlines to differentiate layers of space within an image. In **relief sculpture**, the placement of self-contained bands of reliefs in a vertical arrangement.

registration marks (p. 828) In Japanese **woodblock prints**, two marks carved on the blocks to indicate proper alignment of the paper during the printing process. In multicolor printing, which used a separate block for each color, these marks were essential for achieving the proper position or registration of the colors.

relative dating (p. 12) Archaeological process of determining relative chronological relationships among excavated objects. Compare **absolute dating**.

relic (p. 239) Venerated object or body part associated with a holy figure, such as a saint, and usually housed in a **reliquary**.

relief sculpture (p. 5) A three-dimensional image or design whose flat background surface is carved away to a certain depth, setting off the figure. Called *high* or *low (bas-) relief* depending upon the extent of projection of the image from the background. Called *sunken relief* when the image is carved below the original surface of the background, which is not cut away.

reliquary (p. 366) A container, often elaborate and made of precious materials, used as a repository for sacred relics.

repoussé (p. 90) A technique of pushing or hammering metal from the back to create a protruding image. Elaborate reliefs are created by pressing or hammering metal sheets against carved wooden forms.

rhyton (p. 88) A vessel in the shape of a figure or an animal, used for drinking or pouring liquids on special occasions.

rib vault (p. 499) See under **vault**.

ridgepole (p. 16) A longitudinal timber at the apex of a roof that supports the upper ends of the rafters.

roof comb (p. 392) In a Maya building, a masonry wall along the apex of a roof that is built above the level of the roof proper. Roof combs support the highly decorated false **façade**s that rise above the height of the building at the front.

rose window (p. 505) A round window, often filled with stained glass set into tracery patterns in the form of wheel spokes, found in the **façade**s of the **nave**s and **transept**s of large Gothic churches.

rosette (p. 105) A round or oval ornament resembling a rose.

rotunda (p. 195) Any building (or part thereof) constructed in a circular (or sometimes polygonal) shape, usually producing a large open space crowned by a **dome**.

round arch (p. 170) See under **arch**.

roundel (p. 158) Any ornamental element with a circular format, often placed as a decoration on the exterior of a building.

rune stone (p. 442) In early medieval northern Europe, a stone used as a commemorative monument and carved or inscribed with runes, a writing system used by early Germanic peoples.

rustication (p. 602) In architecture, the rough, irregular, and unfinished effect deliberately given to the exterior facing of a stone edifice. Rusticated stones are often large and used for decorative emphasis around doors or windows, or across the entire lower floors of a building.

sacra conversazione (p. 630) Italian for "holy conversation." Refers to a type of religious painting developed in fifteenth-century Florence in which a central image of the Virgin and Child is flanked by standing saints of comparable size who stand within the same spatial setting and often acknowledge each other's presence.

salon (p. 907) A large room for entertaining guests or a periodic social or intellectual gathering, often of prominent people, held in such a room. Also: a hall or **gallery** for exhibiting works of art.

sanctuary (p. 102) A sacred or holy enclosure used for worship. In ancient Greece and Rome, consisted of one or more temples and an altar. In Christian architecture, the space around the altar in a church called the chancel or presbytery.

sarcophagus (*pl.* **sarcophagi**) (p. 49) A stone coffin. Often rectangular and decorated with **relief sculpture**.

scarab (p. 51) In ancient Egypt, a stylized dung beetle associated with the sun and the god Amun.

scarification (p. 409) Ornamental decoration applied to the surface of the body by cutting the skin for cultural and/or aesthetic reasons.

school of artists or **painting** (p. 285) An art-historical term describing a group of artists, usually working at the same time and sharing similar styles, influences, and ideals. The artists in a particular school may not necessarily be directly associated with one another, unlike those in a workshop or **atelier**.

scriptorium (*pl.* **scriptoria**) (p. 244) A room in a monastery for writing or copying **manuscript**s.

scroll painting (p. 347) A painting executed on a flexible support with rollers at each end. The rollers permit the horizontal scroll to be unrolled as it is studied or the vertical scroll to be hung for contemplation or decoration.

sculpture in the round (p. 5) Three-dimensional sculpture that is carved free of any background or block. Compare **relief sculpture**.

serdab (p. 53) In ancient Egyptian tombs, the small room in which the *ka* statue was placed.

sfumato (p. 636) Italian term meaning "smoky," soft, and mellow. In painting, the effect of haze in an image. Resembling the color of the atmosphere at dusk, *sfumato* gives a smoky effect.

sgraffito (p. 604) Decoration made by incising or cutting away a surface layer of material to reveal a different color beneath.

shaft (p. 110) The main vertical section of a **column** between the **capital** and the base, usually circular in cross section.

shaft grave (p. 97) A deep pit used for burial.

shikhara (p. 302) In the architecture of northern India, a conical (or pyramidal) spire found atop a Hindu temple and often crowned with an *amalaka*.

shoin (p. 821) A term used to describe the various features found in the most formal room of upper-class Japanese residential architecture.

shoji (p. 821) A standing Japanese screen covered in translucent rice paper and used in interiors.

siapo (p. 876) A type of **tapa** cloth found in Samoa and still used as an important gift for ceremonial occasions.

silkscreen printing (p. 1092) A technique of printing in which paint or ink is pressed through a stencil and specially prepared cloth to reproduce a design in multiple copies.

sinopia (*pl.* **sinopie**) (p. 539) Italian word taken from Sinope, the ancient city in Asia Minor that was famous for its red-brick pigment. In **fresco** paintings, a full-sized, preliminary sketch done in this color on the first rough coat of plaster or *arriccio*.

site-specific (p. 1102) Of a work commissioned and/or designed for a particular location.

slip (p. 118) A mixture of clay and water applied to a **ceramic** object as a final decorative coat. Also: a solution that binds different parts of a vessel together, such as the handle and the main body.

spandrel (p. 170) The area of wall adjoining the exterior curve of an **arch** between its **springing** and the **keystone**, or the area between two arches, as in an **arcade**.

spolia (p. 471) Fragments of older architecture or sculpture reused in a secondary context. Latin for "hide stripped from an animal."

springing (p. 170) The point at which the curve of an **arch** or **vault** meets with and rises from its support.

squinch (p. 238) An **arch** or **lintel** built across the upper corners of a square space, allowing a circular or polygonal **dome** to be securely set above the walls.

stained glass (p. 287) Glass stained with color while molten, using metallic oxides. Stained glass is most often used in windows, for which small pieces of different colors are precisely cut and assembled into a design, held together by lead **cames**. Additional details may be added with vitreous paint.

stave church (p. 443) A Scandinavian wooden structure with four huge timbers (staves) at its core.

stele (*pl.* **stelai**), also **stela** (*pl.* **stelae**) (p. 27) A stone slab placed vertically and decorated with inscriptions or reliefs. Used as a grave marker or commemorative monument.

stereobate (p. 110) In Classical architecture, the foundation upon which a temple stands.

still life (*pl.* **still lifes**) (p. xxxv) A type of painting that has as its subject inanimate objects (such as food and dishes) or fruit and flowers taken out of their natural contexts.

stoa (p. 107) In Greek architecture, a long roofed walkway, usually having **column**s on one long side and a wall on the other.

stoneware (p. 20) A high-fired, vitrified, but opaque **ceramic** ware that is fired in the range of 1,100 to 1,200 degrees Celsius. At that temperature, particles of silica in the clay bodies fuse together so that the finished vessels are impervious to liquids, even without glaze. Stoneware pieces are glazed to enhance their aesthetic appeal and to aid in keeping them clean. Stoneware occurs in a range of earth-toned colors, from white and tan to gray and black, with light gray predominating. Chinese potters were the first in the world to produce stoneware, which they were able to make as early as the Shang dynasty.

stringcourse (p. 503) A continuous horizontal band, such as a **molding**, decorating the face of a wall.

stucco (p. 72) A mixture of lime, sand, and other ingredients made into a material that can easily be molded or modeled. When dry, it produces a durable surface used for covering walls or for architectural sculpture and decoration.

stupa (p. 302) In Buddhist architecture, a bell-shaped or pyramidal religious monument, made of piled earth or stone, and containing sacred **relic**s.

style (p. xxxvi) A particular manner, form, or character of representation, construction, or expression that is typical of an individual artist or of a certain place or period.

stylobate (p. 110) In Classical architecture, the stone foundation on which a temple **colonnade** stands.

stylus (p. 28) An instrument with a pointed end (used for writing and printmaking), which makes a delicate line or scratch. Also: a special writing tool for **cuneiform** writing with one pointed end and one triangular.

sublime (p. 955) Of a concept, thing, or state of greatness or vastness with high spiritual, moral, intellectual, or emotional value; or something awe-inspiring. The sublime was a goal to which many nineteenth-century artists aspired in their artworks.

sunken relief (p. 71) See under **relief sculpture**.

symposium (p. 119) An elite gathering of wealthy and powerful men in ancient Greece that focused principally on wine, music, poetry, conversation, games, and love making.

syncretism (p. 220) A process whereby artists assimilate and combine images and ideas from different cultural traditions, beliefs, and practices, giving them new meanings.

taotie (p. 334) A mask with a dragon or animal-like face common as a decorative motif in Chinese art.

tapa (p. 876) A type of cloth used for various purposes in Pacific cultures, made from tree bark stripped and beaten, and often bearing subtle designs from the mallets used to work the bark.

tapestry (p. 292) Multicolored decorative weaving to be hung on a wall or placed on furniture. Pictorial or decorative motifs are woven directly into the supporting fabric, completely concealing it.

tatami (p. 821) Mats of woven straw used in Japanese houses as a floor covering.

temenos (p. 108) An enclosed sacred area reserved for worship in ancient Greece.

tempera (p. 141) A painting **medium** made by blending egg yolks with water, pigments, and occasionally other materials, such as glue.

tenebrism (p. 723) The use of strong *chiaroscuro* and artificially illuminated areas to create a dramatic contrast of light and dark in a painting.

terra cotta (p. 114) A **medium** made from clay fired over a low heat and sometimes left unglazed. Also: the orange-brown color typical of this medium.

tessera (*pl.* tesserae) (p. 145) A small piece of stone, glass, or other object that is pieced together with many others to create a **mosaic**.

thatch (p. 16) Plant material such as reeds or straw tied over a framework of poles to make a roof, shelter, or small building.

thermo-luminescence dating (p. 12) A method of **radiometric dating** that measures the irradiation of the crystal structure of material such as flint or pottery and the soil in which it is found, determined by luminescence produced when a sample is heated.

tholos (p. 98) A small, round building. Sometimes built underground, e.g. as a Mycenaean tomb.

thrust (p. 170) The outward pressure caused by the weight of a **vault** and supported by **buttressing**. See also under **arch**.

tondo (*pl.* tondi) (p. 126) A painting or **relief sculpture** of circular shape.

torana (p. 302) In Indian architecture, an ornamented gateway arch in a temple, usually leading to the **stupa**.

torc (p. 149) A circular neck ring worn by Celtic warriors.

toron (p. 422) In West African **mosque** architecture, the wooden beams that project from the walls. Torons are used as support for the scaffolding erected annually for the replastering of the building.

tracery (p. 503) Stonework or woodwork forming a pattern in the open space of windows or applied to wall surfaces. In *plate tracery*, a series of openings are cut through the wall. In *bar tracery*, **mullion**s divide the space into segments to form decorative patterns.

transept (p. 225) The arm of a **cruciform** church perpendicular to the **nave**. The point where the nave and transept intersect is called the crossing. Beyond the crossing lies the **sanctuary**, whether **apse**, **choir**, or chevet.

transverse arch (p. 463) See under **arch**.

trefoil (p. 298) An ornamental design made up of three rounded lobes placed adjacent to one another.

triforium (p. 505) The element of the interior elevation of a church found directly below the **clerestory** and consisting of a series of arched openings in front of a passageway within the thickness of the wall.

triglyph (p. 110) Rectangular block between the **metope**s of a Doric **frieze**. Identified by the three carved vertical grooves, which approximate the appearance of the end of wooden beams.

triptych (p. 566) An artwork made up of three panels. The panels may be hinged together in such a way that the side segments (wings) fold over the central area.

trompe l'oeil (p. 618) A manner of representation in which artists faithfully describe the appearance of natural space and forms with the express intention of fooling the eye of the viewer, who may be convinced momentarily that the subject actually exists as three-dimensional reality.

trumeau (p. 478) A **column**, **pier**, or post found at the center of a large **portal** or doorway, supporting the **lintel**.

tugra (p. 288) A calligraphic imperial monogram used in Ottoman courts.

tukutuku (p. 872) Lattice panels created by women from the Maori culture and used in architecture.

Tuscan order (p. 158) See under **order**.

twining (p. 848) A basketry technique in which short rods are sewn together vertically. The panels are then joined together to form a container or other object.

tympanum (p. 478) In medieval and later architecture, the area over a door enclosed by an **arch** and a **lintel**, often decorated with sculpture or mosaic.

ukiyo-e (p. 828) A Japanese term for a type of popular art that was favored from the sixteenth century, particularly in the form of color **woodblock print**s. *Ukiyo-e* prints often depicted the world of the common people in Japan, such as courtesans and actors, as well as landscapes and myths.

undercutting (p. 212) A technique in sculpture by which the material is cut back under the edges so that the remaining form projects strongly forward, casting deep shadows.

underglaze (p. 800) Color or decoration applied to a **ceramic** piece before glazing.

upeti (p. 876) In Pacific cultures, a carved wooden design tablet, used to create patterns in cloth by dragging the fabric across it.

uranium-thorium dating (p. 12) Technique used to date prehistoric cave paintings by measuring the decay of uranium into thorium in the deposits of calcium carbinate that cover the surfaces of cave walls, to determine the minimum age of the paintings under the crust.

urna (p. 306) In Buddhist art, the curl of hair on the forehead that is a characteristic mark of a buddha. The *urna* is a symbol of divine wisdom.

ushnisha (p. 306) In Asian art, a round turban or tiara symbolizing royalty and, when worn by a buddha, enlightenment.

vanishing point (p. 610) In a **perspective** system, the point on the **horizon line** at which **orthogonals** meet. A complex system can have multiple vanishing points.

vanitas (p. xxxvi) An image, especially popular in Europe during the seventeenth century, in which all the objects symbolize the transience of life. *Vanitas* paintings are usually of **still lifes** or genre subjects.

vault (p. 17) An arched masonry structure that spans an interior space. *Barrel* or *tunnel vault*: an elongated or continuous semicircular vault, shaped like a half-cylinder. *Corbeled vault*: a vault made by projecting **course**s of stone; see also under **corbel**. *Groin* or *cross vault*: a vault created by the intersection of two barrel vaults of equal size which creates four side compartments of identical size and shape. *Quadrant vault*: a half-barrel vault. *Rib vault*: a groin vault with ribs (extra masonry) demarcating the junctions. Ribs may function to reinforce the groins or may be purely decorative.

veduta (*pl.* vedute) (p. 915) Italian for "vista" or "view." Paintings, drawings, or prints, often of expansive city scenes or of harbors.

vellum (p. 245) A fine animal skin prepared for writing and painting. See also **parchment**.

verism (p. 168) Style in which artists concern themselves with describing the exterior likeness of an object or person, usually by rendering its visible details in a finely executed, meticulous manner.

vihara (p. 305) From the Sanskrit term meaning "for wanderers." A *vihara* is, in general, a Buddhist monastery in India. It also signifies monks' cells and gathering places in such a monastery.

volute (p. 110) A spiral scroll, as seen on an Ionic **capital**.

votive figure (p. 31) An image created as a devotional offering to a deity.

voussoir (p. 170) Wedge-shaped stone block used to build an **arch**. The topmost voussoir is called a **keystone**. See also **joggled voussoirs**.

warp (p. 292) The vertical threads in a weaver's loom. Warp threads make up a fixed framework that provides the structure for the entire piece of cloth, and are thus often thicker than **weft** threads.

wattle and daub (p. 16) A wall construction method combining upright branches, woven with twigs (wattles) and plastered or filled with clay or mud (daub).

weft (p. 292) The horizontal threads in a woven piece of cloth. Weft threads are woven at right angles to and through the **warp** threads to make up the bulk of the decorative pattern. In carpets, the weft is often completely covered or formed by the rows of trimmed knots that form the carpet's soft surface.

westwork (p. 446) The monumental, west-facing entrance section of a Carolingian, Ottonian, or Romanesque church. The exterior consists of multiple stories between two towers; the interior includes an entrance vestibule, a chapel, and a series of **galleries** overlooking the **nave**.

white-ground (p. 141) A type of ancient Greek pottery in which the background color of the object was painted with a **slip** that turns white in the firing process. Figures and details were added by painting on or incising into this slip. White-ground wares were popular in the Classical period as funerary objects.

woodblock print (p. 591) A print made from one or more carved wooden blocks. In Japan, woodblock prints were made using multiple blocks carved in relief, usually with a block for each color in the finished print. See also **woodcut**.

woodcut (p. 592) A type of print made by carving a design into a wooden block. The ink is applied to the block with a roller. As the ink touches only on the surface areas and lines remaining between the carved-away parts of the block, it is these areas that make the print when paper is pressed against the inked block, leaving the carved-away parts of the design to appear blank. Also: the process by which the woodcut is made.

yaksha, yakshi (p. 301) The male (*yaksha*) and female (*yakshi*) nature spirits that act as agents of the Hindu gods. Their sculpted images are often found on Hindu temples and other sacred places, particularly at the entrances.

yamato-e (p. 374) A native style of Japanese painting developed during the twelfth and thirteenth centuries, distinguished from Japanese painting styles that emulate Chinese traditions.

ziggurat (p. 28) In ancient Mesopotamia, a tall stepped tower of earthen materials, often supporting a shrine.

Bibliography

Susan V. Craig, updated by Carrie L. McDade

This bibliography is composed of books in English that are suggested "further reading" titles. Most are available in good libraries, whether college, university, or public. Recently published works have been emphasized so that the research information would be current. There are three classifications of listings: general surveys and art history reference tools, including journals and Internet directories; surveys of large periods that encompass multiple chapters (ancient art in the Western tradition, European medieval art, European Renaissance through eighteenth-century art, modern art in the West, Asian art, and African and Oceanic art, and art of the Americas); and books for individual Chapters 1 through 33.

General Art History Surveys and Reference Tools

Adams, Laurie Schneider. *Art Across Time.* 4th ed. New York: McGraw-Hill, 2011.

Barnet, Sylvan. *A Short Guide to Writing about Art.* 10th ed. Upper Saddle River, NJ: Pearson/Prentice Hall, 2010.

Bony, Anne. *Design: History, Main Trends, Main Figures.* Edinburgh: Chambers, 2005.

Boström, Antonia. *Encyclopedia of Sculpture.* 3 vols. New York: Fitzroy Dearborn, 2004.

Broude, Norma, and Mary D. Garrard, eds. *Feminism and Art History: Questioning the Litany.* Icon Editions. New York: Harper & Row, 1982.

Chadwick, Whitney. *Women, Art, and Society.* 4th ed. New York: Thames & Hudson, 2007.

Chilvers, Ian, ed. *The Oxford Dictionary of Art.* 4th ed. New York: Oxford Univ. Press, 2009.

Curl, James Stevens. *A Dictionary of Architecture and Landscape Architecture.* 2nd ed. Oxford: Oxford Univ. Press, 2006.

Davies, Penelope J.E., et al. *Janson's History of Art: The Western Tradition.* 8th ed. Upper Saddle River, NJ: Prentice Hall, 2010.

The Dictionary of Art. Ed. Jane Turner. 34 vols. New York: Grove's Dictionaries, 1996.

Frank, Patrick, Duane Preble, and Sarah Preble. *Prebles' Artforms.* 10th ed. Upper Saddle River, NJ: Pearson/Prentice Hall, 2011.

Gaze, Delia, ed. *Dictionary of Women Artists.* 2 vols. London: Fitzroy Dearborn, 1997.

Griffiths, Antony. *Prints and Printmaking: An Introduction to the History and Techniques.* 2nd ed. London: British Museum Press, 1996.

Hadden, Peggy. *The Quotable Artist.* New York: Allworth Press, 2002.

Hall, James. *Dictionary of Subjects and Symbols in Art.* 2nd ed. Boulder, CO: Westview Press, 2008.

Holt, Elizabeth Gilmore, ed. *A Documentary History of Art.* 3 vols. New Haven: Yale Univ. Press, 1986.

Honour, Hugh, and John Fleming. *The Visual Arts: A History.* 7th ed. rev. Upper Saddle River, NJ: Pearson/Prentice Hall, 2010.

Johnson, Paul. *Art: A New History.* New York: HarperCollins, 2003.

Kemp, Martin, ed. *The Oxford History of Western Art.* Oxford: Oxford Univ. Press, 2000.

Kleiner, Fred S. *Gardner's Art through the Ages.* Enhanced 13th ed. Belmont, CA: Thomson/Wadsworth, 2011.

Kostof, Spiro. *A History of Architecture: Settings and Rituals.* 2nd ed. Revised Greg Castillo. New York: Oxford Univ. Press, 1995.

Mackenzie, Lynn. *Non-Western Art: A Brief Guide.* 2nd ed. Upper Saddle River, NJ: Pearson/Prentice Hall, 2001.

Marmor, Max, and Alex Ross, eds. *Guide to the Literature of Art History 2.* Chicago: American Library Association, 2005.

Onians, John, ed. *Atlas of World Art.* New York: Oxford Univ. Press, 2004.

Sayre, Henry M. *Writing about Art.* 6th ed. Upper Saddle River, NJ: Pearson/Prentice Hall, 2009.

Sed-Rajna, Gabrielle. *Jewish Art.* Trans. Sara Friedman and Mira Reich. New York: Abrams, 1997.

Slatkin, Wendy. *Women Artists in History: From Antiquity to the Present.* 4th ed. Upper Saddle River, NJ: Pearson/Prentice Hall, 2001.

Sutton, Ian. *Western Architecture: From Ancient Greece to the Present.* World of Art. New York: Thames & Hudson, 1999.

Trachtenberg, Marvin, and Isabelle Hyman. *Architecture, from Prehistory to Postmodernity.* 2nd ed. Upper Saddle River, NJ: Pearson/Prentice Hall, 2002.

Watkin, David. *A History of Western Architecture.* 4th ed. New York: Watson-Guptill, 2005.

Art History Journals: A Select List of Current Titles

African Arts. Quarterly. Los Angeles: Univ. of California at Los Angeles, James S. Coleman African Studies Center, 1967–.

American Art: The Journal of the Smithsonian American Art Museum. 3/year. Chicago: Univ. of Chicago Press, 1987–.

American Indian Art Magazine. Quarterly. Scottsdale, AZ: American Indian Art Inc., 1975–.

American Journal of Archaeology. Quarterly. Boston: Archaeological Institute of America, 1885–.

Antiquity: A Periodical of Archaeology. Quarterly. Cambridge: Antiquity Publications Ltd., 1927–.

Apollo: The International Magazine of the Arts. Monthly. London: Apollo Magazine Ltd., 1925–.

Architectural History. Annually. Farnham, UK: Society of Architectural Historians of Great Britain, 1958–.

Archives of American Art Journal. Quarterly. Washington, DC: Archives of American Art, Smithsonian Institution, 1960–.

Archives of Asian Art. Annually. New York: Asia Society, 1945–.

Ars Orientalis: The Arts of Asia, Southeast Asia, and Islam. Annually. Ann Arbor: Univ. of Michigan Dept. of Art History, 1954–.

Art Bulletin. Quarterly. New York: College Art Association, 1913–.

Art History: Journal of the Association of Art Historians. 5/year. Oxford: Blackwell Publishing Ltd., 1978–.

Art in America. Monthly. New York: Brant Publications Inc., 1913–.

Art Journal. Quarterly. New York: College Art Association, 1960–.

Art Nexus. Quarterly. Bogota, Colombia: Arte en Colombia Ltda, 1976–.

Art Papers Magazine. Bimonthly. Atlanta: Atlanta Art Papers Inc., 1976–.

Artforum International. 10/year. New York: Artforum International Magazine Inc., 1962–.

Artnews. 11/year. New York: Artnews LLC, 1902–.

Bulletin of the Metropolitan Museum of Art. Quarterly. New York: Metropolitan Museum of Art, 1905–.

Burlington Magazine. Monthly. London: Burlington Magazine Publications Ltd., 1903–.

Dumbarton Oaks Papers. Annually. Locust Valley, NY: J.J. Augustin Inc., 1940–.

Flash Art International. Bimonthly. Trevi, Italy: Giancarlo Politi Editore, 1980–.

Gesta. Semiannually. New York: International Center of Medieval Art, 1963–.

History of Photography. Quarterly. Abingdon, UK: Taylor & Francis Ltd., 1976–.

International Review of African American Art. Quarterly. Hampton, VA: International Review of African American Art, 1976–.

Journal of Design History. Quarterly. Oxford: Oxford Univ. Press, 1988–.

Journal of Egyptian Archaeology. Annually. London: Egypt Exploration Society, 1914–.

Journal of Hellenic Studies. Annually. London: Society for the Promotion of Hellenic Studies, 1880–.

Journal of Roman Archaeology. Annually. Portsmouth, RI: Journal of Roman Archaeology LLC, 1988–.

Journal of the Society of Architectural Historians. Quarterly. Chicago: Society of Architectural Historians, 1940–.

Journal of the Warburg and Courtauld Institutes. Annually. London: Warburg Institute, 1937–.

Leonardo: Art, Science, and Technology. 6/year. Cambridge, MA: MIT Press, 1968–.

Marg. Quarterly. Mumbai, India: Scientific Publishers, 1946–.

Master Drawings. Quarterly. New York: Master Drawings Association, 1963–.

October. Cambridge, MA: MIT Press, 1976–.

Oxford Art Journal. 3/year. Oxford: Oxford Univ. Press, 1978–.

Parkett. 3/year. Zürich, Switzerland: Parkett Verlag AG, 1984–.

Print Quarterly. Quarterly. London: Print Quarterly Publications, 1984–.

Simiolus: Netherlands Quarterly for the History of Art. Quarterly. Apeldoorn, Netherlands: Stichting voor Nederlandse Kunsthistorische Publicaties, 1966–.

Woman's Art Journal. Semiannually. Philadelphia: Old City Publishing Inc., 1980–.

Internet Directories for Art History Information: A Selected List

ARCHITECTURE AND BUILDING,
http://www.library.unlv.edu/arch/rsrce/webresources/
A directory of architecture websites collected by Jeanne Brown at the Univ. of Nevada at Las Vegas. Topical lists include architecture, building and construction, design, history, housing, planning, preservation, and landscape architecture. Most entries include a brief annotation and the last date the link was accessed by the compiler.

ART HISTORY RESOURCES ON THE WEB,
http://witcombe.sbc.edu/ARTHLinks.html
Authored by Professor Christopher L.C.E. Witcombe of Sweet Briar College in Virginia, since 1995, the site includes an impressive number of links for various art-historical eras as well as links to research resources, museums, and galleries. The content is frequently updated.

ART IN FLUX: A DIRECTORY OF RESOURCES FOR RESEARCH IN CONTEMPORARY ART,
http://www.boisestate.edu/art/artinflux/intro.html
Cheryl K. Shurtleff of Boise State Univ. in Idaho has authored this directory, which includes sites selected according to their relevance to the study of national or international contemporary art and artists. The subsections include artists, museums, theory, reference, and links.

ARTCYCLOPEDIA: THE GUIDE TO GREAT ART ON THE INTERNET,
http://www.artcyclopedia.com
With more than 2,100 art sites and 75,000 links, this is one of the most comprehensive Web directories for artists and art topics. The primary search is by artist's name but access is also available by title of artwork, artistic movement, museums and galleries, nationality, period, and medium.

MOTHER OF ALL ART AND ART HISTORY LINKS PAGES,
http://umich.edu/~motherha
Maintained by the Dept. of the History of Art at the Univ. of Michigan, this directory covers art history departments, art museums, fine arts schools and departments, as well as links to research resources. Each entry includes annotations.

VOICE OF THE SHUTTLE,
http://vos.ucsb.edu
Sponsored by Univ. of California, Santa Barbara, this directory includes more than 70 pages of links to humanities and humanities-related resources on the Internet. The structured guide includes specific subsections on architecture, on art (modern and contemporary), and on art history. Links usually include a one-sentence explanation and the resource is frequently updated with new information.

ARTBABBLE,
http://www.artbabble.org/
An online community created by staff at the Indianapolis Museum of Art to showcase art-based video content, including interviews with artists and curators, original documentaries, and art installation videos. Partners and contributors to the project include Art21, Los Angeles County Museum of Art, The Museum of Modern Art, The New York Public Library, San Francisco Museum of Modern Art, and Smithsonian American Art Museum.

YAHOO! ARTS>ART HISTORY,
http://dir.yahoo.com/Arts/Art_History/
Another extensive directory of art links organized into subdivisions with one of the most extensive being "Periods and Movements." Links include the name of the site as well as a few words of explanation.

European Medieval Art, General

Backman, Clifford R. *The Worlds of Medieval Europe.* 2nd ed. New York: Oxford Univ. Press, 2009.

Bennett, Adelaide Louise, et al. *Medieval Mastery: Book Illumination from Charlemagne to Charles the Bold: 800–1475.* Trans. Lee Preedy and Greta Arblaster-Holmer. Turnhout: Brepols, 2002.

Benton, Janetta R. *Art of the Middle Ages.* World of Art. New York: Thames & Hudson, 2002.

Binski, Paul. *Painters.* Medieval Craftsmen. London: British Museum Press, 1991.

Brown, Sarah, and David O'Connor. *Glass-painters.* Medieval Craftsmen. London: British Museum Press, 1991.

Calkins, Robert G. *Medieval Architecture in Western Europe: From A.D. 300 to 1500.* New York: Oxford Univ. Press, 1998.

Cherry, John F. *Goldsmiths.* Medieval Craftsmen. London: British Museum Press, 1992.

Clark, William W. *The Medieval Cathedrals.* Westport, CT: Greenwood Press, 2006.

Coldstream, Nicola. *Masons and Sculptors.* Medieval Craftsmen. London: British Museum Press, 1991.

———. *Medieval Architecture.* Oxford History of Art. Oxford: Oxford Univ. Press, 2002.

De Hamel, Christopher. *Scribes and Illuminators.* Medieval Craftsmen. London: British Museum Press, 1992.

Duby, Georges. *Art and Society in the Middle Ages.* Trans. Jean Birrell. Malden, MA: Blackwell, 2000.

Fossier, Robert, ed. *The Cambridge Illustrated History of the Middle Ages.* Trans. Janet Sondheimer and Sarah Hanbury Tenison. 3 vols. Cambridge: Cambridge Univ. Press, 1986–97.

Hürlimann, Martin, and Jean Bony. *French Cathedrals.* Rev. & enlarged ed. London: Thames & Hudson, 1967.

Jotischky, Andrew, and Caroline Susan Hull. *The Penguin Historical Atlas of the Medieval World.* New York: Penguin, 2005.

Kenyon, John. *Medieval Fortifications.* Leicester: Leicester Univ. Press, 1990.

Pfaffenbichler, Matthias. *Armourers.* Medieval Craftsmen. London: British Museum Press, 1992.

Rebold Benton, Janetta. *Art of the Middle Ages.* World of Art. New York: Thames & Hudson, 2002.

Rudolph, Conrad, ed. *A Companion to Medieval Art.* Blackwell Companions to Art History. Oxford: Blackwell, 2006.

Sekules, Veronica. *Medieval Art.* Oxford History of Art. New York: Oxford Univ. Press, 2001.

Snyder, James, Henry Luttikhuizen, and Dorothy Verkerk. *Art of the Middle Ages.* 2nd ed. Upper Saddle River, NJ: Pearson/Prentice Hall, 2006.

Staniland, Kay. *Embroiderers.* Medieval Craftsmen. London: British Museum Press, 1991.

Stokstad, Marilyn. *Medieval Art.* 2nd ed. Boulder, CO: Westview Press, 2004.

———. *Medieval Castles.* Greenwood Guides to Historic Events of the Medieval World. Westport, CT: Greenwood Press, 2005.

European Renaissance through Eighteenth-Century Art, General

Black, C.F., et al. *Cultural Atlas of the Renaissance.* New York: Prentice Hall, 1993.

Blunt, Anthony. *Art and Architecture in France, 1500–1700.* 5th ed. Revised Richard Beresford. Pelican History of Art. New Haven: Yale Univ. Press, 1999.

Brown, Jonathan. *Painting in Spain: 1500–1700.* Pelican History of Art. New Haven: Yale Univ. Press, 1998.

Cole, Bruce. *Studies in the History of Italian Art, 1250–1550.* London: Pindar Press, 1996.

Graham-Dixon, Andrew. *Renaissance.* Berkeley: Univ. of California Press, 1999.

Harbison, Craig. *The Mirror of the Artist: Northern Renaissance Art in Its Historical Context.* Perspectives. New York: Abrams, 1995.

Harris, Ann Sutherland. *Seventeenth-Century Art & Architecture.* 2nd ed. Upper Saddle River, NJ: Pearson/Prentice Hall, 2008.

Harrison, Charles, Paul Wood, and Jason Gaiger. *Art in Theory 1648–1815: An Anthology of Changing Ideas.* Oxford: Blackwell, 2000.

Hartt, Frederick, and David G. Wilkins. *History of Italian Renaissance Art: Painting, Sculpture, Architecture.* 7th ed. Upper Saddle River, NJ: Pearson/Prentice Hall, 2011.

Jestaz, Bertrand. *The Art of the Renaissance.* Trans. I. Mark Paris. New York: Abrams, 1994.

Minor, Vernon Hyde. *Baroque & Rococo: Art & Culture.* New York: Abrams, 1999.

Paoletti, John T., and Gary M. Radke. *Art in Renaissance Italy.* 3rd ed. Upper Saddle River, NJ: Pearson/Prentice Hall, 2005.

Smith, Jeffrey Chipps. *The Northern Renaissance.* Art & Ideas. London and New York: Phaidon Press, 2004.

Stechow, Wolfgang. *Northern Renaissance, 1400–1600: Sources and Documents.* Upper Saddle River, NJ: Pearson/Prentice Hall, 1966.

Summerson, John. *Architecture in Britain, 1530–1830.* 9th ed. Pelican History of Art. New Haven: Yale Univ. Press, 1993.

Waterhouse, Ellis K. *Painting in Britain, 1530–1790.* 5th ed. Pelican History of Art. New Haven: Yale Univ. Press, 1994.

Whinney, Margaret Dickens. *Sculpture in Britain: 1530–1830.* 2nd ed. Revised John Physick. Pelican History of Art. London: Penguin, 1988.

Chapter 7 Jewish and Early Christian Art

Age of Spirituality: Late Antique and Early Christian Art, Third to Seventh Century. New York: Metropolitan Museum of Art, 1979.

Beckwith, John. *Early Christian and Byzantine Art.* 2nd ed. Pelican History of Art. New Haven: Yale Univ. Press, 1986.

Bleiberg, Edward, ed. *Tree of Paradise: Jewish Mosaics from the Roman Empire.* Brooklyn: Brooklyn Museum, 2005.

Cioffarelli, Ada. *Guide to the Catacombs of Rome and Its Surroundings.* Rome: Bonsignori, 2000.

Fine, Steven. *Art and Judaism in the Greco–Roman World: Toward a New Jewish Archaeology.* New York: Cambridge Univ. Press, 2005.

Hachlili, Rachel. *Ancient Mosaic Pavements: Themes, Issues, and Trends.* Leiden: Brill, 2009.

Jensen, Robin Margaret. *Understanding Early Christian Art.* New York: Routledge, 2000.

Krautheimer, Richard, and Slobodan Curcic. *Early Christian and Byzantine Architecture.* 4th ed. Pelican History of Art. New Haven: Yale Univ. Press, 1992.

Levine, Lee I., and Zeev Weiss, eds. *From Dura to Sepphoris: Studies in Jewish Art and Society in Late Antiquity.* Journal of Roman Archaeology: Supplementary Series, no. 40. Portsmouth, RI: Journal of Roman Archaeology, 2000.

Lowden, John. *Early Christian and Byzantine Art.* Art & Ideas. London: Phaidon Press, 1997.

Mathews, Thomas F. *The Clash of Gods: A Reinterpretation of Early Christian Art.* Rev. ed. Princeton, NJ: Princeton Univ. Press, 1999.

Olin, Margaret. *The Nation without Art: Examining Modern Discourses on Jewish Art.* Lincoln: Univ. of Nebraska Press, 2001.

Olsson, Birger, and Magnus Zetterholm, eds. *The Ancient Synagogue from Its Origins until 200 C.E.: Papers Presented at an International Conference at Lund University, October 14–17, 2001.* Coniectanea Biblica: New Testament Series, 39. Stockholm: Almqvist & Wiksell International, 2003.

Rutgers, Leonard V. *Subterranean Rome: In Search of the Roots of Christianity in the Catacombs of the Eternal City.* Leuven: Peeters, 2000.

Sed-Rajna, Gabrielle. *Jewish Art.* Trans. Sara Friedman and Mira Reich. New York: Abrams, 1997.

Spier, Jeffrey, ed. *Picturing the Bible: The Earliest Christian Art.* New Haven: Yale Univ. Press, 2007.

Tadgell, Christopher. *Imperial Space: Rome, Constantinople and the Early Church.* New York: Whitney Library of Design, 1998.

Webb, Matilda. *The Churches and Catacombs of Early Christian Rome: A Comprehensive Guide.* Brighton, UK: Sussex Academic Press, 2001.

Weitzmann, Kurt. *Late Antique and Early Christian Book Illumination.* New York: Braziller, 1977.

Wharton, Annabel Jane. *Refiguring the Post-Classical City: Dura Europos, Jerash, Jerusalem and Ravenna.* Cambridge: Cambridge Univ. Press, 1995.

White, L. Michael. *The Social Origins of Christian Architecture.* 2 vols. Baltimore, MD: Johns Hopkins Univ. Press, 1990.

Chapter 8 Byzantine Art

Beckwith, John. *Early Christian and Byzantine Art.* 2nd ed. Pelican History of Art. New Haven: Yale Univ. Press, 1986.

Cormack, Robin. *Byzantine Art.* Oxford: Oxford Univ. Press, 2000.

———, and Maria Vassilaki, eds. *Byzantium, 330–1453.* London: Royal Academy of Arts, 2008.

Cutler, Anthony. *The Hand of the Master: Craftsmanship, Ivory, and Society in Byzantium 9th–11th Centuries.* Princeton, NJ: Princeton Univ. Press, 1994.

Durand, Jannic. *Byzantine Art.* Paris: Terrail, 1999.

Eastmond, Antony, and Liz James, eds. *Icon and Word: The Power of Images in Byzantium: Studies Presented to Robin Cormack.* Burlington, VT: Ashgate, 2003.

Evans, Helen C., ed. *Byzantium: Faith and Power (1261–1557).* New York: Metropolitan Museum of Art, 2004.

———, and William D. Wixom, eds. *The Glory of Byzantium: Art and Culture of the Middle Byzantine era, A.D. 843–1261.* New York: Abrams, 1997.

Freely, John. *Byzantine Monuments of Istanbul.* Cambridge & New York: Cambridge Univ. Press, 2004.

Gerstel, Sharon, and Robert Nelson. *Approaching the Holy Mountain: Art and Liturgy at St. Catherine's Monastery in the Sinai.* Turnhout: Brepols, 2010.

Grabar, André. *Byzantine Painting: Historical and Critical Study.* Trans. Stuart Gilbert. New York: Rizzoli, 1979.

Kitzinger, Ernst. *The Art of Byzantium and the Medieval West: Selected Studies.* Ed. W. Eugene Kleinbauer. Bloomington: Indiana Univ. Press, 1976.

———. *Byzantine Art in the Making: Main Lines of Stylistic Development in Mediterranean Art, 3rd–7th Century.* Cambridge, MA: Harvard Univ. Press, 1977.

Kleinbauer, W. Eugene. *Hagia Sophia.* London: Scala, 2004.

Krautheimer, Richard, and Slobodan Curcic. *Early Christian and Byzantine Architecture.* 4th ed. Pelican History of Art. New Haven: Yale Univ. Press, 1992.

Lowden, John. *Early Christian and Byzantine Art.* Art & Ideas. London: Phaidon Press, 1997.

Maguire, Henry. *The Icons of Their Bodies: Saints and Their Images in Byzantium.* Princeton, NJ: Princeton Univ. Press, 1996.

Mainstone, Rowland J. *Hagia Sophia: Architecture, Structure and Liturgy of Justinian's Great Church.* 2nd ed. New York: Thames & Hudson, 2001.

Mango, Cyril. *Art of the Byzantine Empire, 312–1453: Sources and Documents.* Upper Saddle River, NJ: Pearson/Prentice Hall, 1972.

Mathews, Thomas F. *Byzantium: From Antiquity to the Renaissance.* Perspectives. New York: Abrams, 1998.

Ousterhout, Robert. *Master Builders of Byzantium.* Princeton, NJ: Princeton Univ. Press, 1999.

Pentcheva, Bissera. *The Sensual Icon: Space, Ritual, and the Senses in Byzantium.* University Park: Pennsylvania State Univ. Press, 2010.

Procopius, with an English translation by H.B. Dewing. 7 vols. Loeb Classical Library. Cambridge, MA: Harvard Univ. Press, 1940.

Rodley, Lyn. *Byzantine Art and Architecture: An Introduction.* Cambridge: Cambridge Univ. Press, 1994.

Weitzmann, Kurt. *Place of Book Illumination in Byzantine Art.* Princeton, NJ: Art Museum, Princeton Univ., 1975.

Chapter 9 Islamic Art

Al-Faruqi, Isma'il R., and Lois Ibsen Al-Faruqi. *Cultural Atlas of Islam.* New York: Macmillan, 1986.

Atil, Esin. *The Age of Sultan Suleyman the Magnificent.* Washington, DC: National Gallery of Art, 1987.

Baker, Patricia L. *Islam and the Religious Arts.* London: Continuum, 2004.

Barry, Michael A. *Figurative Art in Medieval Islam and the Riddle of Bihzâd of Herât (1465–1535).* Paris: Flammarion, 2004.

Blair, Sheila S., and Jonathan Bloom. *The Art and Architecture of Islam 1250–1800.* Pelican History of Art. New Haven: Yale Univ. Press, 1995.

Dodds, Jerrilynn D., ed. *Al-Andalus: The Art of Islamic Spain.* New York: Metropolitan Museum of Art, 1992.

Ecker, Heather. *Caliphs and Kings: The Art and Influence of Islamic Spain.* Washington, DC: Arthur M. Sackler Gallery, 2004.

Ettinghausen, Richard, Oleg Grabar, and Marilyn Jenkins-Madina. *Islamic Art and Architecture, 650–1250.* 2nd ed. Pelican History of Art. New Haven: Yale Univ. Press, 2001.

Frishman, Martin, and Hasan-Uddin Khan. *The Mosque: History, Architectural Development and Regional Diversity.* London: Thames & Hudson, 1994.

Grabar, Oleg. *The Formation of Islamic Art.* Rev. and enl. New Haven: Yale Univ. Press, 1987.

———. *The Great Mosque of Isfahan.* New York: New York Univ. Press, 1990.

———. *Islamic Visual Culture, 1100–1800.* Burlington, VT: Ashgate, 2006.

———. *Mostly Miniatures: An Introduction to Persian Painting.* Princeton, NJ: Princeton Univ. Press, 2000.

———, Mohammad Al-Asad, Abeer Audeh, and Said Nuseibeh. *The Shape of the Holy: Early Islamic Jerusalem.* Princeton, NJ: Princeton Univ. Press, 1996.

Hillenbrand, Robert. *Islamic Art and Architecture.* World of Art. London: Thames & Hudson, 1999.

Irwin, Robert. *The Alhambra.* Cambridge, MA: Harvard Univ. Press, 2004.

Khalili, Nasser D. *Visions of Splendour in Islamic Art and Culture.* London: Worth Press, 2008.

Komaroff, Linda, and Stefano Carboni, eds. *The Legacy of Genghis Khan: Courtly Art and Culture in Western Asia, 1256–1353.* New York: Metropolitan Museum of Art, 2002.

Lentz, Thomas W., and Glenn D. Lowry. *Timur and the Princely Vision: Persian Art and Culture in the Fifteenth Century.* Los Angeles: Los Angeles County Museum of Art, 1989.

Necipolu, Gülru. *The Age of Sinan: Architectural Culture in the Ottoman Empire.* Princeton, NJ: Princeton Univ. Press, 2005.

Petruccioli, Attilio, and Khalil K. Pirani, eds. *Understanding Islamic Architecture.* New York: Routledge Curzon, 2002.

Roxburgh, David J., ed. *Turks: A Journey of a Thousand Years, 600–1600.* London: Royal Academy of Arts, 2005.

Sims, Eleanor, B.I. Marshak, and Ernst J. Grube. *Peerless Images: Persian Painting and Its Sources.* New Haven: Yale Univ. Press, 2002.

Stanley, Tim, Mariam Rosser-Owen, and Stephen Vernoit. *Palace and Mosque: Islamic Art from the Middle East.* London: V&A Publications, 2004.

Stierlin, Henri. *Islamic Art and Architecture.* New York: Thames & Hudson, 2002.

Tadgell, Christopher. *Four Caliphates: The Formation and Development of the Islamic Tradition.* London: Ellipsis, 1998.

Ward, R.M. *Islamic Metalwork.* New York: Thames & Hudson, 1993.

Watson, Oliver. *Ceramics from Islamic Lands.* New York: Thames & Hudson in assoc. with the al-Sabah Collection, Dar al-Athar al-Islamiyyah, Kuwait National Museum, 2004.

Chapter 15 Early Medieval Art in Europe

Alexander, J.J.G. *Medieval Illuminators and Their Methods of Work.* New ed. New Haven: Yale Univ. Press, 1994.

The Art of Medieval Spain, A.D. 500–1200. New York: Metropolitan Museum of Art, 1993.

Backhouse, Janet, D.H. Turner, and Leslie Webster, eds. *The Golden Age of Anglo-Saxon Art, 966–1066.* Bloomington: Indiana Univ. Press, 1984.

Bandmann, Günter. *Early Medieval Architecture as Bearer of Meaning.* New York: Columbia Univ. Press, 2005.

Brown, Michelle P. *The Lindisfarne Gospels: Society, Spirituality and the Scribe.* Toronto: Univ. of Toronto Press, 2003.

Calkins, Robert G. *Illuminated Books of the Middle Ages.* Ithaca, NY: Cornell Univ. Press, 1983.

Carver, Martin. *Sutton Hoo: A Seventh-Century Princely Burial Ground and Its Context.* London: British Museum Press, 2005.

Davis-Weyer, Caecilia. *Early Medieval Art, 300–1150: Sources and Documents.* Upper Saddle River, NJ: Pearson/Prentice Hall, l971.

Diebold, William J. *Word and Image: An Introduction to Early Medieval Art.* Boulder, CO: Westview Press, 2000.

Dodwell, C.R. *Pictorial Arts of the West, 800–1200.* Pelican History of Art. New Haven: Yale Univ. Press, 1993.

Farr, Carol. *The Book of Kells: Its Function and Audience.* London: British Library, 1997.

Fitzhugh, William W., and Elisabeth I. Ward, eds. *Vikings: The North Atlantic Saga.* Washington, DC: Smithsonian Institution Press, 2000.

Harbison, Peter. *The Golden Age of Irish Art: The Medieval Achievement, 600–1200.* London: Thames & Hudson, 1999.

Henderson, George. *From Durrow to Kells: The Insular Gospel-Books, 650–800.* London: Thames & Hudson, 1987.

Horn, Walter W., and Ernest Born. *Plan of Saint Gall: A Study of the Architecture and Economy of and Life in a Paradigmatic Carolingian Monastery.* California Studies in the History of Art, 19. 3 vols. Berkeley: Univ. of California Press, 1979.

Lasko, Peter. *Ars Sacra, 800–1200.* 2nd ed. Pelican History of Art. New Haven: Yale Univ. Press, 1994.

McClendon, Charles B. *The Origins of Medieval Architecture: Building in Europe, A.D. 600–900.* New Haven: Yale Univ. Press, 2005.

Mayr-Harting, Henry. *Ottonian Book Illumination: An Historical Study.* 2nd rev. ed. 2 vols. London: Harvey Miller, 1999.

Mentré, Mireille. *Illuminated Manuscripts of Medieval Spain.* New York: Thames & Hudson, 1996.

Nees, Lawrence. *Early Medieval Art.* Oxford History of Art. Oxford: Oxford Univ. Press, 2002.

Richardson, Hilary, and John Scarry. *An Introduction to Irish High Crosses.* Dublin: Mercier, 1990.

Schapiro, Meyer. *Language of Forms: Lectures on Insular Manuscript Art.* Ed. Jane Rosenthal. New York: Pierpont Morgan Library, 2006.

Stalley, R.A. *Early Medieval Architecture.* Oxford History of Art. Oxford: Oxford Univ. Press, 1999.

Wickham, Chris. *Framing the Early Middle Ages: Europe and the Mediterranean 400–800.* New York: Oxford Univ. Press, 2005.

Williams, John. *Early Spanish Manuscript Illumination.* New York: Braziller, 1977.

Wilson, David M. *Anglo-Saxon Art: From the Seventh Century to the Norman Conquest.* London: Thames & Hudson, 1984.

———, and Ole Klindt-Jensen. *Viking Art.* 2nd ed. Minneapolis: Univ. of Minnesota Press, 1980.

Chapter 16 Romanesque Art

Barral i Altet, Xavier. *The Romanesque: Towns, Cathedrals and Monasteries.* Taschen's World Architecture. New York: Taschen, 1998.

The Book of Sainte Foy. Ed. and trans. Pamela Sheingorn. Philadelphia: Univ. of Pennsylvania Press, 1995.

Cahn, Walter. *Romanesque Manuscripts: The Twelfth Century.* 2nd ed. 2 vols. A Survey of Manuscripts Illuminated in France. London: Harvey Miller, 1996.

Caviness, Madeline H. "Hildegard as Designer of the Illustrations to her Works." In *Hildegard of Bingen: The Context of her Thought and Art.* Ed. Charles Burnett and Peter Dronke. London: Warburg Institute, 1998: 29–63.

Davis-Weyer, Caecilia. *Early Medieval Art, 300–1150. Sources and Documents.* Upper Saddle River, NJ: Pearson/Prentice Hall, 1971.

Dimier, Anselme. *Stones Laid before the Lord: A History of Monastic Architecture.* Trans. Gilchrist Lavigne. Cistercian Studies Series, no. 152. Kalamazoo, MI: Cistercian Publications, 1999.

Fergusson, Peter. *Architecture of Solitude: Cistercian Abbeys in Twelfth-Century England.* Princeton, NJ: Princeton Univ. Press, 1984.

Forsyth, Ilene H. *The Throne of Wisdom: Wood Sculptures of the Madonna in Romanesque France.* Princeton, NJ: Princeton Univ. Press, 1972.

Gaud, Henri, and Jean-François Leroux-Dhuys. *Cistercian Abbeys: History and Architecture.* Cologne: Könemann, 1998.

Gerson, Paula, ed. *The Pilgrim's Guide to Santiago de Compostela: A Critical Edition.* 2 vols. London: Harvey Miller, 1998.

Grivot, Denis, and George Zarnecki. *Gislebertus: Sculptor of Autun.* New York: Orion Press, 1961.

Hearn, M. F. *Romanesque Sculpture: The Revival of Monumental Stone Sculptures in the Eleventh and Twelfth Centuries.* Ithaca, NY: Cornell Univ. Press, 1981.

Hicks, Carola. *The Bayeux Tapestry: The Life Story of a Masterpiece.* London: Chatto & Windus, 2006.

Holt, Elizabeth Gilmore, ed. *A Documentary History of Art.* 2 vols. Princeton, NJ: Princeton Univ. Press, 1982–86.

Hourihane, Colum, ed. *Romanesque Art and Thought in the Twelfth Century: Essays in Honor of Walter Cahn.* The Index of Christian Art Occasional Papers 10. University Park, PA: Penn State Press, 2008.

Kubach, Hans E. *Romanesque Architecture.* History of World Architecture. New York: Electa/Rizzoli, 1988.

Minne-Sève, Viviane, and Hervé Kergall. *Romanesque and Gothic France: Architecture and Sculpture.* Trans. Jack Hawkes and Lory Frankel. New York: Abrams, 2000.

Newman, Barbara. *Sister of Wisdom: St. Hildegard's Theology of the Feminine.* 2nd ed. Berkeley: Univ. of California Press, 1997.

Rudolph, Conrad. *The "Things of Greater Importance": Bernard of Clairvaux's Apologia and the Medieval Attitude Toward Art.* Philadelphia: Univ. of Pennsylvania Press, 1990.

Schapiro, Meyer. *Romanesque Art: Selected Papers.* New York: George Braziller, 1977.

———. *The Romanesque Sculpture of Moissac.* New York: Braziller, 1985.

———. *Romanesque Architectural Sculpture: The Charles Eliot Norton Lectures.* Ed. Linda Seidel. Chicago: Univ. of Chicago Press, 2006.

Seidel, Linda. *Legends in Limestone: Lazarus, Gislebertus, and the Cathedral of Autun.* Chicago: Univ. of Chicago Press, 1999.

Sundell, Michael G. *Mosaics in the Eternal City.* Tempe: Arizona Center for Medieval and Renaissance Studies, 2007.

Swanson, R.N. *The Twelfth-Century Renaissance.* Manchester: Manchester Univ. Press, 1999.

Theophilus. *On Divers Arts: The Foremost Medieval Treatise on Painting, Glassmaking, and Metalwork.* Trans. John G. Hawthorne and Cyril Stanley Smith. New York: Dover, 1979.

Toman, Rolf, ed. *Romanesque: Architecture, Sculpture, Painting.* Trans. Fiona Hulse and Ian Macmillan. Cologne: Könemann, 1997.

Wilson, David M. *The Bayeux Tapestry: The Complete Tapestry in Color.* London: Thames & Hudson and New York: Knopf, 2004.

Zarnecki, George, Janet Holt, and Tristram Holland, eds. *English Romanesque Art, 1066–1200.* London: Weidenfeld and Nicolson, 1984.

Chapter 17 Gothic Art of the Twelfth and Thirteenth Centuries

Barnes, Carl F. *The Portfolio of Villard de Honnecourt: A New Critical Edition and Color Facsimile.* Burlington, VT: Ashgate, 2009.

Binding, Günther. *High Gothic: The Age of the Great Cathedrals.* Taschen's World Architecture. London: Taschen, 1999.

Binski, Paul. *Becket's Crown: Art and Imagination in Gothic England, 1170–1300.* New Haven: Yale Univ. Press, 2004.

Bony, Jean. *French Gothic Architecture of the 12th and 13th Centuries.* California Studies in the History of Art, 20. Berkeley: Univ. of California Press, 1983.

Camille, Michael. *Gothic Art: Glorious Visions.* Perspectives. New York: Abrams, 1996.

Coldstream, Nicola. *Masons and Sculptors.* Toronto & Buffalo, NY: Univ. of Toronto Press, 1991.

Crosby, Sumner M. *The Royal Abbey of Saint-Denis from Its Beginnings to the Death of Suger, 475–1151.* Yale Publications in the History of Art, 37. New Haven: Yale Univ. Press, 1987.

Erlande-Brandenburg, Alain. *Gothic Art.* Trans. I. Mark Paris. New York: Abrams, 1989.

Frankl, Paul. *Gothic Architecture.* Revised Paul Crossley. Pelican History of Art. New Haven: Yale Univ. Press, 2000.

Frisch, Teresa G. *Gothic Art, 1140–c.1450: Sources and Documents.* Upper Saddle River, NJ: Pearson/Prentice Hall, 1971.

Grodecki, Louis, and Catherine Brisac. *Gothic Stained Glass, 1200–1300.* Ithaca, NY: Cornell Univ. Press, 1985.

Jordan, Alyce A. *Visualizing Kingship in the Windows of the Sainte-Chapelle.* Turnhout: Brepols, 2002.

Moskowitz, Anita Fiderer. *Nicola & Giovanni Pisano: The Pulpits: Pious Devotion, Pious Diversion.* London: Harvey Miller, 2005.

Nussbaum, Norbert. *German Gothic Church Architecture.* Trans. Scott Kleager. New Haven: Yale Univ. Press, 2000.

Panofsky, Erwin. *Abbot Suger on the Abbey Church of St.-Denis and Its Art Treasures.* 2nd ed. Ed. Gerda Panofsky-Soergel. Princeton, NJ: Princeton Univ. Press, 1979.

Parry, Stan. *Great Gothic Cathedrals of France.* New York: Viking Studio, 2001.

Sauerländer, Willibald. *Gothic Sculpture in France, 1140–1270.* Trans. Janet Sandheimer. London: Thames & Hudson, 1972.

Scott, Robert A. *The Gothic Enterprise: A Guide to Understanding the Medieval Cathedral.* Berkeley: Univ. of California Press, 2003.

Simson, Otto Georg von. *The Gothic Cathedral: Origins of Gothic Architecture and the Medieval Concept of Order.* 3rd ed. exp. Bollingen Series. Princeton, NJ: Princeton Univ. Press, 1988.

Suckale, Robert, and Matthias Weniger. *Painting of the Gothic Era.* Ed. Ingo F. Walther. New York: Taschen, 1999.

Williamson, Paul. *Gothic Sculpture, 1140–1300.* Pelican History of Art. New Haven: Yale Univ. Press, 1995.

Chapter 18 Fourteenth-Century Art in Europe

Alexander, Jonathan, and Paul Binski, eds. *Age of Chivalry: Art in Plantagenet England, 1200–1400.* London: Royal Academy of Arts, 1987.

Backhouse, Janet. *Illumination from Books of Hours.* London: British Library, 2004.

Boehm, Barbara Drake, and Jiří Fajt, eds. *Prague: The Crown of Bohemia, 1347–1437.* New York: Metropolitan Museum of Art, 2005.

Bony, Jean. *The English Decorated Style: Gothic Architecture Transformed, 1250–1350.* The Wrightsman Lecture, 10. Oxford: Phaidon Press, 1979.

Cennini, Cennino. *The Craftsman's Handbook "Il libro dell'arte."* Trans. D.V. Thompson, Jr. New York: Dover, 1960.

Derbes, Anne, and Mark Sandona, eds. *The Cambridge Companion to Giotto.* Cambridge and New York: Cambridge Univ. Press, 2003.

Fajt, Jiří, ed. *Magister Theodoricus, Court Painter to Emperor Charles IV: The Pictorial Decoration of the Shrines at Karlstejn Castle.* Prague: National Gallery, 1998.

Holt, Elizabeth Gilmore, ed. *A Documentary History of Art.* 2 vols. Princeton, NJ, Princeton Univ. Press, 1982–86.

Ladis, Andrew. ed, *The Arena Chapel and the Genius of Giotto: Padua.* Giotto and the World of Early Italian Art, 2. New York: Garland, 1998.

Meiss, Millard. *Painting in Florence and Siena after the Black Death: The Arts, Religion, and Society in the Mid-Fourteenth Century.* 2nd ed. Princeton, NJ: Princeton Univ. Press, 1978.

Moskowitz, Anita Fiderer. *Italian Gothic Sculpture: c. 1250–c. 1400.* New York: Cambridge Univ. Press, 2001.

Norman, Diana, ed. *Siena, Florence, and Padua: Art, Society, and Religion 1280–1400.* 2 vols. New Haven: Yale Univ. Press, 1995.

Poeschke, Joachim. *Italian Frescoes, the Age of Giotto, 1280–1400.* New York: Abbeville Press, 2005.

Schleif, Corine. "St. Hedwig's Personal Ivory Madonna: Women's Agency and the Powers of Possessing Portable Figures." In *The Four Modes of Seeing: Approaches to Medieval Imagery in Honor of Madeline Harrison Caviness.* Eds. Evelyn Staudinger Lane, Elizabeth Carson Paston, and Ellen M. Shortell. Farnham, Surrey: Ashgate, 2009: 282–403.

Vasari, Giorgio. *The Lives of the Artists.* Trans. Julia Conaway Bondanella and Peter Bondanella. Oxford World's Classics. New York: Oxford Univ. Press, 2008.

Welch, Evelyn S. *Art in Renaissance Italy, 1350–1500.* New ed. Oxford History of Art. Oxford: Oxford Univ. Press, 2000.

White, John. *Art and Architecture in Italy, 1250 to 1400.* 3rd ed. Pelican History of Art. Harmondsworth, UK: Penguin, 1993.

Wieck, Roger S. *Time Sanctified: The Book of Hours in Medieval Art and Life.* 2nd ed. New York: Braziller, 2001.

Credits

Index

Figures in *italics* refer to illustrations and captions

Hitda Gospels 456, *456*
Lindau Gospels 450, *451, 452*
Lindisfarne Gospel Book *436*, 436–7, *437*
Gospels, the 220, 429
Gothic period/style 431, 495, 496–7
 architectural sculpture 500–2, *502, 509*, 509–10 (France)
 architecture 477; in Czech Republic *522*, 523; in England *518*, 518–20, *519*; in France 469, 470, 497, *498*, 498–500, *501*, 503, *503*, 504–5, *505*, 508, 508–9, 510, *510*, *511*, 512, *512*, 514; in Germany 520–21, *521*; in Italy 528, *528*
 illuminated manuscripts *514*, 514–15, *515* (French), 515, 516, *516*, *517*, 517–18 (English)
 map *496*
 sculpture *523*, 523–4 (German), *525*, 525–7, *526* (Italian), *see also* architectural sculpture (*above*)
 stained glass 476, *476*, *494*, 495, 499, *500*, 501, 503, 506, *506*, *507*, 508, 510, *510*, 512–13, *513*
Goths 430, 431
Gozbert of Saint Gall, Abbot 447
Granada, Spain: The Alhambra 280
 Court of the Lions 280, *280*
 Court of the Myrtles *268*, 280
 Hall of the Abencerrajes 280, *281*
 muqarna ornamentation *268*, 280, *281*
Gregorian chant 462, 466
Gregory I, Pope ("the Great") 435, 462
grisaille 540, 549, *551*
grozing 501
Guda: Book of Homilies 491, *491*
guilds, artisan 533
Gummersmark Brooch 433, *433*

H

Habsburg empire 452
Hagia Sophia, Istanbul (Anthemius of Tralles and Isidorus of Miletus) *235*, 235–6, *236*, *237*, 286
 Virgin and Child (mosaic) *248*, 248–9
Haito of Reichenau, Abbot 447
hajj 266, 271
al-Hakam II, Caliph 272
hall churches, German 521, *521*
haloes 215
Harald Bluetooth 442
Harbaville Triptych (Byzantine ivory) 255, *255*
Al-Hariri: *The Maqamat 264*, 265
Harold, King 488
Harvesting of Grapes (mosaic) 224, *224*, 226
Hasan, Mamluk Sultan 279
Hedwig, St. 558
Hedwig Codex *558*, 558–9
Hellinus, Abbot of Notre-Dame-aux-Fonts, Liège 487
Henry I, of England 490, *490*
Henry II, of England 497
Henry II, Ottonian king 454
Heraclius, Emperor 233
Herat, Afghanistan: painting school *285*, 285–6, 289
Herod the Great 217
Hiberno-Saxon art 433
 Gospel books *428*, 429, 435, *435*, *436*, 436–7, *437*
hijira 266
Hildegard of Bingen 492, *492*
 Liber Scivias 492, *492*

Hildesheim, Germany
 Doors of Bishop Bernward 454, *455*, 456
 St. Michael 453
historiated capitals *484*, 484–5, 501
historiated initials 491
Hitda Gospels (Ottonian) 456, *456*
Holy Roman Empire 452, 460, 520, 525, 557, 561
Honorius, Emperor 227, 228
Hosios Loukas Monastery Churches, Greece *249*, 249–50, *250*, *251*
Hospitality of Abraham, The (Rublyov) 262–3, *263*
house-church, early Christian 220, 221, *221*
Hugh de Semur, abbot of Cluny 466
humanists, Renaissance 431
Hundred Years' War (1337–1453) 533, 548, 554
Huns *430*, 431
Hurrem (Suleyman's wife) *288*
Hus, Jan 561
Husayn Bayqara, Sultan 285
Hussite Revolution 561
hypostyle mosques 268, 271, 272

I

Ibn al-Wasiti, Yahya: *The Maqamat of Al-Hariri 264*, 265
Ibn al-Zain, Muhammad: *Baptistery of St. Louis* (brass basin) 284, *284*
Iceland 444
iconoclasm/iconoclasts 247, *247*, 248
icons, Byzantine 246, 246–8, *257*, 257–8, 258, 262, 262–3, *263*
'Id al-Adha 271
'Id al-Fitr 271
Incarnation, the 230
India 267, 286
Infant Virgin Mary Caressed by Her Parents Joachim and Anna, The (Byzantine mosaic) 259, *262*
Innocent IV, Pope 512
International Gothic Style 510
Iona, Scotland: monastery 441
 see also Book of Durrow; Book of Kells
Iran 277, 286
 ceramics 276, *276*
 see also Isfahan
Iraq 269, 277, 286, *see also* Baghdad
Ireland
 high crosses 438, *438*
 see also Hiberno-Saxon art
Irene, Empress 247, 500
Isfahan, Iran 290
 Ali Qapu Pavilion *268*
 Madrasa Imami *mihrab* 282, *282*
 Masjid-i Shah 290, *290*
Isidorus of Miletus: Hagia Sophia, Istanbul *235*, 235–6, *236*, *237*
Islam 216, 266–8
 Five Pillars 271, 282
 map *267*
Islamic architecture *269*, 269–71, *270*, 277, *278*, 279, 280, *280*, *281*, 282, 282–3, *see also* mosques; Ottoman architecture
 and ornamentation 267, *268*, *270*, 270–71, 280, *281*, 281–2, *282*
Islamic art 266–7
 book production *284*, 284–6, *285*
 calligraphy and script *275*, 275–6, *276*, 279, 282, *282*, 283
 ceramics *276*, 276–7, *277*, *283*, 283–4
 metalwork 284, *284*

mosaics *268*, *270*, 270–71, 282, *282*
Isma'il, Shah 289
Istanbul
 Church of Christ in Chora (Kariye Müzesi) 258–9, 260, *260*, *261*, 262
 Hagia Sophia (Anthemius of Tralles and Isidorus of Miletus) *235*, 235–6, *236*, *237*, 248, 248–9, 286
 Topkapi Palace 286–7, *287*; Baghdad Kiosk 287, *288*
 see also Constantinople
Italy 460, 533
 architecture 469, 470, *470*, *471*, 471–2 (Romanesque), 528, *528* (Gothic), 533–4, *534*, 547, *547* (14th century)
 frescos 528–9, *529*, *530*, 531, 539–42, *540–42*, 547–8, *547–8* (13th–14th century)
 literature 532, 533, 539
 mosaics (Romanesque) 472, *472*
 painted crucifix 527, 527–8
 relief sculpture 478–9, *479* (Romanesque), *525*, 525–7, *526* (Gothic), 534, *535*, 536, *536* (14th century)
 tempera painting 536–7, *537*, *538*, 538–9, 542, *543*, *544*, 544–5, *545*, *546*, 547
ivories
 Byzantine *244*, 244–5, *255*, 255–6, *256*
 chest with scenes of romance (French) *552*, 552–3, *553*
 Magdeburg Ivories (Ottonian) 452, *452*
iwans 277, 290, *290*

J

Jelling, Denmark: rune stones 442, *442*
Jerome, St. 220
 Commentary on Isaiah 493, *493*
 Vulgate 223, *437*
Jerusalem 252, 460, 461
 Dome of the Rock 217, *268*, *269*, 269–71, *270*
 Holy Sepulcher 464
 Temples 217, 236
Jesse Trees 493, *493*
Jesus of Nazareth/Jesus Christ/Christ 216, 220, 271
 early depictions 215, 220, 221, *221*, 222, *222*, 226, 228, *229*
 life 230
jewelry
 Danish 433, *433*
 Merovingian 431–2, *432*
Jews/Jewish art 216–17, 221
 catacomb art 217, *217*
 mosaics 219, 220
 wall paintings 217–18, *218*
John, St. (evangelist) 220
John of Damascus 246
Jonah 222, *222*
Judaism 216, 246
 see also Torah
Judith Window, Sainte-Chapelle, Paris 512–13, *513*
Justinian I, Emperor 234, 235, 236, 238–9, 242, 429
Justinian and His Attendants (mosaic) 239, *241*, 242
Jutes *430*, 433

K

Kaaba, The (Mecca) 266, *266*, 271
Kairouan, Tunisia: Great Mosque 271, *271*, 274, 277
Karlstejn Castle, near Prague: Holy Cross Chapel *560*, 561